PAINT

A MANUAL OF PICTORIAL THOUGHT
AND PRACTICAL ADVICE

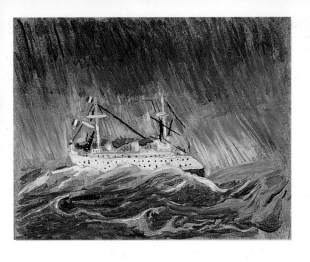

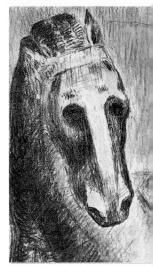

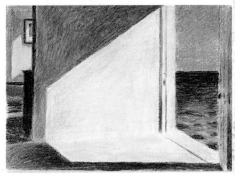

PAINT

A MANUAL OF PICTORIAL THOUGHT
AND PRACTICAL ADVICE

Jeffery Camp

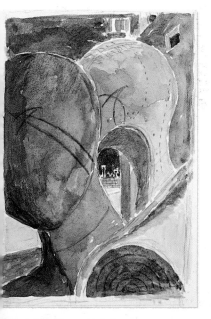

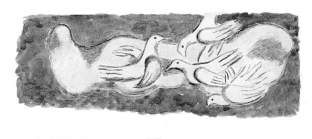

DK

To Dorothy and Alice

A DK PUBLISHING BOOK

Art editor Sasha Kennedy
Project editor Neil Lockley

Senior editor Louise Candlish
Editor Timothy Hyman
Senior art editor Tracy
Hambleton-Miles

Senior managing editor Sean Moore
Deputy art director Tina Vaughan

Production controller Meryl Silbert
Picture research Lorna Ainger
Photography Andy Crawford

First American Edition, 1996
2 4 6 8 10 9 7 5 3 1

Published in the United States by
DK Publishing, Inc.
95 Madison Avenue,
New York, New York 10016

Copyright © 1996
Dorling Kindersley Limited, London
Text copyright © 1996 Jeffery Camp

Published in Great Britain by Dorling Kindersley Limited.

Distributed by Houghton Mifflin Company, Boston.

Library of Congress Cataloging-in-Publication Data

Camp, Jeffery.
Paint / by Jeffery Camp. -- 1st American ed.
p. cm.
Includes index.
ISBN 0-7894-0633-0
1. Painting--Technique. I. Title.
ND1473.C35 1995
751.4--dc20 94-27485
 CIP
Color reproduction by Colourscan, Singapore

Printed in Singapore by Toppan

CONTENTS

FOREWORD 7

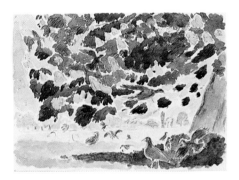

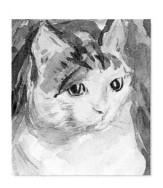

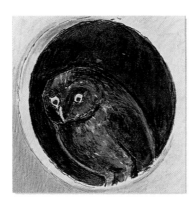

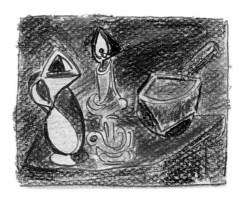

JEFFERY CAMP

Born at Oulton Broad, Suffolk, England, in 1923, Jeffery Camp was taught at Lowestoft, then Ipswich School of Art before moving to Edinburgh College of Art in 1941. He was taught by William Gillies and John Maxwell and received Andrew Grant bursaries for study and travel. He has painted every kind of picture – trees in Constable's Suffolk, portraits, nudes, seascapes, skaters, bathers, fishermen, rocking and jiving dancers, and a large altarpiece for a Norwich church. For a short period he did abstract pictures. In 1961, he was elected a member of the London Group, to which in those days almost every good British artist belonged. Between 1963 and 1988, he taught at the Slade School of Fine Art, London University.

Jeffery Camp has exhibited widely. He has had one-man shows at the Gallerie de Seine, London (1958), Beaux Arts Gallery, London, run by Helen Lessore (1959, 1961, 1963), New Art Centre, London (1968), South London Art Gallery (Retrospective) (1973), Serpentine Gallery (1978), Bradford City Art Gallery (1979), Browse and Darby, London (1984), Nigel Greenwood, London (1986–87), and Browse and Darby, London (1993). He has also contributed to many Arts Council touring exhibitions, such as "Drawings of People", "Narrative Painting", "The British Art Show" (1979), and "The Proper Study: Contemporary Figurative Painting from Britain" (1984–85). The Royal Academy held a retrospective of his work in 1988, which then toured to the Royal Albert Memorial Museum, Exeter (1988), City Art Gallery, Manchester (1988), Laing Art Gallery, Newcastle-upon-Tyne (1989), School of Art Gallery, Norwich (1989), City Art Gallery, York (1989), and Usher Gallery, Lincoln (1989).

Jeffery Camp's work was shown at the Hayward Annual (1974), in the exhibition "British Painting 1952–1977" at the Royal Academy (1977), the Chantrey Bicentenary exhibition at the Tate Gallery, London (1981), "The Hard-Won Image", Tate Gallery (1984), "Proud and Prejudiced", Twining Gallery, New York (1985), "Salute to Turner", Agnew's, London (1989), and "Nine Contemporary Painters", Bristol Art Gallery, (1990). Jeffery Camp has won prizes at the John Moore's Liverpool exhibition, the Chichester National Art Exhibition, and the International Drawing Biennale, Middlesborough. His work is in the collections of the Nuffield Organization, the Department of the Environment, the Contemporary Arts Society, the British Council, the Royal Academy Chantrey Bequest, the Arts Council, and several public art galleries, including the Tate Gallery, as well as being in many educational departments and private collections. Jeffery Camp was elected a member of the Royal Academy in 1974.

FOREWORD

This book balances paint and words. William Blake's books do it at a high level, and when he watercolours Dante's *Inferno*, the power is on. It is said over and over, you cannot teach painting. Please take a brush and prove that painting is as natural as breathing; for I am tired of eye titivations with no paint, of Dada revivalist arch combinations of tricky materials with no paint. When Alice Neel, using an uncouth style, portrays Andy Warhol stark, in a corset, she enjoys journalism in paint. Warhol preserved in formaldehyde would attract more attention. In the fashion blaze of today it is difficult to make the tiny delicate touches of paint made by the young Lucian Freud or Michael Andrews, the gentle purity of a Euan Uglow pear, the rainbow beauty of a black complexion paint-rubbed by Craigie Aitchison, or long brush-drags on raw flax canvas by Francis Bacon seem exciting.

To paint the sea, I travel by train from London to Brighton, I enjoy staring at the passengers; usually I do not need to speak. Beyond them is the world we live in: slices of river, back gardens, factories, and a lot of very beautiful rural England. My fellow passengers do not mind or notice the grimy windows. They read newspapers and discuss problems; their eyes collect matter but they are not experiencing visually.

There are about 1,500 images in the following pages. If you are as shy as I am you will only succumb to a few of them, but you will enjoy having a full brush.

Jeffery Camp

PREFACE
Copying, Practice, and Touch

WETTING THE WORLD WITH NEW PAINT will be glorious. They say you can teach drawing, but not painting. Most of us had one good teacher. Their teaching was verbal: school-books were informative, but sparsely illustrated. It is good that my publishers are specialists in combining words and pictures, and know how to make them flow. Soon all the world's children will be learning by word-images, as never before. Videos have also been excellent, but a book is read at a reader's pace, and can go with you anywhere: prison, beach, bathroom, train, or bed. Such a mass of words and images come together by the great skills of designers and editors. Probably, they secretly shudder at the inadequacy of my diagram-copies. But readers, more lenient, will concede that no reproduction will quite resemble a Titian. I hope they will rush to see the originals, and make their own fast, or long, copies.

> *I actually go and draw from pictures to remind myself of what quality is, and what is actually demanded of paintings.*
> Frank Auerbach

As a young artist, I thought copying was cheating. Children are "copycats", imitating each other's actions. It helps them to bully in the playground. Picasso bullied Velásquez by transform-copying his "Las Meninas" more than was necessary, and then said Goya and El Greco meant more to him. Copying is the way to find "the way".

> *I think one's only hope of doing things that have a new presence, or at least a new accent, is to know what exists, and to work one's way through it, and to know that it is not necessary to do that thing.*
> Frank Auerbach

Since I started writing this book, the "found object" no longer dominates the art scene. I believe paint is a good liquid for feeling, and there are enough young artists who know what paint can do, and will forgive my partial blindness to the metal objects, fats, kitsch, and assembled stuffs that some have found attractive. It was to some extent a "Dada Revival". Revivals are all around us: we fear "revival", and love "renaissance". But more than this, we seek the new. Take brushfuls of passion, and paint life as directly as the human voice is used in a Beatles song. Go in close, privately, intimately. If you paint a toenail, it can exist; be transcendental; ingrow; or become gangrenous. Whatever you know well can be a start, and you will surely paint new pictures. Be vulnerable, suffer, for paint has been spread for thousands of generations. It is one of the great languages of poetry.

Thames-side Chauvinism

London is a good city for painting in, and for finding out how to paint. Come to London. It is an enormous city. London is tight and varied, not as ornamental as Paris, not so built upward as New York. Not so archly – architect – dated as some cities. London is a hotch-potch. It is built so every building will deride its neighbour, and its inhabitants can love and insult one another at close range.

Anarchy thrives in this city, and what more lucid portrayal of the craze of London than Hyman's picture of the sprawl of London? The painter lives in a square on a hill about one mile north of the Thames. In this exhilarating, soaring picture he projects himself high, to see the sights of London in all directions. Such bird's-eye wandering is daring and rare. Kokoschka perched

high in great cities and brushed into the distance with bright colours – but Hyman is a free-flyer, and would not like to travel less in his pictures than Lorenzetti in his fresco at Siena.

Timothy Hyman is editing my text. We mostly agree, because we both subscribe to Odilon Redon's view of art, which puts "the logic of the visible at the service of the invisible".

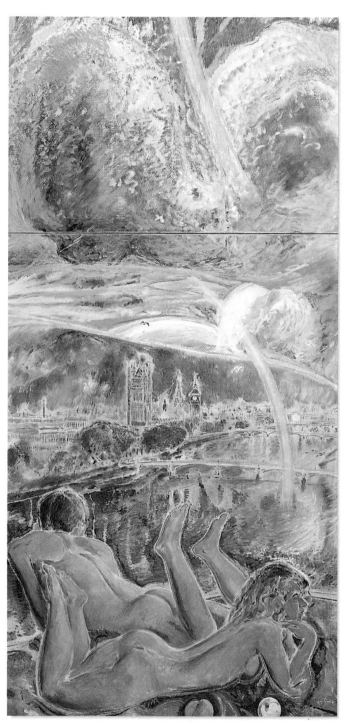

A girl and a boy on a summer evening look towards the city as office lights reflect the Thames. At dusk the sensual, sexual anticipations take over from the stock market speculations of the day. Glass-filled girders strain with desire. London is glamorous. Its daffodil lights shimmer over the mud.

London Rainbows, 1989–90

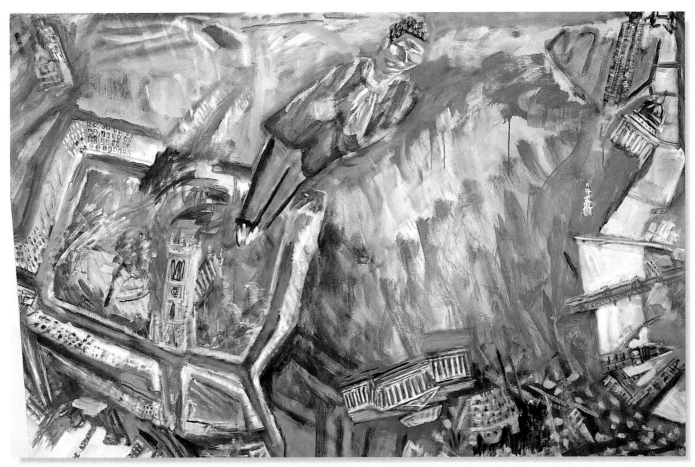

The human projectile is prepared even to turn the British Museum on its pediment, and catch a yellow reflection in his spectacle lens. It is not easy to control so many energies, spaces, and weights of paint.

Timothy Hyman, *Myddelton Square, Springboard of London*, 1980s

The boardroom above the Thames. It is not bugged, but it has a computer. The staff have gone home.

"Paloma" (detail). Painted two days after Christmas, 1953. The child is playing with a toy; Picasso is playing with his paints.

After Picasso

Adrian Berg, *Deutsch's Pyramus and Thisbe*, 1963

Ovid tells the story of Pyramus and Thisbe – how Thisbe, pursued by a lion, loses her veil; and when Pyramus finds it, covered in blood, he assumes her killed, and stabs himself. Thisbe, finding his body, also kills herself. Shakespeare makes use of the story in A Midsummer Night's Dream *and, by parallel, in* Romeo and Juliet. *In the 1970s, Berg made his pictures burst with learning. He was educated in medicine, English, and art, and knew how to delve.*

Practice and the Touching of Hands

PRACTICE IS A HURTFUL WORD for painters these days. You can be coached for sport, playing a musical instrument, and some examinations. Painting comes "naturally", some have thought. But then, nervously we consider – nothing else comes "naturally". Perhaps there are grounds for feeling insecure: as babies, we even had to learn to eat bananas. That is why we flung our custard at them! I will risk it. May I invite you to practise? Any young pianist's mother would do as much. Nobody would question her wisdom, so long as the child enjoyed hitting the keys. Practise! Practise, because painting is a skill. Practise, because every mark you make exposes you, as every word I write exposes me. It exposes, and can betray you, certainly. If you do not touch right, you lose your lover; if you do not brush right, your mark dies. If you will practise, I will offer you a helping hand, show-off that I am. All teachers are. I have painted for over 55 years, and taught for over 40 of them. I know a few ways for paintings to go wrong. I will give you a helping hand. I will give you a hand: it is your hand. All hands are good as models, because they are always available – "model" models. Now you have one hand for painting with, and one for posing. Use a mirror. Hands are mobile and difficult to paint; they are eloquent, and possess a language of movement. Hooligans bunch fists; Indians make their hands dance butterflies. Rembrandt painted three pairs of overlapping hands in "Jacob Blessing the Sons of Joseph". Hands tell of love in "The Prodigal Son" and "The Jewish Bride".

Make your own programme. Paint your "model-hand" with and without a mirror. Paint it roughly, dab by dab, day by day. You will gradually feel it getting easier. If you do it enough, you will become a "dab" hand! Paint someone else's hand; dab-copy a Picasso hand; then a Permeke hand. Practise till your brush wears out. The world-famous pianist, Benno Moiseiwitsch, wrestled – take care, your hands are special, keep them safe for practice.

If you paint a hand, you are launched. Enough! Your programme was rigorous. May I quote from Gide, quoting from Matisse? "Hands are the most difficult of all."

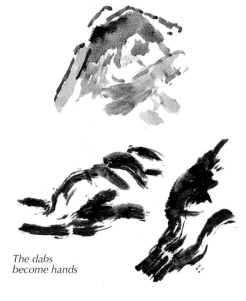

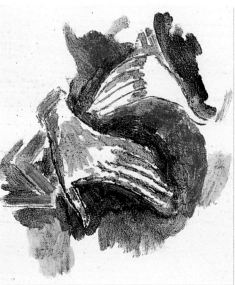

The dabs become hands

Paint these thin, serious, designed hands. No trace of caricature occurs; the arcs and design are too careful for that. Christian imagery is not for laughter.

After Rublev

The shape of the face is made squarish by adding the back of the hand, which is similar in shape to the light area of the face. The convex thumb and the convex cheek straighten as they push into each other. The drawing emphasizes straightness and pure arcs. Where one line is enough, one line is all that is used.

After Kitaj

Adam proclaims his death. Make tentative dabs for the frailty of an old arm, concave and disjointed, rather than plump and swinging.

After Piero della Francesca

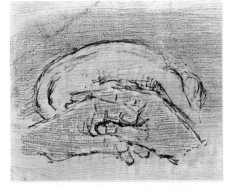

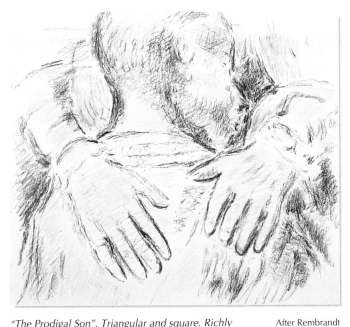

Practise in whatever way you wish.
Be wilful sometimes, careful at others.

Round and warm and elderly, one
hand finds comfort clasped in another.

After Rembrandt

Paint clasping hands.
Then other things will
clasp together, and
soon you will have a
composition. Here is a
body imitated by
clasping hands.

"The Prodigal Son". Triangular and square. Richly
painted, the son is embraced by the father. The
generous use of earth pigment in a rich, oily sauce
is combined with compassionate hand gestures.

After Rembrandt

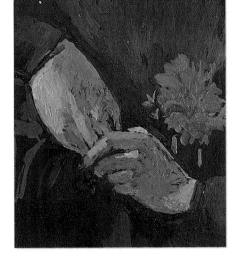

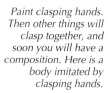

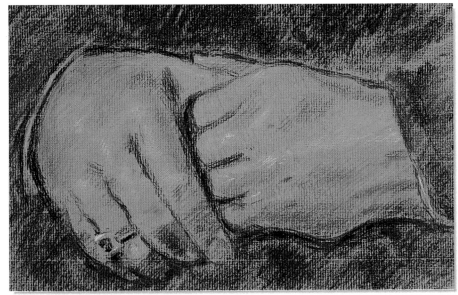

Rembrandt knew how to
overlay hands and clothes layer
upon layer to keep the terrors
of the world's harshness at bay.

After Rembrandt

Raw umber moves into the
pinkish ochres of the hands.

After Corot

The hand modifies the shape
of the face considerably.

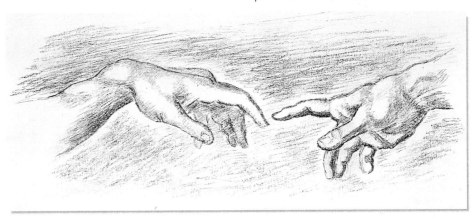

High on the Sistine Chapel ceiling, God releases Adam into the world.

After Michelangelo

The Language of Hands

BE HAPPY IF YOU HAVE ORIGINAL IDEAS, which bubble like pure spring water from the ground, or like new-forming clouds. We like paintings to be original in the West. In China, beautiful paintings are often made to closely resemble earlier versions. An eminent Chinese curator told me that most of the Chinese paintings in the British Museum were copies. To think of a painter in the West who resembles another is not so easy. Yet tradition is about some sort of resemblance; and, thinking in this way, a Manet is indeed slightly like a Goya.

Originality is innate. It is valuable. You will not lose it by returning to your ubiquitous model, your hand. The

After Degas

A singer using her hands to portray a poodle.

explanatory hand is the most frequent illustration-diagram in craft-books. This practical hand will help to demonstrate sowing seeds, knitting, beating eggs, and carpentry. Imagine how various are the movements of a hand in a first-aid manual. Painting hands to order is very difficult. Practise some diagrams. Put your originality on hold. Allow your model hand to be in a "meaningless" pose, a "useless" position. (There is hardly any hand position, however unusual, which could not be used as part of a figure composition.) You need a lot of practice to do hands out of your head. For a real exercise in "How to do it", copy a ruthlessly cruel Japanese print.

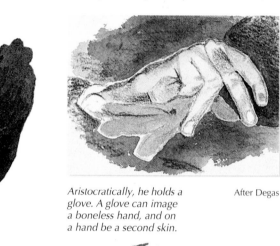

Aristocratically, he holds a glove. A glove can image a boneless hand, and on a hand be a second skin.

After Degas

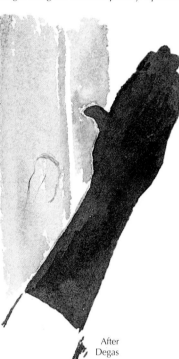

After Degas

The chanteuse gestures with a glove. The glove makes it possible to use a shape for a hand without the complication of separate fingers.

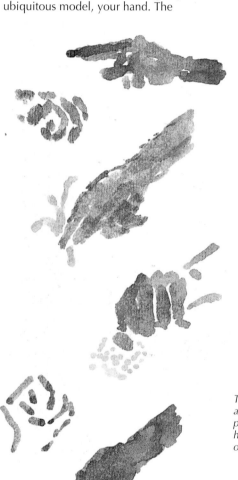

Practical hands: pointing to the bathroom, planting a seedling, and other things.

Describe the subtle differences.

After Manet

The hands grasp the sword in Hara-Kiri. A clear hand-mark in blood acts as a third hand. The hands are pulling the sword inwards for ritual disembowelling. The blood is made to be like a flower.

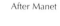

After Manet

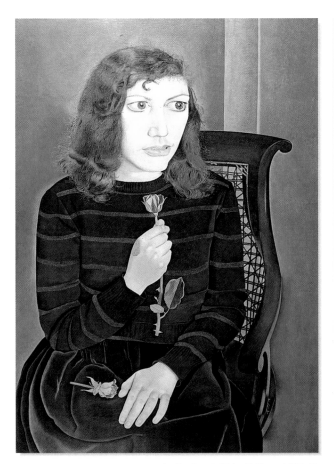

Lucian Freud, *Girl with Roses,* 1947–48

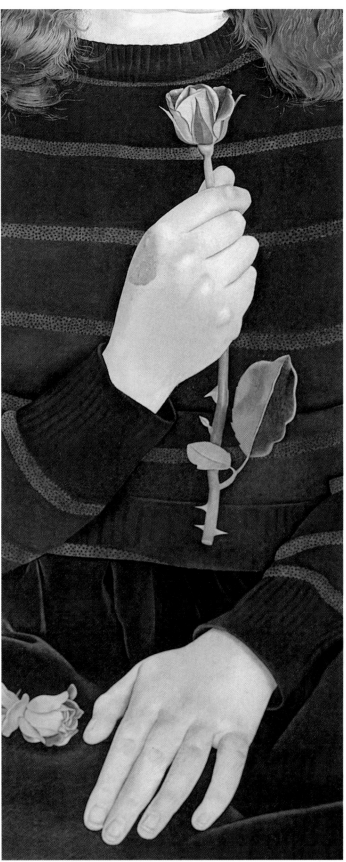

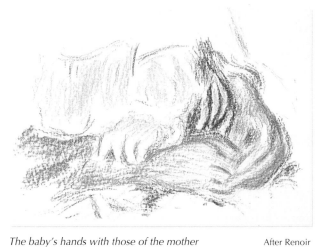

The baby's hands with those of the mother After Renoir

The hands of the mother and child interweave. The edges are surprisingly red. He may have looked at Renoir. After Picasso

Years ago in the art shop, there was no other customer than the young Freud, who was not getting the canvases he had ordered fast enough. He was pacing the floor: a panther about to leap. With energy, there can be hate, love, work, but best of all is painting. Freud channelled a tight sprung vitality into this hard-edged, Botticelli-brilliant, Baldung picture – unique for any time.

Lucian Freud, *Girl with Roses* (detail), 1947–48

Fingertips and Tradition

HOW WONDERFUL IS THE FINGERTIP touch in all great painting. How would a Watteau "Beau" give his girl the eye, except by the tender, tiny movements of the artist's fingertips, holding a small brush, tipping in details. The touch of a great artist is as sheer as an eyelash thrash. Large brushfuls of paint are also dependent on fingertip control. The plumpness of a massive Rubens thigh is also perfectly placed, and touch-steered. When your fingers have become watchmaker skilled you can become fast and fine. The diamond cutter cleaved the Kohinoor diamond with one blow.

Some are nervous, and eat their fingernails away. Some never look at them. Extravagantly, let fingernails be full fan-shaped views, miniature purple evening skies, with rising moons. The thumb moon is the grandest. More extravagantly, make them blood-red; black; false, or golden, for fashion; or razor-ended for horror movies; or long and quivering on Mozart's coloratura *Queen of the Night*. Nails are claws. Turner had a long one for watercolour-highlight scratching.

Fingernails and skies

Another attempt to make clear for myself where tradition lies. One pivot is always to be found in recent history; as with a scientist's balance, weighing Greek and Roman Art against what was to come. The main pivot is Poussin. After Poussin, all eyes were on Poussin and the past. Poussin's eyes were on the past, but also on Poussin when he did the celebrated self-portrait in the Louvre, Ingres copied the hand as part of "The Apotheosis of Homer", whereupon Seurat copied the Ingres with graphite. (There is a faint inscription which says, "There is genius.") Seurat in turn is also a pivot on which much present-day art balances. Go to the Louvre, and for an academic spree with a pencil, copy the pivotal wrists of Poussin, Ingres, and Seurat. Bonnard said modestly that he wished he had been taught by Moreau, as were Matisse and Rouault.

What would have been the effect on the great painter Edward Hopper of a hard traditional start, we will never know. I have copied Hopper hands to show a difference. His draughtsmanship is non-pivotal, neither traditional, nor even academic.

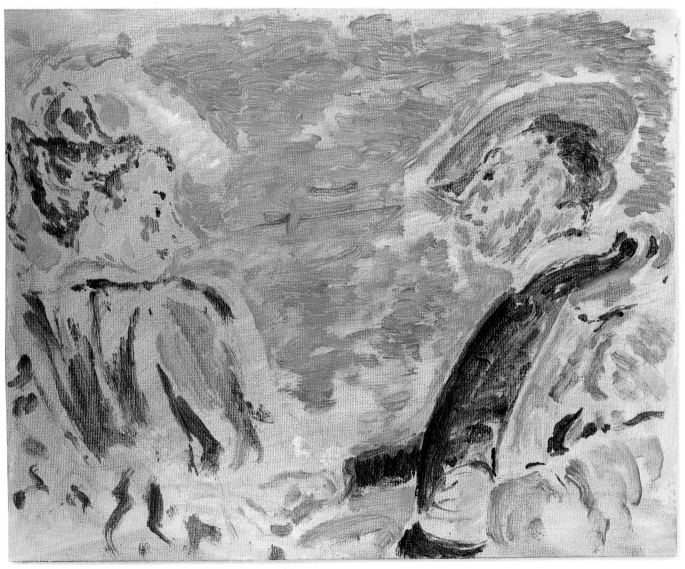

"The Embarrassing Proposition". On a surface stained with rose and Burnt sienna, barely touching the surface, brush in your thoughts, wet-in-damp, Flake white lies cool on the salmon-tinted surface.

After Watteau

Clutching his portfolio; the ring is emphasized. Ingres was plainly not going to allow tradition, in the figure of Poussin, to escape him.

After Poussin

Poussin sitting in the corner of "The Apotheosis of Homer". Its secret is safe. Mark your formal discoveries in a notebook. Drawing focuses the attention.

After Ingres

Touch-dabs and fingerprints. The primed paper was brushed with Charcoal grey, ultramarine, and turpentine, then allowed to dry. White lead became hands. These were glazed when half-dry.

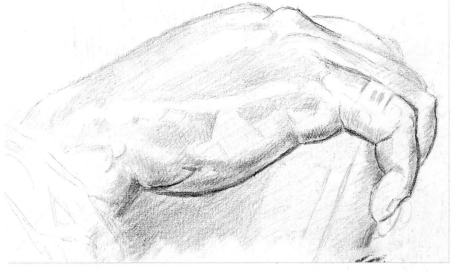

"Creative Man". The fingernails on the podgy hand of a rich man. Mark the fingernails at many angles with a crayon.

After Orozco

Ingres' copy of Poussin's self-portrait hand, in "The Apotheosis of Homer". There are sharpeners for propelling pencils. I do not use them. A .03 lead keeps sharp if used at an angle. A point is useful for investigating the subtleties of great paintings.

After Seurat

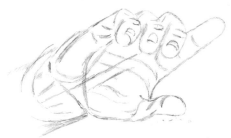

"Creative Man". The fingernails come towards you.

After Orozco

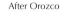

A rising sun over waves is looking like a thumbnail. Dabs of watercolour work wonders.

In spite of being like magazine illustrations when compared with the grand tradition of drawing, drawing by shadows enabled Hopper to the great actuality of his pictures.

After Hopper

Brushes Make Shapes of all Kinds

Aware of Manet and Daumier, both George Bellows and John Sloan made their American subjects grow as lively brush strokes. The children in Bellows' painting, "Forty two Kids" were called maggots by a critic. Maggots are brush stroke shaped.

On a white surface, paint a little blue dot. It is so small, it is almost colourless. A bee in the sky. Stroke a sequence: a blip, a blimp, a long wave, a longer wave. Scumble some fumbling marks. They move at different speeds. The top five lines are with a sable brush, the sixth with a hog-bristle brush, the seventh is done with a small sable brush, trying to make its marks look like a wide brush. Rarely believable!

The mark made by each kind of brush is full of character. The most common has a lozenge shape with pointed ends. If the brush is full of paint, it can make both round and oval marks. Howard Hodgkin uses round, dotting dabs. Bonnard uses similar splodges.

Undulations

Renoir made his paintings of harmonizing ovals – as nudes, olive-trees, cats, babies, hats, and roses. The blimp shape is the most useful; it can have a tail, and will be like the thigh of a newt, or a leg running on a Greek vase.

Go at a fair pace. Undulate "riggers" or "writers" to make snakes, waves, and mountain ranges. Some brushes tend to make marks that resemble the sea, sky, grass, or hair – which is an embarrassment for painters aiming at abstract art, free from associations. They are often driven to using air-brushes, which present them with ghosts, or mists, or clean enamel surfaces that resemble walls, or doors. The pure abstract is as elusive as a temperature of absolute zero. The first in a jungle can cause the most visible clearance. They called Nature the jungle: Mondrian moved painting furthest from the jungle, but ended representing New York as "Broadway Boogie-woogie". His measures were his life, and beautifully simple, never minimal.

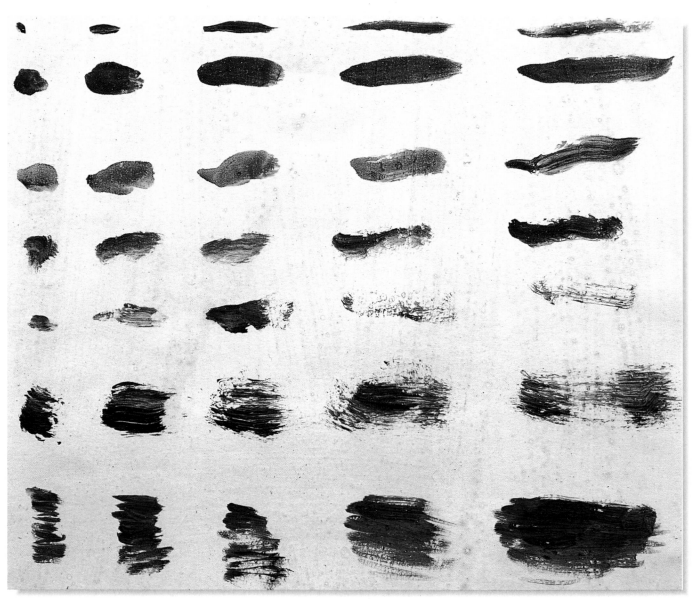

Brushes usually create fast movements if they move fast. But sometimes high-speed marks are painted slowly. Watch what the brush strokes do. Bonnard used a splayed brush to illustrate a famous book about a motor car.

Travelling strokes

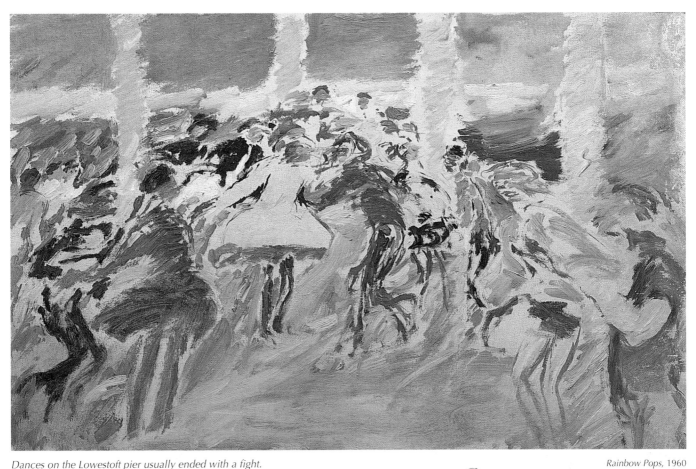

*Dances on the Lowestoft pier usually ended with a fight.
Paint the swinging handbag. Use swing-speed gestures.*

Rainbow Pops, 1960

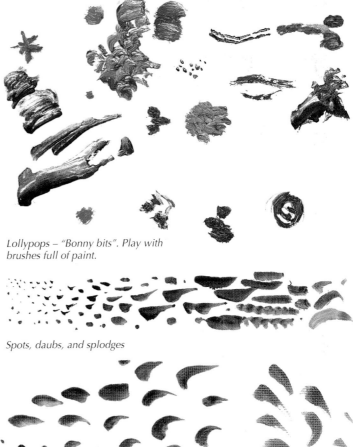

*Lollypops – "Bonny bits". Play with
brushes full of paint.*

Spots, daubs, and splodges

Slow splodges

The tails help the dollops to fall.

The tails help the dollops to rise.

Copy and Be Original

THE STYLES OF THE PAST were developed by copying. Paintings come from paintings. Think of a tree, then a Greek column. Greek temples led to Roman and Romanesque buildings. Giotto was an urgent stimulant for Masaccio, who in turn was painting's greatest all-time leaven. Piero and Uccello put columns in their pictures, then David, Ingres, and early Degas used more columns. Columns show a classical state of mind. Klee proposed the artist as a tree. Columns are not so frequent now, but painting continues to evolve. One last family tree: Giorgione knew Mantegna and Giovanni Bellini, and employed Titian, who knew Tintoretto, who was followed by El Greco, who was copied by Picasso – whom everyone has copied!

A unique originality is not possible, or desirable. An astronaut brought a little moon dust back to Earth, pounded it into paint, and made a picture of the moon. Truly a performance. The painting was usual. The story was a parable.

Pictures may take a long time to paint. In the past, shorter lives and shorter days used time more economically. Picasso did scores of copies of Velásquez' "Las Meninas", fast. Copy to expose secrets, while you stare in exploration. The results – like the diagrams in this book – may be wayward. But every mark you make is a contact with the original. Be inventive: scribble-copy, memory-copy, sample-copy, diagram-copy. Picasso gulp-copied. He was always racing.

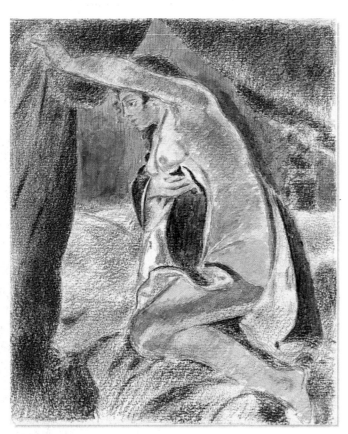

After Courbet

A well palette-knifed nude by Courbet at Birmingham deserved to be copied. Courbet was a fat, strong painter, who looked at Rubens. Rubens was to be Cézanne's favourite painter. Courbet would have seen bodies tenderly painted by Rubens, and Rembrandt's superb "Bathshéba at the Bath" in the Louvre. Courbet inspired the thick, early Cézanne, and "Fauve" Matisse (Matisse owned a Courbet nude) and some of Balthus was first seen in Courbet. I saw the bedclothes, curtains, and shadows had been arranged to make an area of nakedness that was at every point surprising – a body flat, full, and stylish.

Think of the glories of Poussin: of "Venus and Adonis" at Caen, of "Tancred and Ermina" at Leningrad, of "Cephalus and Aurora" in London. To copy an early, pastoral Poussin is to ramble with desire. To do a serious copy of "The Massacre of the Innocents" is the event of a lifetime. Uglow moulds the flesh without sweat, and as the paint goes on, with gentle application, the design tautens. The baby is built tight to bursting. Some blue areas of escape are allowed in this relentless picture. It is a small "machine".

Uglow was allowed to measure "The Massacre of the Innocents", at the Museé Condé at Chantilly. Overlappings make it more sculptural in the main action areas. Some areas are backdrops to the play – these resemble the simplifications of Burra. The bounding energy hoops male and female in a grand ellipse. The light areas of the body are rounded and simplified. An oval tongue cries within the stretching jowl, and the eyes are hard on the diagonal of the main square of light. No millimetre of a Poussin is left unconsidered – see how she scratches his back!

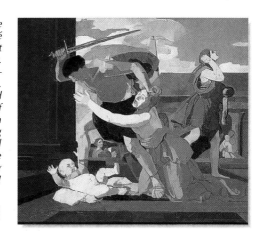

Euan Uglow, after Poussin,
The Massacre of the Innocents, 1979–81 (detail below)

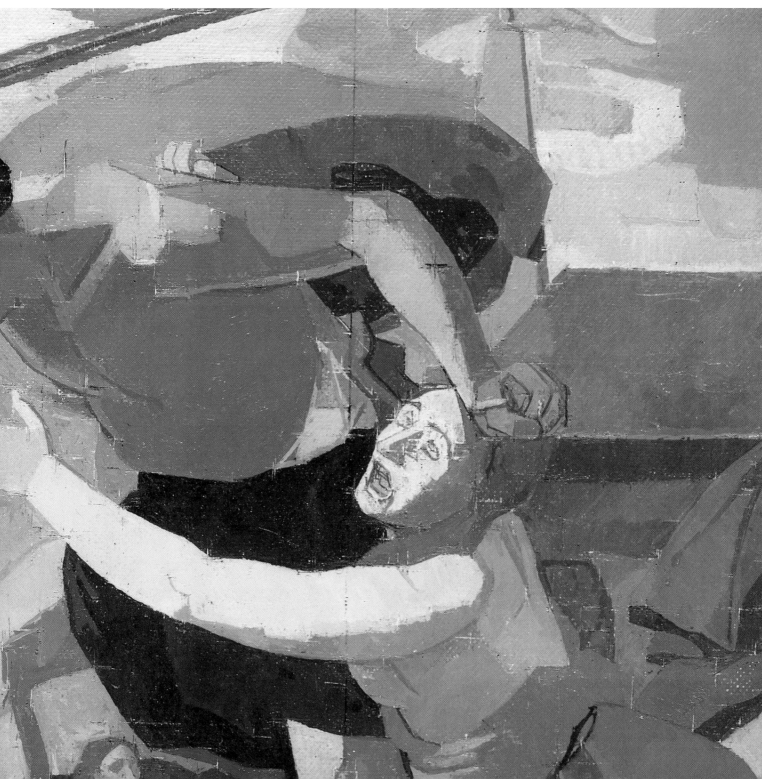

Piero's Baptism

K ENNETH CLARK TELLS US PIERO'S "BAPTISM" is divided into thirds horizontally, and into quarters vertically. It is all geometry and numbers if you feel like pursuing them. Or leave it to feeling and see what you find. Yes, relax, and see what you find.

Pure as freshly-squeezed oranges, or new-baked bread, great paintings are plainly good.

Piero della Francesca's "Baptism" is a beautiful picture – a great "copy", an alienation of a wonderful kind. The vision of God standing in a stream, imagined as in a dream. The figure in daylight, in clear air, alive. But made by way of a drawn design, a full-scale paper "cartoon" traced and transferred to the panel. Try not to mind my use of the word "copy". In this case, a unique authentic

After Piero della Francesca
A scribble

painting but done like an inspired copy, parallel to the cartoon, and painted never imitatively, but closely. The painting is transcendental. It' moves in a mysterious way. It is the Holy Ghost.

Imagine-copy this "Baptism", painting it with the mind's eye, with an imagined brush. Move its tip, find the centre, mark the navel. Sable in the tiny trickle of water falling on the head. Scrub-copy the hill, partly hidden by a tree. Wetly rough in the "way of the cross". Alternatively, smooth in the delicate angel eyes, and tightly copy the falling measured folds, pure as Ionic columns. Choose whichever part of Piero's beneficent world you wish to dwell on.

A column-covered angel. The background detail is brushed in with comfortable dabs, and little editing.

An angels' head. Search, using fine pen, pencil, or crayon. Or paint marks to involve you intimately. Some baptisms are totally immersing.

A pastel pencil will decide how concentric the arcs are around the centre, and how the vertical gradation is controlled. Building a torso is like building a house, a tent, or Mount Fuji.

Be more abandoned. Soften the surface by scribbling some Lead white over it. Dab into it: it will feel soapy. But be a little irresponsible. Find something, lose something.

A line of hands and girdles. Join the distant landmarks to the near rhythms.

A brushed glance

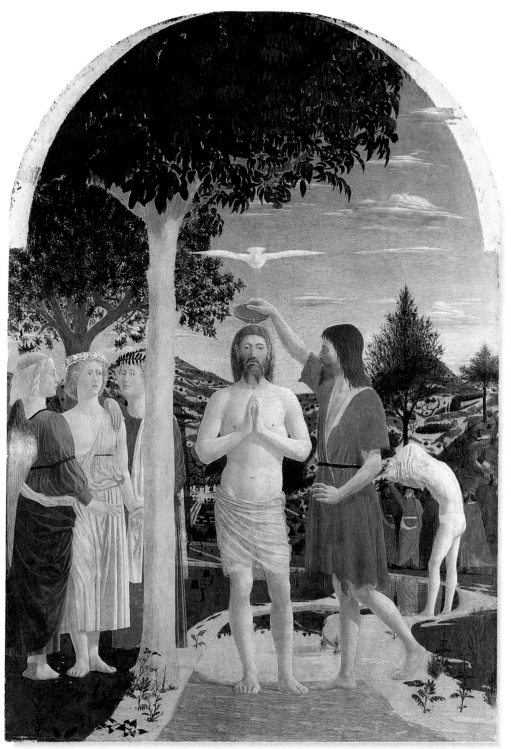

Piero della Francesca, *The Baptism*, 1450s

Piero and Perfection

PIERO DELLA FRANCESCA's "Baptism" is in the National Gallery, London, where a well-formed, uniformed girl stands guarding this perfect picture. She is talking to another guard about her pay and conditions. She cannot be mistaken for an angel, she is not built to the ordered measures of Ancient Greece, and she has no wings. On the left of the tree, from our view – therefore on the right-hand of Christ – are three angels who are as perfect as heaven. The tree is good, and Christ is good. Ellipsoid cirrus clouds float. Leaves pulsate as pads of green translucency. The whole picture fluctuates between perfection and human warmth. What could be better?

Paint a little perfection. Try copying a piece of pure angel. You will not use pimple mixture, or refer to the pictures by Lucian Freud. Piero della Francesca's divine measures are derived from Ancient Greece. No flesh sags. Forms are defined with true arcs and straightness, and surfaces are spread carefully.

Paint the man taking off his shirt, and some of the rough landscape above him, to feel the difference. Although the forms are clearly defined, the body is not idealized, and the bushes are made brusquely, even splodged.

The universe-symbols: circle, square, triangle.

After Piero della Francesca

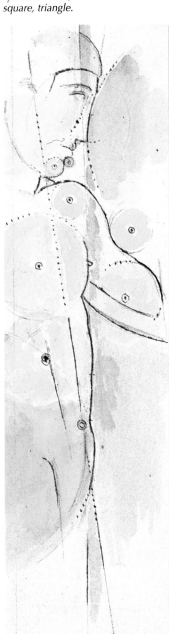

As in Ancient Greece, the forms are made of arcs and straight lines.

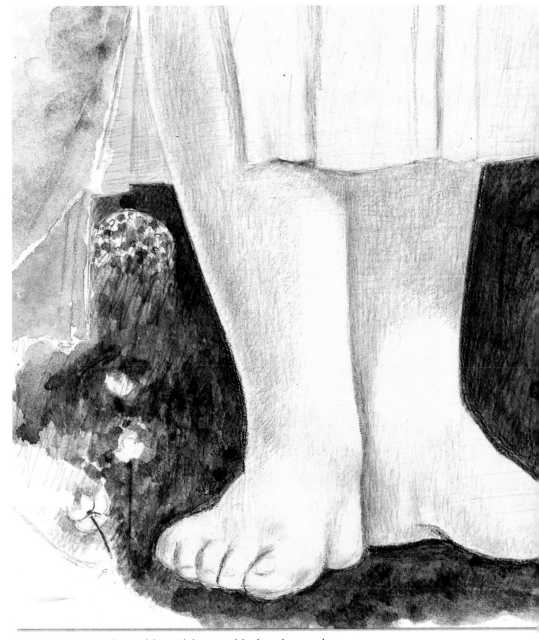

Watercolour, on top of a careful pencil drawing of the feet of an angel.

The body is not muscular, and the soft contours of the legs flow to toes that could almost peel a fruit.

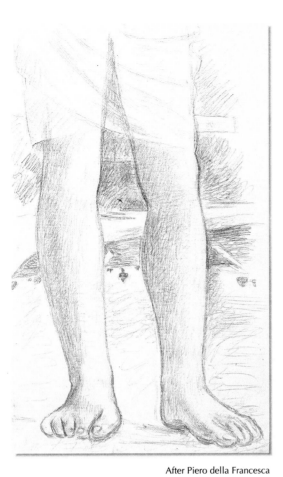

After Piero della Francesca

Dabs are made over a blue underwash.

A free brushing with oil and turpentine

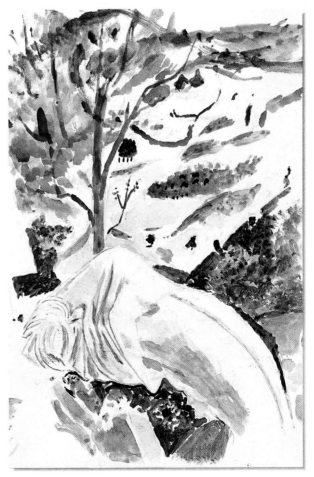

Use a soft bristle brush for the landscape background.

A Free Painting Extravaganza

I F YOU LEAVE THE DREAM, you paint dead paint. Around 40 years ago, painters decided to be free. They were not the only ones! Freedom was in the air. To watch Jackson Pollock on film dribbling paint, with hard, panting gasps at cigarettes, is to know that freedom has its arduous side. For Kandinsky and Klee, thinking in musical terms, freedom did not require muscles.

Come instead for a dab at real freedom. On a non-absorbent surface of shining white, dab with Cerulean blue. Imagine you are running – it is safer than jogging. Become entranced! The blue dab looks dark; add another mark close by, and it appears lighter. With freedom, we are allowed more colours. Now dab as if you were running by the river. Your deliberately planted feet are beginning to dance. The sight of the water has melted your touch: dabs are breaking into

Freely brushed ideas about figures in the sky

flowers! Rainbows! Barges! And palm trees! The landscape is rhythmically passing you by. The brush marks are recognizably your own. As in a dream – on the edge of dreaming – painting….

Start, this time, by scrubbing a surface, making it an equal colour-tone all over. If the underpainting is buff, it is the padding that makes up 70 per cent of all painting, old and new. It is bread colour. In a painter like Titian, this padding is the support of glorious colours and the "the staff of life". But in the archive of the Slade school are stored Diploma "Life-studies". Most are bread colour; syrupy, and dead. Frightening, when you consider they were by young, lively people. It was required work at the beginning of this century. Dead paint can also be seen at the National Portrait Gallery, London; at animal art shops; and at communist and fascist historical galleries.

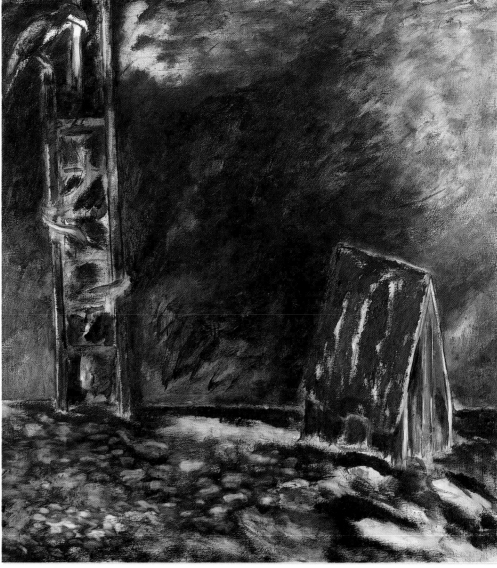

A snowman as a Christmas card. McLean is free to fashion enchanting colours

John McLean, *Snowman*, 1993

Brushed blues over black bread colour

Where one mark leads to another. Extemporization is a large part of painting.

Blue and red dabs overlay each other, to make a painterly brushing, and to suggest the deep stress-space of a Polish astronomer.

Andrezej Jackowski, *The Tower of Copernicus*, 1983

Some of the rhythms of a restaurant still life. Half-baked is not baked at all.

After Picasso

An improvisation

Miró uses large fields of colour on which to place weightless, thin marks and symbols, and large, meticulously flat areas of paint. He is free. He maintains flatness, which with crayon I was unable to do. (No excuse really.)

After Miró

Wasps and passion-flowers, and a sunbathing girl, free and naked. Transparent scribbles are made on a surface the colour of honey sponge.

The Thames Open College of Painting

THE FURTHEST POINT FROM ENGLAND is near Fiji. It is beautiful. I shall never visit it, or even visit those great cultural centres which rival London for art stuff. London is homely, London is cosy; the right size for pictures, pedestrian easy, visually crazy, old, new, and useful. It has a lot of Turners.

I offer you a park bench. From it, you can teach yourself to paint. Take your art school with you, wherever is convenient. Mentally project wall-free art colleges for your delight, in Washington, Tokyo, Berlin, New York, Madrid, or Paris. A site in Central Park is fine, or a Tuileries bower; a Venetian gondola, a Berlin beer-cellar, or coffee and cakes in Vienna or Basel – chocky, creamy, and nice! Teach yourself well wherever you go. Treat yourself well wherever you go.

Enjoy a Thames Open College of Painting. Build it as André Malraux built his book, *The Museum Without Walls*. Build it at Trafalgar Square, where it can include the National Portrait Gallery for flattered faces, and the National Gallery for great paintings. You will tighten your mind for Mantegna, Poussin, and Bellini; expand it with Rubens, Picasso, and Titian, and make never-ending discoveries. The National Gallery is inexhaustible.

Thames riverboat

For your self-lectures use a bench in St. James' Park, near the pelicans. For practice, cogitation, self-examination, and the encouragement of squirrels, lie in a deckchair by the lake. No self-lecture bench is nearer to such a richness and variety of paintings to study. It is an easy walk to anywhere on the map tinted with yellow ochre.

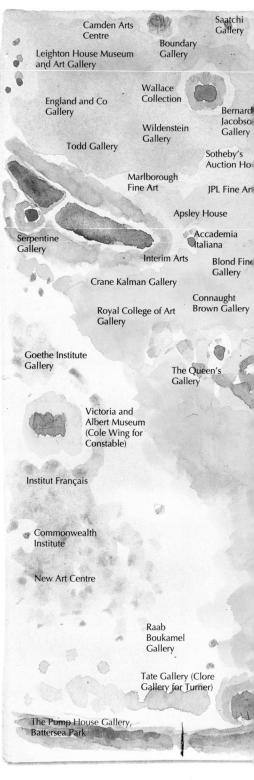

Nelson, pigeon-limed at Trafalgar Square. The pigeons are too numerous, and Nelson no longer suggests security. But the column helps in reading maps, and is high enough to climb and be newsworthy. It has yet to be part of a beautiful picture.

Piero della Francesca's "Baptism" is repeated several times in this book: a sign of quality; it lives at the National Gallery, making all painters feel secure.

Second-hand bookstalls under Waterloo Bridge

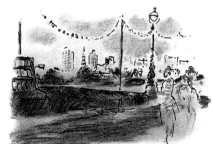

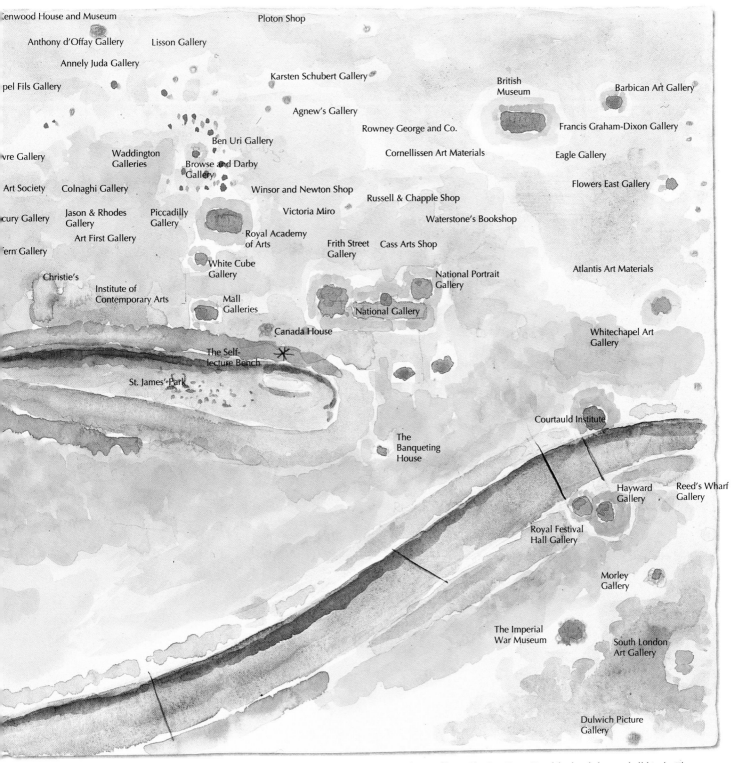

Kenwood House and Museum

Ploton Shop

Anthony d'Offay Gallery Lisson Gallery

Annely Juda Gallery

pel Fils Gallery

Karsten Schubert Gallery

British Museum Barbican Art Gallery

Agnew's Gallery

Rowney George and Co. Francis Graham-Dixon Gallery

vre Gallery Waddington Galleries Ben Uri Gallery Cornellissen Art Materials Eagle Gallery

Browse and Darby Gallery

Art Society Colnaghi Gallery Winsor and Newton Shop Flowers East Gallery

Russell & Chapple Shop

cury Gallery Jason & Rhodes Gallery Piccadilly Gallery Victoria Miro Waterstone's Bookshop

Art First Gallery Royal Academy of Arts Frith Street Gallery Cass Arts Shop

ern Gallery White Cube Gallery Atlantis Art Materials

Christie's National Portrait Gallery

Institute of Contemporary Arts Mall Galleries National Gallery Whitechapel Art Gallery

Canada House

The Self-lecture Bench

St. James' Park

The Banqueting House

Courtauld Institute

Hayward Gallery Reed's Wharf Gallery

Royal Festival Hall Gallery

Morley Gallery

The Imperial War Museum South London Art Gallery

Dulwich Picture Gallery

"The Thames Open College of Painting". New paintings come and go, as do dealers' galleries. For new art go northwards to Bond Street and Cork Street. The Institute of Contemporary Arts is in the park. For the Tate Gallery, go south. For the Arts Council's Serpentine Gallery go west, and for the Hayward Gallery go east. The many beautiful galleries for Old Masters are mapped in red and gold. Art colleges possess libraries. With the fees you are saving, make your own. Visit the stalls below Waterloo Bridge; walk up Charing Cross Road for bookshops of all kinds. The British Museum Library is world famous, and the National Art Library at the Victoria and Albert Museum calls itself a library of last resort! The green areas are practice areas: paint the lake, the Thames, ducks, swans, riverboats, sunbathers, and the enchanting multiracial picnics. Paint the bridges, buildings, flags, canoes, and litter.

Be inspired. Hold tight. Do not fall in. Mind the gap.

27

COLOURS
Studios, Children, and Skills

STUDIO CHECKLIST: A WELL-EQUIPPED STUDIO, and some junk. Some painters can keep everything they need in a box no larger than a suitcase. My room almost buries me in the accumulations of years. To buy every item new would be expensive. Put everything you do not need in the attic – or convert the attic into a studio! Some of the items listed below are useful.

Here is more hand-practice. Your model hand is ready for you, and the exercise is suitably difficult. Let the palm face you and the tips of the fingers come towards you! Make dabs for the fingertips. Ugh! Stay with it, be encouraged. Look at the fingers of Piero della Francesca's "Madonna of the Annunciation". You are sailing: splay your fingers, pretend they are yacht-like and the dabbed fingers are flowing towards their tips, like the seams in a mainsail. After this, consider the palm of the hand as like a cushion – a square with convex sides, the thumb preventing symmetry. Paint the palm. It seems more vulnerable than the back. Here you encounter many of the problems of painting

flesh. In strong daylight it is semi-transparent, and like a cuttlefish fluctuates gently between its blue-violet veins, vermilion lines, yellow-orange fat, and the pink complexion of rosy capillaries. Tickle it to know where the nerves are; scratch like a miser, and the flesh will be a warm pink.

For an extreme exercise, to be done only when in a good mood, make the palm hollow. Pour a little water into it. It is like a dew-pond. It has a visible meniscus. Paint it with a fine sable brush. The water trembles. Your touch must be as delicate as that of Vermeer. Refinement is limitless. I will exasperate you! With your sharpest sable, test your touch. Paint a robin's feather floating on a puddle. Touch it between held breaths. Lie low in a bath. Raise and lower your hand in the water. However thin the refraction makes the hand appear, it always seems real. A hand, seen at an extreme angle in the cinema, convinces. Draw the distorted view. Paint the lines of life, and the lines of fright, on the palm of a half-clasped hand.

Watercolour all the items you can think of, that a painter might need in a studio.
An easel. A good-tempered model. Neon lights. Blue daylight-simulation bulbs. A blind. A chaise-longue. A high stool with a hollowed seat. An invalid's adjustable bed-table. Coloured pencils. A brush-washer. Tubes and cans of paint. A mahlstick. A split-bamboo cane with a rubber band and charcoal. Watercolours. A claude-glass. Scissors. A magnifying glass. Binoculars (or a lightweight monocular) to take with you everywhere. A dipper. Brushes. Palette. Slide-viewer. Plan chest. Portfolio. Central heating. Pencils. Pin-board. Kneadable and stenographers' erasers. Pencil sharpeners. Fixative and varnish in aerosol cans. A table. Cutting knives. A projector. Spectacles. Armchair. Squeegee. Roller. Air-brush. Straightedge. Paint spray. Paint-stripper. Oil. Turpentine. Varnish. Wax. Clips. Clamps. Maps. Mirrors. Masking-tape. Fan. Radiant heater. Staple gun. Ladder. Carbon paper. Adhesive. Pastels. Sand. Sawdust. Sandpaper. Pigments. Protractor. Wedges. Sunhat. Acrylic medium. Stretchers. Canvas. Paper. Primer. Frames. Woodworking tools. Portcrayon. Tin and brass tacks. A sink. Greaseproof and tracing-paper. Drawing-board. Screen. Sponge. Blotting-paper. Plumb-line. Painting knives. Jars and tins. Rubbish-bin. Pens. Ink. Rag. Barrier cream. Gloves. A high window or skylight. A muller. Eggs. A T-square. Ruler. Drawing pins. Nails. Sodium benzoate. Canvas pliers. Magnifying glass. Blender badger. Masking tape.

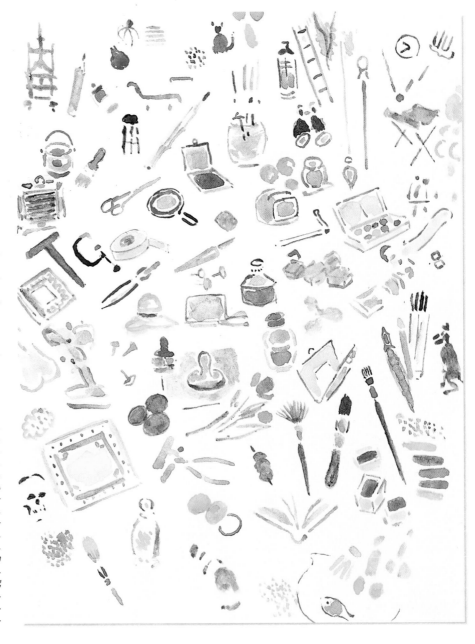

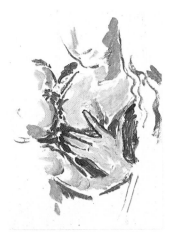

A scribble-copy of the "Madonna" (from Frankfurt). She supports her breast with her hand. After van Eyck

Clasped hands

Two hands often say more than one.

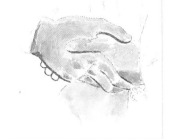

Solomon takes the hand of the Queen of Sheba. The pricks of the pouncing are visible on the wall. After Piero della Francesca

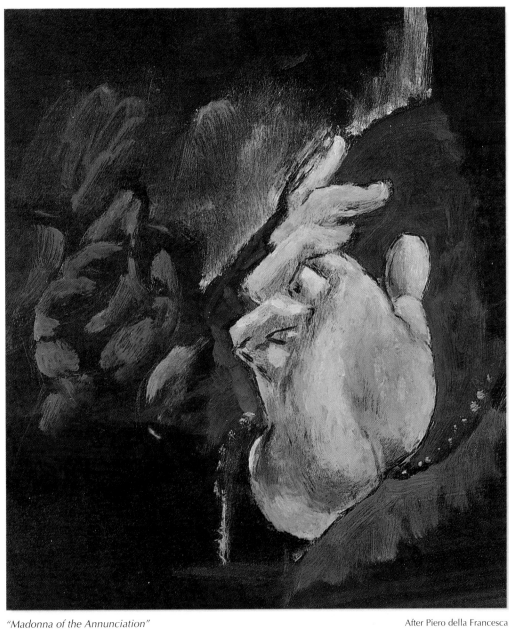

"Madonna of the Annunciation" After Piero della Francesca

A half-closed hand

The lines as the hand closes

Palm of the hand

Large hands holding water After Rivera

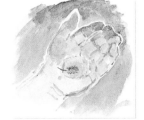

A feather on a puddle

29

Painting Close to White

DEBUSSY ORCHESTRATED "LA MER" in the Grand Hotel at Eastbourne, whitened with many coats of paint since then. We think of a sheet of white paper as empty, of black surfaces as empty, and Turner probably felt his indigo sketchbook pages were empty. A sheet of white paper placed against a bright sky reflects only a tiny proportion of daylight. Eastbourne, because it is beside the sea and affluent, challenges the whiteness of white cliffs with white hotels. Retired ladies challenge the hotels with the whiteness of their hair, hats, and Crimplene. And all is bright until we see the foam! Eventually, we are obliged to close our eyes. Light is the whitest white.

When I was a student, Roberson made three consistencies of Lead white. It needed a Scottish "strengthy" effort to release the thickest white from its tube. This hard, pugged paint was different from the advertised paint of a buttery consistency, fashioned for amateur Impressionists. It was fine to spread with a palette-knife. Any colour could be moved into it; if you wiped the brush after each stroke, the marks were clear. Long ago, I got White lead from an ironmonger who knifed it out of a large drum. Wrapped in paper, it was heavy and gooey. Its long molecules allowed long, exact brushstrokes, the sort of flowing paint used by Rubens, Velásquez, Goya, and Manet. But Lead white is now less easy to obtain. I have found Roberson's Flake white is as heavy as lead.

Here are some whites the Old Masters did not have. The clearest, brightest white is Titanium white. But it is extremely opaque and in practice I find the more transparent whites have a greater versatility. Zinc white is a fine white. On its own, it keeps its whiteness better than other whites. Additions of Flake, Titanium, ▶

"Skulling" (detail) After Seurat

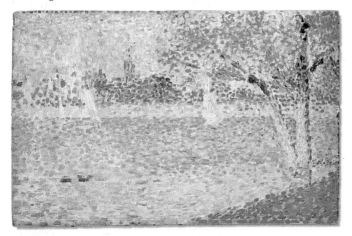

The yacht was too big. Seurat painted it when it was passing. He dabbed sparkling water across it, using blue, orange, Viridian, and ochreous white. It is not complete. But is a bright sketch. Painted on white, not the cigar-box mahogany he more often used.

Georges Seurat, *The Seine seen from the Island of La Grande Jatte*, 1888

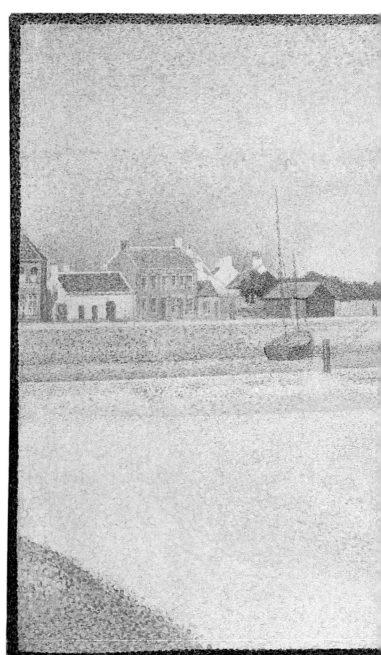

Cherry blossom in spring. Twigs cast sharp, dark shadows on the tree-trunks and on the grass. The blossom bursts with whiteness. (Strangely, we end by painting most of the tree grey.)

Seurat was wonderfully sensitive, and with a perfect system he was able to paint with pale colours. So exactly are the gradations adjusted, our eyes are supported at every point.

▶ or Underpainting white prevent cracking. Underpainting white is a useful colour. It will cover opaquely, dries fast, does not crack, and its slight tooth makes it possible to paint thinly over it. It is made from titanium dioxide, ground in polymerised linseed oil. It contains a lead drier. Flake white and Silver white are Lead white with Zinc white added. Rutile titanium dioxide is the better crystalline form of Titanium white (also named Permanent white).

Obese over thin, fat over lean, oilier over less oily.

Winsor and Newton's oil painting primer is Titanium white in an oil-modified, synthetic thixotropic alkyd resin medium. Thixotropic means it brushes out well. The dictionary defines it as the property of certain gels, of liquifying when stirred or shaken, and returning to a gel state upon standing. Rowney's Gel, Wingel, Liquin, and Oleopasto are all gels that are thixotropic.

Beachy Head, Black Gull Flying, 1972

My picture is a tall picture. It usually has its middle at eye-level. It is a prospect of dazzling whiteness. The tone-range from lightest to darkest at the seaside is too great for the comfort of painters. Rembrandt did a drawing of himself by candle-light. How many candle-power for Beachy Head? It is partly due to the sea acting as a mirror, and clouds being white. I used tints in the painted border to suggest dawn and evening in the adjacent landscape. They helped the whiter parts to give off light. White cannot make light by itself. Robert Ryman's pictures have only the whiteness they were painted with, quiet enough for boardrooms and shiny new museums.

Beachy Head, Black Gull Flying (detail), 1972

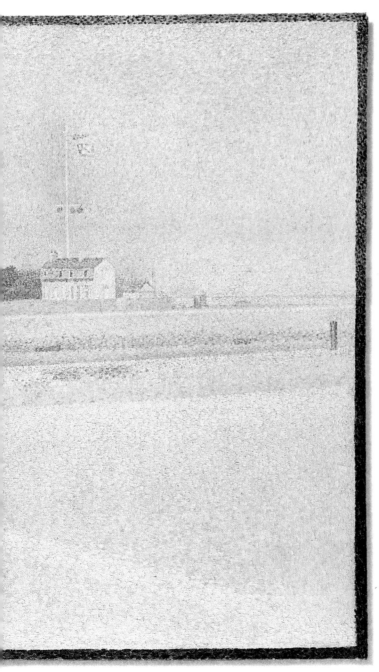

Georges Seurat, *The Channel of Gravelines, Grand Fort-Phillipe*, 1890

The rose is fixed pencil. The sea is White lead laid on with a palette-knife. Done on skin (the thinnest) plywood. The grain is visible. Isolate with shellac if too absorbent.

White Rose (unfinished), 1970

Choose a Fine Lemon

THE BRIGHTEST PART OF A RAINBOW is greener than the lemon. But the fruit is bright yellow, and will freshen thought, just as it brightens food. Darken it carefully.
Take a small canvas. Scrub it with ultramarine, mixed with Burnt sienna or Burnt umber. With a pointed sable, or soft-haired bristle brush, filled with paint of the consistency of cream, make, touch by touch, little islands of Cremnitz white or Underpainting white, in lemon shapes. Continue with touches of Zinc yellow, ultramarine, and Charcoal grey. If you cannot make them sour enough, you might use a little viridian, or Cobalt green.

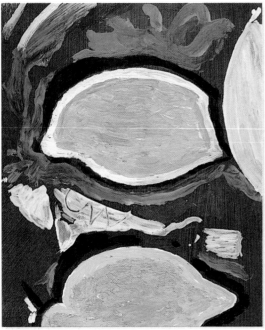

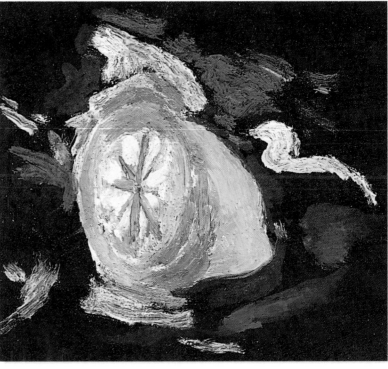

Braque's variations are on a black surface. Their priming contained sand-grit or sawdust, which prevented thin paint running down. It also took the paint off the brush.

After Braque

After Braque

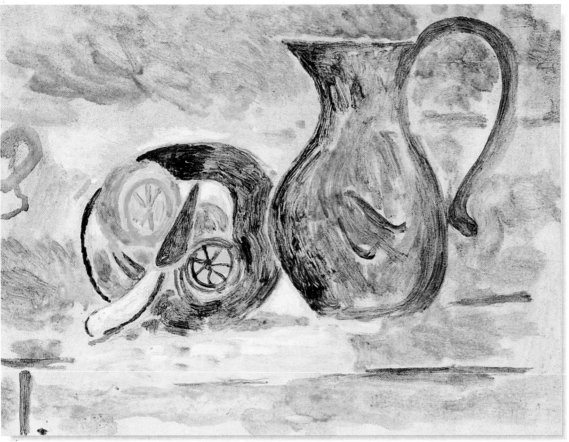

Ben Nicholson used simple objects all his life, never human figures. A lemon is part of the brushwork design of this early painting. His art became as cool as Switzerland, when he grew older and lived there. He designed with great refinement.

After Nicholson

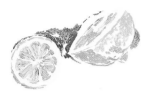

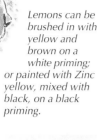

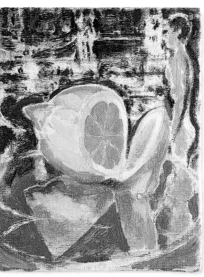

Lemons can be brushed in with yellow and brown on a white priming; or painted with Zinc yellow, mixed with black, on a black priming.

Dab yourself a free version of the famous witty "Fish hat".

After Picasso

A cool black shows off the pale pinnacles of Tower Bridge, and makes the yellow fruit a bright juxtaposition with the naked visitor to London. The pale divisions of the lemon's flesh make a subtle, central star. The composition is made with star variations.

Tower Bridge Lemons, 1986

Lemons brushed with white

After Manet

After Manet

Step-by-step dabs for constructing lemons. Sketch-paint with brown, mixed with yellow.

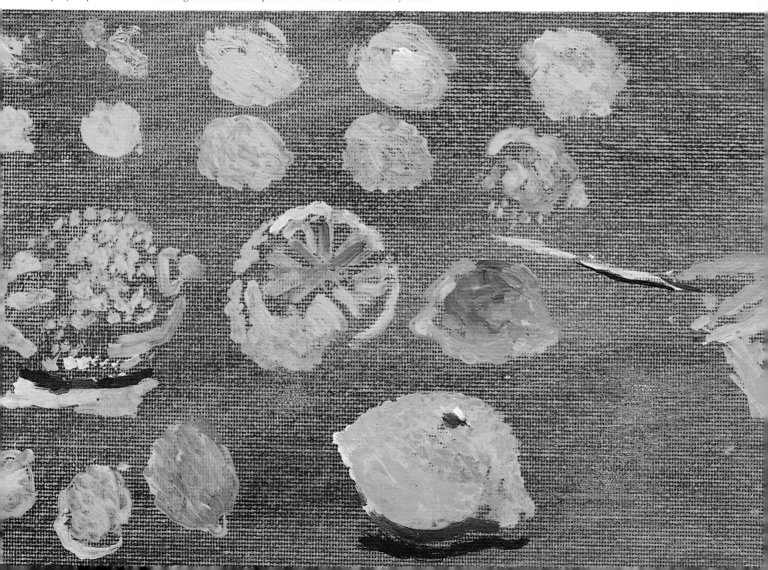

Greens

WHEN BUDS BREAK, the lyrical green mysteries of springtime burst and emerge. Winter is grey, brown, and blue. The fresh spring greens come early – tender and light. The late-summer greens are dark. The middle-summer leaves, as with human middle-years, are difficult to be excited by. Perhaps Paul Cézanne painted too slowly to do pictures of blossoming trees. But Cézanne did do some pale green landscapes, using tiny dabs.

The green colours are mysterious. Even the green gods from Frazer's *Golden Bough* would be daunted by the colourman's chart. There seem to be more greens than there are other colours. Greens come and go. They are difficult – I mean, difficult to make simple visually, and certainly complex chemically. Camille Pissarro, who spent his life with leaves, and advised Lucien his son (in a letter) to mix primaries, might not have wanted to know that Prussian green is a blend of ferrous beta-napthol derivative and copper phthalocyanine. He would have approved of Chrome green, deep and light, being simple mixtures of Chrome yellow and Prussian blue. Cinnabar green is Raw sienna mixed with Chrome yellow and Prussian blue.

So far, Lucien Pissarro's parent would not have needed to worry. But the following greens are not blue-yellow mixtures. The lovely Cobalt greens (which Renoir used towards the end of his life, with Indian red, for bodies) and Cobalt turquoise, and Terre verte which was the underpainting for flesh in early Florentine and Sienese pictures. (Now it is sometimes tampered with by adding Viridian, which is a pity, because the character of the colour is changed.) Terre verte, if used in tempera, can be thick and dark. (See the trees in Sassetta.) The very opaque and beautiful Chromium oxide green (the transparent version has been lost) will not mix comfortably with weak colours. Try mixing it with Monastral blue, or its chemical relative, chromium sesquioxide (which is Viridian). We no longer have Emerald green (Veronese green) which was used by Cézanne. It is a great loss to painting. Cadmium emerald is a poor substitute.

Pissarro would not have wished to use Winsor emerald, and I do not know whether he used black. Black and lemon make a kind of green. There is excitement in mixing greens, especially when secondary colours are blended – violet and green, and orange and green – and when green is beaten into various kinds of submission by its complementary, red.

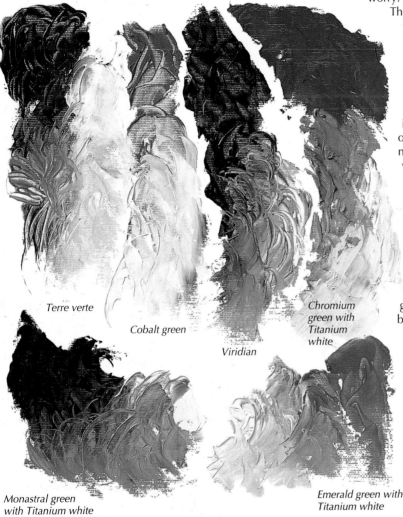

Terre verte

Cobalt green

Viridian

Chromium green with Titanium white

Monastral green with Titanium white

Emerald green with Titanium white

Nickel titanate with Ultramarine blue

Winsor yellow with Ultramarine blue

Yellow ochre with Ultramarine blue

Viridian *Cobalt green* *Chromium oxide green* *Emerald green* *Monastral green* *Terre verte*

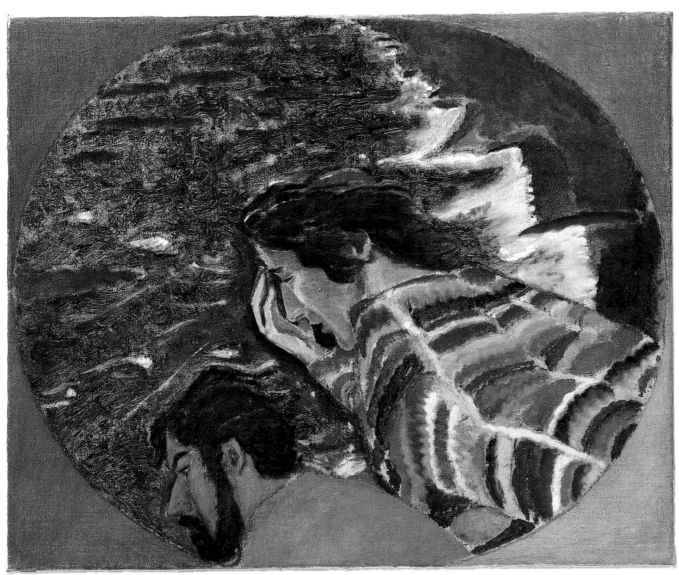

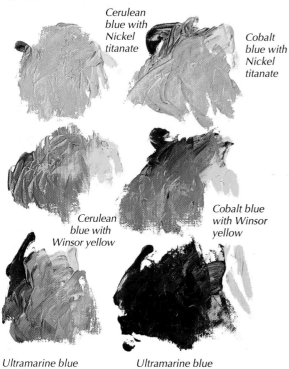

Cerulean
blue with
Nickel
titanate

Cobalt
blue with
Nickel
titanate

Cerulean
blue with
Winsor yellow

Cobalt blue
with Winsor
yellow

Ultramarine blue
with Nickel titanate

Ultramarine blue
with Winsor yellow

Davy's grey was mixed with oleopasto, so it would set
quickly, and partly painted over with Viridian. The shawl
was made with wonderfully orchestrated colours, probably
by an old lady of genius. Certainly, I have never seen its equal. It was crocheted
in short stripes, and wherever it was thrown down it looked beautiful. It seemed
to make the painting very easy to do. The warmish Davy's grey is slightly
yellowish and is activated by the greyed Ultramarine cloud shadows.

*Hastings on
the Pier, 1971*

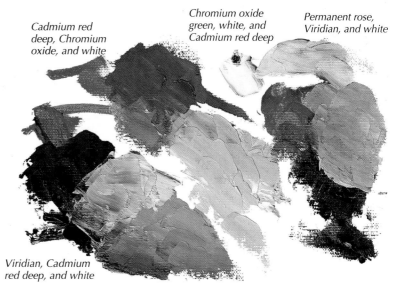

Cadmium red
deep, Chromium
oxide, and white

Chromium oxide
green, white, and
Cadmium red deep

Permanent rose,
Viridian, and white

Viridian, Cadmium
red deep, and white

35

Reds

SATURATED REDS HUM like mighty golden gongs. Matisse used the Cadmium reds. Vermilion is poisonous, and unless protected by glass or varnish, is affected by polluted air. Vermilion was the Old Masters' blood force for painting bodies. Little touches close to the contours made the White lead and ochres live. Used neat it is slightly warm, when diluted it gets warmer, when white is added it is considerably cooled. Craigie Aitchison uses saturated colour of fierce beauty. My free copies in oscillating colours show how pure Aitchison's colour is – like Stravinsky's orchestration, each instrument being made to sound new and profound.

Aitchison told me (rather as with alcohol in the days of Prohibition) where I could buy Vermilion scarlet. We are being deprived of our most important colours by our rulers. They think we must be protected from eating Emerald green, Naples yellow, White lead, Vermilion, Lemon yellow – and, alas, even more are threatened. Other colours, such as Lapis grey, never enter tubes for marketing reasons. Colours made from real pigments are granular, and move from the brush in special ways. They are as different as people. Dye colours cannot replace them. Nickel titanate is no replacement for the Lemon yellow used by Matisse.

Mary Potter was an inspired and sensitive painter of pale harmonies, by the sea. The light from the waves reflected on to the ceiling of her studio (formerly that of Benjamin Britten). She told the decorators to paint her room with brown, and then to give it a coat of pale scarlet – the sort of underpainting that Braque, from a family of decorators, might also have done. The great colourists woo their pigments into glow or subservience, with infinite pains.

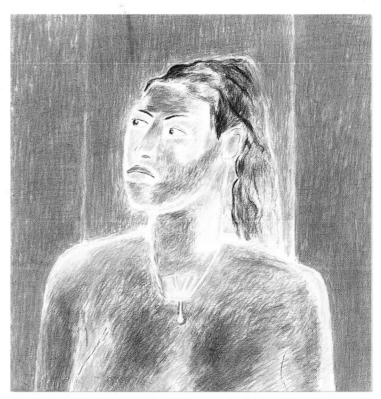

A portrait of a girl named "Comfort" (detail). The colours approach those of flowers: pinks, orange-red, and poppy-red. After Aitchison

A ladybird beetle near a Henry Moore sculpture near the Tate Gallery, London.

Craigie Aitchison, *Dog in Red Painting* (detail), 1974–75

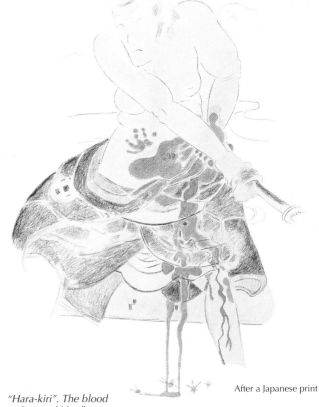

After a Japanese print

"Hara-kiri". The blood is designed like flowers, flowing like waterfalls, spattering like stars.

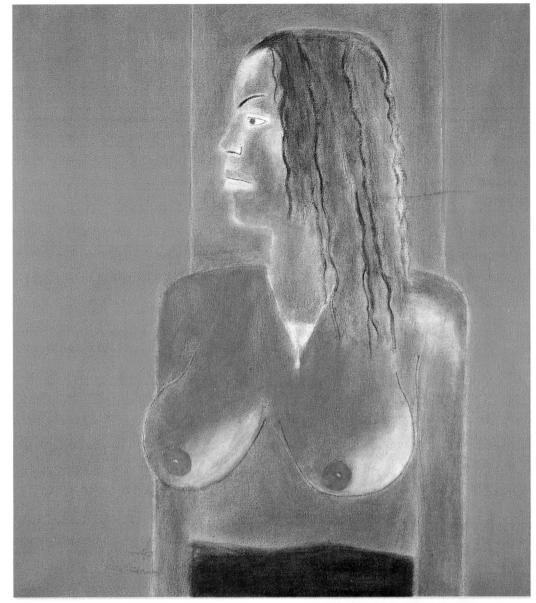

The skirt is painted like a dark Scottish island. The background is like a sunset of pink, howling at red. The girl is brown-black, and restful after a thorough brushing. The light is from below at the breasts, and from above at the forehead. Craigie's light is sometimes a little like a photograph's negative. This is really the inner light of a great imagination, and defies analysis. Practise rubbing colour on to canvas straight from the tube. Even the most opaque of colours such as Chromium oxide green can be scrubbed to a transparent lightness. Thicker colour can be kept in reserve to be added later.

Craigie Aitchison, *Portrait of Comfort* (detail), 1994

With experience, subtle differences are felt between Titanium white mixtures with Cadmium red deep and those with a Vermilion.

Cadmium red, diluted and mixed with Titanium white. Flesh colours tend to become heavy with these reds. For lighter weight mixtures, I might use Permanent rose with Zinc or Lemon yellow.

Vermilion, diluted and mixed with Titanium white. Cadmium scarlet will make wonderful glowing oranges with Cadmium lemon.

Cadmium scarlet, diluted and mixed with Titanium white. A pricked finger will smear in red and oxidize, darkening and leaving the flowery reds like the joyous reds of India to become Indian red, the densest opaque red.

"Pink Vase" After Aitchison

Umbers

Cow-flop

Dog excrement

Horse manure

Rabbit droppings

BURNT AND RAW UMBERS are "earth" colours. They are mined, and consist of ferric oxide, silica, alumina, lime, and manganese oxides. They are intimate as dung. The brown of a cow-pat is the deep organ-note of a Braque. Horse manure is paler, and full of hay. Adding white to Raw umber reduces its strength of colour. Morandi used umbers weakened with white frequently. Perhaps the paint resembled pottery-clay, and since squarish pots in squarish formats were his habitual subjects, every nuance was clear enough. Umbers as liquids over white stain strongly. If you need them to be stronger when mixed with white, add a bright yellow: lemon yellow for Raw umber, Cadmium yellow for Burnt umber. Brown is a low-intensity yellow.

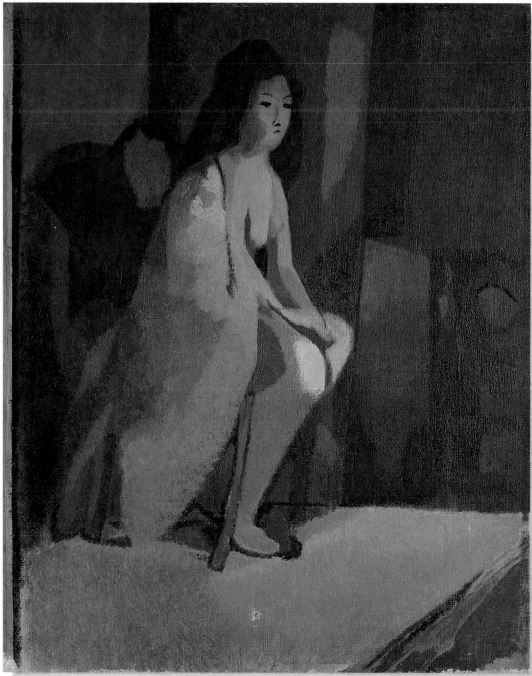

John Dodgson,
Small Nude, 1950s

On the right of this gentle picture, it is possible to make out a girl student holding a pencil at arm's length, sizing up the model. I do not know whether John Dodgson himself was a "measurer". He certainly considered every quantity with care, and as he painted, the composition would change. Here the knee became egg-shaped. The patches of brown paint (greyed sometimes with Cobalt blue) are divided exactly, and nothing is left to chance. (See the 15 millimetre-wide grey border – it was to have been covered by the frame!) Dodgson took as long as a picture required, and many of his paintings were lost in a studio fire. Dodgson possessed a fine painting by Bonnard. Bonnard would touch-up his own work, even when it was hanging in a museum.

Still life in Burnt umber After Morandi

Raw umber with Lead white. Experiment with close-toned colours. They enhance one another, in a climate of pale brown. Pale discords make pleasurable buzzes.

Hang-gliders are made in beautiful colours. Here, a kite lies on the brown grass at Beachy Head. The fabrics reflect the sky.

Raw umber with Titanium white is much cooler than with Lead white.

John Dodgson would have liked the formal shaping of "La Poseuse", and Madeleine Knoblock, who was Seurat's girlfriend. There was a strong desire at the time to eliminate browns from the palette.

After Seurat

Burnt umber above, and below, Raw umber slightly diluted, showing the intensity when white is not added.

Burnt umber with Lead white, intensified on the right with yellow.

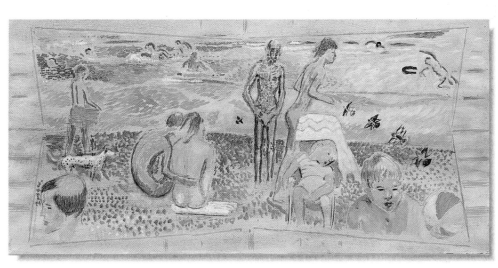

Burnt umber with Titanium white, intensified on the right with yellow.

Although some red is used, the umbers will do for most of the bodies and the beach.

Greys

A SIMPLE GREY IS A MIXTURE of black and white. (Lamp black and Lead white.) Battleship grey, perhaps. Winsor and Newton supply a mixture of Carbon black, Natural earth and Titanium dioxide, in five degrees of darkness. It is a heavy grey, but it can be wonderful as a support for other greys, or colours, as in Braque's studio pictures. A grey which made Battleship grey look clean, even enchanting, was called "sludge" by my father. He was keen on it, it was cheap – it was all the leftover colours mixed together, from a paint factory. It offended me, but it preserved ladders, tubs, tools, doors. He even dabbed it on his hat to make it waterproof. When you clean a palette, the resulting mixture can be dirty as sludge. With a restricted palette, the combination may be acceptable. Gillies said in an interview that he liked using the grey which accumulated in the corners of his watercolour box.

Usually, I try not to mix more than two colours. Burnt umber and ultramarine, for example, will make a useful grey. Davy's grey is made of slate. It can be sharpened by adding Monastral blue, or if you add ultramarine it approaches the beautiful Lapis

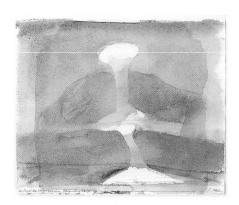

Norman Adams, *Study of the Sun – Evening, Staffin Bay, Skye,* 1965

grey, which is now no longer obtainable. (Lapis lazuli, and Ultramarine ash, were used in Piero della Francesca's greys.) A predominance of greys can make pure colours sing, and in a colourful picture the greys may become dominant.

Much Chinese painting is done with diluted black ink, and Thomas Girtin worked close to monochrome, as did many English watercolourists. In my diagram, the grey mixtures are, instead, very colourful. The beautiful greys that Klee obtained were by superimposing colour upon colour, and by juxtaposing broken colours. When painting with greys, think of them as colours.

My brushes are spoiled by my laziness. I have had some of them for more than 50 years. I was taught to clean brushes properly at the end of each painting day. You wiped them, and one at a time, rubbed them on soap, and then on your hand. (If you have allowed the brushes to become badly caked with dry paint, leave them in brush-cleaning fluid for a few days, then rub them against a scouring pad with washing-up liquid.) Sables do not keep their points well in oil. Sign-writers put Vaseline on them. (Remove it thoroughly before use.)

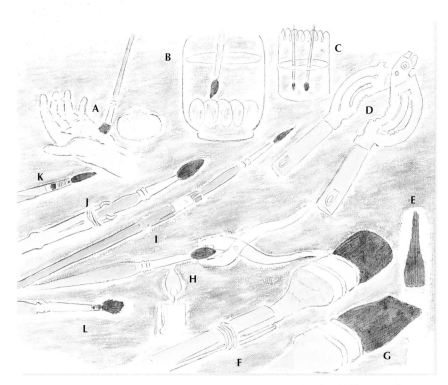

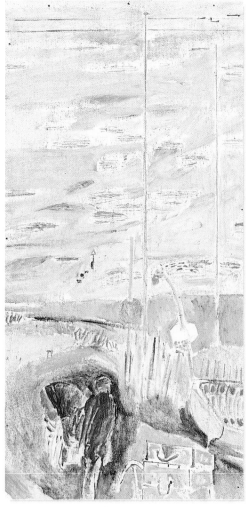

A Brushes soaped and rubbed in the hand

B A brush washer

C Watercolour brushes suspended in water by a spring

D A jar-opener is useful for undoing paint caps.

E Decorating brushes can have some of their outer hairs shortened.

F A decorating brush-handle can be cut to fit into a split bamboo stick, and bound.

G Decorating brushes hold too much paint for some purposes.

H Brushes whose hairs are worn short can be lengthened. Heat the ferrule, and pull – but not too hard or the ferrule can be cut round with a file.

I, J A watercolour brush set in split bamboo

K A sable in a quill can be set on a tapered stick, with a little adhesive.

L A brush that has been lengthened by heating is often fuzzy.

Black, and Transparent golden ochre, are used with Cremnitz white. Brighter colours are used for the cloud shadows.

Fishermen at Pakefield, 1963

1 *Chromium oxide green and Cobalt violet*

2 *Viridian and Cobalt violet*

3 *Viridian and Davy's grey*

4 *Viridian and Cadmium red deep*

5 *Cobalt blue and Davy's grey*

6 *Viridian and Permanent rose*

7 *Prussian blue and Burnt umber*

8 *Cerulean blue and Davy's Grey*

9 *Cerulean blue and black*

10 *Black with ultramarine*

11 *Black with ultramarine, but diluted*

12 *Burnt umber and ultramarine*

13 *Raw umber and ultramarine*

14 *Black*

15 *Black*

16 *Raw umber and Cobalt blue*

17 *Burnt umber and Cobalt blue*

18 *Cerulean blue and Burnt umber*

19 *Cerulean blue and Raw umber*

20 *Prussian blue and Davy's grey*

21 *Prussian blue and Light red*

22 *Cobalt blue and Light red*

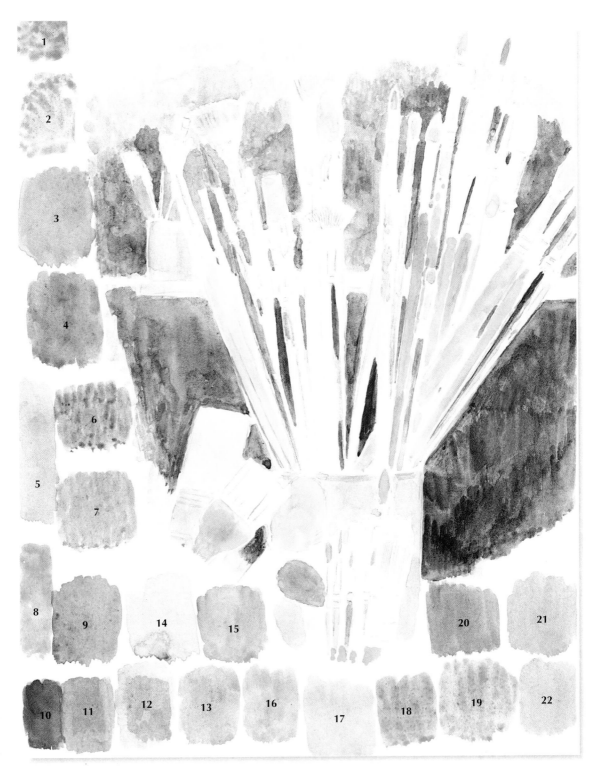

Some of my hundreds of brushes. Do not throw brushes away. Often, they improve with wear, and are useful when fuzzy. Fan-shaped brushes are versatile.

Grey samples show how colourful and simple two-colour mixtures are, if placed side by side. Try as many permutations as you can. Some three or four colour mixtures may also be exciting. If you try mixing together all the colours of your normal palette, you will know what it looks like – you may wish to change the colours you use.

Braque had an enormous number of brushes. Some were in tins, ready for the fray. Miró, Braque, and Nolde would use frayed brushes to give a brushy mark. I knew a painter who rubbed his brushes on concrete.

Blacks

THE CLOCK BELONGED TO ZOLA. Cézanne painted the picture for Zola, in Zola's house, and Zola kept it all his life. If we understand that Miró, for example, depicts objects in oblique ways, and metaphors abound in art, we might dare to essay that Cézanne had painted his school days swimming companion, Zola, as a still life. Whatever its secret, "The Black Clock" is not just a dark setting for a teacup. This famous picture was done when Cézanne was 30. Its blacks are not as seductive as those in later works. As his pictures became more colourful, he would caress Peach black until he had coaxed it into being the most surprising colour in the picture. "The Black Clock" is a beautifully fashioned picture, using black generously. Cézanne built strongly on Spanish foundations and looked at Manet.

Blacks vary a lot. They are important colours, and, with whites, they are eloquent. El Greco, Velásquez, and Goya used semi-transparent whites and blacks throughout their pictures – black, sometimes like mantillas, flamenco-brilliant, over glimpses of flesh made with vermilion, ochre, white and black: a living abundance.

To experience the versatility of this great Spanish technique, make a canvas brownish. Then brush Cremnitz white where you wish. The lead helps it to set. An oily Bone black or Ivory black can then be brushed over it. White made oily will be cooled as it moves over black. Picasso did not use this way exactly, but he looked at Manet and brushed with black and white freely. He wanted to be the top branch of the great tree of Spanish painting, and copied "Las Meninas" over and over.

Try out every combination. With a brush, stir Cremnitz white, or some other Lead white, with Ivory black. Flake white is sometimes full of Lead white, you can tell by the weight. Do the same with Lamp black and Titanium white and compare them; the difference is enormous and will prove to you how necessary it is to examine the latent qualities in all colours.

Colours are from many sources. Some are from plants, some are minerals, others are synthetic. They are ground and put in tubes at the strength, hue, and darkness they become with oil added. Scarcely ever will they harmonize straight from the tube. ▶

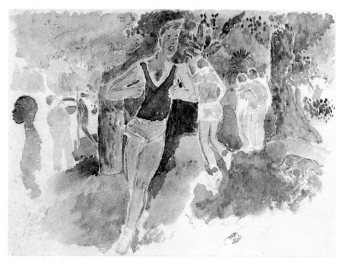

The vest is pale black, and works paired with a darker green. The black face is blue.

The Jogger, 1983

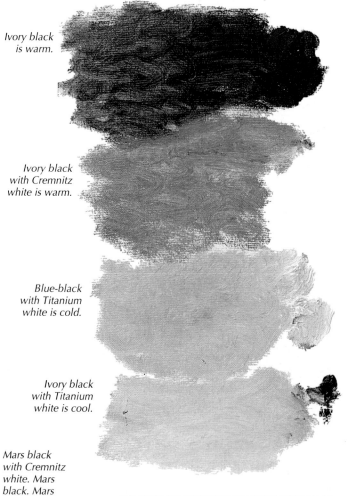

Ivory black is warm.

Ivory black with Cremnitz white is warm.

Blue-black with Titanium white is cold.

Ivory black with Titanium white is cool.

Mars black with Cremnitz white. Mars black. Mars black with Titanium white is cool and dense.

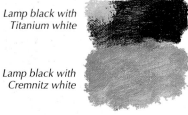

Lamp black with Titanium white

Lamp black with Cremnitz white

Blue-black

Blue-black with Cremnitz white

Charcoal grey with Titanium white. Charcoal grey is transparent. Charcoal grey with Cremnitz white is warm.

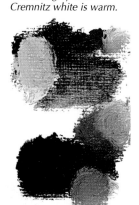

Blue-black is Ivory black, mixed with ultramarine. If it is added to white, Blue-black does not make such warm greys at lower tones as Ivory black on its own. I add blues to Charcoal grey instead.

Davy's grey with Mars black added. When Davy's grey is used as if it were black, it makes a foundation for the last-minute application of Deep black.

Cadmium red, Lemon, and Yellow ochre, stroked with Charcoal grey. Try postponing the use of black in a colourful picture until almost the end, then, supporting it on a grey or a colour, find how movingly it can sing. Uccello painted black over silver foil. Black over white can be sharp as a bell, precious as diamonds.

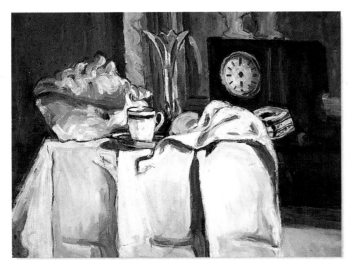

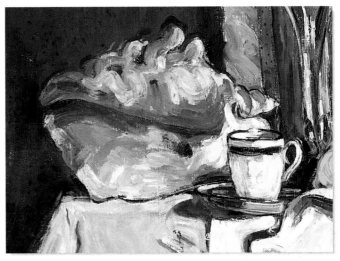

Leonard McComb, after Cézanne, *The Black Clock*, 1988

Leonard McComb, after Cézanne, *The Black Clock* (detail), 1988

▶ Mars black may be tinged red or not. It is the darkest of the iron oxides, and is thick and opaque. When mixed with Titanium white, it becomes a dense battleship grey that will cover anything. At the other extreme, Charcoal grey, which is really a black, will mix with Cremnitz white to be a warm, cloudy grey of a versatile transparency. Charcoal is often used in the preliminary drawing of paintings, and is allowed to mix in with subsequent daubings. Matisse and Picasso often painted in this way.

What courage he has to paint it full-size! McComb knows how to really look at paintings. His brush moves impetuously, almost ahead of sight; the brushing is like looking. If he'd had one of Rubens' apprentices to mix him a leady white, the paint facture might have been softer. The fold of the shell, which the writer Lawrence Gowing found so sensual, was straighter than the original. But this is an exuberant version of the mollusc. Zigzags generate energy. These undulations probably influenced Matisse's use of pattern. A zigzag done with a full brush is serpentine.

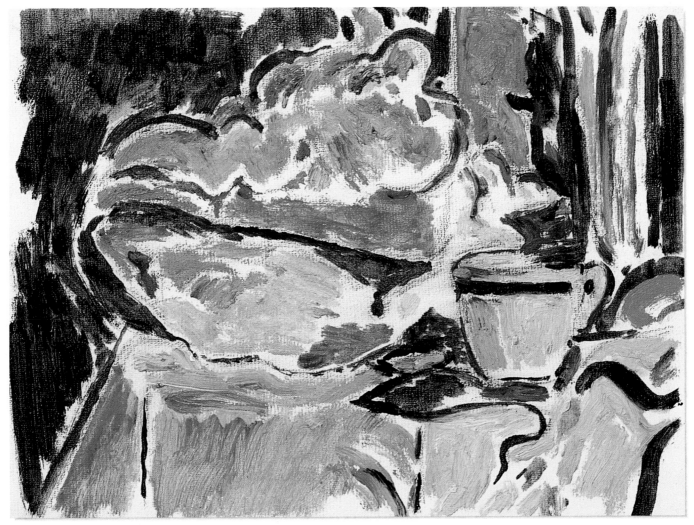

A free copy-dab of the shell. It has none of the weight of early Cézanne.

After Cézanne

Watercolours Can Enchant

STUART DAVIS INSISTED HIS PAINTINGS should be called drawings. Perhaps the difference between painting and drawing will become clear as we contemplate the forms dissolving in the splendours of British watercolour. As with ink landscape-drawing in China, British watercolour is regional and unique. It is rhythmical, of course, but not linear. Turner would scratch in movements, and Constable would flourish wetness. Turner used Rubens-like envelopes of spaciousness, without Florentine lines. He used body colour (gouache) on blue-grey paper, or highly worked watercolour on white paper, to move into miles of depth, to circle around the sun. It is strange that some of the widest, deepest expanses of landscape in art have been depicted on tiny sheets of paper.

Dab some blobs directly, to resemble a pomegranate.

Turner was the greatest European itinerant artist. Much would have been drawn in lead pencil and coloured in later. Back in England, the aristocrats, secure after the perils and delights of The Grand Tour, would recognize in Turner's paintings the high points of their visits. Do not stagger round Europe with a video camera built for boring. Be gentle with yourself: bring back delicate touches – the expressive movements of the brush, on distant mountains, as felt by you and no other.

A watercolour done in connection with a large painting. Cézanne would have used colours closer to simple primaries, but the hatching is similar.

Balthus, *Still Life with Leeks*, c. 1964

"Park Row". Davis liked speed, noise, energy, and visual slang. He wrote: *"The city is man's greatest invention.:.. All my paintings affirm an urban continuity, a measurable juxtaposition."* Gouache can be flatter than watercolour, and because of this the edges have to construe with each other more exactly. Davis said: *"Drawing is the correct title for my work."*

After Davis

John Sell Cotman was a great classical composer, the Poussin of watercolour. The most original painter in the Norwich School, he used a paper that had the appearance of dried porridge, and painted with the soft colours of burnt porridge.

1 *In Cotman pencil drawings, ticks for windows, birds, or cavities would be blacked-in hard: contours would be left for colour washes to define. Two applications for middle-tone. Four for the darks, gave five tones in all, enough for most purposes.*

2 *Two pale washes of colour give three tones*

3 *Three pale washes of colour give four tones*

4 *Four pale washes of colour give five tones*

5, 6 *Play with wet paper, and wet and dry marks, and pretend they depict San Giorgio Maggiore in Venice. This exercise is best done in a gondola on a calm day.*

7 *Ultramarine on wet, and on dry*

8 *Grey on wet paper*

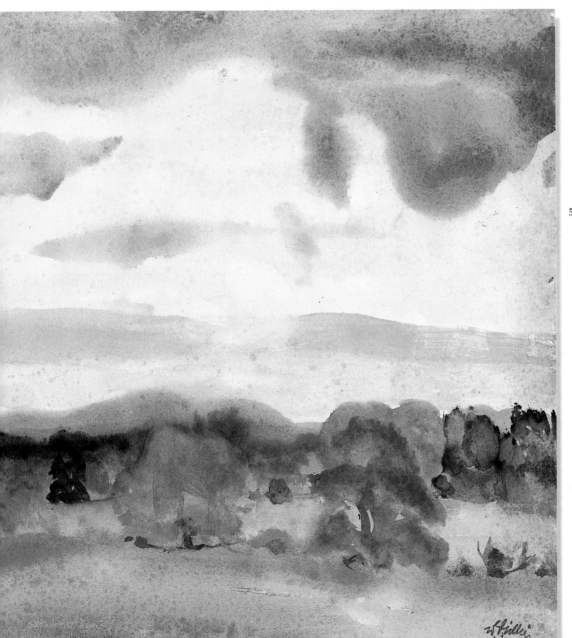

Gillies lived in the village of Temple and painted the lowland hills of Scotland more beautifully than any other painter. He could draw fast. He did everything fast. Watercolour was natural for Gillies, his splodges each became part of the firmament. He made for innovations (although he trained in Paris). His compositions were very exact. He used only the simplest traditional materials – because that is all a genius ever needs.

William Gillies, *Temple, Evening*, 1940s

Gouache

WILLIAM GILLIES WAS NOT A VOLUBLE TEACHER. He said the minimum necessary, and always in the presence of the picture. He said in answer to a desperate enquiry: "It is the way you see it." Absolutely obvious, and sure to take years to accomplish! Look at the early works of any top artists to see how long it took for them to see their way. Henri Matisse was in his thirties before he did any original paintings, and many years older before he painted a Matisse that was all Matisse. Paul Gauguin was the slowest, he was in his forties before he could free himself from a slow Impressionism. (Carving, ceramics, and woodcuts were crafty activities that tempted him to greater freedom of invention.) It is what you bring to the thing seen that makes it possible to see, to paint.

Gillies watched the hills all the time. Cloud-shadow shape, cloud shape, field shape, cornstook shape. In this watercolour of

"Border Fields, Longshaw", the hedged fields made lozenge-shapes, with pointed ends. Variations of lozenges (the old Basic Design "Family of Shapes") will hump up, to be clusters of foliage, or complete trees. He used pen and ink. He made thin pen lines for the horizon, and used a reed or bamboo pen, or a very flexible nib, or a piece of stick such as the wrong end of a paint brush to sweep in gestural, flowing, liquid lines of waterproof ink for the middle fields. Pen and gouache go well together. Gouache is a name for thick watercolour. Body colour. (Pigment, gum, and preservative.) Pen lines are so artificial, they will declare themselves even through rich applications of gouache. (Gouache is "designers' colour", watercolour with white added, to make it relatively opaque.) With his watercolour-whitewash, Gillies watered near and far: the underlying lines, like spines, would hold fields together, almost resembling a sequence of reclining bodies.

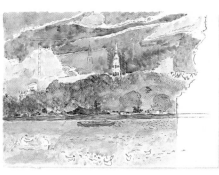

Pen lines over and pen lines under but not in this case, pen lines into wet gouache. John Maxwell and other Scottish painters enjoyed making their pen lines blur and run in the wetness. Two sheets of paper have been joined together, the join is barely visible.

Willam Gillies, *Border Fields, Longshaw* (detail), 1949

Terns on the Thames

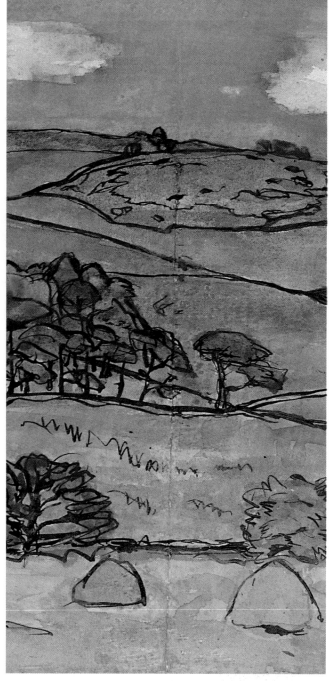

Birch tree and a red bus at Clapham

The Surrealists used rollers, resists, rubbings, combs, and anything that came to hand. Gouache would hold it all together.

Eileen Agar,
Untitled,
(no date)

William Gillies, *Border Fields, Longshaw*, 1949

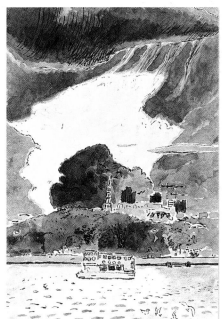

Riverboat on the Thames

A Chestnut tree. Some painters rarely use strong contrasts, but dark colours can be dramatic. Fill a brush and be decisive.

47

Jewelled Water

Some colours are exotic as jewels. All colours are special. A pricked finger exudes a globule of ruby red, which dries to Indian red. Amethyst and sapphire, topaz and emerald, are like brushfuls of watercolour, and if the pigments are applied wetly, the jewel-quality remains. I am a glutton for colours. There is a Robert Rauschenberg painting that has, collaged across it, a colourman's chart of all available colours. I have all the colours depicted on these pages. I try not to use more than two or three at a time. Girtin used almost none. Klee makes it look as if there are more colours than exist in the world. Braque also is a master-chef. They change the priming, underpaint, and juxtapose colours to make optical mixtures.

Because I like having a lot of colours available, I enjoy using the box I made. You need a bundle of balsa wood (which is very strong and light) from a model-makers shop; a tube of balsa cement; a cutting knife; a long plastic hinge, or two short ones; some fine sandpaper; some white lacquer (spray it or brush it).

The cement dries quickly; you can make a box in a few minutes. The cement will secure the watercolour pans; a flanged edge will prevent the colours drying out. Tin boxes are rather unfriendly, but I also have a little metal box. It has a ring for the thumb, a built-in water container, and a tiny collapsible brush. It is good for making colour notes. It is difficult to decide which 12 colours to include. I settled on: Davy's grey, Viridian, Monastral blue, black, Burnt sienna, Ultramarine, Cerulean blue, Raw umber, Lemon yellow, Cadmium yellow, Cadmium red deep, and Permanent rose. Rice-water makes brushmarks happen; distilled water is advised by some. Oxgall, I am told, breaks surface tension.

Balsa wood; balsa cement; cutting knife; white lacquer; hinge; brush

Summer. Watercolour will combine well with pastel pencils to enhance a fixed, squared-up, pencil drawing from imagination.

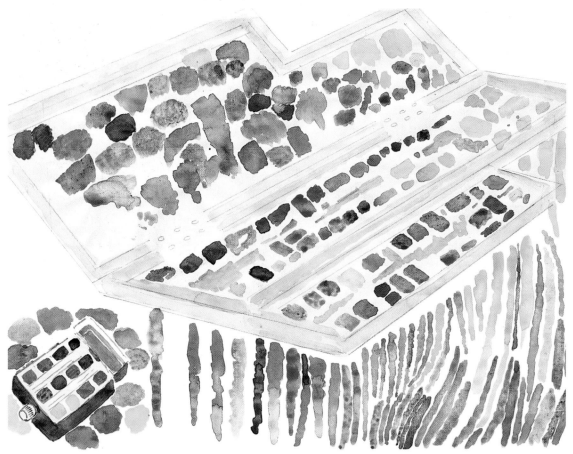

It is useful to group colours in families, they do not sully each other when wetted in the box as easily as contrasting colours, and their juxtapositions suggest fruitful harmonies. An example is Matisse's delight in the Cadmium yellows and reds. At a further extreme, van Gogh's economical earth palette (for potato eaters and weavers) was probably genuine

Naples yellow, Yellow ochre, Raw sienna, Raw umber, and black. The black family extends from the heavy opaque Mars black to the gentle transparent Charcoal black. (Some colourmen supply a transparent black.) The green family is very large, and beware of the colourmen counterfeiters whose muddled and mud making mixtures are given names to lure.

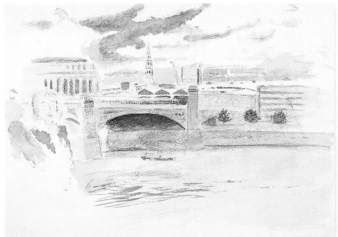

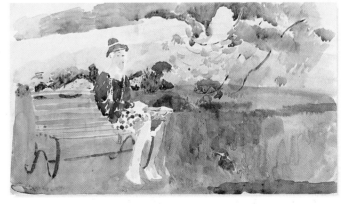

I often add watercolour to drawings when I get home. This is a view of Blackfriars Bridge.

Laetitia and a blackbird at Kew. Bank paper makes watercolour hazardous because thin papers cockle.

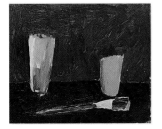

Nicholas de Staël, after being abstract, painted his paints, jars, and brushes.

After de Staël

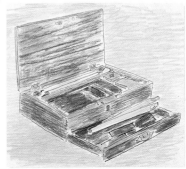

A set of Chinese materials, given to me by a grateful student. All I need now is to know the rituals.

Palettes

MY PALETTE WAS OLD AT AUCTION 50 years ago. A Stradivarius of palettes, it smelled of forbidden megilp. Its deep colour was sensible when primings were brown. You were supposed to rub the wood with oil when new. (If you normally paint on white, you can spray your palette with white car cellulose.) A good palette is balanced by being made thicker where it comes close to the body. It is useful to have a held palette, as the paint can be looked at against the subject, or with the picture as you work.

Artists have used a great variety of mixing apparatus. Bowls, foil pie-cases, cut-down bottles, jars. Bacon and Bonnard used plates. Picasso used wooden packing-cases, and the oil-absorbent boxes tubes are sold in. Rouault and Dunoyer de Segonzac used big tables. Early artists used fewer colours and their palettes were small. Cézanne's had to accommodate 15 colours. Tear-off paper palettes are unattractively floppy when nearly used-up.

My palette

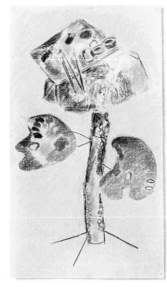

Braque made this palette support from a tree-trunk and wire.

Students, happily for teachers, continue to have palettes; for close to the palette may be found "The Work", almost always powerfully filled with Harrison's red, and dangerous to sensitive teachers. The survival method is to pick up the palette with alacrity, either for appraisal or attack. Discuss the setting of warm/cool, dark/light, opaque/transparent colours, in good order. Add some advice about removing old paint, and you are safe from "The Work" until the light dims. Harrison's red has its teeth drawn in poor light.

The glamour pages at the front of art books often show the encrusted palettes of the Masters. To remove old paint, blow hot air, or use a solvent, or hold face-down over a gas ring, as I was taught 56 years ago, and scrape with a three-cornered scraper. Sometimes, unused paint is scraped to the edges of the palette where it makes thick crusts. For Rouault, the rich accumulations of his enormous palette-table proved an inspiration.

Braque's plate-as-palette

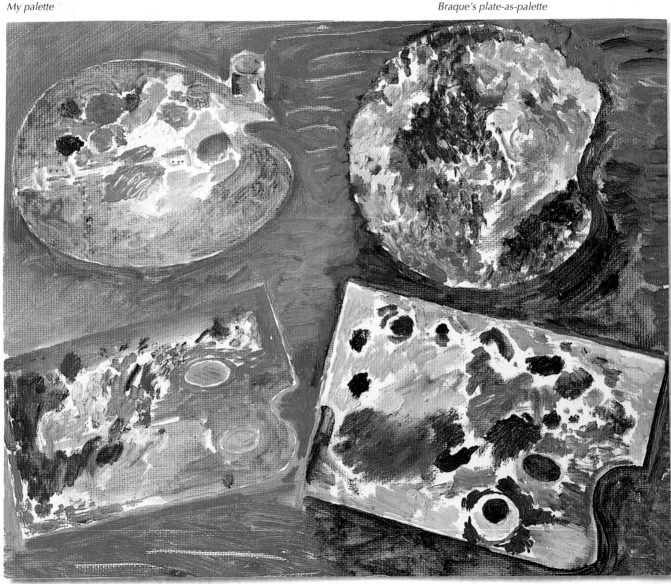

After Gauguin

After Braque

After Corot

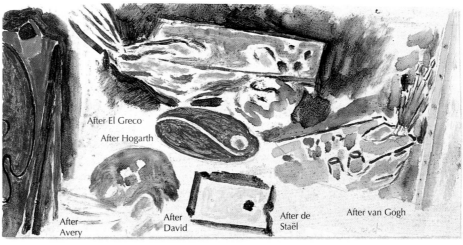

After El Greco

After Hogarth

After Avery

After David

After de Staël

After van Gogh

A brush washer. The spring suspends the brushes.

A base-board with greaseproof paper as a palette. The paper is kept taut by a spiked frame.

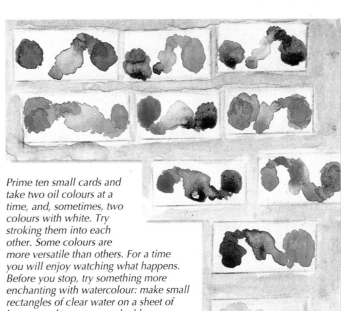

Prime ten small cards and take two oil colours at a time, and, sometimes, two colours with white. Try stroking them into each other. Some colours are more versatile than others. For a time you will enjoy watching what happens. Before you stop, try something more enchanting with watercolour: make small rectangles of clear water on a sheet of hot-pressed rag paper and add some strong colour at each end of the compartment, then add a drop of clear water. With a meniscus-leap, the colours will make towards each other, like trees in a "chemical garden".

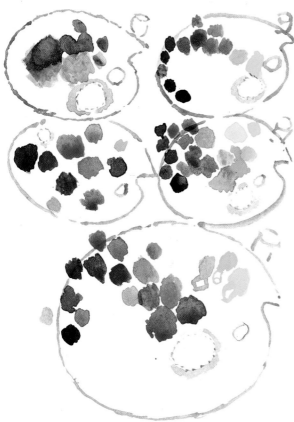

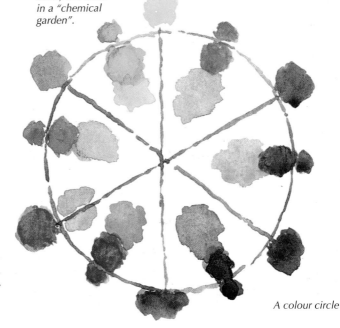

A colour circle

Play-paint some palettes with your chosen colours. One moves from light to dark, another is warm moving to cool. Another is haphazard, and another (a difficult choice) is for painting monochromes. Finally, decide what group of paints you really like to work with. Try two earths, two blues, crimson, two yellows, black, white, and red. This group moves opaquely outwards to transparency.

Making Paint

JOHN MAXWELL THOUGHT HIS RASH was caused by applying paint with his fingers. He said William Gillies also painted in this way. I think Gillies used brushes and painting-knives most of the time. But in Scotland, in Edinburgh, there seemed to be a great love of the look of paint. Maxwell and Gillies had studied in Paris, and would look at paint as thickly applied as that of Dunoyer de Segonzac. When they saw a beautiful picture, a "wee" cry of ecstasy would occur, a delight in its "bonny bits" be manifest. To paint thickly, you were urged to start with a large pile of white paint in the middle of your palette.

Palette-knifing began in England with Constable, and reached its greatest richness with Courbet. Rembrandt had painted thickly, and Soutine had understood the reason for this. Paint can be eloquent. Its special attraction, which is difficult to define, becomes clearer if you make your own paint. It can be very simple to do, for many pigments are finely divided and need only to be mixed with oil, using a spatula. For a start, you could mix cold-pressed linseed oil with Zinc white and two per cent beeswax. If you wore a mask, you could do the same mixture with White lead, which would really be like being an Old Master! This freshly mixed white is so responsive, one begins to sense how Rubens was able to paint a deer-hunt on a tiny panel. The pigment is in thin oil, flows well, and sets rapidly, ready to take thin glazes of colour, or a hound-whisker with a tiny brush.

The delights of paint are infinitely various. Peter Doig spatters in dollops galore: these make optical colours, and are substantial at a distance. Where the knife is used, these days, it has a congealed, constipated look. Eakins managed to combine knife and brush with hard edges. He lived close to the academic edge. A great painter.

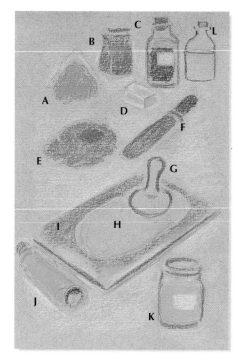

A *Pile of pigment*

B *Packet of pigment*

C *Bottle of pigment*

D *Beeswax*

E *Oil in a hollow made in the pigment*

F *Spatula*

G *Glass muller*

H *Paint being ground*

I *Ground-glass slab*

J *Empty tube*

K *Jar of paint*

L *Bottle of oil*

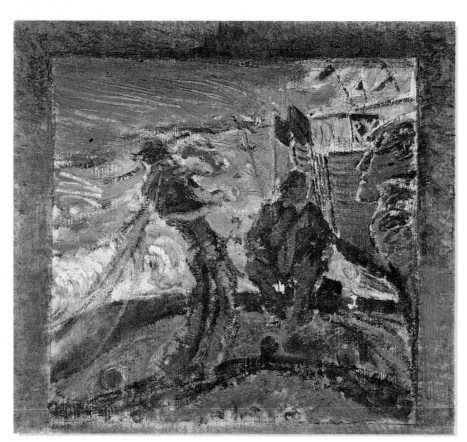

Somehow, the rough work, rough sea, and rough paint seemed to tell it the way it was. Although it is not long ago, it seems a remembrance of things past.

Nets, 1975

The straight lines of railway tracks turn into hand tracks, gestural knifings of paint – tracks that are not so different from the soft Scottish hills. Kossoff may have looked at Soutine, and Gillies would have looked at Munch. The thick paint makes doughty pictures: the raw, puggy stuff becomes real poetry, coming in big tins. These can be seen in John Lessore's painting of Kossoff's studio (see p.83).

Leon Kossoff, *View of Dalston Junction*, 1974

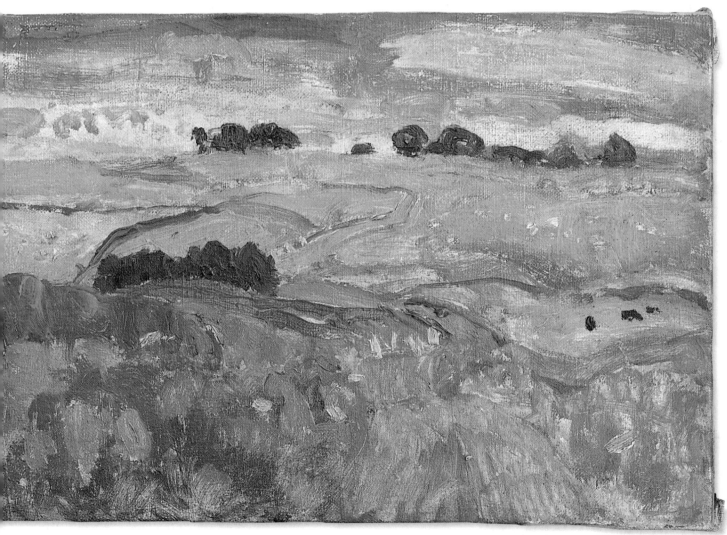

Painted with a brush, the Scottish Lowlands inspired it. A granular textured Cobalt green and Indian red would have been put on with a knife if the picture had been larger.

William Gillies, *Mount Lothian*, 1947

Colour Stores

MUSEUMS CONTROL THE AIR, and make a twilight for fear of fading. Cubists collaged newspapers, which have gone brown. Oils go yellow, wrinkle and crack. Pigments are changed for dye colours, which cost the manufacturers less. Preservatives, moisturizers, plasticizers, extenders, and driers are added to paint, for good, or profit. Lawrence Gowing gave hundreds of lectures on Cézanne. When I asked him what he mixed his colours with, he said he didn't know. There is so much we do not know. When I painted out-of-doors, insects would stick to my picture. I have never seen a midge leg on a Cézanne – do dealers pick them off?

It is probably not good to make complicated mixtures. Venice turpentine, copal varnish, megilp, and asphaltum may be better avoided, although most sticky mixtures will last a lifetime. This is not a recipe book. (Max Doerner and Ralph Meyer have written useful books on materials.) Art can be done with black, white, turpentine, and a little linseed oil. ("Guernica", for instance.) Bonnard used poppy oil; it is good for pale colours, because it is non-yellowing. If you want really thin paint, turpentine and cold-pressed linseed oil makes a basic medium. Use it with oil-paint that has been squeezed on to absorbent paper, and you will have paint as thin as ink.

My diagrams tell a little about the materials, but nothing is sure. Even Joseph Mallord William Turner's spit is not the same as spit today, nourished as we are on fast foods. (Spit contains enzymes, by the way, and is good for removing dirt from some kinds of oil painting.) Turpentine wets more than white spirit.

Daniel Miller, *Tubes of Paint*, 1994

They almost painted themselves.

Oil of spike (lavender oil) smells sweetly and dries slowly, although I have never used it. Eggs will make pigments adhere. Add equal parts of egg and oil to the same amount of water and shake. Add a little damar varnish, if you wish. Stand oil and turpentine in equal parts, added to the same amount of egg yolk with two parts of water, dries fast in both oil and tempera techniques.

Casein (which has been used by Balthus) makes a waterproof film that is strong on paper. Opal medium comes in tubes: it is beeswax, turpentine, and stand oil. It takes the shine out of paint.

Today, a visit to well-stocked artists' colour-store creates the same feelings I had as a child on Christmas mornings when I opened my presents. I was given a large watercolour box one year. Strangely, I fell in love with one colour which I remember to this day. It was a dull buff colour (which might have been a mixture of Chromium oxide green and white). Art shops are an inexhaustible lure. It is economical to remember that a million pound Cubist picture might be made of charcoal, yellowed newspaper, a dab or two, and some found objects. But Cubism was special and allowed many games with materials. Picasso, Braque, and Gris included granules of tobacco, beads, sand, sawdust, powdered cork, etc. And Dubuffet collaged with butterflies, dried leaves, flowers, and charred orange peel. Materials can be almost anything. Whole used paint tubes would be trowelled into John Maxwell's paintings. I had better stop before I include the vast array of collage materials used by Schwitters, Schnabel, Lanyon, Thubron, Rauschenberg, and Mellis, because that way lies sculpture.

1 Turpentine has an attractive smell. It is also toxic, so ventilate thoroughly. I found my paint was remaining sticky. I had tested the turpentine by putting a little on a piece of glass. It did not dry. Now I take care, and keep turpentine in the dark in a full container, and not for too long. If you squash the plastic container until the liquid is at the top, you can screw the cap on tight. Otherwise decant into full bottles.

2 The medium I like is probably too complicated to recommend. It is a combination of varnish, wax, turpentine and polymerized linseed oil.

A Stand oil. (Polymerized linseed oil.)

B Matt varnish. (Synthetic resin turpentine, and wax – not silicone.)

C Turpentine. Matisse is said to have had a little wax in his medium (which would have made it easier to remove the paint for his continual erasures).

3 The paint we buy in tubes is a mysterious mixture of constituents – to prevent settlement, or its failing to dry on the canvas, or going rancid in the tube. Nearly always the artist has to make intuitive adjustments. The substance is probably not worse than the impure paint of olden times. My earliest painting is now over 50 years old, and in good condition.

4 A tub of polymer emulsion paint

5 Acrylic emulsion paint, in a tube

6 Eggs

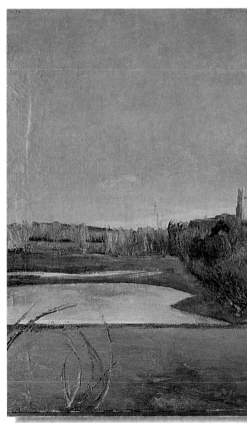

My painting in oil – now over 50 years old.

They are painting the boat. Painters who paint pictures of painted boats, paint paint.

To show how impenetrable the description of materials has become, here is an example: "The equilibrium of dispersed particles is maintained using coalescing solvents. Disruption would cause the emulsion to 'break'. Antifreeze, water-softeners, preservatives and anti-foamers are required. And if the colours are to be in tubes, polyacrylate or cellulose thickeners are added." The guilds had their secrets. But now that scientists tell all, we must trust the colourmen. They charge a lot, and often cheat.

Rough pieces of cardboard would be used to make yacht paint look as precious as jewels.

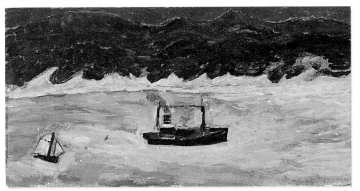

After Wallis

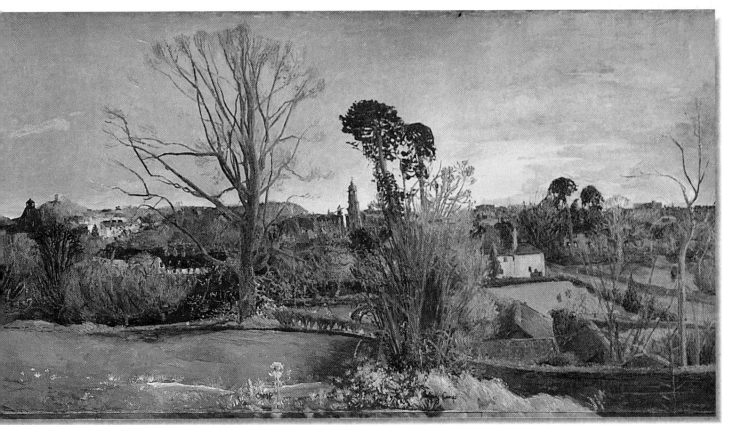

Eye, Suffolk, 1945

Erasure

MANY OLD MASTERS were neat. Jan van Eyck "pencilled in" the details with a tiny brush on to a smooth surface. His mind was made up: why should he change it? Others in Italy would draw "cartoons", adjusting and pouncing and painting as they went.

The rough and repainted and "done-with-ease" look was (apart from Manet, Degas, and some Corot figure-paintings) a Matisse way. Matisse had visited, admired, and bought pictures by Renoir, who believed paintings should look handmade. To achieve the look of ease, Matisse worked hard. All difficulties must be washed out of sight. (For future scholars, he had each stage in the vast number of transformations recorded by photography.)

To make paint look inevitable and untramelled, however hard the journey, is an ambidextrous, athletic act. Actually, it needs three hands: in one, the absorbent, non-fluffy rag, in another, a brushful of solvent,

and in yet another, a brushful of new paint. Paint off! Paint on! Some painters are fast as fountains. Matisse's primings are of remarkable endurance. I looked at the surface of "The Rumanian Blouse" (which had suffered multiple erasures). The whites had a delicate watercoloured rainbow-paleness. Its survival may have been due to a small amount of gum arabic in the priming. (André Lhôte gives a recipe including gum.) Matisse had a little wax in his medium, which would have made the paint easier to dissolve and remove. Preliminary drawing on the canvas with charcoal, and its removal with rag and putty-rubber, would be part of this overall swingeing procedure. An awareness of these techniques by the spectators was taken for granted. Matisse was a great showman. He aimed at simplicity, without loss of meaning.

Emily (unfinished), 1989

The figure was drawn with charcoal directly from the girl, and later the Tower of London was added from the motif. Over the fixed charcoal, a turpentine wash of ultramarine is swept overall, and the board is laid flat. The blue goes into the interstices. Painting then proceeds, with simple mixtures.

The Houses of Parliament, veiled by drops of rain. The painting of the girl went wrong. Now the area has been given a coat of Underpainting white, with Viridian.

Eleven of the 22 states photographed by Matisse. The effect is of a sleepless body, at the mercy of Eros, but by 22 (at the end of October) the final nude has achieved repose. Starting in May, by June (at the tenth state) he is collaging and repainting fiercely. To paint as if he is making a collage, after erasure, is Matisses's middle-period style. Finally, paper is painted, cut, and stuck down for his last cut-out works.

After Matisse

After Matisse

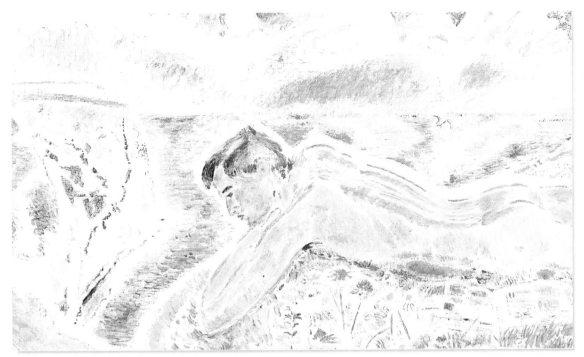

Rubens practically never painted small pictures on white. The streaked boards allowed him to work towards dark or towards light. It was fast, but it did limit the brightness of the colours. Obviously, if he wanted to remove anything (which I expect was rare) the streaky ground would wash away, unless it had been given a long time to dry. For the brightest colours, the white grounds used by Picasso, Matisse, and Bonnard were best, especially if the colours were moderately transparent.

A Nude at Dover (unfinished), 1993

You may prefer not to have to erase. If so, you may (if you do not think fast) adopt a cautious approach. I will give you the whole sequence. Some DIY stores supply hardboard ready-cut. Choose an attractive size and shape. It comes in ⅛-inch thickness; or the ¼-inch which is very rigid. Coat it with adhesive, thinned for a first coat, then stronger for the second. (Acrylic medium is good.) Lay the dry fabric on the tacky surface, and smooth it from the middle outwards. When it is completely dry, give it a coat of acrylic gesso primer. (If you like a surface that has its pores filled, use a spatula, and scrape a mixture of White lead, oil, and gum arabic over it – or White lead and egg, or Underpainting white.) If you wish to paint a figure on the cliffs beside the sea, take the dry board and draw what you discover on your excursion. Then fix it. Paint samples of paint between the marks. This was at one time called "keeping the painting open". It makes for safety, and less erasure. But mind out that caution does not petrify.

Raindrops (unfinished), 1986

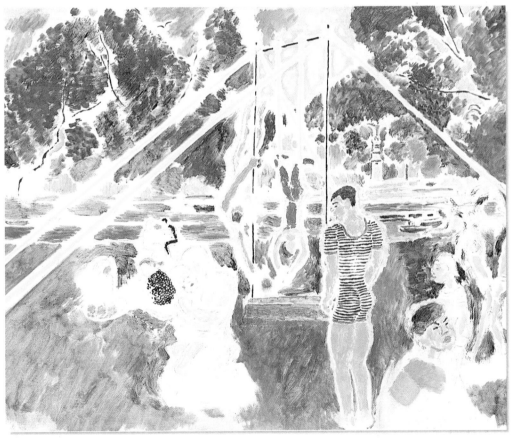

Partly unpainted, drawn on the spot, and partly erased. They were acrobats, and they must be free enough to move, so the surface is not to be lost. For very small, weightless pictures, primed plywood is ideal. You can obtain "skin plywood", ¹⁄₁₆-inch thick.

Acrobats, 1991

Blue Against Yellow Does Not Make Green

THE UBIQUITY OF CHLOROPHYLL BLINDS us to green. Gauguin used the secondary colours, violet, orange, and green. They are more mysterious than the red, yellow, and blue that van Gogh liked. Green is the colour you obtain if you mix blue and yellow, but it is not the same if you put blue and yellow side by side. Weavers know this, and they also know how quantities change the resulting colours. Paul Klee taught textile composition at the Bauhaus, which involved weaving. Klee certainly knew what one coloured wool would do to another. Alternate blue and yellow threads are closer to the colour grey than the green obtained by mechanical mixing.

Colour surprises, and is practically impossible to measure even when on its own: when in pictures, it is totally, incommensurably weird. If you look at a spectrum analysis of ultramarine, you may be surprised at its complexity. Burn some salt, and by its light, see how a colourful picture turns monochrome (because the sodium spectrum is simple).

Matisse made tiny dots (almost as small as those in Seurat's "La Poudreuse"). Gradually, he made the dots larger – first pore-size, then pimple-size, finally boil-size. After this, he used the powerful reaction between colours, as when the green of a philodendron plant is placed against a red curtain. The undulating leaves make long edges for colours to meet and react with. For the rest of his life, large areas of colour would be made to meet each other. Seaweed, leaf, and heart shapes would brim with energy, or suffer in glory.

It is good to actually handle some large areas of colour. Cut straight lines into bright blue and yellow papers, and weave them together.

The sketch for "The Circus". The brushmarks are like a tailor's stitches (tacking), and French chalk markings.

After Seurat

"The Circus" was Seurat's last picture. He was 31. He had worked through the history of art, copying antique casts, Raphael, Ingres, and Delacroix. He painted at first a little like Corot, then somewhat as an Impressionist, then Pointillism, and finally, in a manner approaching Synthetic Cubism. Where would he have gone next? He had succumbed to the River and the Sea, and had done 170 cigar-box lids in front of "Nature". It looks as if he could have only gone one way. But there is a lust in the paint application that makes me believe he might have lived to be the great painter of bodies.

After Seurat

Bernard Cohen, *Spinning and Weaving*, 1994

"Spinning and Weaving" can be hung any way up. It has patterns, and is the most complex picture painted in 1994. Cohen is a painter who thinks about music and mathematics and never loses his way in a rhythmic maze. The attachment to the surface (which weaving, or the tied surfaces of Cubism, achieves) would have had little interest for the heavy painters: Courbet, Rembrandt, or Rubens. Place a rough, white primed canvas supine. Make a solution of ultramarine, and swamp with it. Allow it to dry, the blue will settle in the hollows. Drag a brush filled with yellow of the consistency of cream across it. Some parts will be blue, some yellow, some greenish, and others an optical grey.

Little discs of cardboard will spin yellow and blue. If they were giving off pure coloured light, white would result. As it is, you obtain grey.

Coloured Squares

OFTEN A RECTANGLE will fill with squares. Squares appear more square if made wide. (Pure squares look narrow.) Squares are satisfying, and it often seems a shame to clutter them up. Rule-up some squares. (Use pale lines.) Believe you are going to fill the squares as enchantingly as did Paul Klee. He would use attractive surfaces of plastered burlap, or pasted paper or card. Klee was very experimental in his use of materials. Sometimes, the priming he used was absorbent. Sometimes, the pictures were called "magic squares", or some similar name. We can call our pictures fair names, but we cannot fill the squares as movingly as Paul Klee.

Watercoloured fillings for meadows

Fill some squares! Jeffrey Dennis' picture is made into compartments beautifully arranged and filled with foam-like circles. Fill squares with whatever attracts you most – wasps, larks, or even Boxer dogs. There is a sky by Magritte filled with raining men in bowler hats. My squares are rather sedate. Perhaps, if I were filling them in a studio in the Bauhaus and making the world's first pictures full of coloured squares, the sap would have risen. Noel Forster has an intimate feeling for the weave of canvas and paint. He makes flowing ways for rectangles to exist. Primary-coloured strokes have bound a rectangle into a larger rectangular canvas. Like a fault in a rock-face, he makes a slide in the harmony.

Beautifully arranged figurative interludes slide across rectangular compartments.

Jeffrey Dennis, *Heartwood,* 1989

Oil-painted fillings

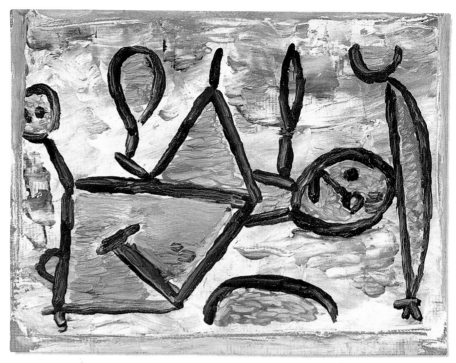

Fill the squares, thinking of colours and squares. Then, if you feel mighty experimental, fill in the squares thinking of the night sky.

"Hardship by Drouth". Even here, there are rectangular ties. A line at an angle within a rectangle demands another at right-angles or parallel to it for resolution.

After Klee

Bowed diagonally, criss-crossed, rectangled, dabbed until red, yellow, white, and blue shine silver-and-gold.

Noel Forster, *Untitled*, 1976

Primary Colours

LOWESTOFT IS THE MOST EASTERLY SEASIDE resort in Britain. Its coat-of-arms has the motto "Point du jour". Dawn comes early, but spring comes late. Each year the crashing daffodil colour of spring shocks me, and then a little later the laburnum trees demand that I paint them – and I always make them too yellow. Azo yellow is the kind of yellow advertisers know will – if used with black and white – be visible from Mars. The yellow of spring rivals Azo yellow. Bonnard would take laburnums and mimosa in his stride, claiming that pictures could not be too yellow. To find out something about the breakfast egg, consult Velásquez' painting "An Old Woman Frying Eggs". Then confront an egg itself.

One will do. Paint the white as a solid puddle-shape in bright white. We will call the white 100 per cent of light, and the yellow about 75 per cent of that. The yolk must glisten as the sun. Van Gogh used Yellow ochre, Chrome yellow, and white, striving to paint corn fields, lemons, sunflowers, buttercups, and even the sun, with the limited brightness of paint. "The Red Vineyard" was painted after an inspirational walk with Gauguin and it is a once-in-a-lifetime heartbreak. The artist desperately pitches at the sun, using the primary colours red, yellow, and blue. The effect is ravishing. A spiritual bonfire.

Red, yellow, and blue converge, hating each other. Hans Hoffman would have "push-pulled" them together.

Paul Klee played a violin. Noel Forster plays the piano. Forster likes entwining painted colours over woven surfaces. Klee taught weaving at the Bauhaus. Forster makes magical silvery webs out of red, blue, and yellow brush-rhythms. He rarely uses more complicated colours. They do not look Islamic, but are mesmeric and sublime – and his large paintings are almost mosque-complex.

Noel Forster,
Untitled, 1992

The sun need not be round. It is seen so little, only in tiny flashes. This is probably a phoenix-feathered sun; or are they palm-leaves?

A Daffodil

The super-hued power-flower. Colours rotate, radiate, changing with their situation, frail yellow Flower Power compares with large areas of subdued, sharp, and edgy stone tones. Both seem to give out light.

The 15th-century floor of St. Mark's, Venice

"Peace" (detail)

After Picasso

The blue wooden bars swing around the red triangles. It is more representational than at first it seems. A self-portrayal as a small Greek island, bright and sunny in the blue Mediterranean. Red, yellow, and blue for happiness.

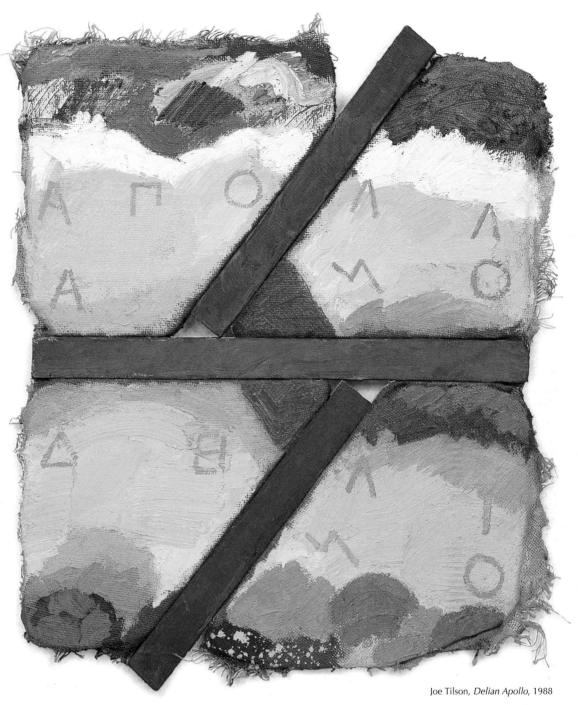

Joe Tilson, *Delian Apollo*, 1988

An art deco lunette incorporating a rayed sun.

"Peace" After Picasso

"Vision After the Sermon" After Gauguin

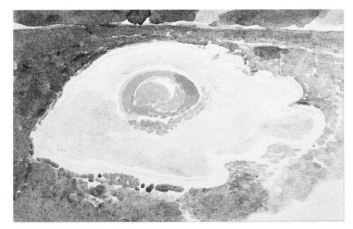

A fried egg. It seems like paint itself. The great float-splodge of egg white with its golden orb of yolk. Paint a target of creation.

"The Red Vineyard". The colours explode, jazzy as trumpets, briefly as primaries, when the sun leaves the fray, and drops towards the horizon. After van Gogh

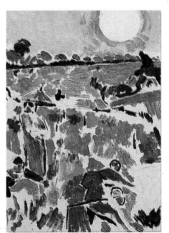

"The Red Vineyard" After van Gogh

Suggestion

SOME EASY WAYS are saying it, placing it, or thinking it. Another way is by suggestion. Fast is not slick. Slick is incompetence, or the product of a horrible mind. Good painting is as fast as the painter can make it. Good painting can be slow, but most aware artists are in a hurry. An amusing game might be to guess each painter's dab-rate. Rubens, Goya, van Gogh, and Manet lost no time. Picasso's show-off speed we know from a film. White paint would fly off the brush on to thin paint fast as a laser, sure as a Japanese calligrapher. Suggestion in painting can be useful and wonderful. Goya, a Spaniard, had to be able to produce a bullfight crowd fast, and could suggest a coven of witches with a wave of his brush. Joseph Mallord William Turner RA was able, late in life, to suggest people in rooms, deer, trees, sunsets, and most things. Suggestion gained him enough time to go fishing. Petworth was full of suggestions.

Impressionism had to be fast enough to capture clouds. Pointillism was slower. The Ashcan artists had often been newspaper illustrators, with a daily deadline. American racers were Bellows, Sloan, and Whistler, but not Eakins. They certainly made the brush strokes move! I do not believe children can paint slowly, and I think Seurat would not paint fast. Suggestion is different from sketching – unless Constable, Turner, Toulouse-Lautrec or Boudin are doing the sketching.

On the White Cliffs of Dover. Suggestion-dabs are instigated by birds, wavelets, flowers, sunbathers, and myself. The viewer enjoys deciphering these clues. A knowledge of the actual subject helps. Obviously, only tough, formal suggestion is worth having.

After Turner

After Turner

Donkeys touched in fast

A concourse at Petworth After Turner

The magnificent room with a round window that Lord Egremont put at the painter's disposal at Petworth House. After Turner

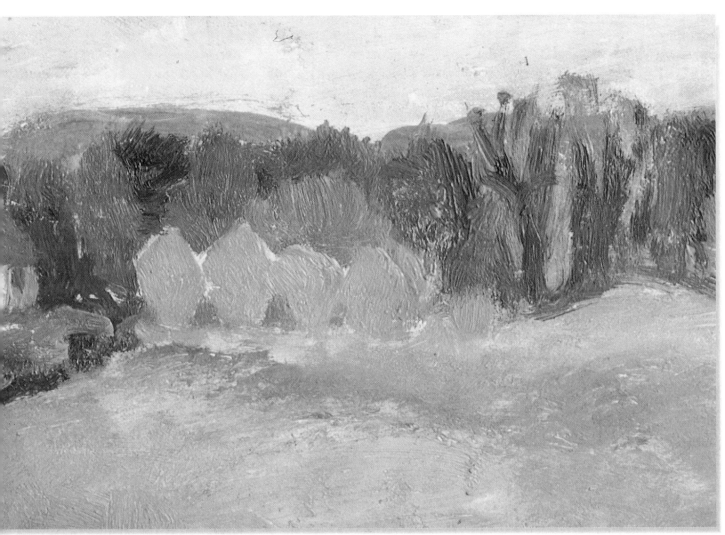

Choose quickly-moving subject matter to help make your painting faster – though William Gillies always painted at great speed, in the quiet landscape of lowland Scotland. Quick thinking does not require a fast subject. The influence of Dunoyer de Segonzac can be sensed. A delight in sumptuous resinous paint, but Segonzac is thicker.

William Gillies,
Lowland Landscape (detail), c. 1942

"Witches". Goya's late paintings are as haunted as the death of Duncan in Macbeth. *Deafness may be lonely and quiet. Owl screeches and screams penetrate the silence. Forms loom out of the gloom.*

After Goya

Daumier's drawings can resemble paintings. For an artist-caricaturist to be a painter's painter is surprising. When is drawing painting? He poses the question in a flurry of marks. Stuart Davis insisted his paintings were drawings. I think of drawings differently.

After Daumier

65

Glazing

PRETEND YOU ARE PAINTING THE FIRST EVER – and painting particularly fast; slow up for a glaze. A glaze is a colour, thin and transparent enough to change the colour of underlying paint, and usually in a medium rich enough for it not to crack.

Stir the paint with a medium, to the consistency of double cream. With an almond-shaped brush (filbert brushes are too short) make a splodge; call it a brush stroke.

By a leap of imagination do a splodge, believe it to be a face – it is a face! Make a big splodge below – it is a body! You believe the marks you make are real? Good, you are secure. Splodge, splodge, splodge. Brushings are gifts; they will make you hands, arms, breasts, even mountains. Like the oriental story of the leap through the waterfall, a leap of imagination. Like St. John's "word" in the Bible, incarnate, the splodge lives, moves, and tunes in with the flux.

The flux was hot news for the newspaper illustrators of the Ashcan School. With splendid memories, they showed off at speed to meet daily deadlines. "Slick" is an abusive word. "Decorative" was derogatory, until Matisse made it plain that for him decorative was special. Slick is wonderful if it means the painter can get things done fast. Most great painters were in a hurry; fast, even slick, but never superficial. Manet, Hals, Tintoretto, Picasso, Dufy, Velásquez were fast. Chardin and Seurat may have been slow. Bellows was a wondrous, rapid brusher, equipped with the special flowing Maratta paint, as advised by Robert Henri. He dabbed swimmers' and boxers' muscles at speed. It is possible to increase the speed of painting, up to the speed of thought. If you go faster, the paintings become empty, like those done by chimpanzees. Make your own deadlines. Be a brave disciplinarian. Win some games. Be a good coach.

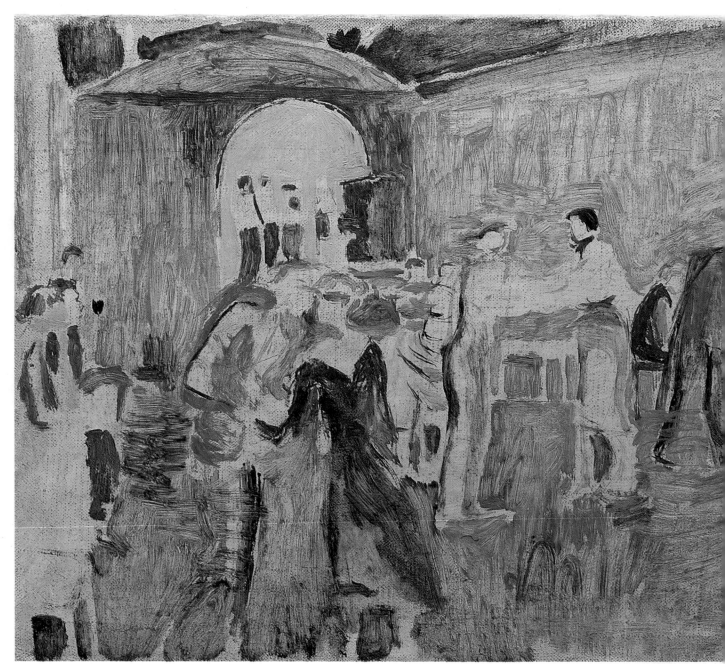

I scrub-splodged in poor, yellow light. However gloomy it is, once you begin dabbing, the colours usually behave.

Skiffle at Lowestoft, 1958

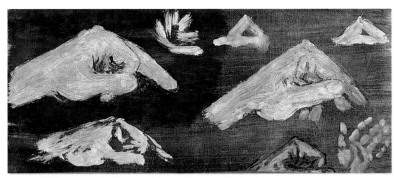

Stodgier, triangular daubs make hands "kippered" with rich glazes. Use White lead and think of pyramids.

Semi-transparent blue paint is supported on a strong, yellow base. A light touch is needed to keep the colours separate.

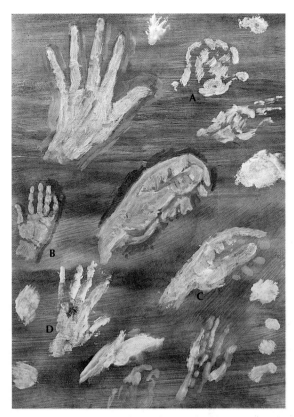

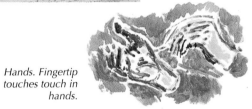

Hands. Fingertip touches touch in hands.

A *Dabs very thinly glazed* **B** *A brown glaze*
C *Almost a glaze of pink* **D** *A palette-knife astray*

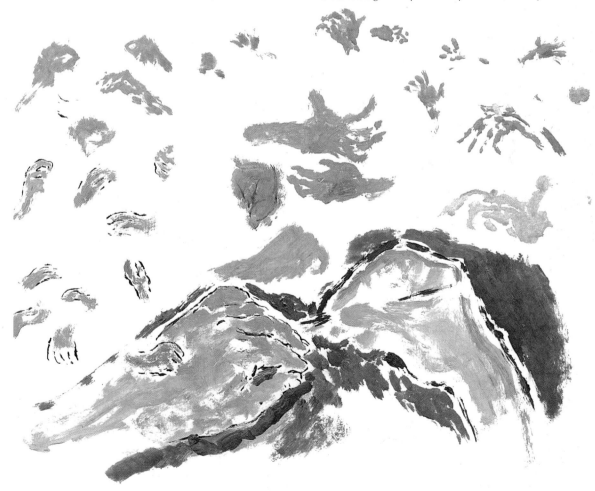

Oily dabs on paper. Picasso said: "I do not seek, I find." Splodge and splodge until you find yourself living in paint.

Bonnard's Diary

BONNARD SAID: "ALL ART IS COMPOSITION. That's the key to it all." (This statement would be a cliché if stated by anyone other than Pierre Bonnard.)

Bonnard kept a two-day-per-page pocket diary. It served as a sketchbook. Whether the vivid sights that sparkle from its compartments were drawn close to the dates shown, I do not know. Each day he noted the weather, and most days that was "beau". He liked the informality of drawing across the printed divisions and dates, with a short soft pencil – the page almost as tiny as Constable's proper little sketchbooks. (They both had careful looks at the skies.) Bonnard was free to live and paint as he wished. Complete freedom is unnerving, and I sense his need was to tabulate his time and work: diary days, meal times, dog walks, Marthe's bath times. And the pieces of canvas were pinned to the wall, looking like various sizes of diary page. The studio-cum-landing was compartmented too, as views through windows, and postcards.

Bonnard like a prowling cat, always looking.

He said: "I like to work on an unframed canvas that is larger than the intended picture. This gives me room for alteration. I find this method very agreeable, especially for landscapes. For every landscape, you need a certain amount of sky and ground, water and verdure, and it is not always possible to establish their interrelation right from the start."

Just as the dachshund "Poucette" would move from smell to smell, so on his walks around the house and garden, the artist would scribble in the diary. He was fortunate and fulfilled, and rather lonely, painting his beautiful surroundings over and over.

John Maxwell, the Scottish artist, told his students to draw whatever they wanted to paint with a thick-leaded, blunt soft pencil on a little piece of paper – and then make the painting from it, with as little alteration as possible. The subjects you see close by, or on an excursion, are at the mercy of your fat black pencil. Perhaps you even possess an old (or new) diary. Even, perhaps, a dachshund, to help you follow your dream.

Bonnard saw a lot of different subjects on his walks. Diary pages.

After Bonnard

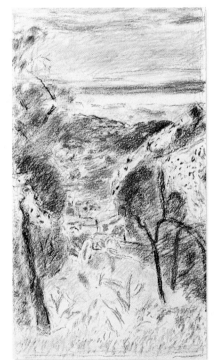

"Paysage du Cannet". McComb copied the central part. Bonnard was excited by the views around his newly-purchased house in the south of France.

After Bonnard

A scribble-drawing at Hastings Beach. (It would conform to John Maxwell's instructions, but was probably drawn with conté crayon.)

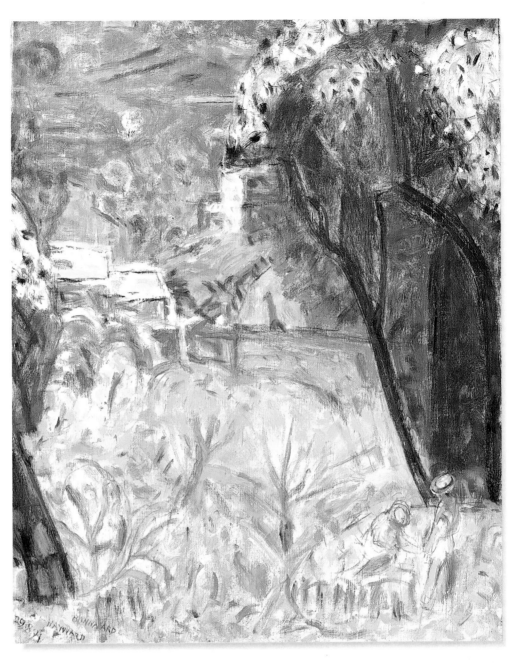

Overwhelmed by its beauty, McComb first said: "Bonnard had heaven in his head, and his work is starred in shimmering sunlight." Then: "Bonnard made gems of incomparable beauty." Then, when asked again: "Amongst the lemons, the greys, greens, dull oranges, wine-reds, a trace of glittering black across the space." Finally: "Across the waves of lemon-pinks, greys, azure blue-greens – finger-dabs of brown and black – glittering summer stars!" McComb did his copying three hours before the public ten o'clock opening time. And he went six days running.

Leonard McComb, Copy of a part of Bonnard's *Paysage du Cannet*, 1994

On the cliff, South Coast

"Terrace au Cannet". Painted with watercolour and gouache, soon after his wife died. Bonnard himself died about five years later. It has an unearthly icy summertime heat, a spiritual vision. Perhaps Marthe is the figure on the left. Some of the brush strokes look as if they were done with a bristle brush, which is often good for gouache, as it can keep the paint light and airy.

After Bonnard

A little drawing that resembles the view in McComb's copy.

After Bonnard

69

Detail

ETAILS AS SMALL AS A MOSQUITO'S FEELER, an eyelash, or a distant beak; details of bumble-bees, mice, midge-wings, and tiny grasses; all should live well under the brush. With good sight we see in detail. Indian miniatures try our seeing. Turner made drawings that dot ornaments and windows profusely. I lose patience drawing architecture. I find I am doing a window on the wrong building. Canaletto insists Mannerist wavelets and manikin figures combine with traced camera-obscura views, smooth and detailed, to become surfaces of resinous, sun-thick, oily gloss. Most paint has been smooth and glossy. A Vermeer is smooth as a lake on a windless day. Smooth, oily, resinous surfaces, when slightly wet, will gracefully receive tiny details of egg-tempera white (its water-wetness preventing it spreading). Cranach's "Adam and Eve" in the Courtauld Gallery, London,

shows how splendidly clearly lined grasses and pale details can lighten areas of dark paint, without mixing. Indian miniatures avoid "mechanical" mixture by overlaying patterns, colour over colour.

The most popular room at the Tate Gallery includes British Victorian and Pre-Raphaelite Brotherhood paintings. I really only enjoy Ford Madox Brown; he was not of the Brotherhood. The Pre-Raphaelites often made their details by painting sharp colours into tacky White lead surfaces. Some of the world's marvellous paintings are full of details; Jan van Eyck's "Madonna of Chancellor Rolin" in the Louvre is one.

Tackle a moth, brave a mouse, confront an oceanic insect: nothing is too small. They challenge the careful painter. You need a tiny brush. I wish you luck with the brush, and hope it points up well to delineate the mouse whiskers.

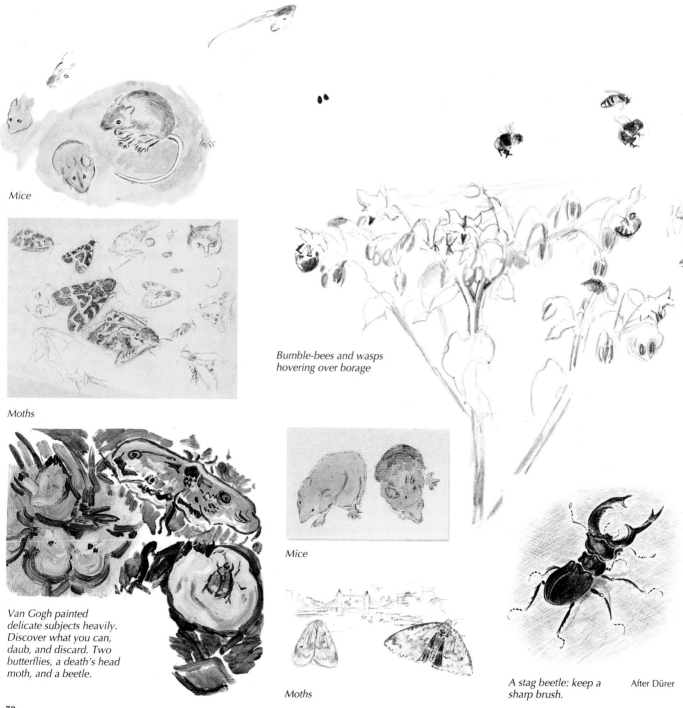

Mice

Moths

Bumble-bees and wasps
hovering over borage

Van Gogh painted
delicate subjects heavily.
Discover what you can,
daub, and discard. Two
butterflies, a death's head
moth, and a beetle.

Mice

Moths

A stag beetle: keep a After Dürer
sharp brush.

Bumble-bees at Beachy Head, 1990

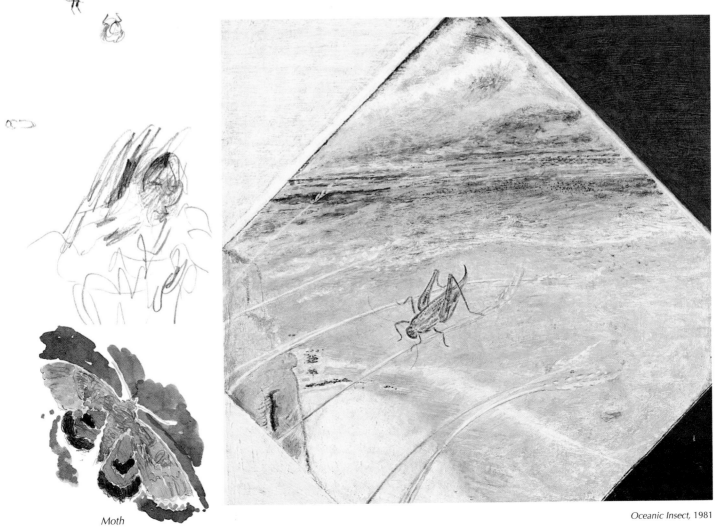

Moth

Oceanic Insect, 1981

Verisimilitude

WITH GOOD EYESIGHT, what we see in a camera obscura does not surprise us. What we see is raw and accurate. High, near Edinburgh Castle, a lens projects a part of the city on to a white horizontal screen.

The material of sight surprises us if we find it in unusual places: a photorealist head nine feet high, or Central Park crushed into a book.

The manifest act of seeing is so wonderful that when we approach verisimilitude we must take care that we do not mean *like photography*. Photography is the world's light collected randomly, mechanically, by a lens.

It is what a temperament can do to the raw material of sight, that makes truth possible. It is when Velásquez brushes with a strange transforming passion close, but never too close, to eyesight. Then verisimilitude is truth. Vermeer was inspired by the pellucid charm of the camera obscura. But art need not approach physical sight so closely. Hokusai, Watteau, and Cézanne knew other ways to be truthful. Brueghel is universally believed even when Icarus falls out of the sky.

A backyard view in East London. Daniel Miller bought a house in Hackney, to be warm in winter. As he looked out of the window of his painting room, he saw back gardens. Each little walled plot eccentric in a particular way; small squabbles between man and nature. Lopped trees and grass patches; tiny stand-ins for the meadows and trees of grand estates, rendered bodged, burglar-alarmed, child-scribbled, dog-shaped, and twiggy.

Stanley Spencer lying on a grave looks innocent and young. He is newly resurrected at Cookham churchyard.

Daniel painted it as a mass of present material to make intimate contact with his environment; then he would know his view. There must be no mannerism, just enough style to keep the twigs alive. A lot of patience, and a lot of looking.

Stanley Spencer worked in a similar way, painting Cookham as secure home views. Stanley was unique. I once saw him walking, and heard him talking. He was like an electric-sewing machine. No reworking was ever required. He was very fast. His was the gift that could make sense of the muddled English way of life. He could digest corrugated iron, chickens, pigs, mud, garden paths, old clothes and clothes-pegs, mangles, and Christ. Britain has thrown up other artists to deal with its dishevelled beauty. Bratby painted golden outdoor lavatories. Leon Kossoff jerk-dabbed junctions of rail. Burra watercoloured motorways and lorries in curious landscapes. John Nash painted rough and scrub and ponds.

"Montmartre" After van Gogh

Overlooking Gillespie Park.

Daniel Miller, *Backlands*, 1990–91

Veiled by twigs, they rise naked and reluctant. One floor down, the cat food calls.

A first look at the new day: roses, bricks, and cats. From time to time, I notice what is happening in the house at the end of the garden. The figures struggling to get clothes on in time to go to work seem too large for the windows.

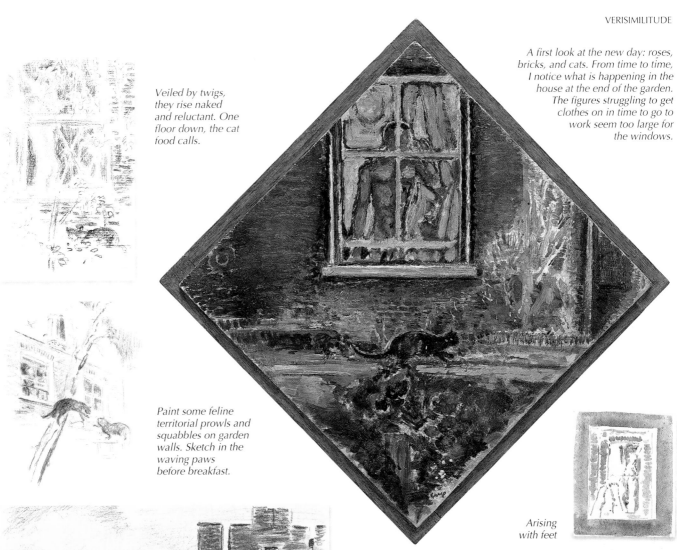

Paint some feline territorial prowls and squabbles on garden walls. Sketch in the waving paws before breakfast.

Arising with feet

"A Street in Delft". This dry chalk diagram is to remind you of the famous "View of Delft". It is made with tiny drops of paint, into wet resinous paint. These effects are similar to the burrs made when the lens of a camera obscura is slightly out of focus. Vermeer chose subjects where sparkling dimpling liquid beauties could be presented.

After Vermeer

Arising with violets. Bricks were stuck together with soft mortar, oozily it solidified. Brick-like rectangular dabs fill the rectangular pictures. Pectorals and window-panes, wardrobes and curtains meet cat tails and intimate tales.

Children's Art

M Y FRIEND WILLIAM THOMSON taught at an Edinburgh Boy's Club. The older boys told the younger ones it was sissy to do art; sport was important. Unusually, he gave them paint in a range of soft colours. One of the resulting pictures is shown here. Could child art be more varied than we had thought?

Be generous. Children have the law on their side now: if you do not buy them lovely paints, they leave home immediately. When I was eight, I painted a mermaid with phosphorescent paint on my bedroom wall. If a child can spare you the time, she will teach you most of what you need to know. Late in life, Matisse said he wished to see like a child. One of Picasso's finest periods was soon after the Second World War, when his children were young. He loved to paint them with their toys.

Take a canvas and streak with a rich, deep, warm blue, made from ultramarine, Charcoal grey, and a little Permanent rose, thinned with turpentine. Share it with a child. Race to paint all the toys you can think of. He will give you tips, especially on new inventions. Take him to a children's museum, such as the Bethnal Green Museum in London, to see old toys. If there is any flagging of interest, treat Liquorice Allsorts as individual still lives.

The first childhood of a painter grows towards a second. Picasso said he never drew in a childlike way. I expect he was mistaken and forgot; or his special gift may have been to see brightly like a child all his life. Peter Pan's young friends were surnamed Darling. Children are not darlings. They are imitative: if parents fawn, they may fawn back. I was bored as a child. Little children demand repetition and are boring. Like Warhol soup, after he has advertized the advertisement, it is all the same – flour paste. Child vocabulary is small. Children pose questions continually, to get the attention of a parent, not for answers. Childhood is mysterious. The child makes rapid marks on paper, doing it as compulsively as it kicks.

Is there a survival mechanism preventing the infant from poking a finger in its baby sister's eye? A baby can distinguish at a glance between a card with 19 dots on it, and one with 18. I am unable to do this. Children are prodigies in music, mathematics, and sucking ice creams.

In Brueghel's "Children's Games", 84 games have been identified. Paint a game.

After Brueghel

Much child art surprises at first sight, then the pleasure wears off. But even after 50 years this seems a marvellous picnic poem. Mix gouache or other "body colour" *in several tones of, say, Burnt umber and other colours. The effect engendered can be as softly harmonious as Picasso's Pink period.*

Watercoloured toys. Old toys are more simple and recognizable than new toys.

Liquorice Allsorts

18 dots, or 19?

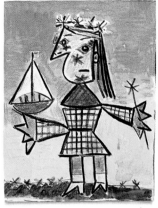

"Yacht Girl" After Picasso

A "pudding head", by Will

Various joke-shop items, sweets, and a bursting firework.

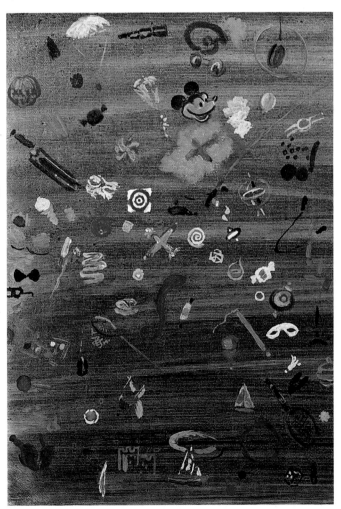

Toys in oil. Toys are often painted. Just play at painting.

The Stripes of Tutankhamun

KING TUTANKHAMUN was bandaged and embalmed, bound in stripes of fabric. His gold mask was striped with glass imitating lapis lazuli. Real lapis surrounded the eyes. Egyptian art is measured and layered throughout, from architecture to a small bead. Paul Klee was inspired by a visit to Egypt to paint profound layer upon profound layer; like striations of rock, like sandwiches of surprising colours. At Alum Bay on the Isle of Wight, they fill lighthouse-shaped vases with layers of coloured sand from the cliffs.

Straight lines are rare in the natural world, so it was possible for Wyndham Lewis, Léger, and Paul Nash to surprise in their day by ruling lines. Horizontal bands make us feel secure. Opposite the Albany is Savile Row, the home of the well-cut pinstriped suit. If we want to show how proper we are, we get well-striped-suited. Stripes bend, and camouflage zebras in forests. Stripes will make eloquent every departure from the strict and straight, however small; but also, wonderful wild variations, as in a Hockney swimming pool, surrounded with straight edges, where undulating water deforms the known straight race-track lines marked on the bottom.

Practise brushing lines: parallel, ruled, and free. The widest stripe is the rectangle of the picture. A small line is the warp of the canvas. Sign-writers know it is safer to make slightly fluctuating lines as straight lines than free-handed to attempt a perfect straightness. Max Bill of the Bauhaus made straight edges very straight. Only a laser would shake them. We live in a striped world. Stripe, then, and as you mark, consider whether you wish to stripe all your life. There seems to be a market for banded pictures. They fit well in frames, in rooms and offices where serious men in serious well-striped suits need calm environments. Stripe painters include: Scully, Stella, Barnett Newman, Noland, Klee, Riley, Jaray. The gold mask of Tut is a world image. Sam and Will Southward grasped it with conviction. The nose is much the same each time. The stripes are various and emphatic: yellow for gold, blue for the stripes. They made my copy look tame. A child's-eye view of Tut is our challenge. Two or three colours are enough to distress the Sphinx. A child's certainty is envied by me.

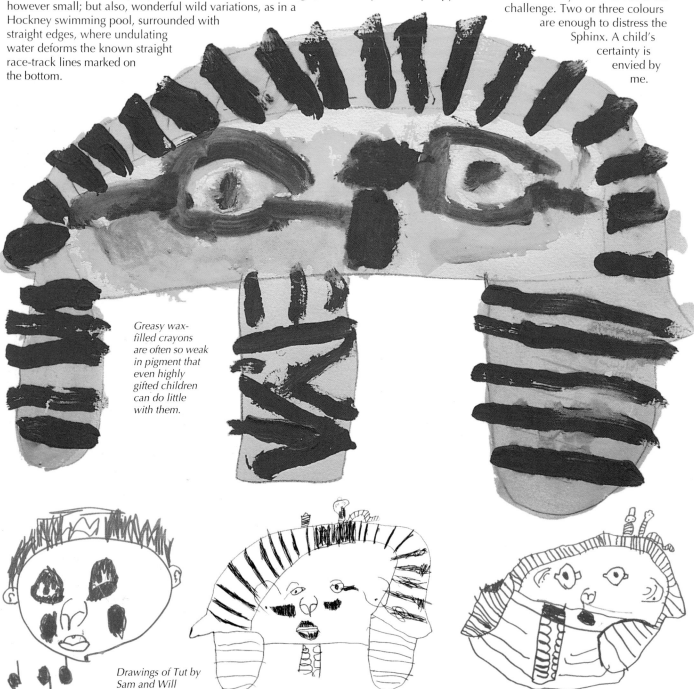

Greasy wax-filled crayons are often so weak in pigment that even highly gifted children can do little with them.

Drawings of Tut by Sam and Will

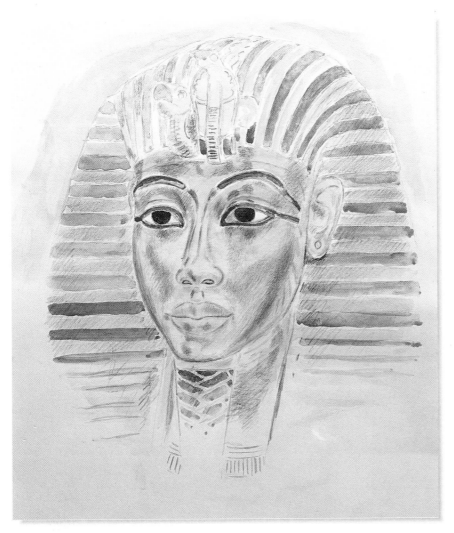

This fractal has stripes curving like zebras. They are as active as African dancing.

Ruled lines almost blend with hand-drawn lines. But some people can draw straighter than I can. Obviously, the turquoise ones are hand-drawn.

The striped head-dress of King Tutankhamun

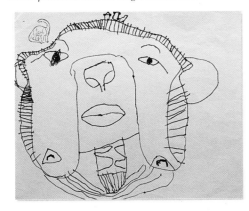

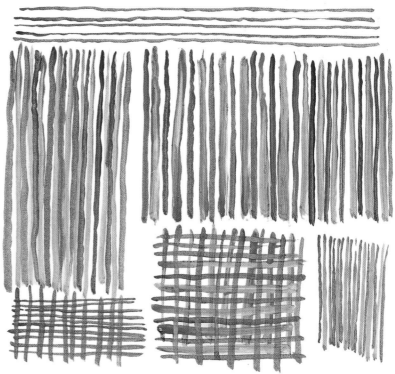

Practise striping. Mine are very wobbly. By the time I had done them, I was getting better. But stripes are always good unless you are unlucky. Practise striping with a brush; criss-cross, and you are close to tartan.

Rich Painting

I F YOU USE DARK HUES, be careful to keep them clear. Some colours are naturally dark: Ultramarine deep, Alizarin crimson, Monastral green, Prussian blue, and Mineral violet, for example. The support of a half-tone ground, or underpainting in colour, makes deep transparent colours look more secure when applied over them. Rich, dark colours over white must obey the "fat over lean" rule, or crazing, cracking, or bleeding will result. Underpainting white, a gel, a wax, even stand oil, fat oil, or

sun-thickened oil can be useful in preventing this. Try painting with colours straight from the tube. Without adding white, make the colours paler by scrubbing with a brush, scratching with the handle of the brush, scraping with a painting knife, or (if you like) using the teeth of a comb.

As the sun goes down, the red glass of Chartres Cathedral deepens like rubies before night takes over. The Daniele da Volterra "Descent from the Cross" mourns in blackened reds and pinks.

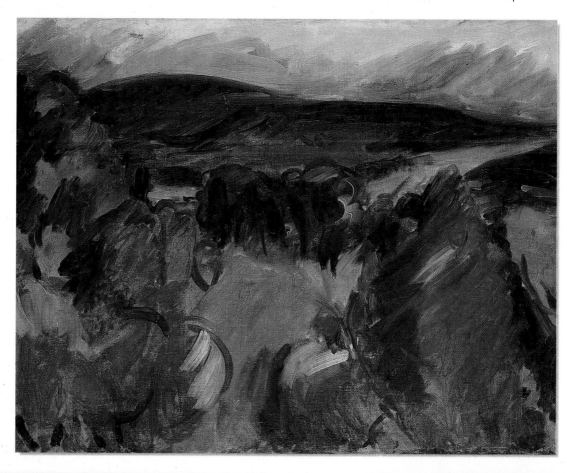

Matisse gave Smith sufficient confidence to paint near Cézanne's "Mont Sainte Victoire". He rarely added white to his rich colours.

Matthew Smith,
Provençal Landscape, 1935

Sutherland was isolated from Europe by the Second World War. Seeing Picasso's work freed him; looking at Blake and the young Palmer influenced him. Pembrokeshire inspired sumptuous gouache and crayon landscapes.

Graham Sutherland,
Landscape with Estuary, 1945

It is said Hitchens did trials on glass, then copied them on to canvas. I suspect even this would not be spontaneous enough for Hitchens' pantheistic bravura.

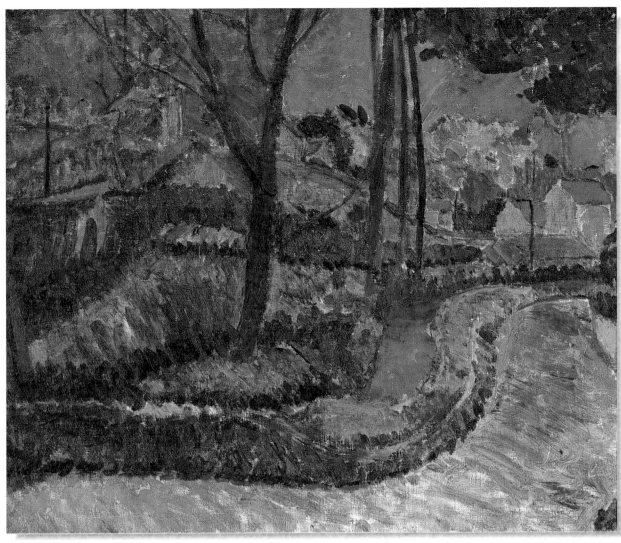

By using paint with a thick medium, with little mixing, and with close tones, twilight was made to glow.

Matthew Smith, *Winding Road – Cornish Landscape*, 1920

Ivon Hitchens
Tangled Pool, 1946

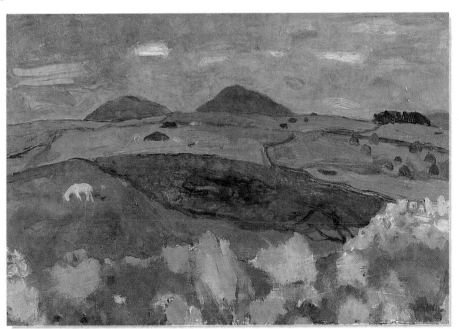

Lowland Scotland inspired Gillies most. He disliked the stridency of autumn colours, and (except on camping holidays to Iona or the Highlands) hardly needed mountains, or people. The west coast of Scotland is renowned for the saturation of its blue waters.

William Gillies, *Eildon*, 1949

The Working Drawing

Painters vary. I imagine Milton Avery, Modigliani, Matthew Smith, and Renoir splashed straight in and painted without a preliminary drawing. Some revise on the canvas. Some, like Edvard Munch, do different versions of the idea on new canvases. William Roberts did careful designs in full-colour, most perfectly squared-up for secure enlargement. (Sickert said that all drawings are improved by squaring-up.)

I am not neat. The making-up of my mind is desperate. I begin with thick, tough watercolour paper, and draw roughly the proportion of the picture. It is possible I will use all or some of the following: charcoal, knives, fixative, pencils, pastels, crayons, watercolour, putty (kneaded), rubbers, typewriter erasers, gouache, oil paint, collaged paper, spit, and tears. During this, and later, I consult drawings, done at various times, of the same

South Downland, 1992

subject. I do not mind how scuffed and rough the working drawing becomes, so long as all the shapes, and the subject matter, become exactly considered and disposed. It is like the plan of a circus: knowing where to put the cages, clowns, audience, and ring, and trying to pretend you are the ringmaster, and knowing all the time the "Big Top" may fall on you. But in the really good working drawing, if it is complete, the painter can move about in comfort as if in his own head.

The next stage I rather like. I transfer like a craftsman, watching each enlarged square, making arcs and straight lines, and thinking little about the subject depicted. Finally, primed ready for the explosive to go off, the picture can be painted as freely at arm's length, as Edvard Munch in the snow in his outdoor studio. After such a lot of preparation, the brush is keen to move, it still has a lot to do.

The weight of the various elements has to be measured intuitively. The main figures must not fall out of the sky.

South Downland (detail), 1992

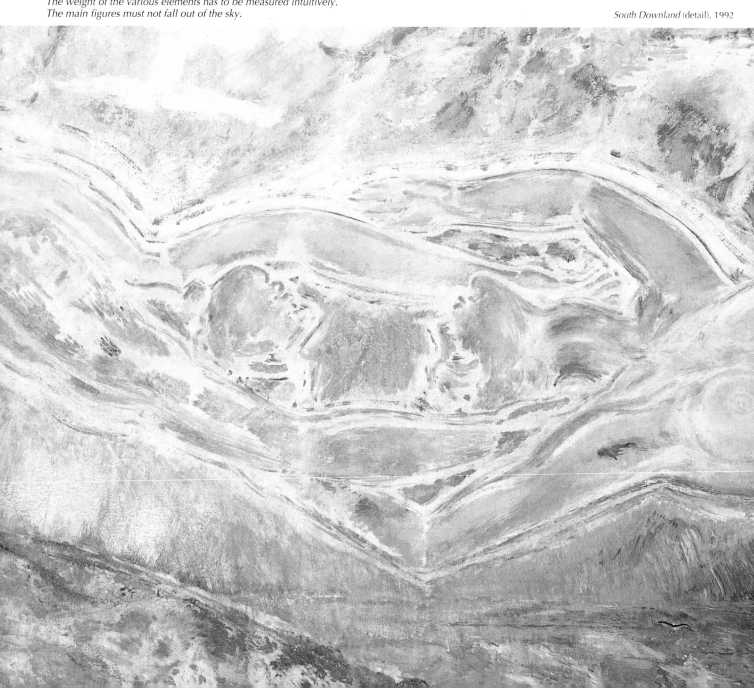

The Thames curves, and the painter can pretend it curves even more.

Extended Figures, 1992

Sickert said all drawings were improved by squaring-up.

William Roberts, *Folk Dance, 1938*

A working watercolour sketch for "South Coast". This was a preliminary drawing, but often what museums label "studies" are done when the picture is completely finished. Only the artist would know.

The paint is thick enough to keep them safe. Like mountainous contour maps. Repeated applications of paint make islands and the shapes stabilize the athletic rhythms of the subject.

Figures Somersaulting at Beachy Head, 1992

One of the working drawings for "South Downland". The self-portrait head was removed. The squares are visible. Watercolour and pastel pencils work well with each other.

A crayon moves the figures fast at Beachy Head. A self-portrait is making its exit. Bach sounds magnificent on various instruments. He did not always specify which ones. Rembrandt would use a variety of media to express his themes. A quill-pen drawing has a different effect from a heavy paint surface. He did a lot of schematic drawings that prepared the way.

Cloud Figures, Beachy Head, 1992

The Studio

THERE ARE FASHIONS IN ARTISTS' WORKPLACES. When Clement Greenberg passed away, a whole scene went with him. In the 1960s, David Sylvester, the famous perfect placer of pictures, who knew the needs of vast white museums, advised bright youth to paint big. To do this usually meant hiring a large space: in the United States a loft, or disused factory; in Britain, a big room, or a warehouse divided by screens. It slightly resembled an art college, or the corporate offices that, with the museums, were the main patrons for large pictures. Big pictures can be wonderful. Michelangelo's "Last Judgement" is large, but often the large pictures become inflated or decorative. In London's East End live countless painters of large canvases; many are poor; a large primed canvas costs as much as a bicycle. When in the days of the New York School, Jackson Pollock dribbled house paint, and massive rollings were harmonized by Rothko, excitement was in the air. Now that graffiti wet our cities, dribble and spray are everywhere.

Delacroix had a proper portrait-painter's studio with a waiting-room like a doctor. Monet had a waterlily-pond size studio. Alexander Lieberman's book, *The Artist in his Studio*, shows some of the great peacocks in their nests. Braque had a large area with several easels and palette supports, which he made himself out of tree branches with the bark left on. He mixed his paint in old paté or tomato-paste tins, one brush per tin. It looked very comfortable. I have usually worked in a room adjacent to my bedroom. It has nasty advantages. Gertrude Stein was sorry for painters because they could not get away from their pictures. She was right. The unfinished picture hangs on the bedroom wall, a horrible indictment. The artist desperately tries to make it better – starts touching it up when needing breakfast – or even takes it into the bathroom.

Any room will do to work in, if it fits you. L.S. Lowry looked comfortable; he had painted in his armchair in a Victorian parlour for many years. For a few weeks Nigel Greenwood lent me his beautiful gallery as a studio. It was blindingly light. It was the nearest I have been to having a "real studio" to work in. I had liked painting in the midst of landscape, in parks, on beaches, ice rinks, piers, bathing pools, dance-halls, or beside rivers. The weather could make things difficult. For years a Morris Traveller served as a tiny studio. It had good flat sliding windows. It went to the cliff edge at Pakefield, settling amongst the burdock, ragwort, nettles, and thistles. In winter, I put a paraffin heater in the rear, and an easel in the front, with a rug over my knees. I witnessed night and storms, mist, drizzle, buffeting winds, and at other times, the hot sun scorched. In a car you are often invisible; you can be very close to people's intimate gossip (usually about money, hospital, and television soaps). It was also luxurious painting watercolours in a rowing boat in the middle of the Waveney River, at Beccles in Suffolk. Monet and Daubigny had floating houseboat studios. William Gillies had a tent.

Although any part of a building will do for a studio (and I had a friend who painted secretly in the drawer of his government office), it is sometimes worth planning a studio. Make a sketch and a list of your needs. An easel can wind-up; the older ones can tip the canvas to an angle. A trolley and shelves will accommodate brushes, tubes of paint, a palette, brush washer, sketchbooks, straightedge, set square, clean rags, compass, watercolours, hi-fi, and art books.

For winter, have a lot of artificial light, and see that it resembles daylight and falls in the same direction. I suggest six 100-watt "daylight simulation" bulbs, and four eight-foot long "north light" or "colour matching" neon tubes. It is useful to pin drawings up. Bulldog clips are convenient. Paintings will hitch on to nails. If you get backache or a bent posture, hang up a trapeze.

Now that models are employed less, studios can be lonely rooms. Some of the greatest pictures are lonely pictures. Remember, your studio is your home to think in. If you need solitude, make it private.

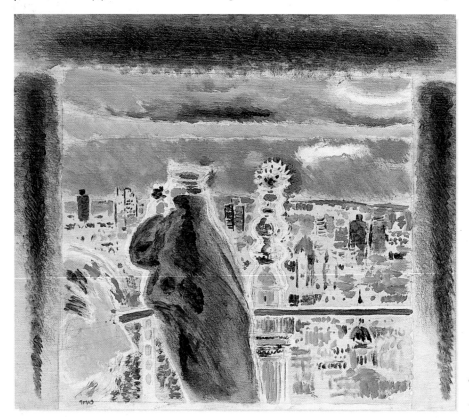

Timothy Hyman draws the monument built by Christopher Wren to commemorate the Fire of London.

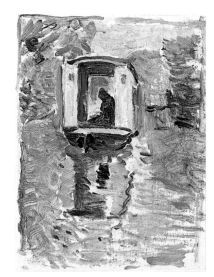

After Monet

Matisse would paint from his car. This is a poor copy of a beautiful picture, "The Windshield".

After Matisse

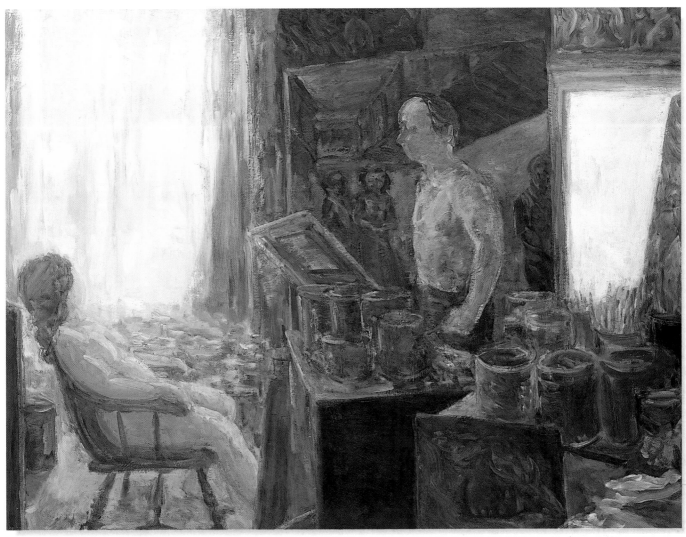

Lessore paints with gooey grey paint. The artist depicted is Leon Kossoff, who uses big tins. With so many grey days in England, it all looks very real.

John Lessore, *Artist And Model III,* 1988

Drawing a bonfire on the beach

Winslow Homer

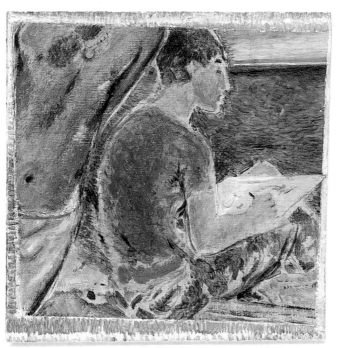

Some days it can be comfortable drawing on the beach, but it is nearly always better in the shade of a boat or a windbreak.

After Goya

Goya at work with candle-holders around his hat.

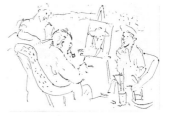

Milton Avery painting out of doors, freely, with pure imagined colours.

83

OPEN AIR PAINTING
Wild and Urban Encounters

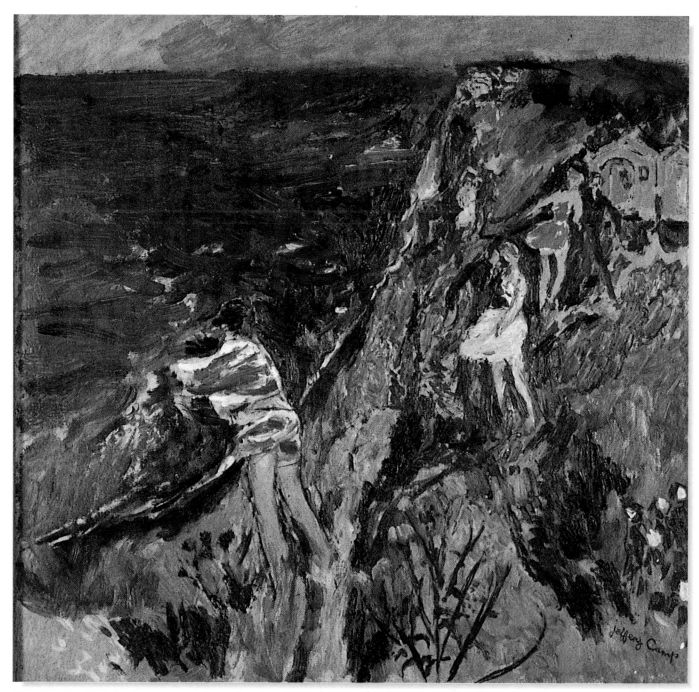

The clay cliffs of Suffolk, where ragwort, bindweed, and thistles proliferate, are gale swept. The water is whipped into dark Ultramarine greys. It gobbles great chunks of the coast. Each girl has a boyfriend, except for the nearest, who appears ravished by the great North Sea itself.

 Paint from the protection of a motorcar. The splodges will take over, until the rhythm becomes all-embracing.

 Outside, the charging wind is holiday-brochure-bracing, blowing canvas against brush and stiffening necks. Lapis grey is no longer obtainable, but Davy's grey or black can be blued with ultramarine. "Blue-black" is a ready-mixed black. Blues are clear and poignant, but not necessarily as sad as country-singer "blues". The following are good, cold blues: Cyanine, Prussian, Monastral, and Manganese. Warmer blues (if blues can ever be thought of as warm) are Cobalt, Indigo, Cerulean, and Ultramarine, as well as Ultramarine ash. Paint on a blue ground for clean surprises.

Windblown Lovers, Pakefield, 1960

The stones in the wall are fastidiously designed. Ravilious is more descriptive than Seurat; but it does feel like being on an island.

Eric Ravilious, *Convoys Passing an Island*, c. 1940–1

Blues in watercolour are naturally enchanting. To make them equally beautiful in oil needs more skill. Underpaint and juxtapose.

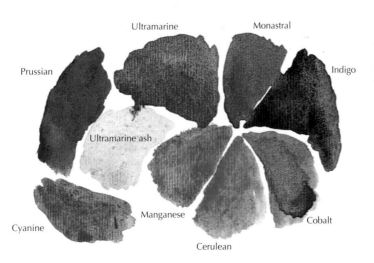

Prussian

Ultramarine

Monastral

Indigo

Ultramarine ash

Cyanine

Manganese

Cerulean

Cobalt

On a Clear Day You Can See France

DOVER PRIORY IS THE NAME OF THE RAILWAY STATION. From it, walk up high. The White Cliffs of Dover are known, but are seen mainly from the ferry. The terminal is noisy. The cliffs rise two-tiered, tinged off-white by soot. Further north, they are clean and bright. Small blue butterflies waver and flutter; deep in the grass, among knapweed, buttercups, and dandelions, lovers sweat. In the vastness, where cumulus clouds form and evaporate in blueness streaked with skeins of icy cirrus clouds, the flux is perfume-pathwayed, buzzed by bumble-bees, bees, flies, and wasps.

Give a canvas a scrub with a blue diluted with genuine turpentine, until it looks filled with desire. Make a little mark with blue-black. It is a jackdaw, I discover; the blip of white is turning into a yacht with its spinnaker filled. The undercut cliffs are set shimmering by a black flint beach.

The cliffs on either side of the Channel are marked by history. The choice is yours: Monet, Braque, Matisse, Turner, Seurat, Graham Bell, and many others dazzled their eyes here.

Do not fear past painting. With no food, you are anaemic. You cannot be in this world without ancestors. Do not fear to look at the English Channel. It has been looked at before. If you fear Impressionism, Cubism, or any of the past ways of painting, your art is weakened by fear. Past art is a protection from the dangers of academicism.

"The Cliff, Étretat" After Braque

"Étretat" After Matisse

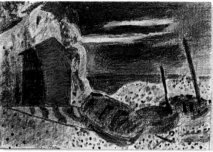

"Dieppe" After Braque

The rock formation (rather like a flying buttress) allowed the water to be a larger part of the design. After Monet

Dover. On very thin plywood, small and light to carry

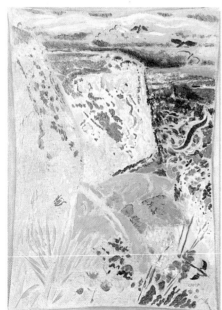

From eyehold to eyehold, grasp grass, chalk, thistle, flint, and wave, then, beyond the clouds looking back, see yourself looking towards France. Painting, like a magic carpet, will take you anywhere. Dover, 1994

Dover above the ferry, with knapweed

A work-along drawing for "Dover" (see p.87). Push the components until you know the most eloquent arrangement.

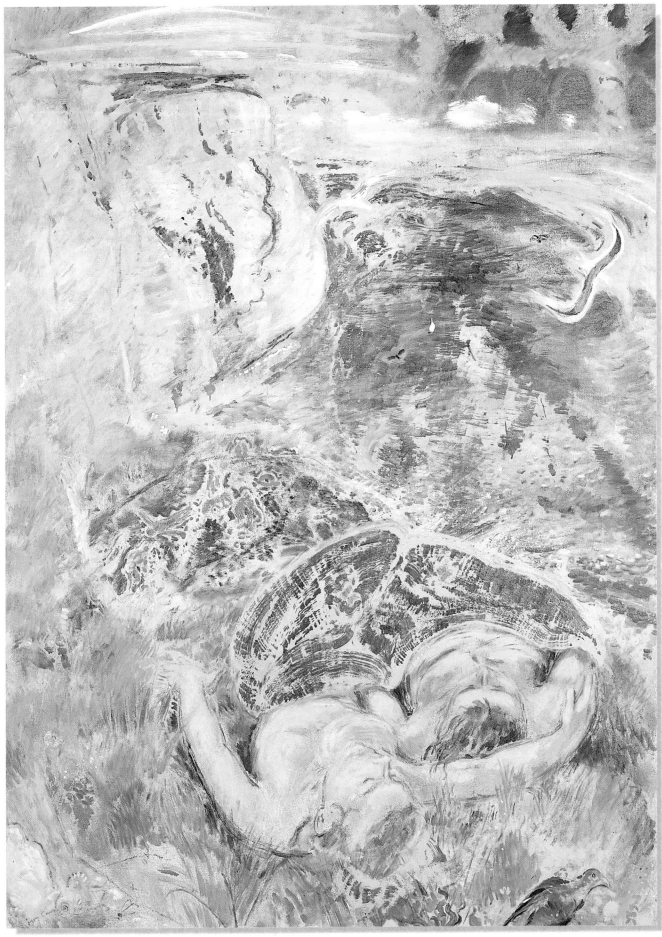

Dover, 1994

Rain

Rain is sad without a rainbow. Liquids paint liquids. It has been said that Cotman, Constable, Crome, and other outdoor painters flourished in East Anglia because of the low rainfall. In autumn, the monster skies are splendid. We hardly see rain before it wets us. George Bellows painted approaching storms and rain-filled landscapes with a bravura use of dark transparent colours. Rain made Chinese minds glide like snails, and wring forth beautiful poems. Braque, Sickert, and van Gogh used short diagonal strokes on horizontal formats. Their surfaces were crusty: they did not want to imitate rain's liquidity.

Laetitia Yhap is the only painter who has made visual poetry from raindrops on window-panes. They are so exactly painted, the

surface tension of the water is visible. The golden toad's eye does not see the roundness of a headlight or consider the fast rain-marks, sharp as cat-scratches. The toad stays still as the stones. The picture is a liquid building of vapours condensing in a vast alembic-shaped vignette. Vignettes were used by Bewick, Whistler, and Turner in books and etchings. But used as it is here, it can imply a vastness, and make the falling rain important.

Thames, 1986

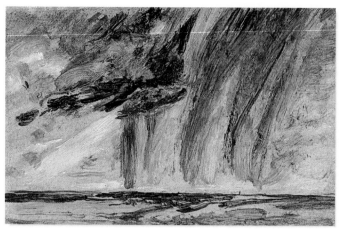

After Constable

After Constable

Constable was a miller's son, conscious of the weather. A windmill would turn according to the direction of the wind. He was excited by dew and rain, and made a physical engagement with the wetness, using big brushings of white and black over warm-coloured paper. (I expect he coated thick paper with White lead.) Constable's tiny sketches evoked large expanses of landscape and influenced Delacroix, and consequently French Impressionism.

After Rousseau

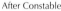

After Hiroshige

Hiroshige would make a hard poetry from rain traces, but here rain mysteriously obscures a hunting lodge called "The Temple", soft in the fall of leaves over the lake. Using paint as if it were mud, subdue a landscape, brush roughly thinking of a Turner storm.

After Kandinsky

Laetitia Yhap, *The Rain Storm*, 1967–69

After Braque After Henri After Seurat *Viewing Constable sketches*

Snow

I REMEMBER THE WHITE-ON-WHITE of snow on apple-blossom. Snow makes the White Cliffs of Dover appear chocolate-brown. It is soupy in London; slushy in Venice. But wherever snow goes, it is exciting.

When years ago I painted hard-blown snow, the streaks made it move fast, and straightness tied them to the picture plane. Brueghel painted dabs of snow liquidly, a little proud of the picture plane, slightly, lusciously law-breaking. But the flakes are small. When you copy a Brueghel

picture you realize how perfect and painterly is his control. You find yourself dolloping too much, or snowballing a donkey. Much of the painting seems to be wet-in-wet.

Try some flaky dabs of paint on a dark surface: wet-on-dry, wet-on-wet, and in other ways. Brueghel's "Hunters in the Snow" is the greatest snow picture ever painted. The dogs' paws sink in the snow exactly the right amount. In "The Numbering of the People at Bethlehem", snowballing is done seriously. Brueghel's pictures work on every level.

A Hawksmoor church. St. George's in the east, with falling snow. The world is different for some. You may have a glowing log fire, but it is as likely you are protected from the snow-filled cold wind by the invisible warmth of central heating. The bent body is a dramatic subject against the dark dawn.

St. George's in the East, 1988

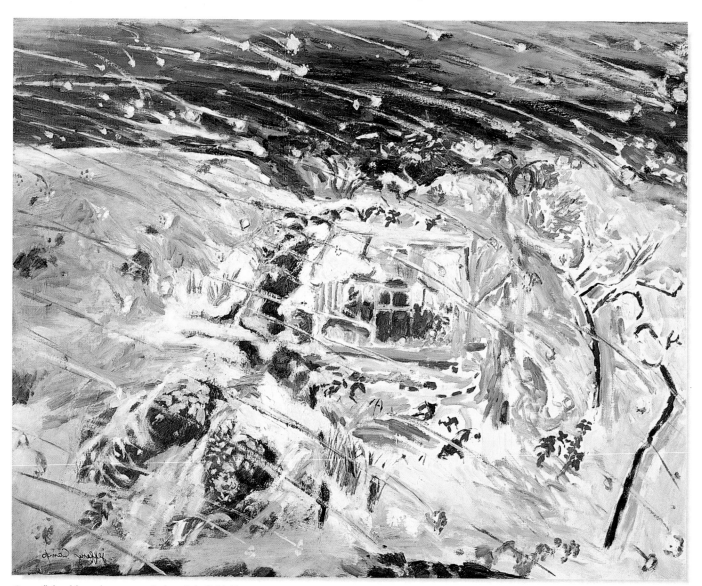

Snow flakes blown by severe winds at Pakefield. The long tails were painted from behind a large window.

Seaside Garden in Snow, 1960

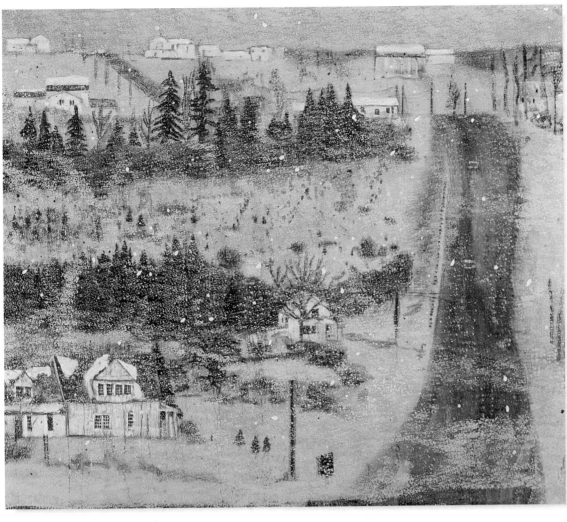

Doig uses elaborate spotting – dark marks on light, and sometimes, really large light splodges, which jump forward to surprise, to create shocks of depth.

Peter Doig, *Hill Houses*, 1991

Various dots, splodges, and curlicues: liquid white on black; liquid white on wet black; black over white; spots with tails.

A Cat in the Snow

Snowballing. They wore many layers of clothing, and looked like walking haystacks. When I painted in the snow, I wore a flying suit and an overcoat.

After Brueghel

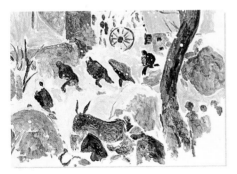

See if you can discover the luminous semi-transparent Brueghel way. Perhaps a golden ground will help.

After Brueghel

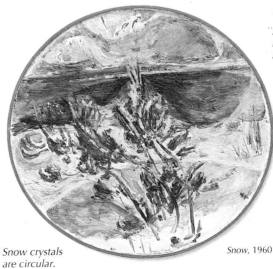

Snow crystals are circular.

Snow, 1960

Paint a snowball, or a ball of white wool. Like an old-time exercise.

Van Gogh and the Sun

THE CORN IS SOWN, GROWN, AND SCYTHED. Van Gogh, in the harness of his vocation, is held within his picture, like his weavers at their looms. The sower is a self-portrait of the artist, the tree is also one, and the whole picture, bisected by the horizon, is his cleft personality. Vincent is as harrowed as the field. Religion frightened him. As a parson's son, church law was on his back. He survived being a schoolmaster and an art dealer. He saw the degradation of poor miners. He wrote "Vincent" on the tree, loaded against a winter sky. It survives, a maimed but living cross with an amputated bough: the cut ear of the tree, a painful pink disc against the apple-green sky. (The apple-green of early Mondrian.) The picture is a symbolic prayer. An enormous sun palpitates against the head like a weighty halo. After the expulsion, toil punishes. The paint is worked hard with a Western force; the format is designed like the Japanese prints loved by the painter. If you think there was ever a comic face marked on the sun-disc, do not believe it: there is scarcely a trace of humour in the letters Vincent sent to Theo. Prussian blue was used for the figure and the tree. It can be a savage colour. Vincent wrote that time would tone down the Impressionists' unstable colours, and therefore not to be afraid of applying them too crudely. He asked to be sent Geranium lake. The tender pink clouds may have been a mixture of Geranium lake and white. Like his hope, this pink was destined to fade.

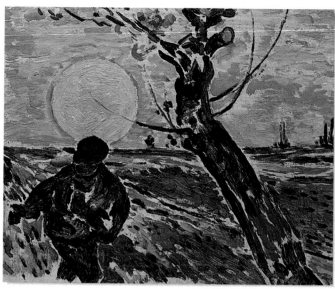

"The Sower". Hold a coin close and it obscures the sun. A coin-sized sun will not, however bright yellow, burn you a vision unless your painting is tiny. Looking at the sun fills your view with after images.

After van Gogh

As if overcome by the heat, like a jerking raven trapped in the sun; Soutine-like, the Munch-mad heat-strokes of red paint are melting the Midi. These Bacons, when new, were shown at the Hanover Gallery in London and made it stink of drying paint.

Francis Bacon,
Studies for a Portrait of van Gogh, 1957

"The Sower". A sun will become large as it approaches the horizon. Try painting a big area of Cadmium or Chrome yellow as a disc for the sun. What will the rest of your picture be like? Perhaps the sun will free you from a lax verisimilitude or habit.

After van Gogh

Van Gogh used Chrome yellow for his wonderfully luminous yellow and yellow-green juxtapositions. The Chromes have had a poor reputation for being blackened by polluted air. They are said to be improved, and should perhaps be used again. Chrome yellow is very intense.

After Bacon, after van Gogh

After van Gogh

After Millet

A smaller version of "The Sower". The simpler elements, the arc of the twig and the straighter furrow, may have been possible because it is smaller. It is rewarding to compare different versions. He did two copies, and several drawings, after Millet's "Sower". His figures swing into becoming images of power.

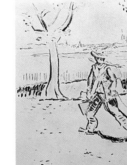

After van Gogh

After van Gogh

After van Gogh

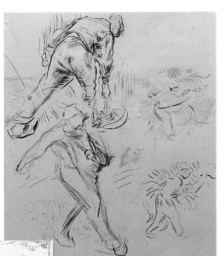

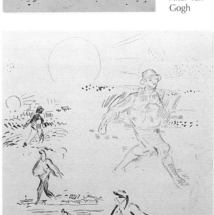

Small drawings were often in letters.

After van Gogh

After van Gogh

After van Gogh

"A Weaver"

After van Gogh

After van Gogh

"The Artist on his way to work". The "Sower" paintings were not actually done as self-portraits. The sowers spread hope as they stride across the fields. In this earlier painting, he depicted himself; trying to look blue as a peasant, and burdened with a painter's paraphernalia, he strides a little like a sower. But the time is August, and the shadow is from a hot sun.

This small picture inspired Francis Bacon's large, vividly coloured pictures. The painting-knives and large dripping brushes had never been used with such bravura before. The Bacons were very exciting, new, and melodramatic. But in the van Gogh, although the painter is weighed down, a bird may yet sing and the corn is bright.

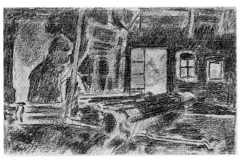

"A Weaver". With a windmill outside the window, the picture is full of crosses. The weaver is imprisoned by overwork and poverty, and the loom resembles a torture-machine in its complicated woodwork: windlass, guillotine, rack. The painter knew the labyrinths of torment. These early pictures of weavers were influenced by Rembrandt. The beautiful, heavy, grease-grey greens and hot browns are as moving as the bright colours of the later paintings.

After van Gogh

After van Gogh

Leaves

VINE LEAVES, FROM BEING PALE GREEN, go paler and yellower and begin to flow with streams of wine-colour between the veins. The woodlands are soggy after rain. Over dark streams, the yellow chestnut-leaves float in the air, and lie in the mud. Make some Concorde-aeroplane shapes on Raw umber mud. The ginkgo leaves are exactly that shape. They are yellow. (The soft tawny, milky yellow that Vermeer floats into his pictures.) Ginkgo leaves look contented in the fall, but the horse chestnut leaves flame in Cadmium yellow rigor mortis, cracking with apparent agony, soused in the black mud.

Take a bag full of leaves. Paint them at home when it rains. Paint some simple green leaf shapes. Compare

Ginkgo leaves

them with the completely dead leaves, which can shrivel out of cognisance. Mud is difficult to recognize in small areas of a picture. It needs a whole woodland path to declare itself. There was a time, in the "Pop" era, when David Hockney might have labelled "mud" with a ticket (as they do paté, in delicatessens).

Adrian Berg has painted views of London's Regent's Park like musical firework displays – splendours of rockets, and Debussy or Ravel colour poems: like Roman fountains, concoctions of wonderful ruby leaves. Berg is a most inventive designer. Sometimes, he moves around his pictures, rotating the trees. Sometimes, they follow through the seasons: twiggy for winter, bud-bursting in spring.

By doing a number of drawings, Kinley would gradually eliminate complications.

Peter Kinley, *Leaves*, 1977–78

Pinks sizzle and glow, discordant with orange (because in a rainbow, red would normally be darker than orange) but resolved here by being of equal darkness. Adrian lived beside Regent's Park.

Adrian Berg, *Gloucester Gate, Regent's Park, Night, Autumn,* 1981

Shrivelled leaves in pastel pencil

Horse chestnuts

Trial dabs on black

Vine leaves, with the curious wine-coloured streaks. Crimson capillary veins decorate the cheeks of drinkers. The leaves seem right to decorate Bacchus.

Try out green dabs for trees of scribble-foliage.

Leaves on mud

Chalk Landscape

BEACHY HEAD IS A "BEAUTY SPOT". What makes one vantage point right for beauty, rather than another, is useful to know. People visit Beachy Head to smoke, click a camera, cuddle a lover, pretend to push a parent over the edge, or throw a Coke tin. The danger is part of the fascination, with the possible dive to a death too far away for the gore to be seen. More than 20 jump every year.

A border of horizontals suggests a receding suggestion of skylines towards deep space, and the colours at the edges promote moods and times of day. (Violet for evening, lemon-green for morning.) When the picture is square, or diamond-shaped and on its point, it has its angles at its edges. Stability is achieved by emphasizing horizontals and verticals: let the picture be active, and self-contained as a gyroscope.

Beachy Head is high. It makes the second-by-second dying of thoughts more intense – like gulls dropping from the cliffs, like leaps of consciousness, like quick film rushes towards death. The immense white chalk promontory can stand for whatever you want, and reflect any mood. Covered with snow, it is brown as chocolate. It changes colour week-by-week: blue, yellow, green, or dazzling white.

Beachy Head, Evening, 1975

The movements, dynamics, and depths are served by progressions. The compression of the stratified chalk is paralleled by the compressed design.

The lighthouse casts a long shadow, almost vertical; or it could be its reflection, on a special day. Cloud-shadows, and ripples, are damply rendered towards the edges.

This drawing almost maps a chunk of England. I enjoyed itemizing it , point-by-point, weed-by-weed: burdock, viper's bugloss, Carline thistle, sea poppy; chalky crack, black flint, jackdaw, and gull; and drawing the undulations of the downland as it reaches the sea a mile away. All is visible, vantage point to vantage point. Little has changed. Old postcards make contact with loved ones at the turn of the century: they show almost the same shape for the headland (and very proper messages). The perspective is controlled with a few "passages", and the weightlessness of a pencil point. Wild marjoram scents the air. The sea soothes.

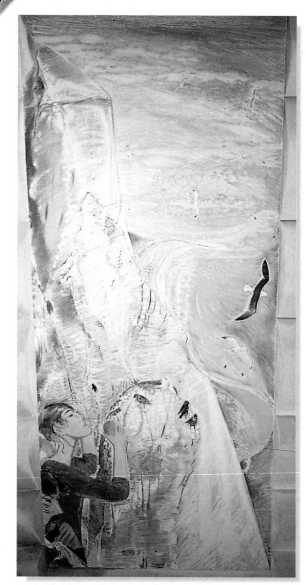

Spatial ladders of flint and chalk shine. All the resources of Manganese and Cerulean blue, Cremnitz and Titanium white, charcoal and Charcoal grey, were involved.

Beachy Head, Black Gull Flying, 1972

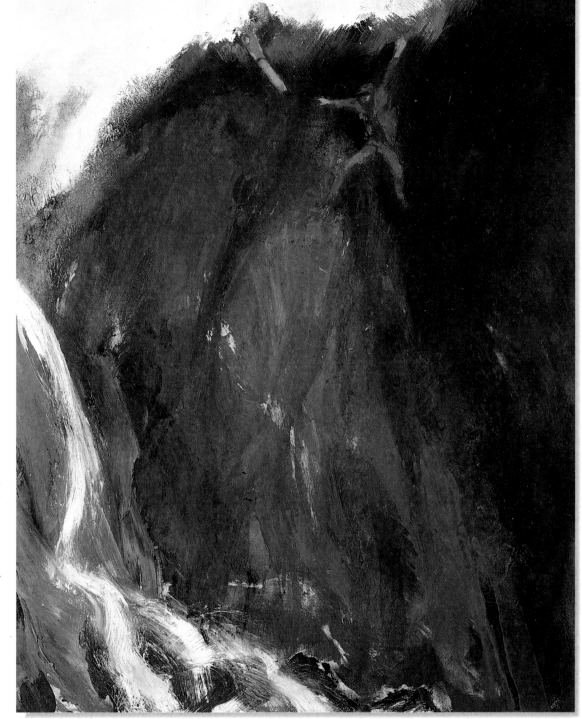

I had watched the cliff-rescue team abseiling at night at Beachy Head. The spotlights made it dramatic. I had often imagined a figure falling from the high white cliffs, the lighthouse beams flashing. And, as if to show just how it would be, Andrews painted this self-portrait of his own narrow escape from death.

Michael Andrews, *Into the Tobasnich Burn: Glenartney. Saved by the Water*, 1991

"Le Bec du Hoc". Across the Channel, the coastal structures resemble Beachy Head. The diagram is of the picture in the Tate Gallery, London.

After Seurat

The shapes of the figures lying at Beachy Head, near the immense drop, resemble the silhouette of the downland against the sea.

Fishing

THE FISHING BEACH AT HASTINGS in East Sussex is at first sight picturesque. Its tall black huts, with caves and rocks in the background, are guidebook material. Only a few things change: the nets are no longer black, and satellites forecast the weather. But fish die in the nets when days are rough, and the shingle beach is swept to an angle by storms.

Laetitia Yhap paints the stuff of the past in the present, with new pictures, much as Benjamin Britten wrote music for the opera *Peter Grimes* (based on Crabbe's early 19th-century poem). She bravely analysed its ruthless, macho world, and was accepted by the fishermen. Perhaps they even realized the seriousness of her paintings as she kept warm with a hot-water bottle. She sees those on the beach straight and vulnerable, as they swear, lean, doze, or depart to collect the dole. The drawings are taken back to the studio, and memory does the rest.

A drawing of Laetitia Yhap, drawing on Hastings Beach

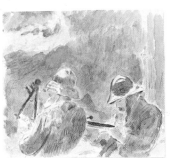

A very scribbly depiction of "Sou'westers". They were made of oilskin.

After Homer

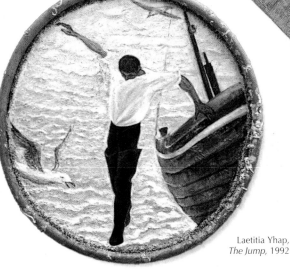

Often the first to leap ashore is the dog, barking with excitement, from the prow. The launching and beaching of the boat is dramatic. Catch the excitement with a pencil; dab in the first leap, and memorize all you cannot do fast enough.

Laetitia Yhap,
The Jump, 1992

Pushing the boat out may take several fishermen. However much they squabble, they have to help each other, and even tow each other home when the engine fails. This was a way of making a grey mood, without slowing the central activity. The wind is blowing hard.

Launching the Boat, 1976

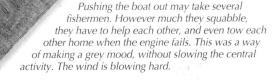

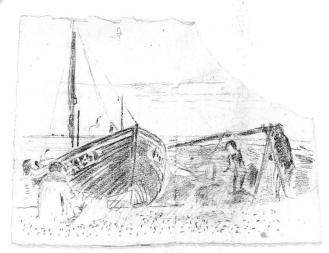

A drawing of Laetitia Yhap, drawing on Hastings Beach

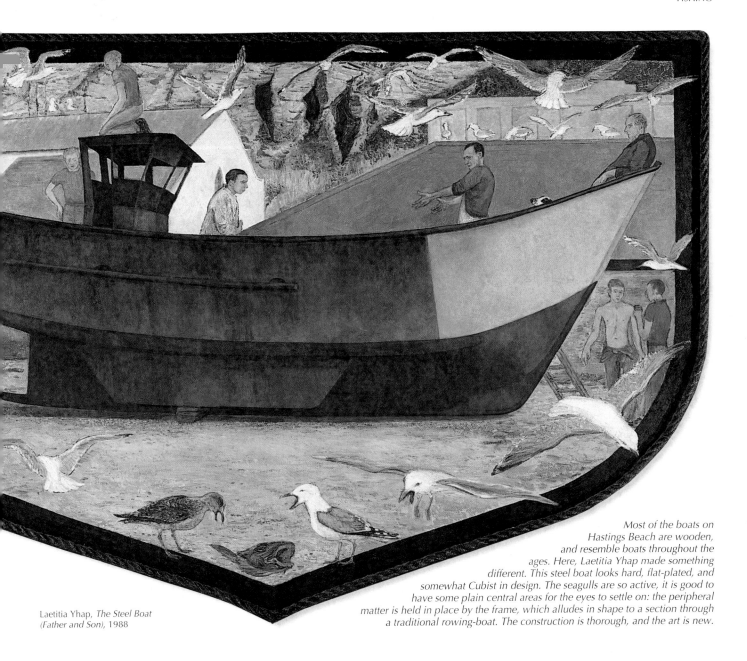

Laetitia Yhap, *The Steel Boat
(Father and Son)*, 1988

*Most of the boats on
Hastings Beach are wooden,
and resemble boats throughout the
ages. Here, Laetitia Yhap made something
different. This steel boat looks hard, flat-plated, and
somewhat Cubist in design. The seagulls are so active, it is good to
have some plain central areas for the eyes to settle on: the peripheral
matter is held in place by the frame, which alludes in shape to a section through
a traditional rowing-boat. The construction is thorough, and the art is new.*

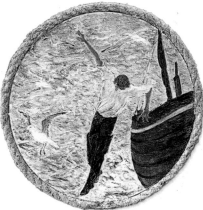

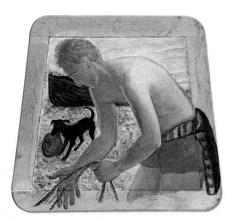

*Fishing can be gruelling. The
seagulls are desperate too. A foot
has left the picture. Compare the
compression of the boxed-in
design of "Exhaustion" with the
open space of "The Jump".*

Laetitia Yhap,
Exhaustion,
1992

*A smaller version of
"The Jump"*

Laetitia Yhap,
The Jump, 1992

*Bare or clothed, the body shape
is made to fit with the boat
shape. Rembrandt made the
thumb of a portrait come in front
of the frame. Here, thigh, waist,
and hands are coming forward.*

Laetitia Yhap,
Sun on his Back,
1991

In the Park

I
T IS COLD AND "PARKY" some days, but there
are shelters if it rains. Van Gogh painted
four pictures of public parks. They were
called "The Poet's Garden", and he did
them to be hung in Gauguin's room, in the
yellow house at Arles. The first was called
"Public Garden with Weeping Tree" – it
weeps citric lemon-yellow, brassy from the
sky, and batters its way into the lush, green
grass. Gauguin would certainly know he
had arrived! "Entrance to the Public Garden"
was another picture of a park. Parks are
convenient. If you call a park "your outdoor
studio", all sorts of benefits accrue. Trees
and shrubs are often closer to human size,
and flowers are large and special. Paths,
benches, and fences are clear to see, and
people are not upset if you stare at them.
Usually, there are lavatories, and a café for
drinks. It is possible to be remarkably
private. Select a path that leads nowhere. If
you are pretty, or magnetic in other ways,
wear a Walkman radio (switched on or off)
and you will be secure from interruption. A
park is not like farm-land, or open country.
Vincent would paint a park as a park.

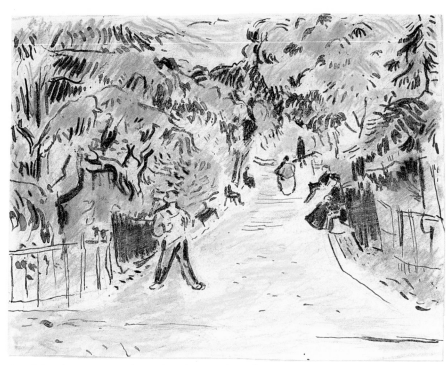

*A park in Arles. Using pastel pencils and watercolour, thrust colour with
van Gogh impatience, person beyond person, up the park path.*

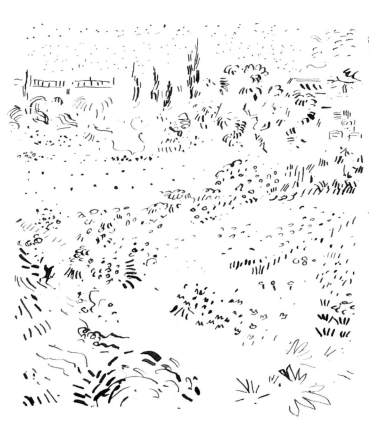

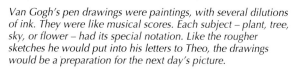

*Van Gogh's pen drawings were paintings, with several dilutions
of ink. They were like musical scores. Each subject – plant, tree,
sky, or flower – had its special notation. Like the rougher
sketches he would put into his letters to Theo, the drawings
would be a preparation for the next day's picture.*

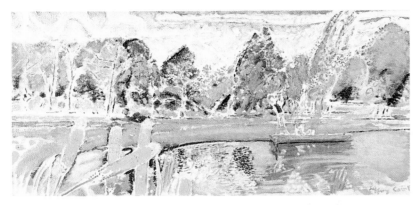

A boat on the lake. The canvas was marouflayed to hardboard. *Regent's Park, 1992*

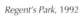

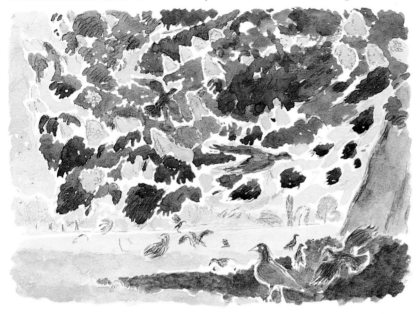

Windblown chestnut tree flowers, with pigeons. Blank spaces become flower-candles.

Buckingham Palace. By including a large number of subjects, it becomes possible to choose those that mean most for future pictures. Fountains, geese, lake, and trees are easy of access, and the painter can practise his personal shorthand with a thick, soft-leaded clutch pencil. A soft Conté crayon makes painterly suggestions easy, sharpened charcoal is fast, and feels like paint; take a tin of fixative with you if the medium is likely to smudge.

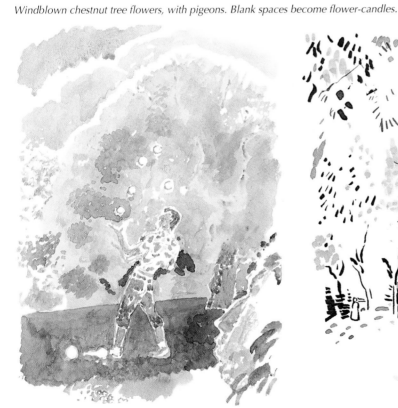

A juggler in the park. Juggle with a pencil and watercolour. *A pen drawing in a park in Arles. Dense overlapping made clear as patterned paint marks.*

Learn to See

I VISITED A PATIENT IN A HOSPITAL in Florence and was surprised by the length and power of the staring on every side. Here in Britain, "An Englishman's home is his castle" – not only his home, but even his person may not be invaded by looking. Eye him and he may even ask you what you are staring at. I was shy when I first began painting, but I wanted to paint humans. "Know then thyself, presume not God to scan/The proper study of mankind is man." (Alexander Pope, *Essay on Man*.) I decided to be brave. I took a box of paints and a folding palette and sat in the middle of the action wherever I wanted to – roller-skating, dancing, swimming. I even painted a picture on the stage of a holiday camp while a knobbly-knees competition was in progress. The list of subjects is long. I had an insatiable appetite for looking. Museums, aquaria, public gardens and zoos, fishmongers, jazz clubs, trawlers, yachts, surfing, Rugby, promenading, parties, pubs.

Paint the world. Be committed. Paint as well as you can. The world is filled with half-felt pictures. The only paint we want is whole-hearted painting. It comes from intense, continuous looking at the life that surrounds us. You must be a voyeur, a professional snooping artist. You must cultivate the ability to be an observer everywhere. On hot randy beaches at Brighton, family beaches at Worthing, pretty adolescent beaches at Eastbourne. On tube trains. At parties. Indeed, wherever the rapacious, ravening, all-ingesting criminal eye will dare to go. Without this terrible visual appetite little can happen.

Just a "Peeping Tom", I stare towards the sea. I expect I am looking at a Japanese family on the beach. They are pale. They discover I am drawing them, their faces wreath with smiles. The creases on their faces are made especially for smiling. I am happy. They are difficult to draw. It is hot, humid, and windless. Boudin coped with wind and dazzle. Brighton is flashing and burning bright with sunlight. They enjoy being together. There is no tension or ill temper. The group is beautifully balanced. Though the clothes are vulgar, the wearers have poise. I find I cannot follow the form of "Mum's" tiger-striped bikini, linked as it is by lacings to a kind of side-apron. I decide with some relief to look instead at the simpler, nubile daughter. Her two-part garment is loud in yellow and black. Its abstract violence attacks her soft form at every point. I draw the boy. His elegance is sullied only by pink boxer shorts. His dental braces gleam in the sun.

The brilliance of the light after London is formidable. My eyes are tired at the end of the day – the perfect day, when the helter-skelter tower at the end of the pier shines, reflecting in the sea, and large jellyfish pump along in the green water.

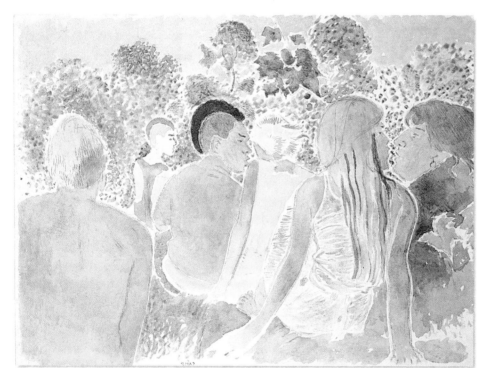

Brighton Beach

Stylish hair on Clapham Common. Watercolour is added to a pencil drawing done on the common.

Afro Haircut, Clapham Common, 1983

Sunbathers and tankers at Worthing

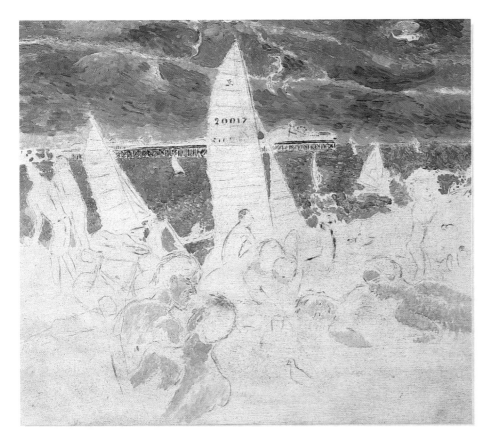

Brighton Beach. An unfinished painting, drawn on the beach. Yachts and bathers. Make out what you can. I believe a helicopter is in the corner.

Boats and Bathers, 1992

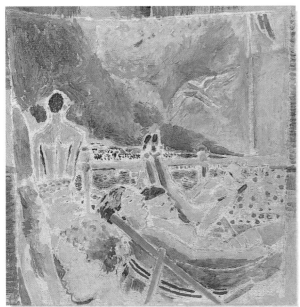

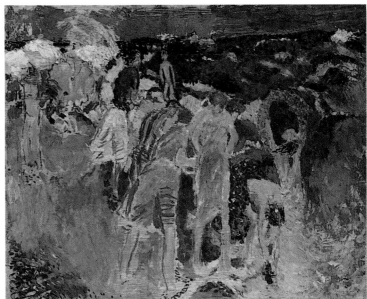

Brighton from the Pier, 1993 *Painted directly in the wind, at Lowestoft.* *Parachute,* 1954

Substance and Weight

AMONG THE GREAT SCULPTORS, Donatello is the most like a painter. Clay is thick and waterbound like paint. Some pictures, which are hardly heavier than canvas, look as if they weigh a ton. "Beachy Head, Dawn" was about the accumulation of chalk over vast periods of time, together with the claustrophobic memory of reading Jules Verne's *Journey to the Centre of the Earth*. Weight in painting can be achieved in several ways. The obese Courbet knifed into dark earth colours (Raw sienna, Lead white, ochres, black, and umber), yet with great delicacy. The heavy opaque colours are the iron reds (Terra rosa, Veronese, Indian, and Light reds, and Caput mortuum) as well as vermilion, Mars black, and Chromium oxide green.

"E.O.W. Nude", 1953–4, by Frank Auerbach, painted when young, is the heaviest application of paint I know. A beautiful and determined painting, the image does not weigh much more optically than thin paintings by Matthew Smith, Renoir, or Rubens. A Rouault watercolour of a girl, using darkly flowing evocative lines, is as massive as a horse.

There is no reason why a cliff that weighs billions of tons should be painted with thicker paint than a Matthew Smith girl. But thick paint can add strength, help a canvas become an object, and establish a secure surface. Thick paint may be slow and hard work to do, it may not last well. It can be beautiful as tree-bark, or merely an oily excrement.

Watercolours are less heavy, usually. Nevertheless, Nolde, Rouault, and Burra make substantial pictures.

Clapham Common, 1980s

I often keep light colours low in my pictures. Here, the framework is made heavy at the base. A corpse feels heavy. Permeke painted large, earthy peasants with enormous hands. Masaccio was the first to paint "the human clay".

For Hodgkin, a frequent visitor to India, red probably means passion, rather than the pain of the West. The paint is heavy-laden. He scrubs and brushes red over green much as the painters of Indian miniatures overlay green patterns with red. He may have used "Liquin", a thixotropic medium.

Howard Hodgkin, *Foy Nissen's Bombay,* 1975–77

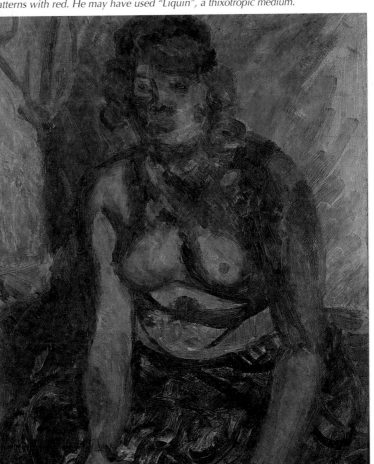

Beachy Head, Dawn, 1975–84

Smith may have used Maroger's medium, which is still available. It pre-dates the gels that can be obtained now. The lavish brushing (using big dabs) – and the roundness – gives the fatness.

Matthew Smith, *Nude Girl, 1922–24*

Death's Dark Tower

LEIGH IS ON THE NORTH SHORE OF THE THAMES ESTUARY. Anthony Farrell paints bravely the popular escape to Southend from "Town". He accepts the flux, the crowds, sea, and sky. John Constable looks stylish now but was considered a natural painter in his day. He changed the brown, ornamental tree into green foliage. He flicked in dew, snow, and light effects with a palette-knife. Hadleigh Castle is visible from Leigh, and caused a profound work by John Constable, whose noble style is style indeed, compared to the clear brave-faced Farrell confrontation of the Cockney invasion at Leigh-on-Sea. Although only a short distance from London, it is far enough for Farrell's freedom from fashion to be preserved. He neither uses conformist recipes for flatness, nor flirts with abstraction. From the long, long, Southend pier, watch him paint his son windsurfing, a balancing of wind, body, and water. He once copied "St. George and the Dragon" by Tintoretto. Anthony is a painter in mid-career. He makes painting seem like a bareback rider, balancing on tiptoe on a sweating horse at a gallop. The four little paintings are of winter, spring, summer, and autumn and were painted small for this book.

But the sea changes little with the seasons, compared to the tree-filled inland world of Constable. Constable did not depart wildly from the conventional design of the pictures of his time; and reading his lectures it seems he was unaware that pictures could be built as coloured architecture, as Seurat and Gris would design them later. Constable's style

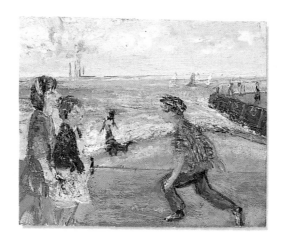

Anthony Farrell, *Spring*, 1993
Leigh-on-Sea. The horizon is the other shore of the estuary.

was like the fine handwriting of his time, or like the fine Georgian building style, ordered and serious in mode. Constable would apply paint with vigour and sketch fleeting effects. Gestural knifings of paint done directly from nature showed him to be a revolutionary painter. The last works such as "The Cenotaph" became nervous, colourless, and dryly monumental. (I remember the dismay of Scottish artists when Edinburgh's National Gallery acquired Constable's late painting, "Dedham Vale"; they thought it brown, very overworked, and dry.

Claude Lorraine was the envy of both Constable and Turner; like them, he studied out-of-doors. Constable copied a Claude, and Turner asked in his will for one of his pictures to be hung beside a Claude. This has been done in London.

Constable had an influence on Eugène Delacroix, but the French classical tradition was one of such firm drawing and design that some Constables look slack and billowy compared with a Chardin.

Constable was a great artist who was always threatened by perspective. His strong intuition enabled him to shape up the moisture of his leafy river pieces, yet his control of depth is not as lucid as Seurat's. Compare crayon drawings by Seurat with similar drawings by Constable. To paint "A Sunday Afternoon on the Island of La Grande Jatte", Seurat used the drawings imaginatively, making the figure groups smaller and higher on the picture, as they got further away. Anthony Farrell and Boudin do not do this.

After Boudin

"Le Pont de Courbevoie". After
Mark the intervals on Seurat
tracing paper.

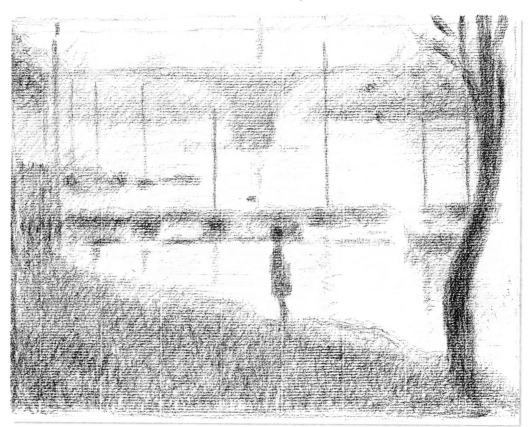

The drawing, "Le Pont de Courbevoie". Seurat said painting is the art of hollowing a surface.　　　After Seurat

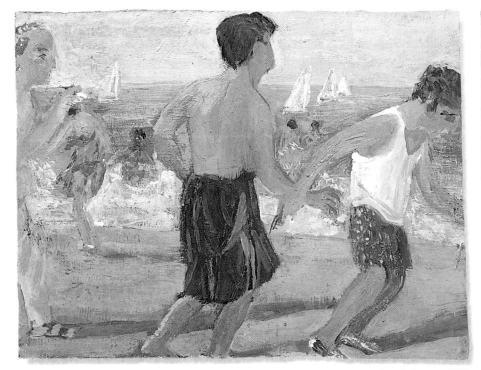

Anthony Farrell, *Summer*, 1993

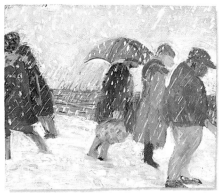

Anthony Farrell, *Autumn*, 1993

Anthony Farrell, *Winter*, 1993

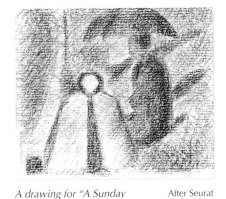

A drawing for "A Sunday Afternoon on the Island of La Grande Jatte"

After Seurat

It takes no more than a few dots and a scribble to trigger a memory of Constable's "Haywain", Britain's best-known picture.

After Constable

"Hadleigh Castle"

After Constable

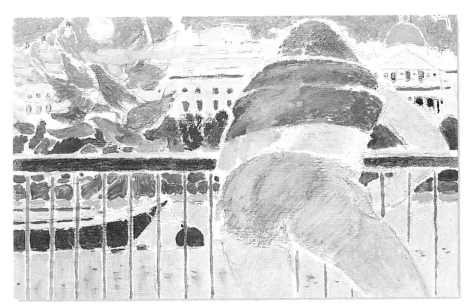

The pigeons flutter over the Thames near Somerset House. A large, awkward, foreshortened figure is held in place by the straight lines of the vertical railings.

After Constable

After Constable

Vastness

EYES CAN TRAVEL UP the tall silk of a Chinese painting, encountering mountain tops, trees, waterfalls, and sages. The intervals are for contemplation and rest – and recession. All the climbs towards the vastness are by the dilutions of ink.

Poets need little baggage. Anthony Eyton needed more, to brush bright figures at Western perspectival intervals on to the snow-slopes of a blue-grey mountain. But he travels light and constantly, without a razor, but with a few well-loved colours. Canvases are unwieldy, and take the wind like yachts. Traveller-painters are brave. Turner and Delacroix carried only little drawing-books, and when Turner was tied to a mast in a storm he took only his imagination.

An aside: how did Oskar Kokoschka, planting his feet high above the roofs of European cities, manage to have materials with him? Affluent when old, perhaps he bought them as he journeyed?

Beachy Head, Chasm, 1970s

Because there is a free choice of level when painting these cliffs, the disposition of figures is made easy.

The trees float as in a dream, blending close tones mysteriously. Fry is a much travelled artist and has crossed the desert.

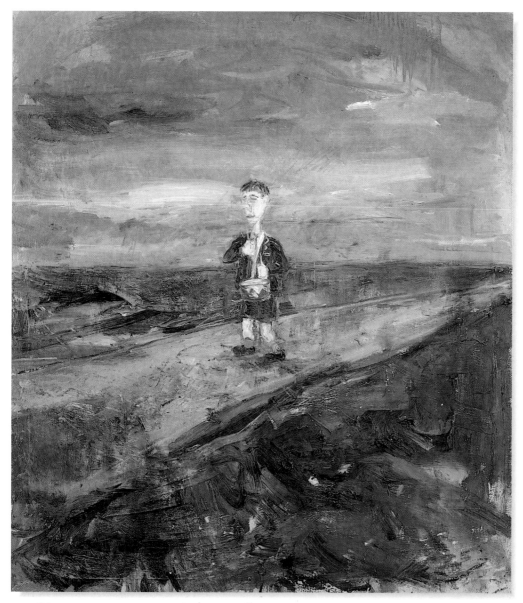

A small figure is surrounded by wide, open space, created by expressive, intuitive brushing. Kondracki is the best Scottish painter-poet since Gillies. Hopper and Lowry use a central figure surrounded by large open spaces for moods of loneliness.

Henry Kondracki
On the Road Alone, 1989

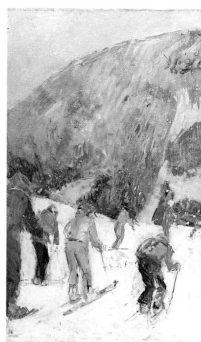

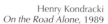

Anthony Fry, *Mango and Rice
Paddies, Thirunelli*, 1991

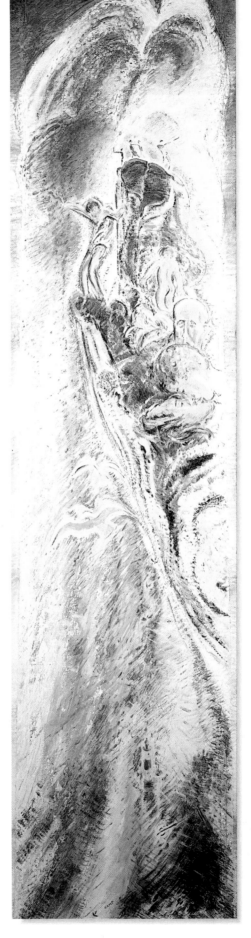

The contrasts of tone and colour are
"open" (i.e. laid side by side, unmixed). After Munch

He travels constantly, and – as was said of
Sickert – his mixtures go with him. There are Eyton
landscape subjects worldwide, from India to Brixton.
As his brush thrusts, the spaces expand. With such
constant practice over a long life, every gesture is
decisive. He is one of the few remaining serious
painters to work directly from the subject. Soutine,
van Gogh, Bomberg, and Pissarro also did what
Degas disgustedly called "standing about in fields".

Anthony Eyton, *Skiing*, 1990

When I was
young, and
lived on the
East Anglian
coast, the sea
encroached
considerably.
Week by
week, the
cliffs receded.
One day, a
round tower
stood on the
beach as if
by magic. It
turned out to
be a brick
well. I seem
drawn to the
peninsular of
chalk, the
towering cliffs
at Beachy
Head. Here
the risings are
related to the
various ages
of humans.

*Old and Young
at Beachy Head*,
1980s

A Marine Bullfight

PICASSO LIVED A LONG WHILE and made many new styles – his subjects were old. He painted simple, well-used themes, except for one spectacular subject, "The Bullfight", which is a complicated, difficult purge. It had been painted by Goya; Picasso felt the bull-drama in himself, and in art. The fisherman forks his fish with the same vehemence and deliberation as the matador plunges his sword into the bull. "Night Fishing at Antibes" was a sea-corrida against a balmy Beulah night, whose depths are charged with amethyst and black – all moves on. The girl groupies of the fishermen, dressed in the headscarf and snood of the time, are on tiptoe with excitement, the bosoms of the near biked "broad" ecstatic with pinkness spreading into the arms of her companion – although she has stayed cool, even inquisitive.

After Picasso

Diagram-copy small parts of this large picture, wherever you feel most involved. And if the main compositional ties (the schema) are seen to carry the meaning, pass over the details, and describe diagrammatically. Think in terms of a body, and the parts of a body. Picasso was always thinking in Picasso's-body terms. His own body, although small, was robust and good for use as a pattern.

Subjects are very important. They must make it possible for you to paint the shapes you need.

This is my favourite Picasso. I do not know what it contains. Sometimes, a scribble-think will make clear what is mysterious and determine the black, violet, and green areas of the night. The gradation from golden water to Viridian green below the boat revives memories of childhood dreams and strangeness below.

After Picasso

Electrically gleeful, the pink flapper licks a double-scooped ice, with a bluely lascivious tongue. Picasso often painted close to monochrome – the black-and-white of Spanish painting, of Ribera, Velásquez, and Goya. But in this picture, he went through every colour in the spectrum.

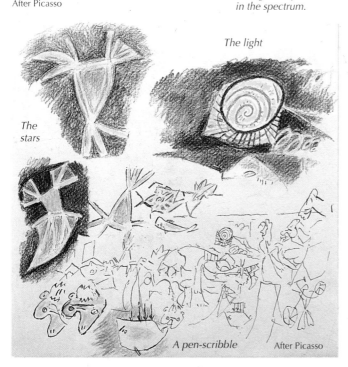

The light

The stars

A pen-scribble After Picasso

The Polyphemus-eye-ruddy-moon-glowing light for attracting fish, in the centre, is like the peak of an erupting volcano. (In "Guernica", the electric light and oil lamp are at the summit of the design.) As advertisement designers know, the loudest attention-capturing colours are yellow with black. A little red increases the heat, and a little white takes it to white heat. Tear a black hoop around a square. Paint rays as black lines, add a yellow coil spiralling away to the right. The main red spiral is to show Picasso's passion is like a sun.

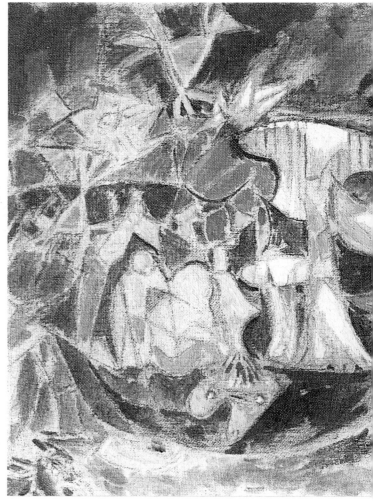

"Night Fishing at Antibes"

The reflection of the light After Picasso

A moon face After Picasso

A moon-pale face, grainily intent After Picasso

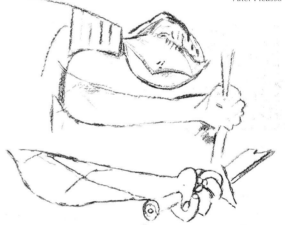

After Picasso

Thrusting arms. The lower arm, with a broken sword, is from "Guernica". After Picasso

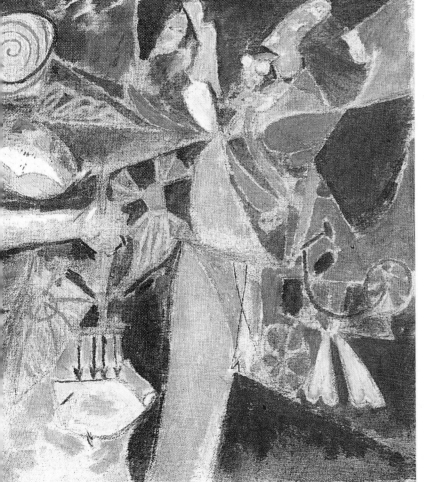

After Picasso

Using a brush, and a brash will, crash through to beauty, shut your eyes to the particulars, and search out the massive, structural organ alembic and the toreador/sailor. After Picasso

Although Picasso copied figure-filled Poussins, this is almost the nearest he came to a figure landscape. After Picasso

111

Keys

P ABLO PICASSO WAS FOND OF THE BEACH, and of a little beach hut. It is depicted in several of his lively paintings dating from the 1930s. An arm playful with desire, thrusts a key into the keyhole.

Léger, who had experimented with Cubism and abstraction, in order to prove to himself that almost any object could be used for art, took a ring of keys from his pocket, and painted it with a postcard of the "Mona Lisa" and a sardine-tin. Léger expanded the range of objects available to art. He painted roots, belts, corkscrews, ball-bearings, and spoons. He painted them as calmly as he could, with a control equal to that of a Japanese print. Léger hardly lifted his brush from its convoluted fluctuations. The bunch of keys makes a muddled image, but Léger sorts it out. Chance had presented him with more associations, perhaps, than he had expected.

Keys look stiff at first, then are found to be telling tales throughout past painting. St. Peter holds the keys of Heaven, Rodin's "The Burghers of Calais" give up keys – as happens also in Velásquez' "Surrender of Breda". In this large picture, the key becomes the focus, the interlocking point of the whole painting.

A key is usually rounded at the handle end, and squarer at the keyhole end; and these are connected by a shaft. The lock holds all the entrail-maze – mysteries of labyrinths, fractals, and uncrackable codes. Paint or draw some keys and other convoluted forms. Attempt a knot out of your head, it will quickly make clear your capabilities (some can imagine easily in three dimensions). Draw a granny knot, then a bowline, then a reef-knot. There are lots more. I rapidly became entangled. The elaborate margins of *The Book of Kells* were maze-like, and intended to keep the devil from reaching the sacred text.

A simple key for St. Peter to hold

After Jacopo di Cione

After Crivelli

Crivelli's design is so tightly organized that these two long keys were able to be attached by cords, and stand in front of the tempera surface.

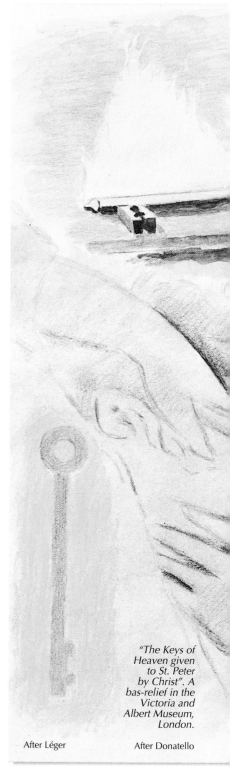

"The Keys of Heaven given to St. Peter by Christ". A bas-relief in the Victoria and Albert Museum, London.

After Léger

After Donatello

Playing at watercolouring locks, keys, and darknesses.

"The Surrender of Breda" (detail) After Velásquez

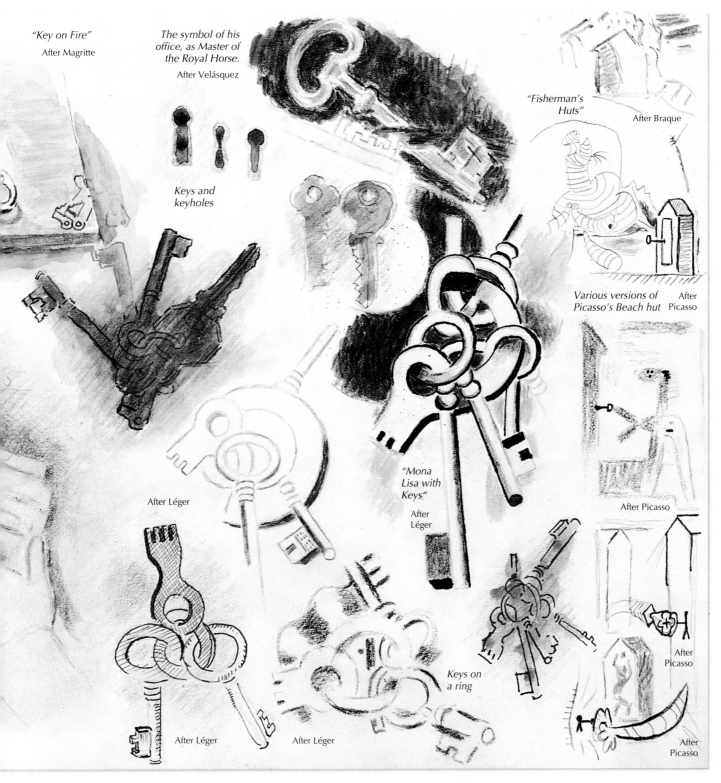

"Key on Fire"
After Magritte

The symbol of his office, as Master of the Royal Horse.
After Velásquez

Keys and keyholes

After Léger

After Léger

After Léger

"Mona Lisa with Keys"
After Léger

Keys on a ring

"Fisherman's Huts"
After Braque

Various versions of Picasso's Beach hut
After Picasso

After Picasso

After Picasso

After Picasso

"The Surrender of Breda" After Velásquez

Knots: **A** Reef **B** Granny **C** Bowline

"Bather". A design wild with distortion, about a visit to a beach hut which was naughty with memories and some surrealism.

After Picasso

Art Holiday

A HOLIDAY WENT ON FOR YEARS, when like Matisse you lived in a hotel by the sea. Claude imagined a "golden age", and others yearned for Utopias of the future. Come then with me, as if it were in times gone by. You are in a little hotel almost by the sea. Jacques Tati as Monsieur Hulôt is enjoying the holiday. You think of Proust and Balbec; and settle, for your feet's sake, on low tide at Le Touquet. Your toes enjoy the wind-shivering glitter of the wavelets, and as Luchino Visconti directs the shutters to open, and a universal light floods in from the Lido at Venice, a pang of conscience assails you. You have lain on the hotel bed a full hour and have not unpacked your painting materials. You must be up before breakfast. The porter will carry an easel, croissants, a jug of coffee, and a dazzling white canvas. You will carry brushes and paints. The canvas will absorb the light and give it forth later, in Pimlico, London, where your sister will always enjoy it.

Enough of fancy. To work outside by the sea you have to be strong. The wind blows the palette, the brushes, the canvas, and your ears. Boudin must have been hardy. He was a starter for Monet, who also braved the weather. To work out-of-doors, it is useful to know a few versatile, fast ways. The St. Ives painters worked, if not outside, at least close to the beaches and the sea. Alfred Wallis was the most direct, and he worked from memory, with yacht enamel on pieces of cardboard, whose rough-cut shapes suggested his superb arrangements. Enamel had never before made such creamy waves. More artistically aware was Christopher Wood. (He had known Picasso and Cocteau in Paris.) Wood knew ways of coating white gesso with black, and scraping it, and painting – with the enchantment of glossy fresh enamel – many of the little beaches, boats, harbours, and churches of Cornwall. It seemed as if, because of the crinkled nature of the Cornish coast, the painter could be close to the subject. Add to this a concentration of Parisian Cubist space, and a new kind of condensed picture became possible.

The opposite thing, which Peter Lanyon did – since he wanted to paint open-space pictures – was to go gliding, climb over the rocks, and pick up evocative junk from the beaches. He made his own paint, by knifing up pigment with a glossy vehicle (such as stand oil and varnish) and thus took on some of the breadth of The New York School, where he won recognition before his youthful death.

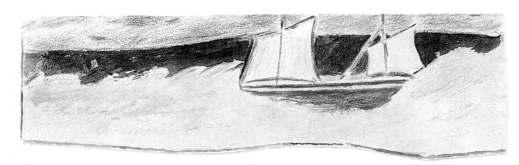

"Fishing Boat at Sea". Take a piece of the sea-washed driftwood, or odd-shaped card, and to broaden your mind, paint in tune with its shape-surprises, as if you were building sandcastles.

After Wallis

Picasso and Matisse each painted large pictures on the theme of Joie de Vivre *– an idea of Arcadia.*

After Picasso

Gliding was Lanyon's sport. Its influence was apparent in the sweeping, cloud-like gestures of paint and open design.

Peter Lanyon,
Backing Wind, 1961

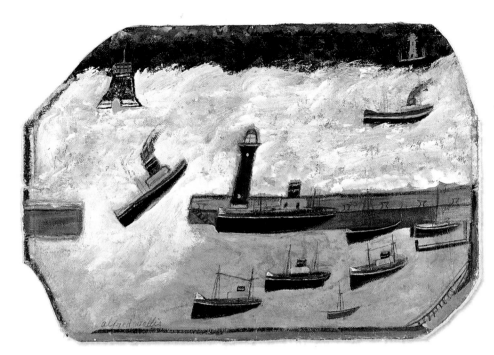

Wallis dabbed his way around his oddly cut shapes of cardboard (sometimes shoe-box card). In imagination it was as if he became the water washing against the rocks, jetties, inlets, and coves near St. Ives, Cornwall. He had begun painting at the age of 70, as he said, "for company".

Although technically Cornwall is a peninsular, after a whizz from its North Coast to its South Coast on a motorbike, or a flight in a glider, it seems like an island. Its artists, Nicholson, Wood, Lanyon, and Wallis, painted as if their surfaces were islands, and were to contain all the items they wished for. They distorted perspective, and played with their subjects as if they were toys. And everything was got in.

Alfred Wallis,
Penzance Harbour, (no date)

Christopher Wood, *Le Plage, Hotel Ty-Mad, Treboul*, 1930

Seaside Glare

JOHN WONNACOTT LIVES ON THE THAMES ESTUARY. Once it was an open sewer for London. When the tide is high, it is the sea coast; when low, it seems more like river mud. Wonnacott was taught by Frank Auerbach, as different from him as Gustave Moreau was from his pupil, Matisse. Not frightened of the glacial effect of white, Wonnacott explores, like Degas, the hinterlands of photographed effects – the terror-lands where so many have come to grief! Degas despised painting in the open air, but achieved some naturalistic race-course pictures. He scarcely painted the sea.

I found to my dismay that Gustave Courbet's small sea pictures were done from

photographs. I had imagined his solid corpulence standing on the shoreline, like the older McTaggart in Scotland, with a rock hung from his easel, painting in the teeth of a gale. Wonnacott's beach has all the fright of a Pinter play about an English seaside holiday, with rain. He admires Lucian Freud's expanses of White lead flesh, and treats the dank shine of mud-banks with as much attention as Freud gives to the itchy veins, expansive buttocks, thighs, and hairy corners of post-natal bodies. They both try to tell it true, and believe that this is obtainable close to appearances – the "verisimilitude" Michael Andrews spoke of.

The pattern of the iron railings on Brighton Pier made watery whorls of light. The girl wore the shine like a flower. Chalk cliffs are in the distance.

Brighton, 1989

Whether this magnificent dark wave is painted over black, I do not know. These small pictures are often painted on dark grounds. When using a palette-knife, dip the paint into medium, then it will flow. Thick paint can have a nasty tightness if used straight out of the tube.

Gustave Courbet, *The Wave*, 1869

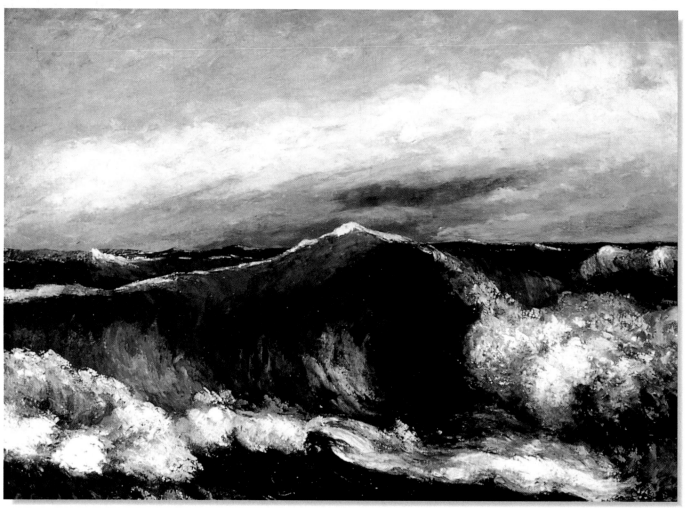

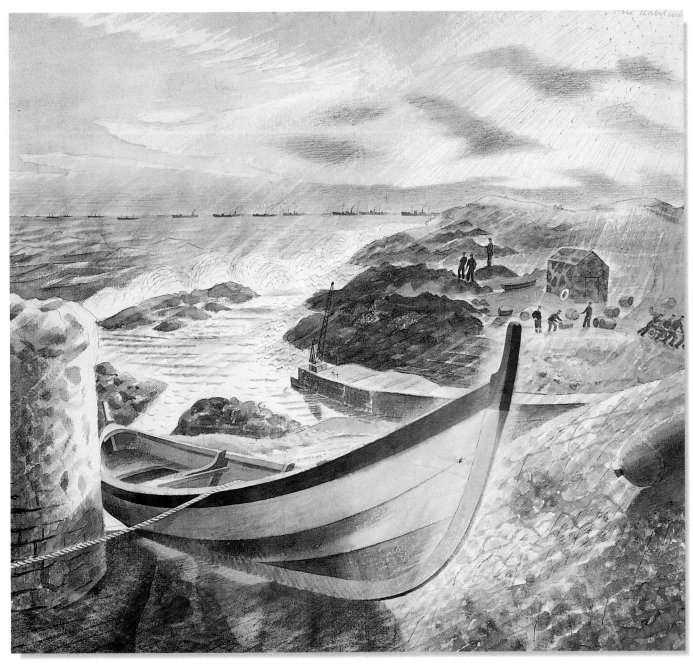

Ravilious was the clearest watercolourist ever. Water painting of water and light has always succeeded in Britain – land of the damp weather forecast. On humid days there is a chance of working wet-in-wet for longer. Ravilious knew the value of clear white paper. He scratches and uses masking fluid where useful.

Eric Ravilious, *Storm*, c. 1940–41

The Pre-Raphaelites painted their sharp colours into a White lead priming before it had dried.

Paul Gildea is a young painter who paints people (often actors) who take up extreme positions at his request in his compositions. They are brushed in fast on wet, white canvas. Gildea paints only while the subject is in front of him. Try painting into a stiff ground of wet Lead white with a soft long-haired bristle brush. Wipe the brush between brush strokes.

On beaches, the closer arcs are to straight lines, the bigger the expanse – especially if they curve outwards from the middle. The large number of notice-boards show fears of all kinds.

John Wonnacott, *Chalkwell Beach, Floodwater Overflow, Late Afternoon*, 1989–92

Rainbows

A RAINBOW WAS A PROMISE TO NOAH that there would be no more world floods. William Turner, John Constable, and Rubens painted fine rainbows. They are so exciting against dark skies that the tendency is to make them more colourful than they appear. If you place a prism in sunlight, you will see all the hues that are visible to the human eye. The bulk of the light is yellow-green. The hues are in harmony. Some are darker than others. If the natural overall tone is changed (as when a pale blue is placed against a deep orange) discords can occur. Colours of equal tone often enhance one another.

A rainbow in
a fountain

The fountains in Hyde Park in London did not make good rainbows, except when the wind shook them. They were red on the outside and violet on the inside. William Blake moved through the colours of the spectrum as he watercoloured his illustrations to Dante. Many great artists keep to a part of the spectrum-sequence of colours in building forms. Chagall used them particularly brightly, André Lhôte diagrammed the way Cézanne moved through the warm part of the spectrum to the cool blue (a blue that Cézanne said gave air to his pictures). Lhôte showed that you could move through the sequence orange-red-violet-blue (or by way of orange-yellow-green-turquoise-blue), which is more like moving around a colour circle than across a spectrum. But colour can build wonderfully.

The further away the spots are from the eye, the greyer the effect. Close to the eye, the blue is blue and the yellow is yellow.

The human eye can distinguish an enormous number of tints. The stained glass at Chartres is wonderful. They probably used only a few colours, but it is lit from behind. Crayons can be more various. Here are about 78 hues of the 120 the manufacturers sell. (They include silver and gold.) This is only a tiny fraction of the thousands of tints used in Gobelin tapestries at the turn of the century.

Rainbow,
1989–90

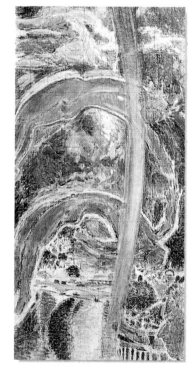

*Crayon
Spots*

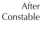

A double rainbow. This is puzzling – its colours are reversed, and it is shown against a light part of the sky. But as Constable was a master of sky painting, it must have happened.

After
Constable

Rain, Bowed, Thames, 1989–90

A nocturnal wake in rainbow colours. Aitchison used some of the darkest parts of the spectrum for the deep night, as his beloved Bedlington terrier ascended towards the golden ray from heaven. The waning moon illumines the yellow and green birds below the bright star. The tree yearns sadly from pink to blue. I have an irrational feeling night should have its rainbows.

Craigie Aitchison, *Wayney Going to Heaven*, 1986

Dive

ANCIENTLY, THE ELEMENTS ARE EARTH, AIR, FIRE, AND WATER. The setting sun, refracted in a polluted atmosphere, I thought of as "Fire". Thames mud could be "Earth". "Air" might choke an asthmatic. There is no swimming in the Thames: the "Water" would poison a bather. The Thames is too much encroached by government buildings and business greed. Wandering close to the water, I considered the concept of lowering the Thames Barrier, and gently allowing the water to rise; the cellars gradually submerging; Hansard and other records pulping, as a few more acres of water wash among the buildings….

A London aping Venice? No! Both cities are fine as they are. So I plunge in paint, in imagination; and in imagination, the waters are pure as thought in purest dreams. The down sun allows the electric lights to take over, and the yellow disc-eyes of Big Ben stare – witnessing the spirit's dive, from "Air" to "Water".

Fill a brush with semi-transparent paint, made liquid with turpentine; and on a pale grey ground, smother areas with thin, backward-moving paint of an advancing hue. (Warm colours come forward, cool colours recede, by their nature; so you have to work at it.) Load with cool paint the portions that you must make come forward. In the past, impasto was usual for light, advancing areas such as clouds. In these defiant days, the artist may be excited to do the unexpected. Over thick crumbles of Flake or Cremnitz white ("Lead white"), flick flecks of colour so that they will combine to equal the sodium-lighted, iridescent glamour of the roseate evening sky, and the clanging clock of Parliament, reflected in "Water".

Made in painted metal, the body enters an undulating wave.

Neil Jeffries, *Diver*, 1992

"The Divers". A little brush, with long Kolinsky sable hair, is called a "Writer" if pointed, and a "Rigger", or "Liner", if the hairs do not come to a point. Dip one in a sign-writer's consistency of paint, and try painting the kind of fluctuating contours Léger was to use for the rest of his life. Each movement is taken to a firm connection, or conclusion, usually making a closed shape. Each part resembles a factory-made component, to be assembled for the construction of a building.

After Léger

"The House in the Trees". Léger tried to do a different kind of Cubism from Picasso or Braque. It was not easy – to understand Cézanne, to be excited by the new, and not paint like Picasso. Cubist paintings by Braque and Picasso are similar; they signed their pictures on the back. Picasso acknowledged Léger, but said: "He is not really one of us."

On primed canvas, with thin charcoal, mark straight lines. Where they do not meet other lines, they will lie on the surface. Arcs will evoke volumes; but they will also lie on the surface.

Fix it. Then, with a soft brush, and a thin mixture of turpentine, black, and a little white, turn the surface pale grey. Then dab with red, blue, and green, until the surface is as substantial as you wish. This is an enjoyable exercise in the application of colours, and for watching them lie cleanly; and for considering how such an open style of painting was completely different from all of Léger's tightly closed manners after he returned from being a soldier.

After Léger

Diving Figures, the Thames, and a Bed of Roses

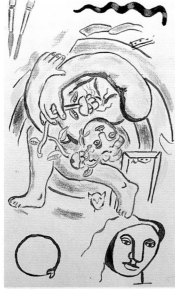

Undulate a Léger movement, slow as a slug, or bumptious as a Niki de Saint Phalle.

After Léger

Make a snake the Léger way, without lifting the brush, until the snake eats its tail. Now that the paint is flowing, move the liquid around a mask and watch it humanize.

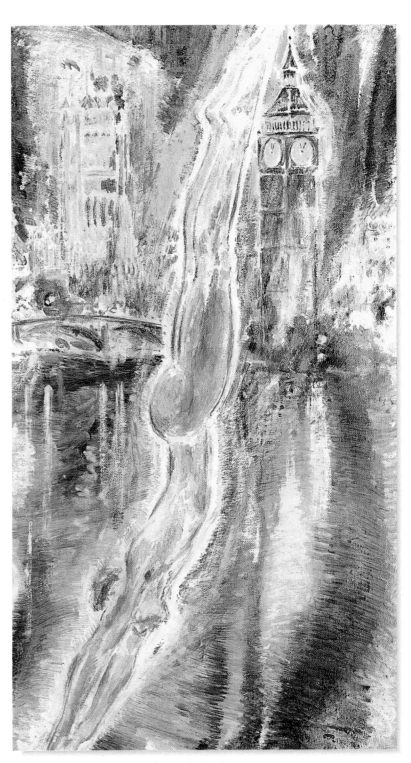

Paint for yourself a pure spirit, close to the harsh House of Politics. Use your own means, and make it hurt!

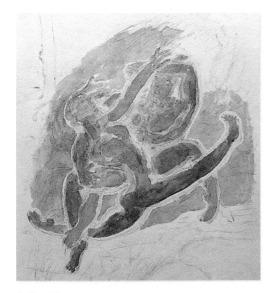

Falling Figures

A diver near Tower Bridge

After Chagall

A Royal Pond

THE LAKE IN ST. JAMES' PARK lies between the Thames and Buckingham Palace. In the summer it supports a mass of wildfowl, which feed on soggy bread. Painters need not go voyaging. Cockneys or visitors can begin their pictures here. This little lake is at the centre of the world. It is the cosmopolitan pond. It sifts history like a pelican's beak. It is the essence of dust, bubbly green with fountain spray. There is more tame wildlife here than anywhere I know. Pigeons, black swans, ducks, sparrows, geese, and pelicans. It is a good place to take a little canvas. If you take it in a plastic bag, you will not be without models, since every bird and squirrel knows every rustle of every bag in the park. All around are old clubs. Members lie in quiet rooms, to the sound of geese and Pall Mall.

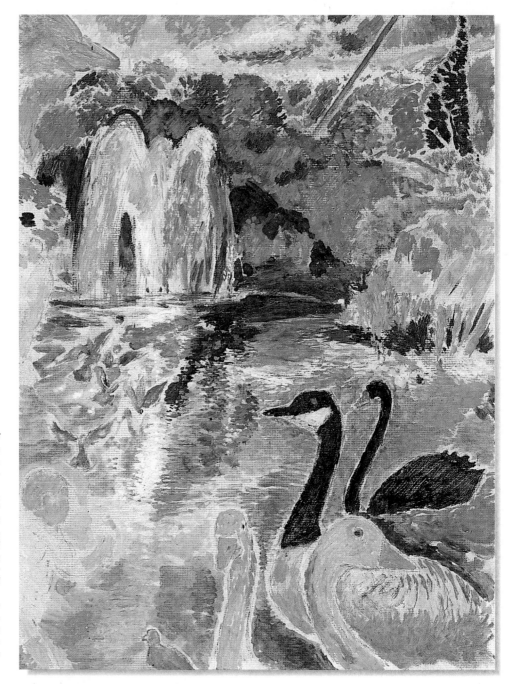

To the left of my picture, a cloud of pigeons. The fountain fails to move. The up-movement is opposed by the down-movement. I am driven to scratch. Beak-shapes are holding the design together. The crane is boring, the foliage is boring. Corot could use this "usual" green. Shall I blacken some yellow? If I had drawn the red beak of the black swan well enough, I could have painted it large…. On palest buff, try pencilling in, or marking with a tiny brush, every flicker and sparkle, goose eye, and feather, or part of a feather: rachis, barbule, barb, and vane. What I mean is, do not leave anything out which interests you. Be prepared to get in a muddle. Unless memory treats you badly, remember to remember the colour of every item.

Pen marks are fast, and pastel pencils suggest colour. Spray with odourless fixative if indoors.

A slightly more descriptive watercolour of the birds. Two of them had blue beaks. The dark shadow at the top moves them along. A hard, sharp pencil drawing on hot-pressed paper can be touched with colour from memory.

Water birds and ripples. Use a pencil and a small watercolour brush. Remember to memorize the colours and illuminate at leisure.

William Nicholson, *Two Black Swans On A Bank At Chartwell*, 1934

William Nicholson made pictures with a natural feeling for paint. He maintained a careful balance between subject and gesture. He painted brushy swans, and used the wrong end of a brush to scratch in twigs and necks. William was always painting different subjects, and they link his paintings, in my mind, with the poems of Thomas Hardy. Both Ben and his father achieved silvery harmonies.

Ben Nicholson liked to give his pictures an up-to-date appearance. The way at the time was to show off technique, and prove by a lot of scratching how wonderful a surface could be. Only occasionally was it necessary for him to depart from the simplest of subjects. Cornwall as a jug, or Switzerland as sanded hardboard! I decided a piece of a jug would become a swan's neck. Matisse talked frequently of the arabesque, the decorative beauty of swelling female throats and ogee rhythms.

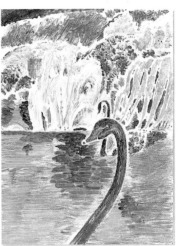

Whites link the beak, fountain, and distant clouds. It is painted over grey.

Swans' necks are mysterious. Old depictions of sea-monsters had curvaceous necks. Pencil in the swoop. If you find the bird's neck sags a little, as if a taxidermist had failed to keep it smooth, take no notice. It is in his nature. Make it as smooth as the etching by Matisse. Later, when convenient, brush it as feathery as you wish, with black against black feathery wavelets on Cobalt green. White, lemon, and Cobalt green flow as foliage to the sky. A sky of Cobalt blue plumage: the sky, as a majestic blue bird whose neck enters the lake by way of the fountain.

Aim to be painting intuitively. Feel you are in there with the swans, and become each thing as you paint it. Undulate the paint as naturally as it comes. Think of a beak-like brush stroke extending as a swan's beak, the eye follows a neck, which is pursued by the body, which is trailed by wing tips, a tail, and a wake of foam.

Pigeons and Peacocks

S T. MARK'S SQUARE IN VENICE is full of fluttering pigeons. London's
Trafalgar Square is grey with them – lusting, eating, grooming,
sleeping. Many people enjoy filling the birds with bread. Cockney
pigeons are grey as dusty roofs. Try and watercolour-sketch a pigeon.
You must be fast. First, mark the white heart-shape above the beak – it
is the only part you can be sure of. The rest is a flurry. At first, its body
is small; then, if it is a male, it puffs its feathers to be large, then
deflates instantly if it sees no chance of satisfaction. The patrolling is
faster than it seems. Fanciers breed exotic birds. The wood-pigeon
with its white collar and pale pink-over-grey is obviously beautiful,
but then with feathery legs like ballerinas in fluffy trousers, comical and
witty as close-clipped poodles, the dull taxi-dodging bird is common,
and it is good to paint what is close to us. The pattern of feathers
seems infinitely various. Try and get a feeling for the rhythm of the
overlapping shapes, or you will never be believed. Even if your mind
is full of the painted paradise-wings of the Italian Renaissance, an
encounter with a peacock is always surprising.

*A Cycladic Greek dove is as
Brancusi-smooth as feathers.*

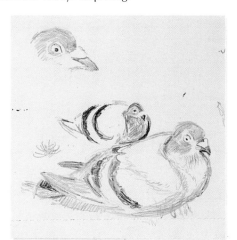

*A pencil used on
smooth paper is the
swiftest way to
secure information
about birds.*

*The carmine-footed pigeons scatter water
at the edge of the lake. Their feathers
dishevelled, they are silhouetted
against the clouds and a setting sun.*

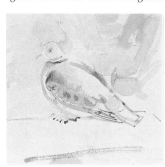

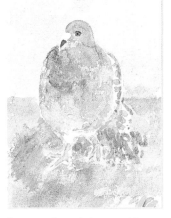

Daniel Miller, *Pigeon*, 1994

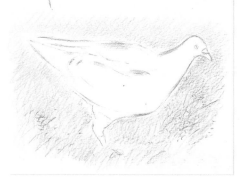

An elegant pigeon, in pencil and crayon

*A watercoloured pigeon, with
green-grey and pink-grey plumage*

A feather. Draw it for a practice in refinement.

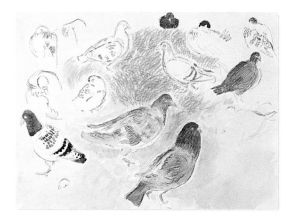

After Picasso

After Picasso

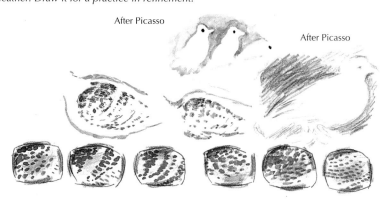

Pigeons resting, preening, and displaying

Some patterns make more convincing pigeons than others. The intuition must decide.

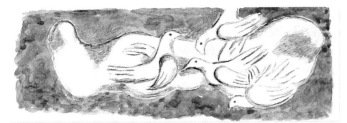

Pigeons and a cloud After Léger

A girl, a boy, and a pigeon. Cover the pigeon with a thumb, and the figures almost cease to exist. A pigeon is often a lead-in for adjacent subject matter.

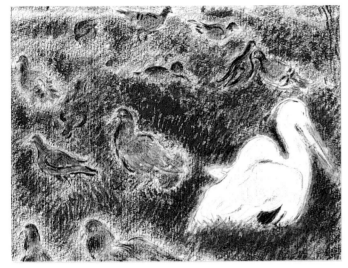

A pelican dozes among the pigeons at St. James' Park. Use crayon on rough paper until the only area of white paper left is a pelican.

Peacocks

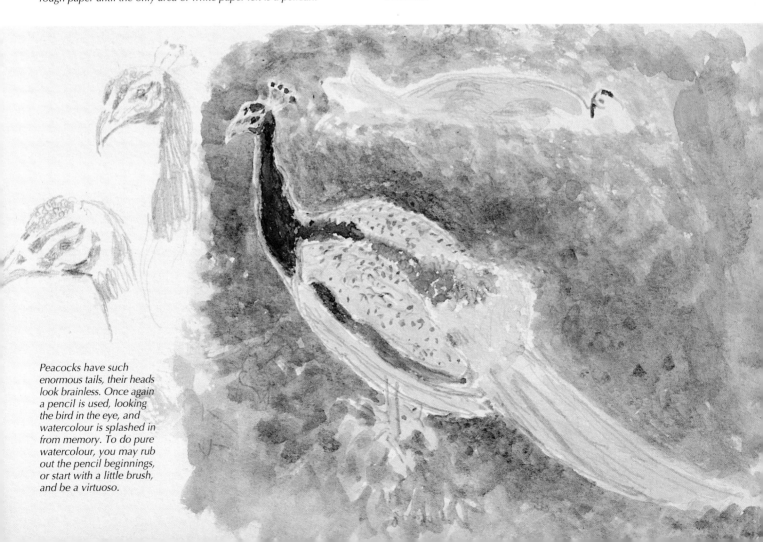

Peacocks have such enormous tails, their heads look brainless. Once again a pencil is used, looking the bird in the eye, and watercolour is splashed in from memory. To do pure watercolour, you may rub out the pencil beginnings, or start with a little brush, and be a virtuoso.

City Splendours

Turner and the early Chinese painters steamed up the finest mists. Dickens wrote of the worst fogs, and of corpses floating in the Thames. T.S. Eliot made poetry out of "the yellow fog that rubs its back against the window panes". The Thames keeps mud moist, and reflects magnificent sunsets above Chelsea Reach. Whistler painted the nocturnal Thames softly absorbing fireworks. If you paint wet-into-wet with Lead white, with a light touch, it is not difficult to set off fireworks. To paint mist, squeeze the tones together as things get further away. Distance is achieved in the same way and is called "aerial perspective" (or "tone values"). Only sensitive artists are able to keep control. Seurat, because of the perfection of his design, could work close to white.

As the sun goes down over London's Primrose Hill, the fiery fairy lights glow;

Mud and mist near Vauxhall Bridge

historical, homely, and ghosted by so many admirable painters who would have walked up to the highest point, to see the domes and chimneys of the "great wen" emerging from the coal-fired fog with all the beauties of pollution. Turner, and later the Camden Town painters – among them Harold Gilman, Charles Ginner, Walter Sickert, and Spencer Gore – condensed the city to crimson and gold. The attachment Frank Auerbach may feel to Primrose Hill is for its centrality. London extends far in every direction. Lawrence Gowing said it felt as if every breath had already been breathed a hundred times.

Some deep-coloured paintings by Matthew Smith were done in Cornwall. Howard Hodgkin's brushings are as broad as those of Ivon Hitchens; his mergings intoxicate with voluptuous memories, and past epiphanies in Venice, India, and other faraway places.

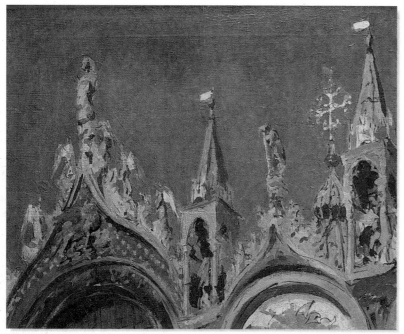

The gold is made to shine in the rich blue of the sky. The ogee-arching rhythms counterchange through the picture.

Walter Sickert, *St. Mark's, Venice*, 1896–97

In the first of the trials that have become so effective in giving publicity to good and bad artists, Whistler received a farthing damages for not doing what Ruskin said he did.

After Whistler

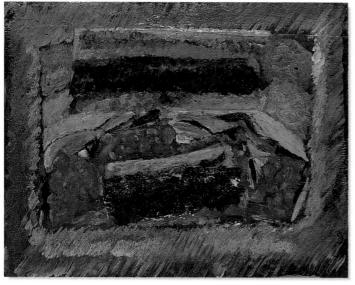

Hodgkin's pictures depend to some extent on the close appreciation of the applied seductive caresses of paint. To reproduce them is an affront. To copy is an abuse of their bodies. It amused me to see what ravishing accident might occur on a wooden panel, with a Hodgkin in mind.

Slightly after Hodgkin

The streetlight gives out pure yellow, which knocks out all other colours. It gives a harsh atmosphere to the unloved suburbs, where the past is often no more to be seen.

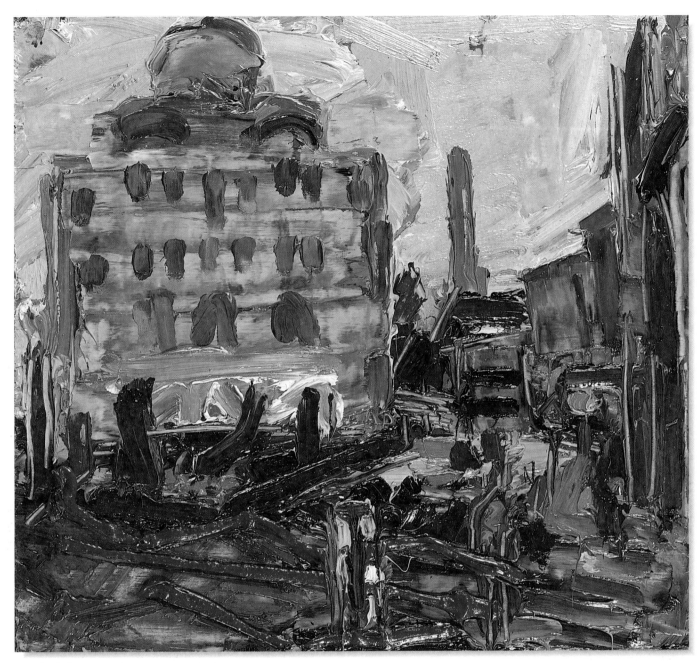

"London belongs to me", went the popular music-hall song of Sickert's theatre world. Mauled, scraped, daubed, knifed, and smeared – a falling empire of crimson memories in the light of the falling sun. Auerbach always takes his paintings to the edge. Here lies the intimate oily argument of painting today.

Frank Auerbach, *The Camden Theatre*, 1976

Leap through the waterfall, brave the rainbow shape. But the golden silk takes centuries to darken.

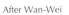
After Wan-Wei

Paint the Thames

THE SUN OVER THE THAMES flashes reflections from its waters at every twist of its snaking way. If your art does not demand vastness, vistas, seas, or mountains, you can find in London views that resemble almost anywhere in the world. Those British who eat fine food in Italy sacrifice an "eel-and-pie" indigenous visual language. The robust smut of Hogarth's "Shrimp Girl" cannot survive too long away from its source.

Sometimes, the water is so low near the Tate Gallery, you can walk on the little islands of mud and junk close to the middle of the river. You can stand on the pasty clay of London's past, to draw the view through the spans of the bridges. After being a mud-lark, climb to the top of Tower Bridge and draw the river from the glass walkway, looking up or down river. Upriver, see the bridges, and many of the sights of London. Draw with that special sort of drawing found useful to painters: the chalky-charcoal-dusty-crayon-black-pencil-Titian-Bonnard-Sickerty kind of drawing, which confuses dashes and thumb marks. Add your personal abbreviated colour notes: "Raw umber and skim-milk" for the Thames, or "bath water after washing the dog". At home, coat the drawing with acrylic medium, or shellac, and dab it with some paint.

Each time you paint something from your memory, you will determine to memorize more thoroughly for the future. It is necessary to concentrate and to keep an open mind. Looking at the river, you missed seeing the geese fly by. Captivated by the tug, you did not care that the wasp on the glass was the same stinging yellow.

Big Ben at night. It is convenient to draw on the thinnest plywood and paint it the next day in oil.

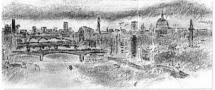

The bridges looking up the river from Tower Bridge. Neatness is not required.

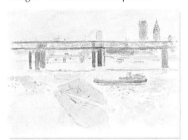

Hungerford Bridge

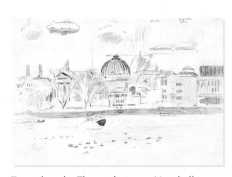

To explore the Thames between Vauxhall Bridge and Tower Bridge could take a lifetime. A pencil drawing is a quick, always available means of meeting a subject for the first time.

A youth, posed high, overlooking Somerset House from the Queen Elizabeth Hall. The roof was without shade and very hot.

Hungerford Bridge

Hungerford Bridge

St. Paul's Cathedral from Hungerford Bridge

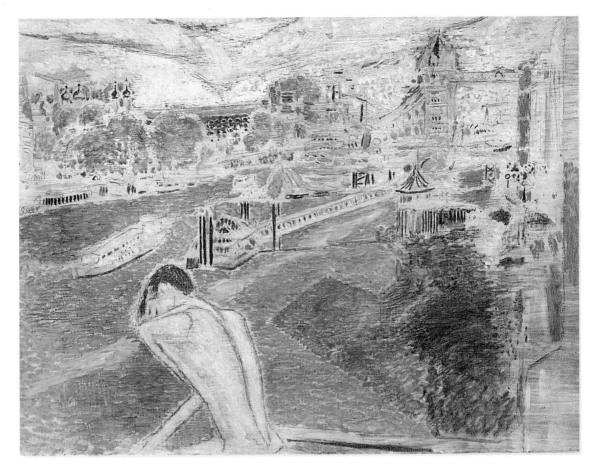

From London Bridge the view looking towards the Tower of London is complex as a lock. It is built around the unclad youth. In other directions are St. Paul's, Cannon Street Station, and Southwark Cathedral.

A squared-up drawing of the view from the glassed-in walkway of Tower Bridge. Across London Bridge, the office workers of the City run to catch their trains. Depict them any day after tea at a pose-run for you, umbrella and briefcase in hand.

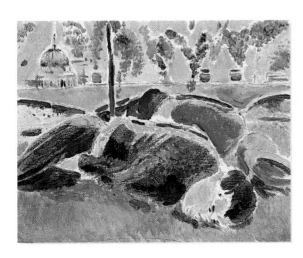

St. Paul's with sleeper

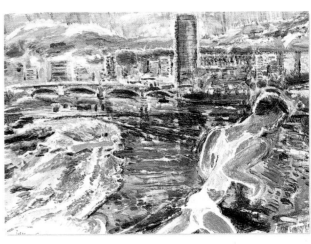

Joggers on Westminster Bridge

129

Nocturnal Sparkles

TOWER BRIDGE CAN BE SEEN under Cannon Street railway bridge. The river glitters in glancing stripes. It is not far from "The Clink". Watercolour it, unless it is too dark to see. Often, if you paint in the dark, and you know where the colours are that you used in daylight, you will find only a little adjustment is needed next day. When it is too difficult to paint, mark circles for lights, and if you have a repertoire of signs for everything, and write in the colours, you will find it possible to paint the dreamy river with its staccato lights. Another way is to draw with conté crayon on rough-textured paper, as Seurat did.

When painting a dark picture, underpaint with a paler than half-tone warm grey (not too fat) and paint on it with brushfuls of darker medium-rich colour. The Matthew Smith way of painting, with jammy, dark, transparent colours, with no white. Alla prima, was a success for him, but is liable to bleeding and cracking. (Fortunately, Smith did not need to repaint.)

From Bermondsey. I kept the big contrasts to the edges of forms. The tiny silver glitter seemed – along with the heat of the sky – to express the flagrant urgency of the city. *The Sights of London, 1985*

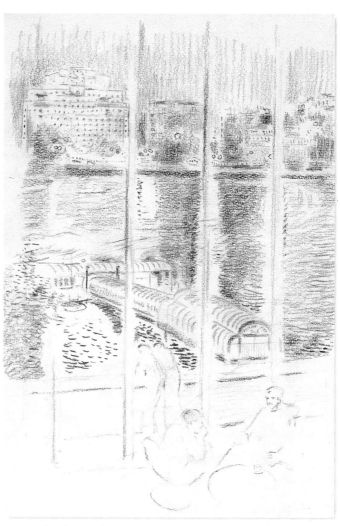

From within the Royal Festival Hall. Long, vertical windows are crossed by the river and Embankment. The pier moves at an angle. Using a pencil is the most convenient way to assemble the complicated flickers of the river at dusk. While the fading light allows a lot to be seen. Lights are continually being switched. The middle dusk is the colourful time.

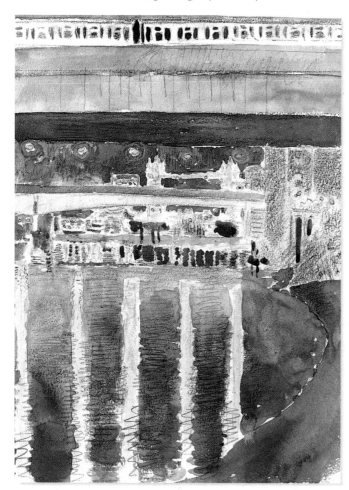

Three bridges. London Bridge is in the middle. (Munch liked painting reflections of the sun or moon as golden columns in the water.) When a boat goes by, the vertical tranquillity will shatter into a diagonal wildness.

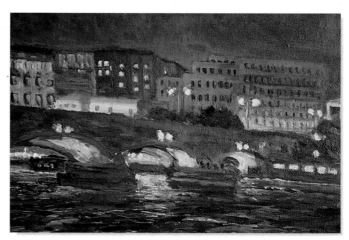

If the main forms are drawn at dusk, the positions of the brighter lights can be recorded when they are switched on later. The arches of Waterloo Bridge have their own illumination. This causes a surprise lightening at the centre of the picture. Victor Willis, *Waterloo Bridge, 1995*

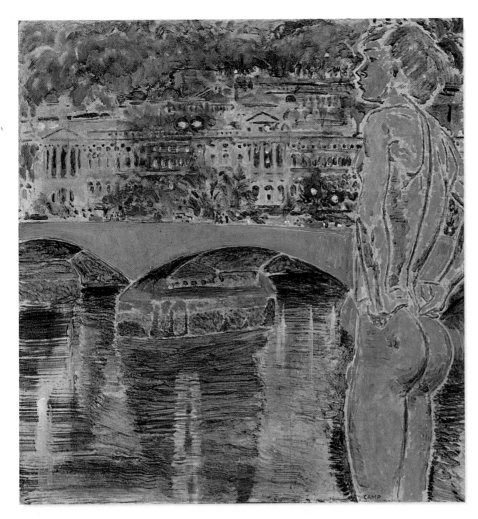

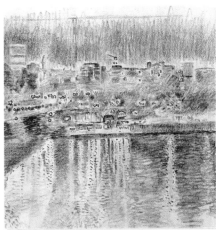

Hungerford Bridge at Charing Cross. Circles and points show where the lights are. While darkness can be evolved by overlapping layers of transparent paint, it is useful to keep in mind some opaque mixtures for elimination. Mars black with Titanium white, for example, will obliterate most things. Some other combinations for density are: Cobalt blue with Caput mortuum, Chromium oxide green, and Mars black.

The horizontals of the buildings, the Embankment, the ripples, and the vertical reflections make a calm setting for the naked figure, who looks towards Somerset House. Close tones make a twilight. I tried to make a pale nocturne.

Moonrise Over Somerset House, 1987

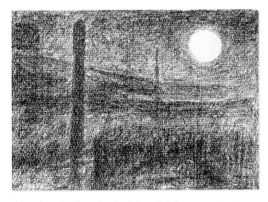

"Courbevoie Factories by Moonlight". After Seurat
The paper gives you the sparkle.
Conté crayon (soft grade, then fix) with
Michallet paper or Ingres paper,
which also has ribs.

A girl sleeps, and the trawler passes in the blackness. This painting is close to the limit of darkness, for a design to work. There have been darker pictures, even pure black pictures. Ad Reinhardt has painted blues against blacks, which are so dark it is difficult to distinguish them. To sleep is to die a little. The night, full of strangeness goes on without us. Ships pass in the night. It is often rewarding to paint night pictures, it is easy to hide areas of little interest in gloom and (thinking of Rembrandt) to bring up important parts as impasto.

PARTS OF THE BODY

Births and Stories

PICTURES ARE LIKE CHOSEN FRIENDS. Wherever you are in the world, you are in known company. Although it is good to see pictures in the countries where they were painted, it is also wonderful to see Brueghel in Vienna. Scribble a copy of

Rembrandt's "A Woman Bathing" (now in London). It is of Hendrickje Stoffels; she bore him a daughter in 1654, the year this picture was painted. A Rembrandt looks at home in London. A Matisse painting sends the viewer seeking Mediterranean warmth.

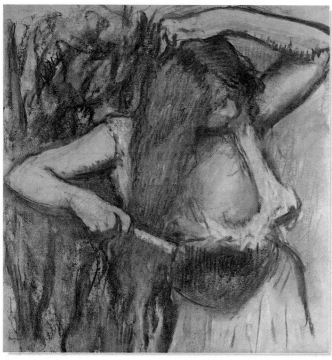

I wonder how much Degas thought about Rembrandt. Here, he enjoyed the brandish and "déshabillé". See the brave thrust for the nose, and the marks on the arm, like staples to join it to the background.

Edgar Degas, *A Woman Combing Her Hair*, 1904–05

My own self-portrait and a chalk copy of Sickert's late self-portrait "The Servant Of Abraham", which was such an inspiration to the painters at the Beaux Arts Gallery – before Helen Lessore was obliged to sell it to the Tate Gallery.

After Sickert

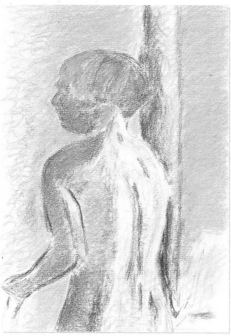

A hesitant pose. The crayons make the plumpnesses by means of hollowing marks. Rembrandt models with impasto.

After Bonnard

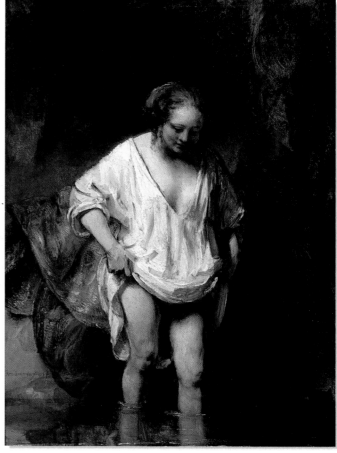

Rembrandt, *A Woman Bathing*, 1654

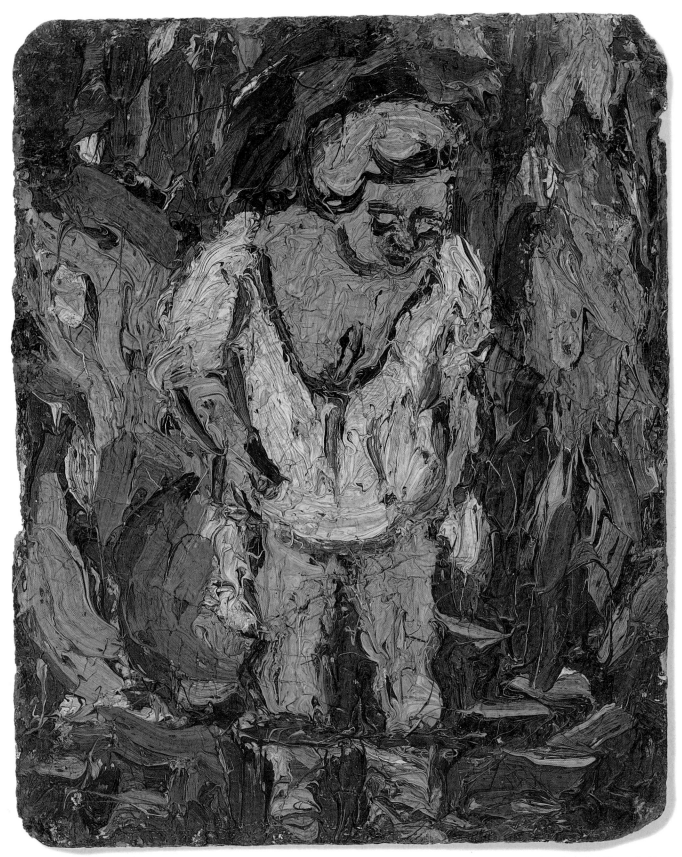

Kossoff lives in the paint until it is all his own picture – hollowing, realizing, impasting – with passion, because he admires Rembrandt so much.

The Rembrandt was cleaned until the wood showed, using solvents. I feel that with microchip control there will, in the future, be dry ways of removing dirt, and only dirt, from pictures, and that liquids penetrate too deeply.

Leon Kossoff, *A Woman Bathing*
(*Study after Rembrandt*), 1982

Body Cuts and Paul Klee

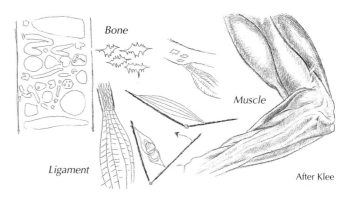

Bone

Muscle

Ligament

After Klee

Paul Klee, at 23, was a paragon student. He wrote in his diary that he would continue to study anatomy with medical students – "More as a means than an end". He dissected cadavers from 8.30 a.m. till 10.30 a.m. and attended a life class at night. Klee's anatomy studies involved taking the body to pieces. In composing a picture he often seems to be putting it together again piece by piece. Klee's youthful anatomy drawing is hatched in the same direction as those of left-handed Leonardo da Vinci. Some lines follow the muscle fibres. In Edinburgh College of Art, the muscles were drawn on a living model with charcoal. I had learned the bones and the origins and insertions of the muscles at Lowestoft Art School from a skeleton and a book. More recently, I became interested in books of photographs of dissections, but found them too difficult to draw from. The Greek sculptor Praxiteles would have thought little of Arnold Schwarzenegger, the hero of the film "Pumping Iron", who proudly believed he was building his body harmoniously, muscle by muscle. His face did not fit his thighs.

Pablo Picasso said: "I want to say the nude, I don't want to do a nude as a nude. I want only to say breast, say foot, say hand or belly. I don't want to paint the nude from head to foot…to find the way to say it, that's enough."

The little diagram above is the body in pieces. Sculptors since Rodin seem to be able to accept dismembered bodies, legless, headless, armless, never breastless. Mediaeval reliquaries were sometimes in the form of arms and hands.

Muscled figure

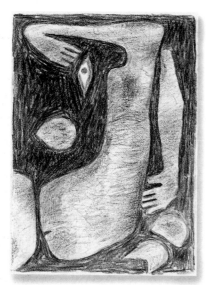

After Picasso

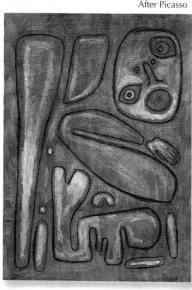

After Klee

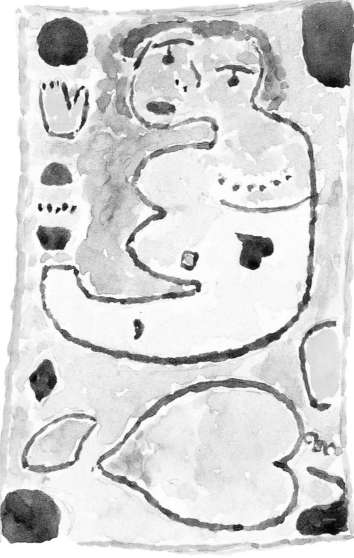

"Outburst of Fear"

After Klee

Dissecting the right knee

After Eakins

Claude Rogers, *Nude*, 1960s

Paint a canvas thinly with flesh colour, a mixture of Permanent rose, lemon, and Raw umber over white – do not use artificial limb paint or Flesh pink. Flesh pink is the nastiest colour ever invented. Dab in without lines all the parts of the body as you think of them. Dab with childlike thrusts, not artistically but to make a piece of body. Sometimes strange things happen, a nipple becomes a rose, a pelvis becomes a lobster. The whole canvas surface changes to a body or a face, then the belly and navel are an apple – Chagall and Gorky could be extravagant.
Continue to dab-report all the sags and plumpnesses and unnamed pieces, even dimples, freckles, scars, and pores – leave nothing out a painter's imagination can encompass.

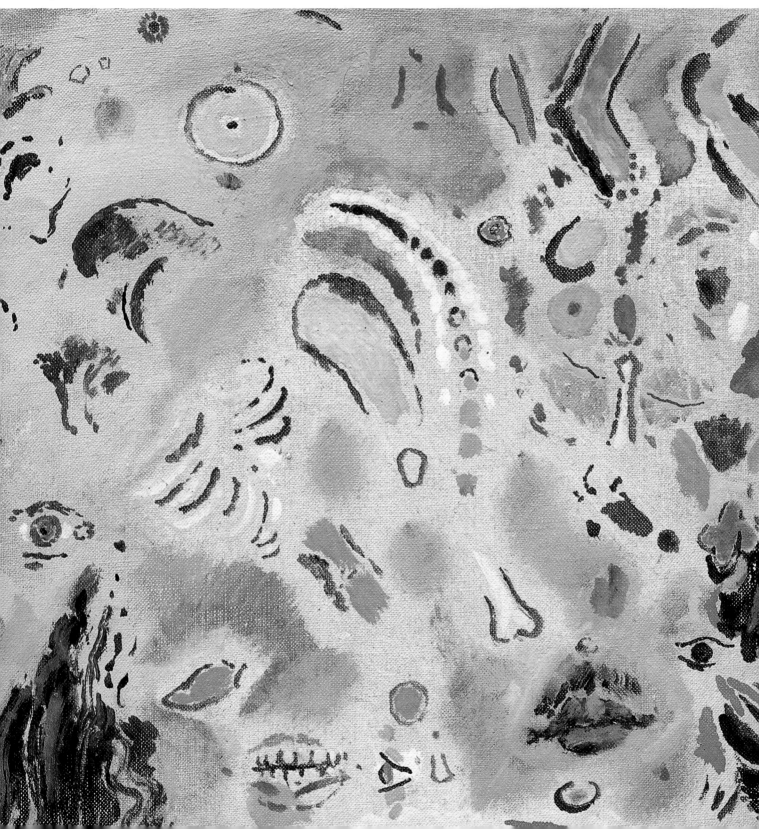

Life

MY EDITOR, TIMOTHY HYMAN, who is younger than I am, kindly tries to protect me from being labelled a fogey whenever I write positively about life rooms, but I battle on because this is the first period for hundreds of years that has tried to manage without them. There were private schools of drawing, and academies, in Italy by the 16th century. Giambattista Tiepolo did a drawing of one (which might have been Lazzarini's Academy). The students were depicted sitting around a nude model. There is also a Rembrandt drawing of a similar arrangement. I suspect that great masters, even as early as Giotto, might have seen to it that their apprentices drew from each other.

In Hyman's time, the Slade school had an Indian summer of "Life": Coldstream's measuring "Life", Auerbach's luscious, thick "Life", Michael Andrews' making-up-your-mind "Life", Claude Rogers' secure "Life", my "Life", and even other "Life". Because students came to believe that their futures depended on their producing personal pictures for fame, self-fulfilment, the market, and their final graduation

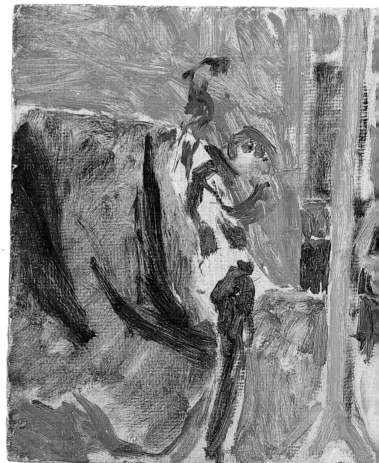

exhibition, some of the life rooms became empty. The rich, old, and famous Matisse could send round to his local film studios for six beautiful girls to model for him. For others less fortunate, there is the life room, where a human being will lie still for you, for as long as you wish, while you endeavour to find a wondrous shape that will do justice to a unique mouth and allow you to move a brushing of golden watercolour towards a round belly. Such rooms were – once upon a time, and only occasionally – quiet retreats for strong contemplation. Matisse spoke of the almost religious feeling he had when painting from the model.

What are the alternatives? Mouths are everywhere. Those of relatives and friends are available, but sometimes they refuse to be still. You have to give them drinks and nuts, and they have appointments. Very few will stand naked with arms strung to the ceiling for you.

You can hang a plumb-line in a life room, but you do not have to use it. The models link students with the common existence in the world outside. Many were memorable. Miss Deladier's big toe; graceful old Mancini, of a famous family of Italian

After Clemente

Mouths, eyes, nostrils, and ears show little heads looking out. Whatever use Clemente might once have had for life rooms, he is unlikely to use one now.

Watercoloured lips

After Léger

Lips that hardly needed a life class

After Léger

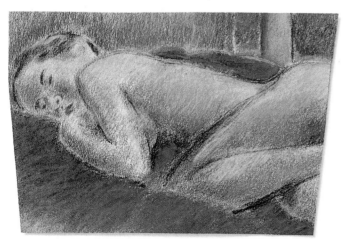

A model resting. Often the best poses are in the breaks.

This was painted in a life class at Chelsea School of Art. Two models are posing, and one student seems to have little on.

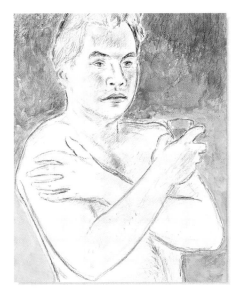

Andrew, a friend, posing, warmed by wine.

Bonnat's studio in the Ecole des Beaux Arts. There are between 30 and 40 students visible. These Parisian life classes were for the acquisition of skills, not for gentle inspiration. If you were a long way from the model, you were not very advanced in the art world.

▶ Italian models (he would have hairy sweets in his dressing-gown for the students); the beautiful Renoir-shaped girl who had a back street abortion, and died. Actors "resting", jugglers resting, black, undulant pregnant girls. A young mother looking after her baby. A very fat girl with opalescent thighs. Girls so beautiful no boys could deserve them. And they all had mouths.

Gleyre said to Monet, "Here you have a dumpy little man with big feet, so you have given him big feet! It's very ugly, that sort of thing! Instead, you should always have the Antique in mind!" Well, Gleyre is obviously one teacher we would not listen to today. But to be fair, if a student at Julian's did not wish to be corrected, he was allowed to turn his canvas to face the wall.

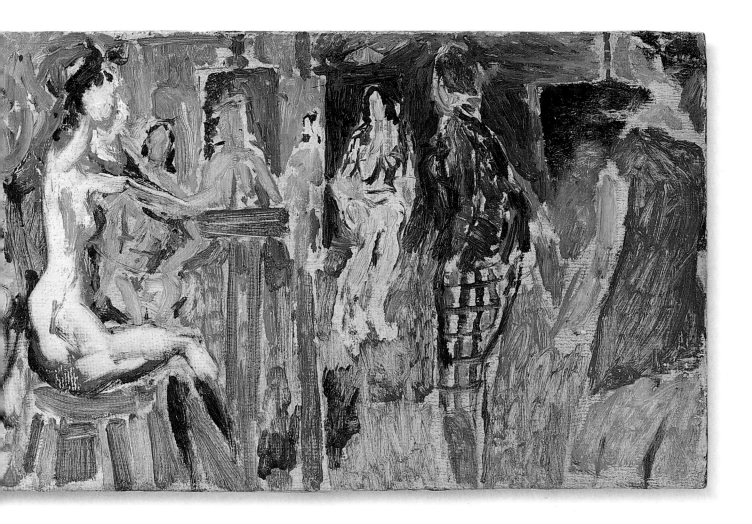

Eakins' Academy

MATISSE, EAKINS, BALTHUS, AND DEGAS could paint from the model wonderfully well. Thomas Eakins studied at the Pennsylvania Academy of Fine Art in Philadelphia, and then at the Ecole des Beaux-Arts in Paris, where he was taught by Jean Léon Gérôme. He then returned to Pennsylvania. Eakins was a brilliant teacher. He visited twice weekly for short periods, as Gérôme had done. He thought young men better at drawing than young women, but that women should be given an equal chance, and taught as seriously as those studying medicine. Eakins was against drawing antique plaster casts, which he considered was imitating imitations. Instead, the students were encouraged to work from life using a brush, which Eakins thought more powerful than a point or stump. Painting was to be done from the middle of forms, working outwards. Modelling in clay or wax helped to make figures substantial. Athletes, trapeze artists, cows, and horses were engaged as models. He had little interest in art history or aesthetics, but was keen on perspective, and the reflecting or refracting qualities of water. He constructed pictures seriously, slowly, and exactly. No painter knew more about how a rower's arm muscles moved, when sculling on wavelets (done strictly in perspective). Firm as a fortress, Eakins' brownish brushmarks

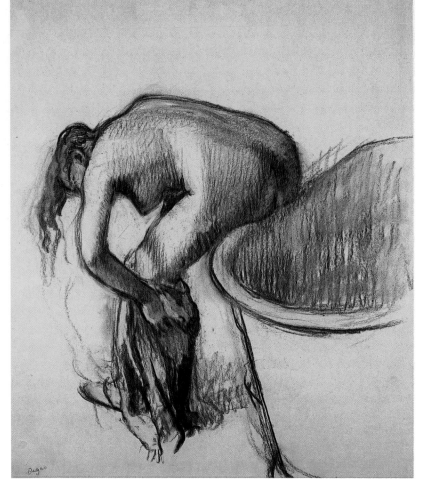

The ladies' clay modelling class at Pennsylvania Academy of Fine Arts. They are sculpting a cow. The cow did not have to wear a mask.

helped to build the best of the French tradition in America. Eakins' ideas were carried on by Anschutz, and I think Matisse would have agreed with the teaching; but not with the cloths and masks that the models were required to wear. Hypothetically, if the over-tasteful Clement Greenberg had been less powerful, if Edward Hopper had been better trained, then on the shoulders of Thomas Eakins, on the back of Degas, on the broad back of the biggest painting tradition ever, American painters would have shattered the world with greatness.

But be content. Nobody knows what might have been. When painters are killed in war, die young, are ill or poor, it affects the course of art more than such chances in other vocations. The spiritual starvation that has killed painting in past periods is close to us. If the painter lives in the wrong place and knows only the wrong people, there is little chance of learning this profound and sensitive language. There is one painter who suffered no such privations. Balthus' parents were artists, and knew Bonnard. Rilke helped him to see pictures, and Rodin's sculptures, and to love reading. He lived in Paris, travelled, and copied the art he liked and aspired to emulate. With his passionate temperament and long life, the scions of tradition could send out tendrils rare enough in our days. Sometimes, the life of art seems to hang by a thread.

After Eakins

An early life drawing, and a drawing from the antique

After Matisse

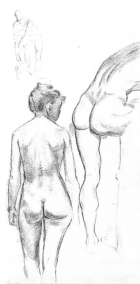

This charcoal drawing is of a very frequent position, which does not involve the complications of the face, and is as far removed from the syrupy salon decorum pose as Degas could get.

Edgar Degas, *Woman Drying Herself*, c. 1903

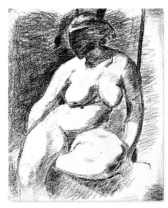

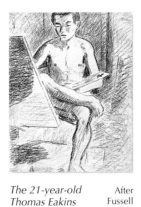

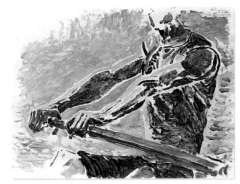

After Masaccio

A masked model shows the prudery of the time. Eakins' teaching of human anatomy caused his dismissal. After Eakins

The 21-year-old Thomas Eakins painting when naked. Eakins may have been painting Fussell at the same time. After Fussell

The satisfaction to be obtained watching sports is about muscles moving well. Here combined with art, the arms are muscled strongly like oars. After Eakins

A copy by Balthus of Masaccio After Balthus

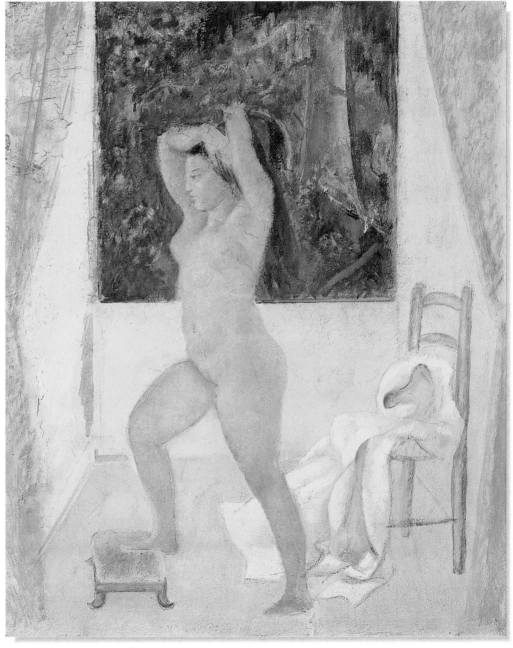

After Eakins

Robert Henri in the dissection room at the Pennsylvania Academy.

The model poses against a painting of a woodland scene.

Balthus, *La Toilette*, 1958

Folds of Life

What cosmic jest or anarch blunder
The human integral clove asunder
And shied the fractions through life's gate?

Herman Melville

After Mantegna

The cleavage folds
of peaches

SUMO WRESTLERS LOOK LIKE massive cells dividing. Through microscopes we can watch cells divide, and sense a resemblance in this unfolding to the shapes of larger forms. There is a kind of cleavage visible – in peaches, pectorals, buttocks, breasts, and in art. When it is good and simple, it may approach the divided spherical form.

The roundness of cells has been closely approached by the sculptors Arp, Barbara Hepworth, Henry Moore, Constantin Brancusi, Naum Gabo, and several Cornish pebbled coves. In Plato's *Symposium* a figure is described, as a perfect combination of male and female – the state to which men and women desire to return. To realize how words are less concrete than paint, try to paint such a combination. It has two spines; knee and knee; thigh and thigh; stomach and stomach; breast and chest; and kissing lips.

To paint the living figure, a feel for symmetry, cleavage, and balance is fundamental. Brush with subtlety, nuance by nuance, with eyes travelling down the body, and find temple balancing temple, cheek/cheek, eyebrow/eyebrow, eye/eye and so on. The central line of the body makes delicate balances visible – dimple by dimple, hairy patch by hairy patch. Even when canvases are abstract, a vertical division will not fail to suggest a man's erect spine. Mondrian, whose recreation was dancing, knew the level of his hips and the direction of his pumps.

A figure from
Plato's Symposium

Sumo
wrestlers

Dividing cells

Asymmetrical
figure dabs

After Brancusi

A row of sleepers in an
air-raid shelter.

It has two breasts, but
otherwise seems bisexual,
and asymmetrical enough to
be the figure suggested by
Plato's Symposium.

After
Moore

Dabs around
a figural
centre line

A round form

After Moore

One face looking in After Donatello
two directions

Cleavage and After Mantegna
equal wings

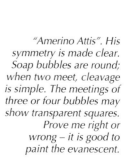

"Amerino Attis". His
symmetry is made clear.
Soap bubbles are round;
when two meet, cleavage
is simple. The meetings of
three or four bubbles may
show transparent squares.
Prove me right or
wrong – it is good to
paint the evanescent.

After Donatello

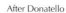

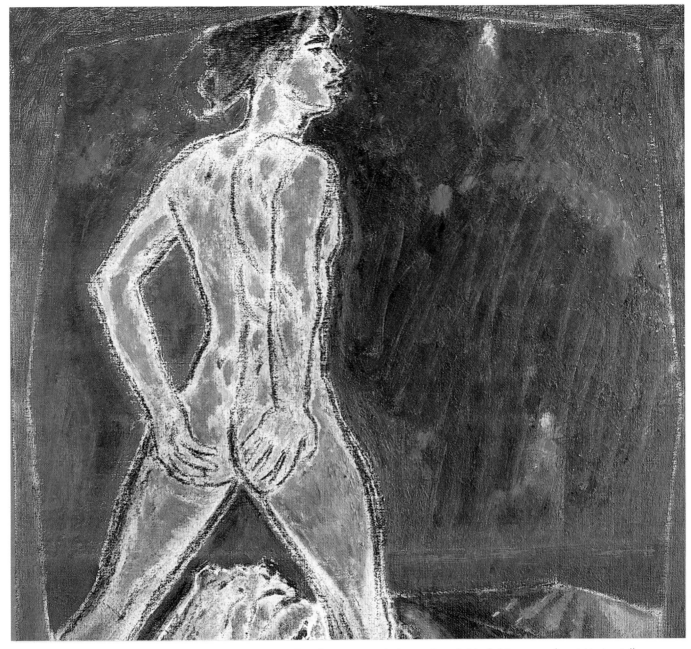

A figure with legs apart at Beachy Head. A three-quarter view of an almost symmetrical pose. An unfinished picture severely cut. Horizontally.

A drawing from a sketchbook. The vertical symmetry is plain in the pelvis. Only in the soft parts of the body (brain and abdomen) does the figure become substantially asymmetrical.

After van Gogh

By following a monograph on Mondrian, see how the complicated colours and shapes of landscape gave way to simpler balancings. For example, a pier made as a vertical was surrounded by crosses for waves. Later, as here, simpler elements were balanced obliquely.

After Mondrian

Profiles

THE PROFILE OF BATTISTA SFORZA cuts across the blue infinity of the sky like ivory. It links to points and measures innumerable. Try and see what moving a ruler around uncovers. Her husband, Federigo da Montefeltro, lost his eye and damaged his nose in a tournament. Piero, knowing that all parts of the Duke were valuable to God, carefully measured the moles and acne, and delicately touched them in. It seems as if there was good feeling and humour when they posed so exactly opposite each other, with these such disparate noses. Portraits in the 15th century were often in profile. Pisanello and Alberti made medals of profiles: they are formal, and require less information than three-quarter views. The piece above the lip and the piece between the eyebrows are hollows, so are invisible from the side. Profiles have to be invented.

After Piero della Francesca
Profile tracings of Battista Sforza. Sforza looks towards the Duke.

Rosie and Juliet, her mother, seem alike and closer in age than I expected. When Rosie laughed, the transformation was incredible; the resemblance to her mother instantaneously included the sparkle of her father. The media continually remind us of the DNA double-helix. We sense a necklace of genes making a family likeness. We feel it is important, like "begat" in the Bible. Ask some close relatives to pose for you, nose beside nose. William Coldstream painted both W.H. Auden and his mother as separate portraits. Auden's big, boy-like English face was to collapse, becoming drink-wrinkled. His mother certainly looked like him, in the form of an overused tent.

The temple is where the early photographers would ask their sitters to put a hand, so as to prevent movement. The angular furrow at the temple expresses the sort of thinking Rodin's "Thinker" does.

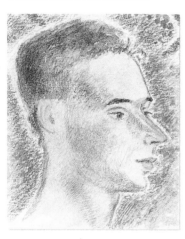

With two mirrors, do a sequence of self-portrait sketches: turning, watching the nose disappearing behind the cheek. Do the same, drawing someone else.

A three-quarter view. Full faces show more than profiles, but less than three-quarter views.

Laetitia in profile in an aeroplane

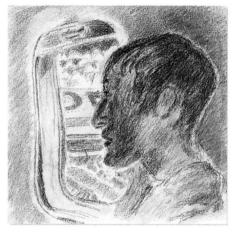

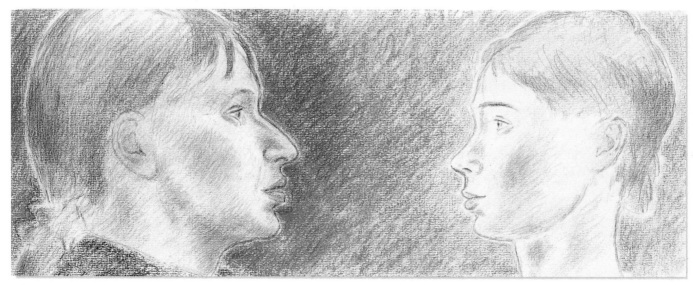

Juliet in profile looks towards Rosie

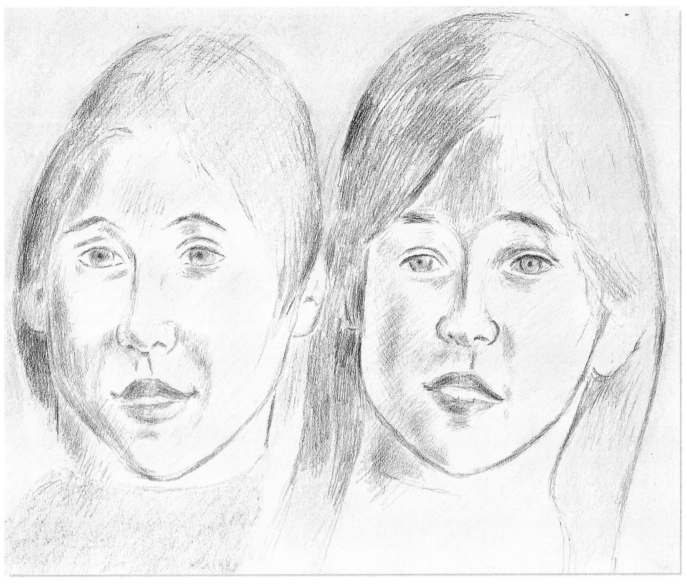

Dorothy and Alice

A profile tracing of Battista Sforza, with an added thickness to the contour where the forms are more substantial.

After Piero della Francesca

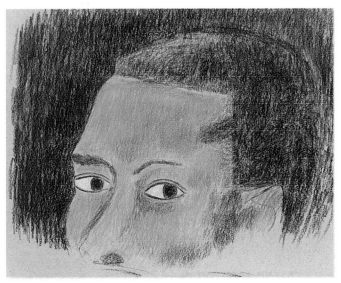

The temple of Gorgeous Macaulay. A square hairline, but the temple possesses a diagonal darkness.

After Aitchison

Nose-to-nose

WHEN LOVERS ARE NOSE-TO-NOSE, eye-to-eye, eyelids, like bridges, span the world. The undulations of the body initiate sensual expressions. Some portions are simple, obvious, and have simple names; the eye can weep or wink. The piece between the eye and eyebrow is involved when the very expressive eyebrow is raised in question, or lowered to frown. The nameless areas are important for painters. For a child, the face is a nose, a mouth, and two eyes. But painters can self-educate, until the body is seen totally, as a realm of visual sensation.

Outside the ivory tower of art, murder, work, sleep, touch, smell, and taste – indeed, all our experiences modify or intensify visual responses. Play a little: as an opening gambit, list some specialists for particular parts of the body. Gentileschi and Géricault were good for severed heads; Renoir for rounding plumpness; Castagno and Botticelli for bright clear eyes. Giovanni Bellini for veins, Grünewald for scabs, and Mantegna for open, singing, or howling mouths. Every mortal item, named or

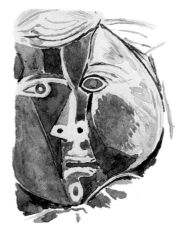

After Picasso
"Marguerite"

not, will express your body-minded will. Play some more: mark some strange places. What do you feel about the valleys between the fingers? Is the crease above the navel agreeing with a new double chin? Have you considered the corner of the mouth?

Look at nostrils, even at nose-hairs. The orifices of the body engage us, as do caves. It is a physical shock to see a cow put its tongue up its nose. The frontal portrait is structurally difficult, unless you have a way with nostrils. Children, babies, the snub-nosed, and pigs show two holes. Hockney, van Gogh, and Picasso could do these with single dabs. People with cream fed, well-found noses must have harmonious nostrils, swept sideways, and increased to counteract perspective. The vertical nose and horizontal nostrils give the portrait stillness and dignity.

Take a notebook, and walk through a gallery rich in Botticelli noses, sketch-copying with a blunt, black pencil. The more you concentrate, the more significant the shapes become, however small. The nostril as a world of wonder?

Skeletal nasal holes

After Ensor

Even the baby is coughing in the chill blasts of flu-filled air.

After Daumier

After Brueghel

Above the maw of Hell, an owl roosts in one nostril, and from the other, twigs grow downwards. With a dotting sable, explore the nooks and crannies of this strange world. Most of Brueghel's inventions are based on what he has seen in the life around him.

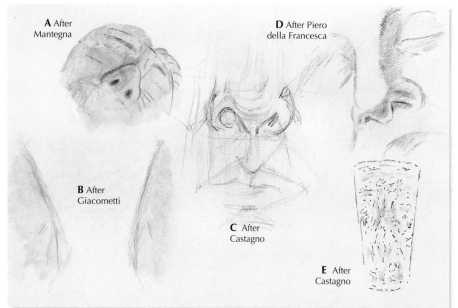

A After Mantegna

D After Piero della Francesca

B After Giacometti

C After Castagno

E After Castagno

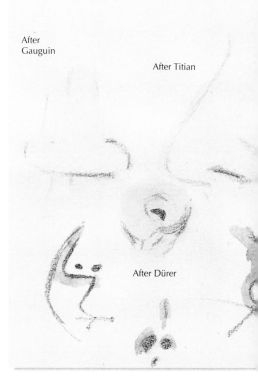

After Gauguin

After Titian

After Dürer

A *The nostril position declares the angle of the head.*

B *All our seeing is done between blurred noses. I can see a small part of my nose if I look askance. If I saw all of it, it would be the height of a man at three metres, or as high as a distant mountain. The right eye sees the right side of the viewing nose, and the left eye sees*

the left side. This leaves an attractive shape, rather like the shield of Castagno's "David".

C *One round nostril, and one angular*

D *"The Sleeping Soldier" – possibly a self-portrait – whose nose is again foreshortened*

E *The shield-shaped "David"*

The committed parent-painter will never stop doing it. Never stop brushing in babies. Your baby is crying, brush the baby's nose. Baby has a cold – paint the streaming sore. Baby is at a party, nose in pink jelly with cream. Paint a baby each day until the little darling believes it to be normal for adults to play in this way.

Daniel Miller,
Joe Four Times, 1988

Cartilages, cavities, sinuses, and snot. The nasal connection to the lungs and air passages – imperfectly, epiglottally separated from the food gullet – is not a very good arrangement.

Start several little paintings, and fidget after fidget, dab after dab, gradually, around the nostrils, plump, baby faces will accrue.

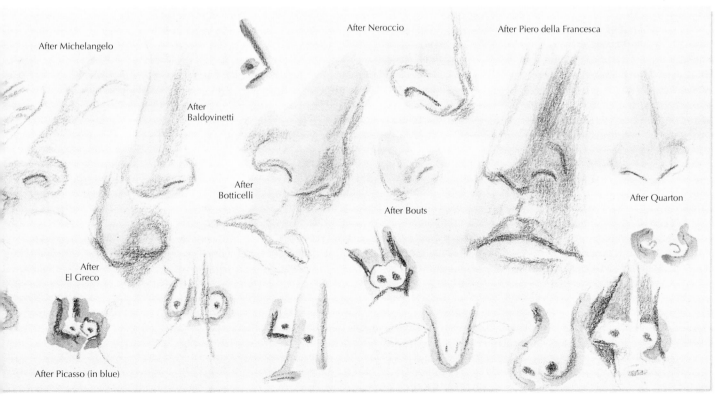

After Michelangelo

After Neroccio

After Piero della Francesca

After Baldovinetti

After Botticelli

After Bouts

After Quarton

After El Greco

After Picasso (in blue)

The Philtrum

A GUTTER-SHAPED RUNNEL is not often an attractive feature. It is difficult for some people to know whether to grow a moustache. The moustache we do not dare to paint was worn by the mad Hitler: a nasty little black carpet, it was the focus of massive adulation. How could a countenance appear if we beheld it newly, as when Miranda saw Ferdinand for the first time in Shakespeare's *Tempest*? We have minds full of faces. An empty mind would be equally surprised by ogres, unknown animals, and humans.

The philtrum is the least familiar part of a face. It is often surprising. When I had a copy-look at Donatello's "St. George", I found he had swept the forms up to the nostrils, with very little runnel. His "Judith" is wide-guttered, with

After Picasso

almost no pause at the lips. I had expected a dimple below the nose, a finger-touch in the clay. But great art continually surprises. Much of the great Italian painting that follows benefits from Donatello's controlled depths. He practised sculpture in-the-round, and also at all the levels of relief, short of painting. Mantegna was able to paint pictures that resembled bas-relief sculptures. Try doing some diagram-copies of several overlips from Mantegna's "Camera degli Sposi".

The ageing process is apparent; but although young lips can jut almost as far forward as a nose-tip, and in old folk the philtrum-angle can relax, there is less of a law about it than I had expected. Using a slab of clay, try incising or modelling in shallow relief.

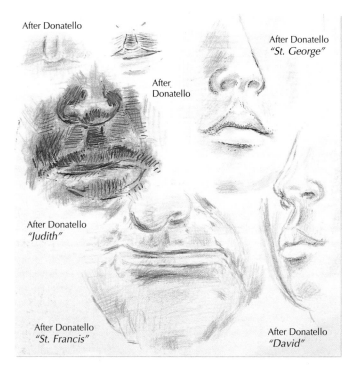

After Donatello

After Donatello
"St. George"

After Donatello

After Donatello
"Judith"

After Donatello
"St. Francis"

After Donatello
"David"

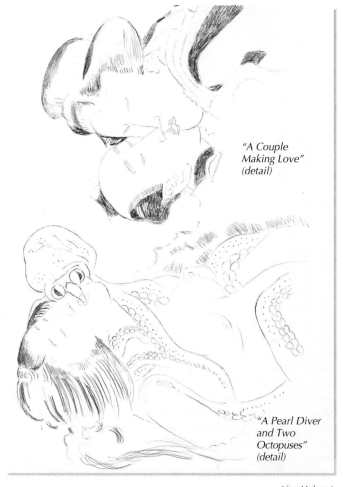

"A Couple
Making Love"
(detail)

"A Pearl Diver
and Two
Octopuses"
(detail)

After Hokusai

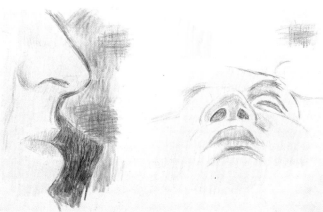

Look at the family in Mantegna's "Camera degli Sposi". Theoretically, philtrum-angles can monitor the ageing process. Touch in some philtra next time you have a family or friends at your mercy.

The philtrum, as reflected by Gonzagas.

146

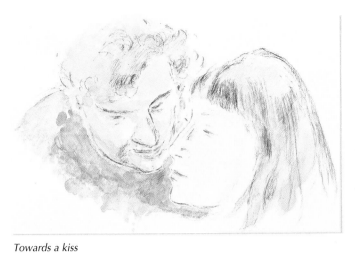

Towards a kiss

Coldstream called the undernose part of the face "The Rower". It is sometimes useful to think in oblique terms when confronted by demanding sitters avid for likeness.

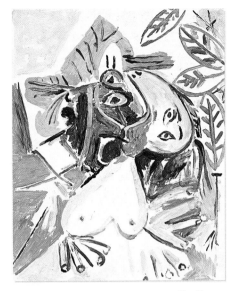

After Picasso

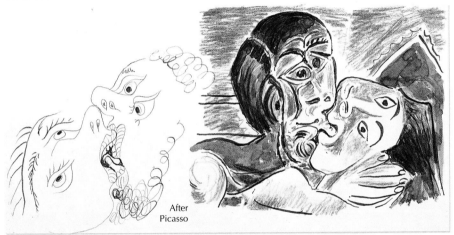

After Picasso

After Mantegna

After Mantegna

Kissing, while frequent in the world and in films, is rare in painting. Picasso is the only artist to enter the fray, even painting the insides of mouths and thrashing of tongues.

After Picasso

The sensual lips of Francesco Gonzaga

A moustache which has taken charge of the picture.

After Léger

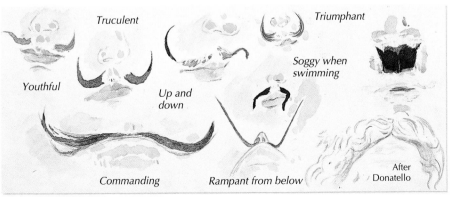

Truculent

Triumphant

Youthful

Up and down

Soggy when swimming

Commanding

Rampant from below

After Donatello

A moustache can be grotesque, yet cherished by the wearer. Dali's waxed horns were very long. The Dali "Gigolo" moustache could be variously expressive.

St. John the Baptist is always hirsute. Patriarchal whiskers fill up the philtrum.

Dali as a window-dresser and Surrealist so aggravated Picasso by his commercial exploits he nicknamed him "Avida Dollers".

147

Round Heads

Ovals and scribble make a crowd in an etching. After Goya

CIRCLES, AND CIRCLES THAT LOOK BACK at you, and circles who know you. Klee, Matisse, and Léger all, for a short time, painted featureless circles to stand for heads. This was new. Although recognizable forms accompanied them, these circles were abstract. Much of the material in older pictures was abstract – Italian Renaissance figures were surrounded by patterned surfaces, marbling would often be juxtaposed with gold (and most gold is non-figurative). Using the word "abstract" loosely, it could be said that the head on the right of Matisse's monumental "Bathers by a River", and a nimbus in a 15th-century Italian painting, are both almost abstract.

When Goya put crowd-fillings into his little pictures of bullfighting, he used suggestion-dabs. They were confidence tricks, helped by memory. The people were made with oval dabs and scribble; only occasionally were features indicated. Try some crowd-like calligraphy, using brushfuls of gooey cream paint over a brown-toned ground. If you do it small, your bluff will not be called. A Goya bull-ring format is dramatic, as bent on drama as a theatre's proscenium stage. The crowd Goya portrays is contained by the fenced ring, and is entirely believable.

I ask too much! Here is an exercise, which is about a subtle incarnation: touch softly! For this eclipse of intelligence, make ovoids of pale paint. One can be as round as a halo, or a billiard ball; another can be as exact as a Brancusi egg; let another be a rough bonce, an oval dab like a face in a Goya crowd; another can be as real as a very special aunt.

All kinds of circle, knob, or oval may stand in for a head. Matisse, or a child, will paint a head as a simple oval. (Matisse knew that added features would sway the attention away from other parts of his picture.) Picasso, Schlemmer, Brancusi, Gris, and Klee designed heads close to abstraction, which meant close to the simplicity of a circle. But the less formal painters of the time, such as Miró and Dali, painted heads as curvy as in dreams – bendy knobs and soft fungus crania. And curiously, and frequently, Italian artists employed a dressmaker's dummy: these and other figments were used to disconcert by Carra, de Chirico, Morandi (to begin with) and others. An oval for a head can be an equivalent, an evasion, or an unsettling symbol. Ultimately, an android is not a lovable human being.

Ellipse-shaped hats and little flicks of White lead make up the suggested crowd, keen to see the horn killing the toreador. A bullfight is massively complicated, simplifying heads allows the main theme of courage and death to be shown carefully. After Goya

Early bubble-heads after Morandi. He was really yearning for the pot-shapes which would occupy him for the rest of his life.

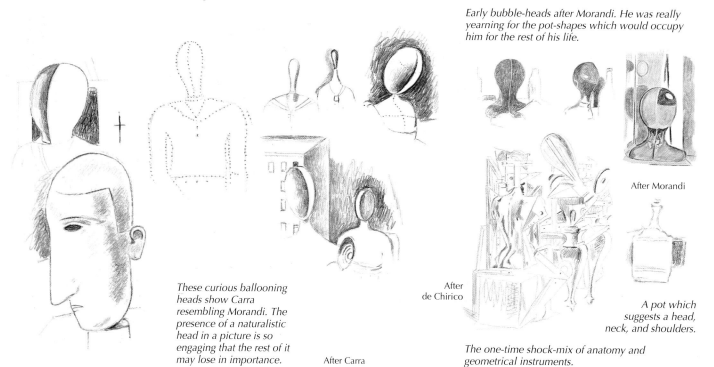

These curious ballooning heads show Carra resembling Morandi. The presence of a naturalistic head in a picture is so engaging that the rest of it may lose in importance. After Carra

After de Chirico

The one-time shock-mix of anatomy and geometrical instruments.

After Morandi

A pot which suggests a head, neck, and shoulders.

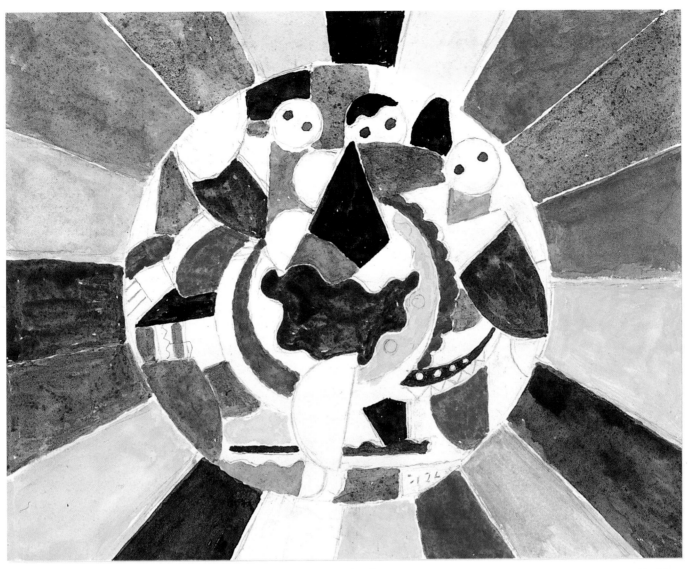

The simple use of circles for heads allows Léger a corresponding freedom with colour.

After Léger

Simplified heads

After Avery

After Picasso

After
Matisse

Simple heads

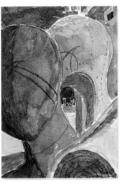

*Bubble-heads
and a funnel* After
de Chirico

A featureless face After
Avery

After Miró

*A simplified head.
Brush lines to become
rectangles and rectangles
to be plump as faces.* After
Léger

Circles transforming from abstract to faces.

149

Feet

MARK TWAIN'S *INNOCENTS ABROAD* found the museums of Italy more than their feet could endure, and containing numberless "Madonna with Child" depictions, which were all the same. A tourist of stamina has always been able to do three galleries in the time I need for looking at a single Watteau. They do not see how various are Madonnas. It was an excuse to paint a girl and a baby – often a local girl who wanted her pride and joy to be on show for ever in her church. This was the ultimate baby show. The formal religious placing was in the middle of the picture, as it should be. But look at the dandling: the positions, and the feet are so various, even Mark Twain would be persuaded! For there are no gold haloes at the toes. They are the feet of God made man. These wonderful pudgy, unruly babies are the way in: like the free dreamy predellas, these feet are the rewards for those who linger. (There is a ravishing book called *The Predella*. The painter Craigie Aitchison once said, "No-one should be without it".)

Diamond-shaped pictures often have fewer inactive parts than rectangular pictures. They will include more items. This picture is in relief and still surprises me. It is a painting of feet and alludes to buttercups, dandelions, a plate, a table, a chair, thighs, clouds and the wide ocean, dark grass, and the colours of passion.

Dandelions, 1970

Your own feet will model for you, separating areas of pebbly beach, and sparkle. On the whole, if your feet are warm they make better models than hands.

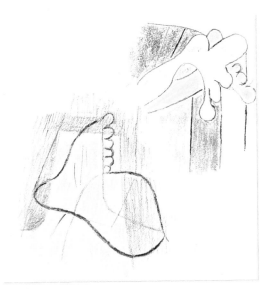

Make-believe feet, feet that nobody can believe in – but Pablo's feet are always neat and clean, and good to look at.

After Picasso

Patricia holds her new baby. Try drawing the feet with a pencil. The mother's hands enfold the baby, whose hands enfold its own head. The feet are contained in the triangle of the elbow. All fits together so lucidly it would be a shame to alter it much. All babies should be drawn continually. They grow up fast. Patricia will paint continuously and know her baby's feet better than her own.

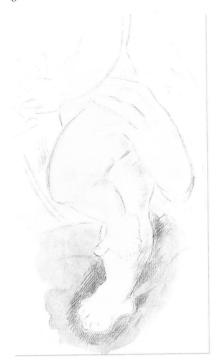

Study the toes of babies in the laps of Madonnas.

After Cranach

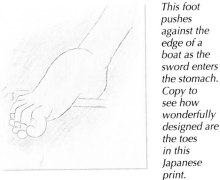

After a Japanese print

This foot pushes against the edge of a boat as the sword enters the stomach. Copy to see how wonderfully designed are the toes in this Japanese print.

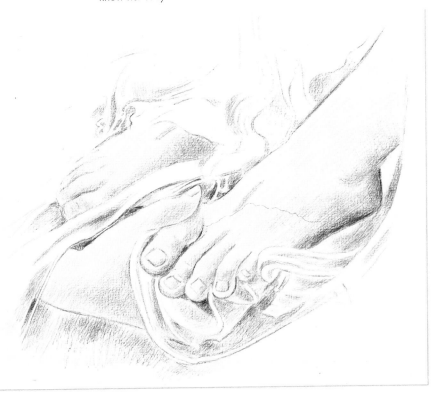

After Botticelli

Copy with a sharp point (or a 0.3mm Pentel propelling pencil) the perfectly composed feet of Christ in the late "Piéta" by Botticelli. There is no place for uneven toenails here, and the wounds are clean as well-cut marble. Your disciplined style cannot fail to approach a "foils-man" precision for really hard, sharp definition. Thinly prime hot-pressed watercolour paper with a Zinc white watercolour (sometimes called "Chinese white"), then with a sharp 6H pencil, incise it true.

Cherubs

CHERUBS ARE NOT MUCH LIKE BABIES, but let us pretend. Be rejuvenated. Flattery gets results. Today, you will paint. Your child is a wonder! Unique in the world! This certainly is true. On the assumption of parental love and proximity, and however beautiful, plain, or hideous your offspring has turned out to be, she is still bound to be of overwhelming interest to you – and therefore, the subject you should paint. Judging by the enormous population of cherubs, putti, and Madonna-lapped babies in world art, you are not the only painter to be holding the baby. The new race of parent-painters mix the paint, tell children stories, change nappies one-handed, as never before. Rubens, the great master of the picture-filling cherub, would have had a wet-nurse. Babies, unless they are asleep, move a lot, but usually have only a few set positions. Start

Will, attempting to look cherubic

several sketches. One or more will be lucky. In any case, you know your way around your paragon. Rubens found that gessoed boards, streaked brown, and not too absorbent, would take creamy White lead paint from his tiny brushes most accurately, and as fast as he was thinking. To see how he did it, find the little panels, scattered in many museums around the world. (I have a book that reproduces 140 of them.) Whatever your ultimate way, the Rubens touch is redoubtable. Considering the ease with which the Old Masters expressed adult desires using cherubs (I'm thinking of Mantegna, Titian, Rubens, Poussin, and others), it is strange how rarely cherubs are to be found in paintings today. But with such encouragement you will paint your best beloved. He can be a pictorial device for space control, or a darling portrayal to please a grandparent.

The pupils of the eyes are usually dark. This baby's irises are dark, and the middles are bright reflections.

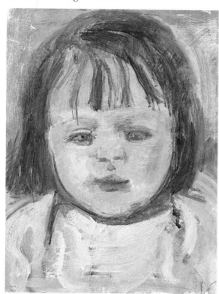

A fairly placid baby, swept in intuitively, leaves the rectangle in turmoil.

Daniel Miller,
Dora, 1994

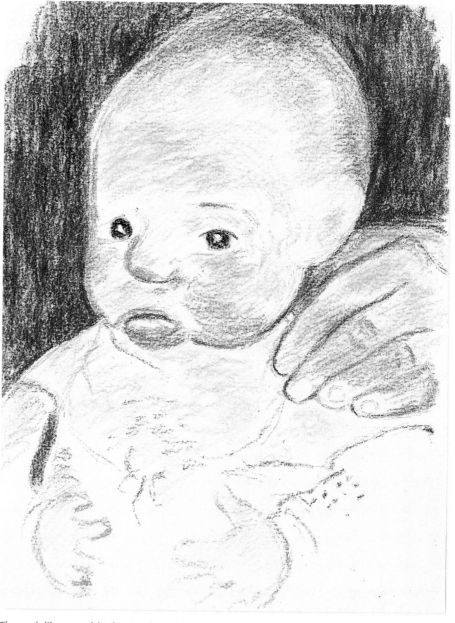

The mask-like area of the face is where the artist has concentrated most. The hands are oval swirls. With your baby on your knee and one arm free, brush in cherry lips, peach cheeks, blackcurrant eyes, fast, before a new aroma causes a change.

After
Modersohn-
Becker

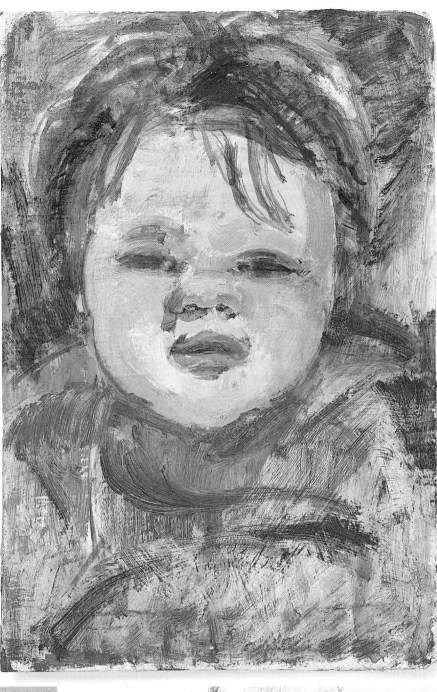

With a pen and slightly diluted non-waterproof black ink, sketch around some cherubs in Mantegna's "Camera degli Sposi". Poussin's cherubs, or those by Titian are well worth copying.
From William Blake's A Cradle Song:

After Mantegna

Sweet babe, in thy face
Soft desires I can trace
Secret joys and secret smiles,
Little pretty infant wiles.

Almost as though kissed or pressed against a window-pane, Dora is lively and only a little way towards being a cherub.

Daniel Miller, *Dora*, 1994

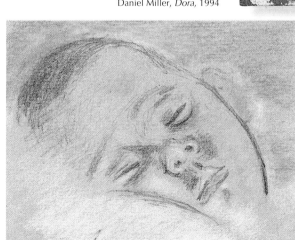

A sleeping child will keep still until a dream comes along. Draw her in graphite pencil. Additions with a pastel pencil will suggest the colour.

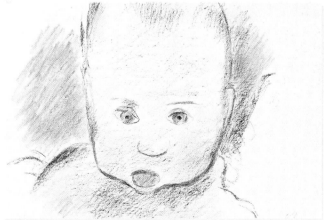

She was the top painter of real babies and I suppose shows up cherubs to be pictorial, rather than of this world.

After Modersohn-Becker

First Steps

SOME ANIMALS HATCH AND LEAVE the egg ready for life. Not humans. Trauma follows trauma. In 1943, Picasso painted "First Steps": a child learning to walk. It is a self-portrait. It has Picasso eyes staring into the future, tottering forward, anxious. Wartime increased angst.

Goal follows goal. The learning can often be embarrassing. Learning multiplication tables can take too long; or caresses fail. Mothers guide. Picasso painted pictures of most of the stages of life. Even a child holding its mother's hand becomes a little monument, and, scribble-pen at the ready, drawing a peeing baby becomes a spree. When he was old he painted "Nude Man and Woman 1971". It resembles the great "First Steps". The man, who is Picasso again, of a great age and with no goals left, totters forwards. He is as nervous as ever.

I expect Paddy's other hand is being held. He is closer to the water than grown-ups. The duck is big enough to swamp a yacht. It is a water-filled picture, with near boats and far boats. His knees are the shape of the water.

Henry Kondracki,
Paddy, 1992

"First Steps" (in chalk) After Picasso

"Paloma Asleep". All the parts of the body are presented clearly. After Picasso

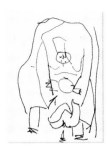

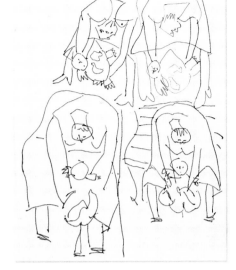

"Dandling a Baby". Pen and ink can be fast. These sketches call to mind the fast quill drawings of Rembrandt. Great painters build on the common life around them. The protecting mother. The Madonna and Child. The enfolding, caring, even smothering, loving relationships are important themes for painting.

After
Picasso

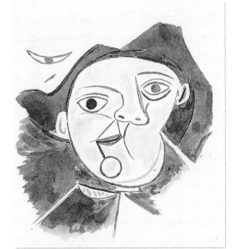

"First Steps" After Picasso

(Picasso tried doing the feet first on newspaper.) Picasso did criss-crossed soles for the feet in *"First Steps"*. As I looked at late Picasso paintings with the undersides of feet in mind, I realized how continuously Cubist he remained even to the end. Explaining each part of the body in an innocent way: top of foot, side of foot, sole of foot. Although Degas was not childlike in the same way, he also did drawings of nudes and ballet dancers from the back, front, and side. It is an instinctive way, aiming at complete realization, without making sculpture. Picasso does not usually repeat soles or other features. His economy allows a frontal eye, and a profile eye.

"The Child's Face". The drooping eyes of the mother are two waning moons on their backs. She will worry at his every step. The wartime pictures were done in blacks and greys and were profound, anxious, angular, and fearful.

After Picasso

Rough sketches of "Nude Man and Woman"

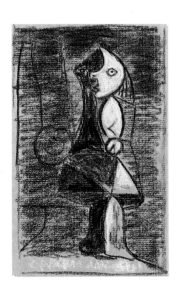

A little girl holding her mother's hand After Picasso

After Picasso

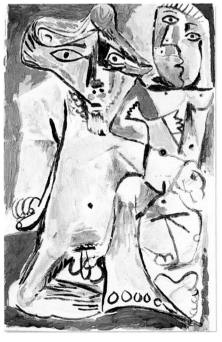

After Picasso

Knees

SHRINKS WRITE ABOUT "THE GOOD BREAST" but never refer to the back of the knee. All joints complicate – and we do not have knees in mind so much as other parts of the body. This may be why painters avoid knee-backs. Also, knees break the long rhythm joining leg and thigh. It is interesting to note how cunningly the passionate artist smooths the tender back of the female knee. Pierre Bonnard noticed how, when bodies are young, the knee-joint is flexible, almost double-jointed. The gastrocnemius muscle tendon (as a pad with fat, covering the meeting of the femur and tibia bones) is forced backward between the "hamstring" muscles. (They join the thigh to the leg.) This is most pronounced when the girl wears high-heeled shoes. (Chinese foot binding and the fashion for high heels show a dissatisfaction with the natural shape of the female leg.) To me, most legs are visually bountiful. But Bonnard made girls on high court shoes, stalked like flowers, into beautiful paintings, and the near-dislocation makes all the difference.

Ingres smoothed the knee-back of his "Bather of Valpinçon", whereas Oedipus, looking at the Sphinx, has muscular knees. Skateboarders and scrubbers wear knee-pads, rarely used in pictures.

After Ingres

Knees tilted by high-heeled shoes

After Bonnard

Natural knees. Paint some knees simply. Knees, elbows, and knuckles can look odd on humans. Where are the knees of dogs, kittens, and sparrows? Draw from armour (at the Wallace Collection, London) space-suits, puppets, or lay figures for knee variations.

"Mars and Venus". Mars is with Venus, and Venus shows willing by covering the back of Mars' knee with her paler leg.

After Veronese

"Knees" from a sketchbook. Van Gogh was a great self-teacher, focusing problem after problem. Look to see ways to worry – draw knees. He suffered over knees, brave as a footballer. Rembrandt etched knees, and made them dumplings, dimpled and real.

After van Gogh

"Women in an Interior" (detail). Formalized knees. Later on, Léger dispensed with patellas altogether.

After Léger

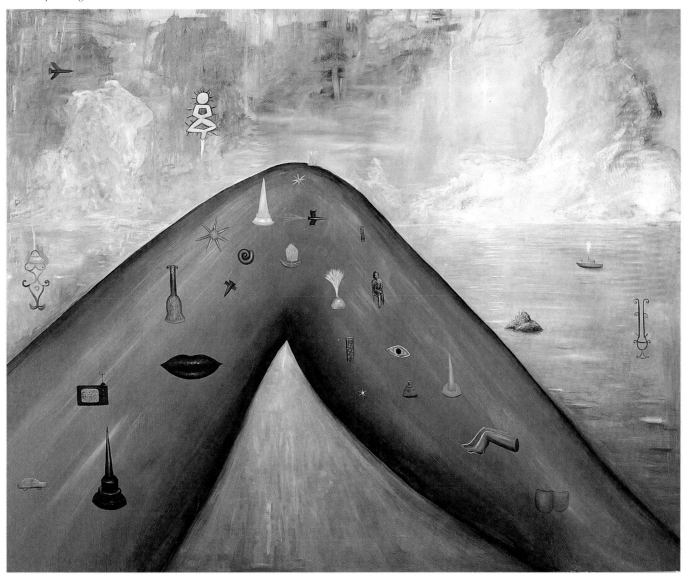

The knee is as high as a mountain. The sharp points and edges are wayward as Nature. Compare the gradations with those of Léger. Stahl's pictures are often large. He breaks a lot of old-time rules about tone and recession. Here, it is as if, climbing an enormous leg, his brush is slipping in little, meaningful items, unrelated compositionally to the immense background of sea. Late Poussin included giants, and surprising scale-jumps, but everything remained formal. Stahl's awkward poetry concerns an oceanic, eerie feeling about distant travels.

Andrew Stahl,
China Beach, 1992

Armpits and Violet

THE HAIR OF THE HEAD, chest, armpits, and beard join shadow-darks to help make areas of flesh live luminously. There is a Matisse of a girl with her arms above the head. He liked poses where the rhythms could be dolphin-smooth and dolphin-long. The tufts of hair are exultantly brushed in, above breast level: the contrasts are bright as starlings on stone. The armpit is a complicated structure. Muscles from the back, front, and side leave a hollow for hair, sweat, and shadow. Brush it in cleverly with dark paint, and you have a shoulder.

We are naturally drawn to certain artists: others, just as good or better, we pass by, sometimes for years, and then we want to look at them. I cannot look at Memlinc for long and am only now beginning to be able to look at Tiepolo. (His son, Domenico, was never a problem.) Zurburán remains for me a mystery. David is difficult for many – there is a leathery, guillotine dullness that does not beckon.

But early or late, move into David's corpse-pallor and curious satisfactions take over. With the arm down, David has drawn a shoulder, with classical restraint, a formal rigor. Do you think him a killjoy? Extinguish for a little the peacock colours of today, and engage with this hard, arched arm. It is squared-up for enlargement with white chalk, and pounce holes.

Consider figs and armpits. Fig-leaves never succeeded in quenching desire.

A green stalk increases the violet of its hairs, until it reaches a violet flower.

Lilac is First in the Year, Violet is the End of the Rainbow

The end of the spectrum, the end of the day. Funereal when with black, violet colours the end of the year with Michaelmas-daisies, buddleia, and asters.

If you use the many available transparent dye colours, support them on greys or whites. Alizarin crimson is very dark. Permanent rose and Permanent magenta are strong and can be mixed with Cobalt, Ultramarine, and Cerulean blues. Various violet dyes can be as fierce as endorsing ink. The pale Cobalt violet that Bonnard used is expensive but good. Other darker violets are Cobalt violet dark, and Mineral violet. Strange pigment colours are the sticky Ultramarine red, and the weak but permanent Potters' pink. Rose madder is durable and dear: it will mix gently and transparently with Ultramarine blue. Crimson lake has been made durable, and is comparatively cheap. Mauve is made in red and blue shades, and, like Winsor violet, is a dye colour.

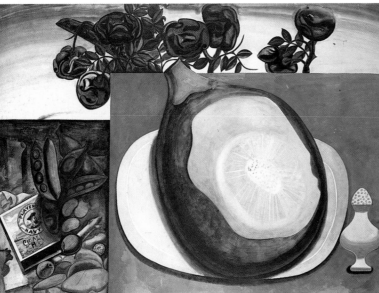

Black seems to have been added to the red and to the contrasting green of the fig. It is really a still life about a sailor's love life, and the sea.

Edward Burra,
The Green Fig, 1933

Fig-leaves

After David

Watercolour flows erotically and triangularly.

After Clemente

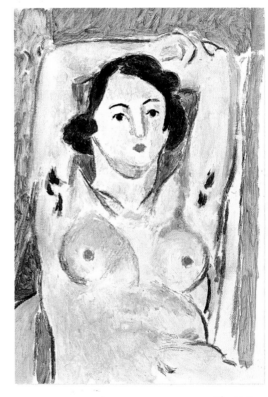

After Matisse

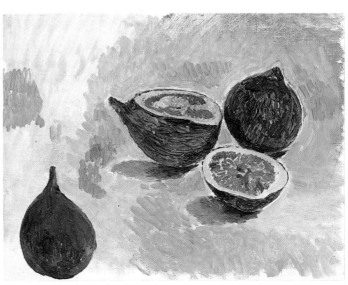

The colour of a ripe fig is between violet and green. Some colours will only mix cleanly if the mixing is done optically. Cobalt violet, dabbed lightly against Cobalt green, makes violet-green. Viridian will increase the darkness. Stab into the indigo-velvet-fruit. The interior flesh is crimson and gold, in a covering of apple-green as pale as pastry.

Rainbow in Venice,
1985

The Massive Eye Lock

GUIDES AND LECTURERS in front of pictures sometimes say: "See how the eyes follow you around the room." We feel we move our eyes, directing them at will, much as we point an electric torch. Scientists say that eyes flit about all over the place rather as flies fly. We direct our attention without being aware of this. The limitation of the activity of the eye may account for the relaxation of looking through binoculars.

Since we are not taught to look at pictures, do we naturally "go for a walk with a line" as with Paul Klee, or comprehend immediately. Snakes and ladders? Perhaps we take the physical looking at pictures too much for granted. Oriental reading of pictures is different. The movements of people's eyes when looking at famous pictures have been charted as dots, clustering around certain attractive areas. Great painters know how to direct the attention of the viewer.

No painter, however astute, can move the eyes of a dog lover away from a trace of dog. Bonnard's slightest dabs about his dachshund are sufficient to engage the attention of a dog lover. Bonnard is very good at controlling the spectator's attention over his surfaces.

Ninety years of staring in and out. The poignant expression is fearful of death's imminence.

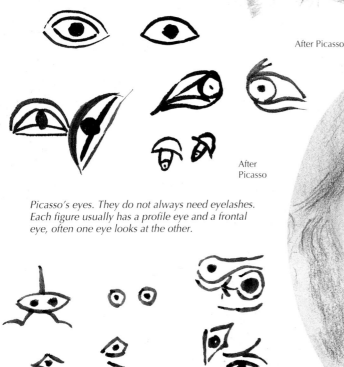

After Picasso

Picasso's eyes. They do not always need eyelashes. Each figure usually has a profile eye and a frontal eye, often one eye looks at the other.

After Picasso

Piero and the great painters are always painting encounters between humans. Piero paints eyes with vitality, the whites of the eyes bright as in Japanese prints and vividly directed. It is difficult to know how much the painter relies on spectator knowledge of the direction of a glance for the drama within his picture. Even if we cover the eyes, we remember the direction somewhat, and even upside-down (as with Baselitz), some of the effect survives.

The design with eye is strong when storytelling, and such linkages could not be made in a purer design. Figurative art is seen to be strong when Piero della Francesca, using tiny triangles and circles for eyes, links them to a massive design telling stories of love, war, annunciation, revelation, and monumental calm.

"The eyes follow you around the room." The guide is aware that something mysterious is going on. It would be truer to say eyes move your eyes through the picture. But he might be close, for we confront eyes with eyes. All figurative pictures have at least a ghost mirror to them. Francis Bacon, the great croupier, insisted on glass and frames, and these would part reflect the punter.

One of the most dramatic eye-to-eye encounters is when Judas betrays Christ in the fresco in Padua by Giotto.

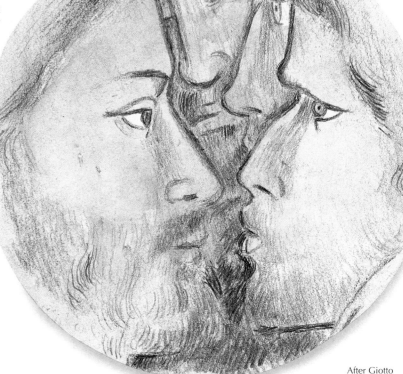

After Giotto

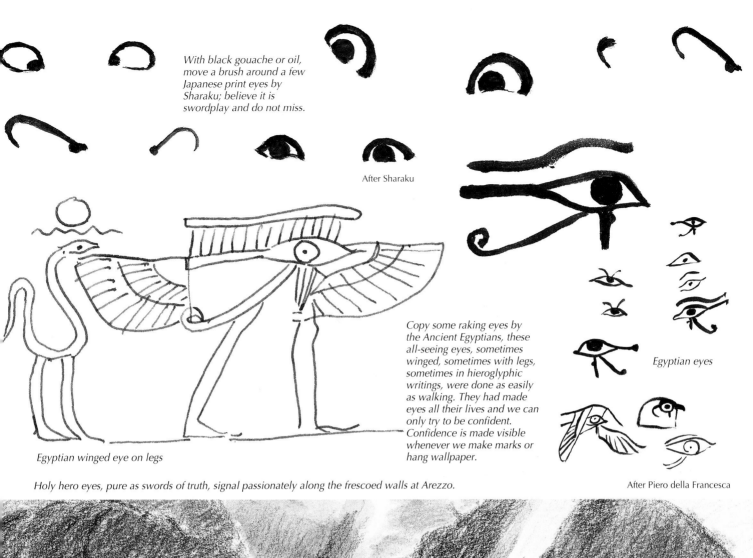

With black gouache or oil, move a brush around a few Japanese print eyes by Sharaku; believe it is swordplay and do not miss.

After Sharaku

Egyptian winged eye on legs

Copy some raking eyes by the Ancient Egyptians, these all-seeing eyes, sometimes winged, sometimes with legs, sometimes in hieroglyphic writings, were done as easily as walking. They had made eyes all their lives and we can only try to be confident. Confidence is made visible whenever we make marks or hang wallpaper.

Egyptian eyes

Holy hero eyes, pure as swords of truth, signal passionately along the frescoed walls at Arezzo.

After Piero della Francesca

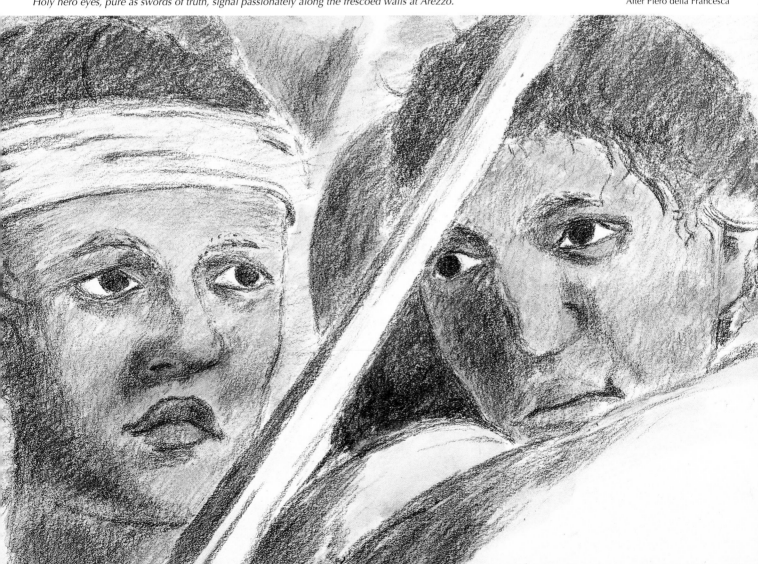

Modigliani

W E HAVE BECOME ACCUSTOMED to the blank eyes of ancient sculptures. Once they were filled with precious stones. Modigliani was a sculptor, a painter, and a Cubist. He could get a good likeness. He would fill the eye-shapes with a simple colour or even criss-crosses. The eyes of Neil Jeffries are central and over life-size to confront the onlooker dramatically.

Brush self-portrait eyes, or stare into the eyes of the beloved. Make little marks and dabs for wink-eyes, sultry eyes, and wide eyes, and then double mirrored, or as requested of your partner, side-long glancing eyes – these are the flashing, healthy, heaven-sent eyes of Piero.

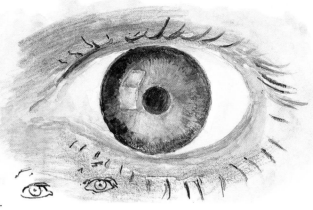

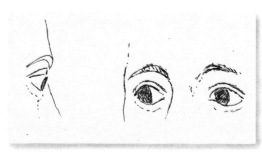

Piero exaggerated eye irises in "The Death of Adam" at Arezzo. A profile iris is actually painted in front of an eyelid and often the circular irises are very large and dramatic.

After
Piero della
Francesca

A profile turned until the eye is no longer visible. It is difficult to do but Piero knew how to do it. Adam's eye in profile is clear and high on the wall as he looks for the last time. "The Death of Adam" is at Arezzo.

After
Piero della
Francesca

Choose a video or television programme that will anchor your sitter's eyes. Think of isosceles triangles and how eyelids and triangles can become arcs and watercolour some diagrams.

The tiniest marks against the white of the eye will make a directional glance.

Modigliani eyes, like ancient statues stare mysteriously ahead.

After Modiglia

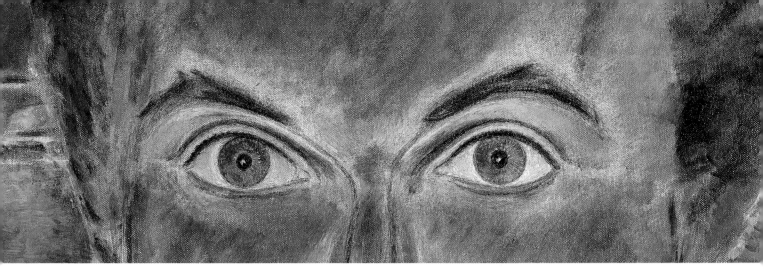

These are the eyes of the young sculptor Neil Jeffries near the Thames at Chelsea.

Chelsea (detail), 1988

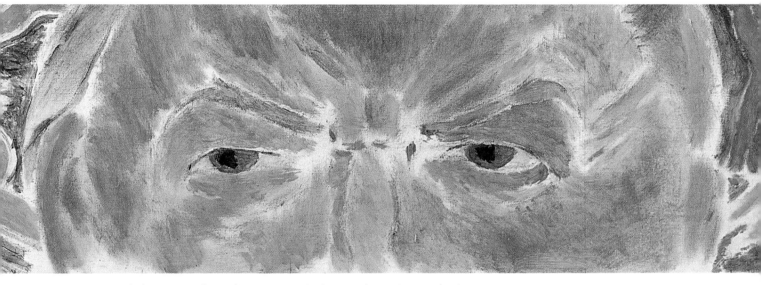

My eyes move towards the viewer and away from a panoramic view over the sea (not seen here).

South Coast (detail), 1990

Crayon the whites of the eyes at night, small against the mysterious dark rocks and caves of Rock-a-Nore.

Once again I wanted to make a clear triangle of the profile eye. It rhymes with the angular background.

Spectacles

SPECTACLES DISTORT AND CHANGE the dimensions of everything. Hollywood stars would pretend to be ugly ducklings and turn into glamorous swans when their spectacles were removed. Spectacles are the frames of eyes, and change people's appearance as much as picture frames alter pictures. In portraiture, spectacles can take over. Picasso's portrait of "Jaime Sabartes" is mainly glasses. Sickert made Hugh Walpole around a circular lens. William Coldstream's painting of Lord Thomson was a bespectacled barrier, and a barrage of measurement marks. The camouflage and partial disguise that spectacles provide, makes life easier for the sitter. Hockney lives his life behind enormous lenses. Vuillard's mother wore little ovals. Some people appear so naked, if they remove their glasses you expect them to blush.

Choosing spectacle frames is the nearest many people come to abstract art, and the choice is very serious: for a politician in the public eye, a millimetre mistake might change his election chances.

Dark glasses were fashionable when abstract artists taught at the Slade. They even wore them in winter, as protection against "Jungle Art"!

Try variations of a circle in a square. Try hoop against hoop. Spectacle lenses can be thick and convex. A goldfish bowl is thicker. Fishes are eye-shaped; eyes are spherical. Paint eyes through a goldfish bowl. Paul Klee in "The Thinking Eye" placed a simple fish-shape in a rectangle, as a representation of a fish tank. If we call the rectangular tank a spectacle frame, the fish becomes an eye; and if the eye is a fish, then it is a symbol for the Resurrection.

Often improprieties reflect from Anthony Green's spectacles. In his self-portrait surrounded by fireworks, he probably remembered a little mirror in a favourite picture, "The Arnolfini Marriage" portrait by Jan van Eyck in London's National Gallery – a most proper arrangement.

The mind's eye version of an eye is a sphere, shuttered by arc-shaped eyelids. Looked at carefully, an eye is more complicated. The eyelids are not pure arcs, and the orb eye has a projecting cornea; and when you try painting the turned eye, the elastic eyelid surprises. If the eye also wears a contact lens, the forms are even less predictable.

Doodle some rounded forms within some rectangular formats.

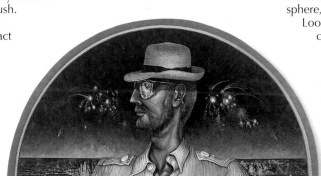

Anthony Green, *Cannes/The Lover*, 1977

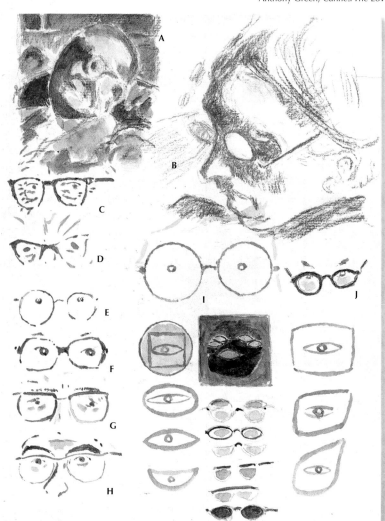

The spectacles of various famous people

Anthony Green posesses the visual gluttony of Carpaccio, Stanley Spencer, and the old German masters.

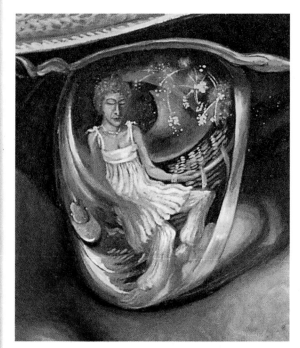

A Hugh Walpole, after Sickert
B Mrs Vuillard, after Vuillard
C Coldstream
D Gowing
E Eurich
F Mary Potter
G Michael Andrews
H Anthony Green
I Hockney
J Le Corbusier

Anthony Green, *Cannes/ The Lover* (detail), 1977

Anthony Green uses hardboard with a white acrylic priming. It is more difficult to manoeuvre small details in oil than in oily tempera, or even when using fine grain canvas, but he works bravely brusquely and the images shine forth with surprising force.

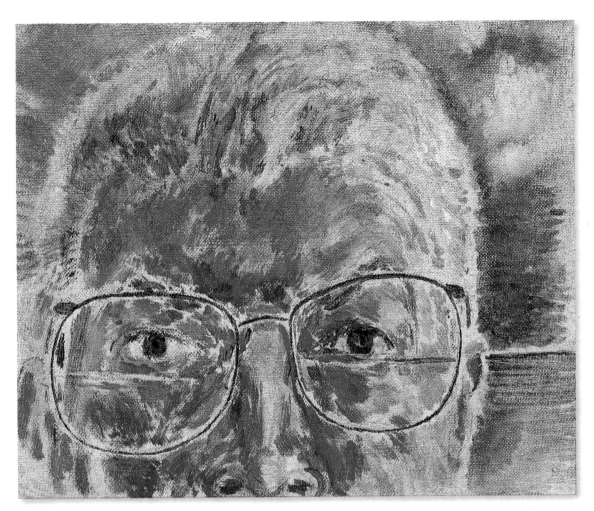

Eyes within ovals and rectangles. Pupils, irises, and lenses are somewhat eccentric.

After Klee

An oblique view makes an even more complicated self-portrait.

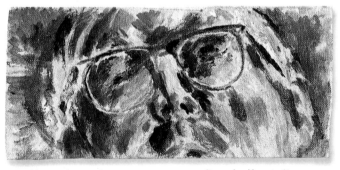

Spectacle still lives

Brush-doodle some doodles.

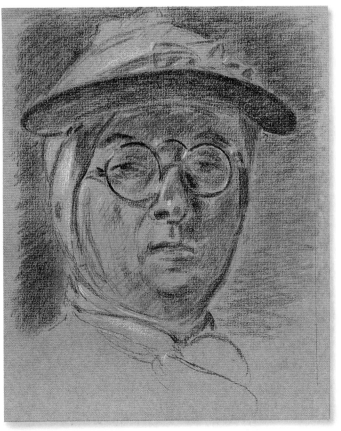

"Self-portrait". Baseball, or other sporting eyeshades might be useful. A straw hat is comfortable. Chardin is so swathed, bespectacled, and shaded it is easy to realize that he was professional, and warm and as great as they come.

After Chardin

165

Staring Skull Heads

THE CLOSEST PART WE HAVE to the mind is the skull. The best teachers have known the importance of learning the bones. Eakins, Anschutz, and McComb are examples. McComb would place a skull at the same height beside his portrait model. It made for a serious atmosphere. Late Picasso self-portraits relate to skulls. Picasso painted numerous absinthe glasses, but even more skulls. Cézanne had several skulls on his shelves. Skulls vary, and I think we do not see certain heavy European skulls; most are from India. The finest drawn skulls are by Leonardo da Vinci. Hans Baldung painted an "Allegory of Vanity". Death drips some flesh, but is skeletal. He waves an hourglass over a beautiful girl, who holds a hand-mirror.

Skulls are head-shaped, but are made up of small, concave surfaces that are home to muscles – together with fat, these create the plumpnesses. Make studies of skulls if you can. Blur your way into the hollows. New skulls and skeletons are pale. Bratby painted them with pale ochres. These are cheaper than most colours; thick painters often use them.

Edvard Munch's predicament was horrible. Rooms with choking and dying loved-ones filled his mind and drove him crazy and drunken. We are able to endure agony if an end to it is in sight. The idea of a terminal ache appals.

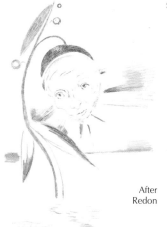

A swamp flower, which is a sickly visage. Skulls have a greater ferocity.

After Redon

A painted metal sculpture

After Neil Jeffries

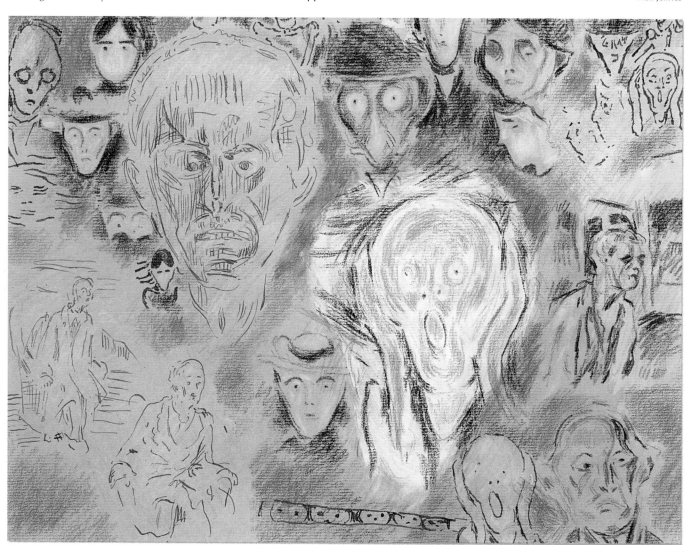

Self-portraits in old age, with various frightened, ghostly, and ghastly heads

After Munch

"Anais Faure on her Death Bed". It contrasts with the Expressionism of Munch.

After Seurat

"Self-portrait at 2.15 a.m." and
"Self-portrait: The Night-Wanderer"

After
Munch

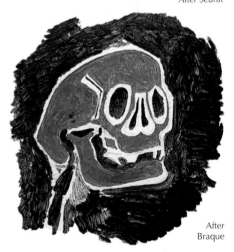

After
Braque

In old age, Munch
shows himself as if
embracing Death, but
also gently pushing him
away. *"Half in Love
with Easeful Death."*

After
Munch

*Study for "Death
in the Sick-room"*

After
Munch

As if measuring Munch for
a coffin, the clock will
continue into the future.
They both have faces and
hands. The clock has an
escapement, but for the
painter there is no escape.

After Munch

*"A Death's
Head". Violet
and black are
the colours for*
memento mori.
*(Latin for
"remember you
must die".)*

167

Flying Figures

HOWEVER HARD YOU WAVE YOUR ARMS, you will not rise an inch. There is a lot of great art that depicts figures in the air. Certainly, if there is no more than clouds to support them, it must be imagination they depend on to keep them in the sky.

Eastern England is flat. The skies are enormous. In the autumn, they build like sheep and lambs to the zenith; when low-lighted at evening, they appear solid enough to sit on. To make lowland figures steady, a long, horizontal shadow can be attached to the feet; to settle them compositionally, the heads can be attached to the horizon. Koninck, Cuyp, and Boudin knew how to manage low horizons.

Leaving the low cliffs of East Anglia, for the high chalk promontories of the South Downs, I could see the figures in the sky, hang-gliding in bright colours. Bodies can be put anywhere, on any level, or in the sky. It took me a long while to feel free to put figures anywhere, and to soar adolescents over Venice. I could not give Nancy, Daniel, and Francis wings. I had to be fearful, and spare them an Icarus fate.

Paint the sky. Here are a few gerbil-shaped cumulus clouds seducing a desirable angora-rabbit-shaped cloud. It is all about stroking! With turpentine and medium, swish a canvas with pale Cobalt violet, then stroke it with pale Cobalt green until it is as blue as it will go. Into this damp surface, using a pointed sable brush, mark out a few cloud shapes with ultramarine: into the middles, brush in a whitish-blackish grey, or a whitish-violetish grey mixture.

An enormous rain-cloud over a flat expanse. Draw with a soft pencil on rough paper. Fix and watercolour it from memory.

Various flying figures from the Dante illustrations Blake was employed on at his death. Inverted figures will fall or fly. After Blake

Figures flying above a lurcher. The sky is made substantial, to support the figures. Rhythmic layers of Lead white combine with liquids to hurry movements along with brush and stripe at greyhound speeds. Pop artists incorporated a greater variety of formal devices than I do and could change speeds more easily.

Isle of Wight, 1991

"The Dance". Diving and acrobatics were nearly flying. Léger painted everything – even comet tails. After Léger

"Great Journeys". A tree and a village-figure float over a mountain. Invention approaches imagination.

After Magritte

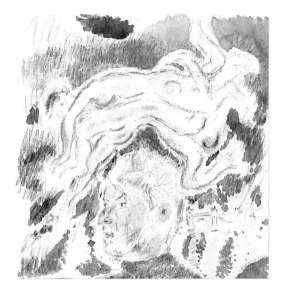

A self-portrait, Tower Bridge, and two grappling figures

Nash painted various flowers in the sky. Here, the sunflower seems to rotate. He often used a painting knife (a small trowel) and did not dilute the buttery paint.

Paul Nash,
Eclipse of the Sunflower, 1945

After Tiepolo

After Tiepolo

"Allegory with Venus and Time". Her breasts are even further apart than the floating hemispheres by Léger. Tiepolo used clouds creatively.

Red Kite Lift-off, 1978

The paper-dart shape of the hang-glider fits well in the diamond shape. A long format was intended to suggest the vast spaces at Beachy Head. Concave frameworks might have been more expansive.

Yourself in Fur

Peter Paul Rubens painted a grand souvenir – a world-famous painting of his wife, Helena Fourment, posing as Aphrodite. It was called "Little Fur" in his will. If we are enjoying a happy time, we are almost immediately disturbed at the anticipation of its passing. The great performances of music are sometimes preserved on disc. In the past, they remained only as a memory. Mortal, we clutch at souvenirs: tapes, videos, photographs, perfumes, letters, even locks of hair. Rubens was schooled in the grand tradition of Italy, by copying and practising. Imagine, extravagantly, that you are the Prince of Painters, with all his powers at your command. Helena has just left a hot bath, and stands in her fur wrap enjoying the cool night air, anticipating the warming-panned bed. Your dream allows that you are indeed Rubens, and are contentedly watching Helena from the soapy warmth of the bath. Suddenly, you become aware, and everything falls into place: a hide-and-seek of texture. Tomorrow, one of the wonders of the world will be achieved. The result hangs in Vienna, and for around 350 years, has embodied a wonderful moment for the artist.

Rubens had previously copied "The Lady in a Fur Cloak" by Titian, which is also in Vienna. (The Rubens copy is owned privately.) He learned by copying. Be daring! Be cautious! I know the dangers of copying paintings as old as this. But art can also be a source of real and sustaining power.

Stay with Helena. She is no ordinary woman. Rubens had known her as a child of 5 – 1 of 11 children. He chose and married her when he was 53, and she 16. Do not expect your copy to come alive. Only the brimming confidence of Peter Paul could achieve this Pygmalion miracle. But stay with Helena. She changes all the time. Make dabs for what you discover.

All the features are at their fullest. The hard little animal nose flares its nostril within the invented shadow, which belies the illumination from the shoulder below – which is made to reflect on to the chin and eyebrow. The plumpness is controlled by a sharp, contrasting pearl earring, and a highlight in the far eye. More enigmatic than the "Mona Lisa". There is no naturalism in this wonder concoction. Copy her vitality and wit. Does she whisper a naughty joke? Mark where the cherry cherub lips come together. See how, at the wild limits of possibility, the eyes are enormous, and will bounce meanings across the room.

Be up to date. Anoint your body with moisturising cream. Be your own model. Helena as Aphrodite is a sumptuous spectacle because of the textural contrasting of fur and flesh. As you leave the shower, there is no fur – but an enormous fluffy towel will be more colourful. Drape it carefully around you. Its long rhythms will camouflage a boasting abdomen. (For ruined feet, wear socks.) If you continue to fret, arrange a ravishing accompaniment of flowers and fruit, even attract your cat with a sardine. Paint a self-portrait as lurid as cosmetics.

In large mirrors, the students of Chelsea Art School are painting self-portraits. The girls know what they look like, and what they want to look like. They invent their appearances considerably. Take the girl rattling in a tube train. She makes a large brushing of "blusher", with an almost unbelievable skill. Aided by a tiny mirror (and with the train rattling hard as a road drill) a sure hand sweeps in a narrow line round the eyes, raising the corners minutely. Then, as the train lurches from a stop, mascara is added. Ever since Ancient Egypt and before, girls have changed their appearance. Gwen John would have done her self-portrait "plain", with no-nonsense mouse-brown eyelashes.

A line-up for a portrayal of self

A sketch of the whole picture

After Rubens

The newly married Rubens in his garden After Rubens

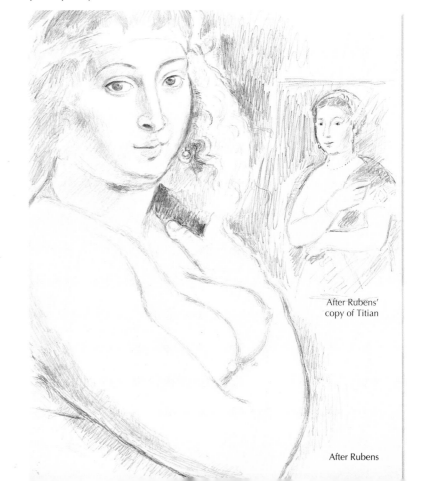

After Rubens' copy of Titian

After Rubens

After Rubens

Use a rich medium, and paint over a streaky underpainting.

After Rubens

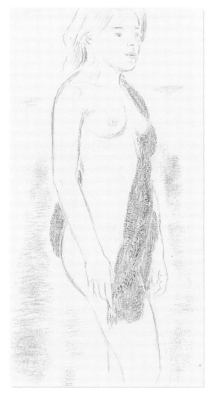

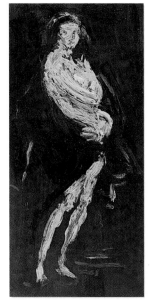

An oily scribble over black After Rubens

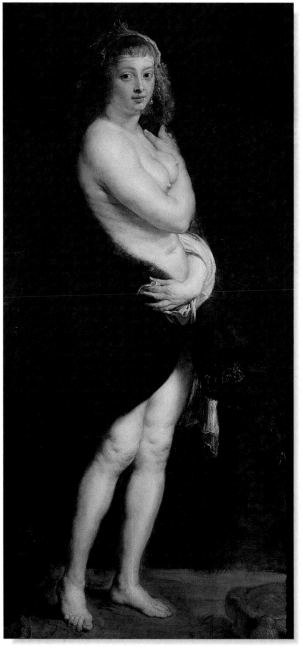

A fluffy towel will enhance your smoothest attractions and can leave the exact shape of flesh you need for your painting.

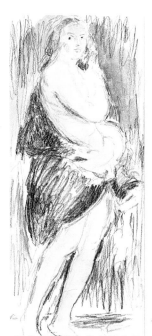

On the underground railway, a girl applies lipstick. In Ancient Greece and Egypt, mirrors were only as bright as you could polish copper. Hand-mirrors were a frequent accompaniment to the figure.

A scribble-copy of Helena After Rubens

Peter Paul Rubens, *Helena Fourment with Fur Cloak*, 1638–40

Self-portrait

JOHN DONNE ENDED A POEM, "Death, thou shalt die." For Bacon, Death was the end. Francis Bacon gambled, and drank champagne, and there must have been many times when he looked at himself in the big, circular, paint-spattered mirror in his studio, sore with a hangover, pursued by The Furies (Bacon read Aeschylus); and other times, elated by a gambling win, when his reflection in the mirror, beyond the paint-spots, was pleasurable, like Narcissus reflected in a pool. Francis Bacon did a lot of self-portraits. Accidents in paint were cherished, but his "accidents" were really more like violent gestures done with a lifetime's experience – a fly-fisherman casting. He did not miss. Willem de Kooning and Jackson Pollock would also set the paint flying at this time.

Most bodies resemble each other, in the main. One way to have a body-compendium at your disposal is to prop up three mirrors and be between them. You will surprise yourself, and unsettle your nearest and dearest. Palliate by inviting them to join you; you then have two models, and an enormous number of reflections. Draw-paint everything; act out useful performances because painting depends as much on acting as does grand opera.

Then do some paintings of your own face (before plastic surgeons make face-transplants general). Move a long-haired brush around as if you know you will be lucky. Curiously, only a little repainting will be needed; intuition, as usual, is in command. Try again, this time beside a large mirror, and use a small make-up mirror. Closely explore your features one at a time, brushing diagrams as you go. Dab at your nostrils, dilate them attractively. Open your mouth, paint an arch of flashing teeth. Tint your lips with cosmetic flair. Do not miss any part of the visage-compendium. It looks different every time.

Put the mirror aside. Imagine you are Narcissus. The pool is as round as Bacon's mirror, the water is rippled, obscured as the looking-glass, blotchy with paint. But however disturbed the water, you know you are substantial, and when it calms, you will be "present". "Presence" was a term much used, at one time – for example, Rembrandt surrounded his subjects with darkness, and achieved "presence". Bacon often used three gold-framed, glass-covered canvases, and would paint the figure in each, at about the size of a reflected onlooker. The floor was painted as if continuous with the carpet of the gallery. They achieved a "presence". My mother, who had been a nurse, said it is a great pity we cannot turn our bodies inside-out. Bacon, who liked a book called *Positioning for Radiography* and another, more colourful book on wounds, would probably have agreed.

After Picasso

The frontal top is combined with a profile.

Skulls in hats

After Ensor

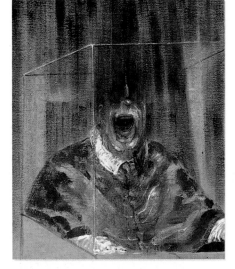

Francis Bacon, *Head VI*, 1949

Oil on a black ground, a free variation on a self-portrait

After Bacon

A free brush drawing of myself

Crayon variation-copies of a Bacon self-portrait. They were often done in threes.

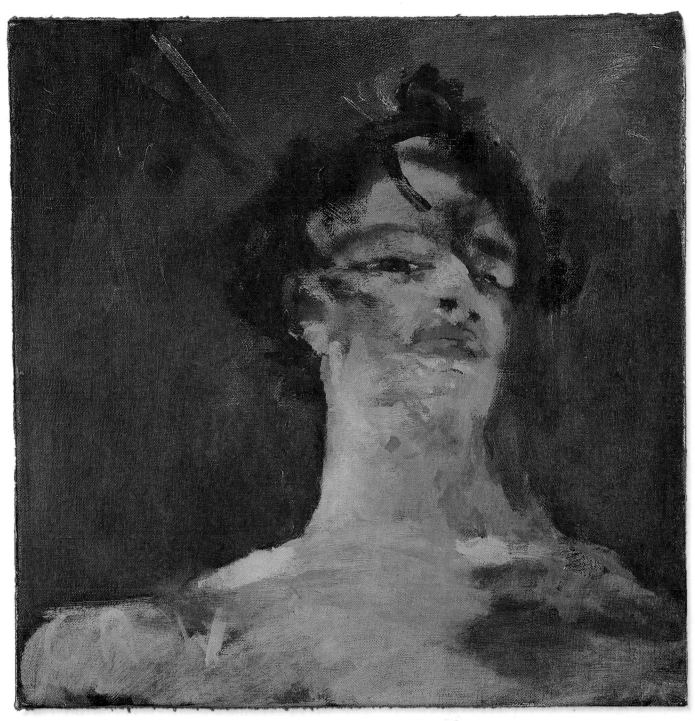

An intuitive, freely-brushed painting

Daniel Miller, *Self-Portrait*, 1977

After Mantegna

After Mantegna

Self-portrait, ear

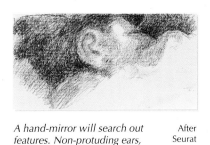

A hand-mirror will search out features. Non-protuding ears, and fundamental regions will require two mirrors.

After Seurat

Self-portrait, nose

Stories

ASKED WHETHER HE BELIEVED in God, Matisse said: "Yes, when I am working." Paint only what you believe in: once you start painting, you will find yourself more of a believer – or more gullible, or more inventive – than you expected.

For about 30 years, Paula Rego has painted the fright and fortune of European folk-tales. Animals are made to act out cruelties and inhibitions. Sometimes, a friend will pose as a toad, and sometimes the stories are Rego's own, impregnable and special. Acrylic is dabbed on paper (later supported on canvas). She begins on the floor, almost as a child might play, but completes the picture vertically. As a child she was safe in her playroom, but the dark corners of the house were grim with terrors: blind mice had their tails cut off with a carving-knife, and far, far worse. Paula Rego says: "When the pictures are going well you just can't wait for the next morning to come. And that's very good. A very good feeling. Painting is practical, but it's magical as well. Being in this studio is like being inside my own theatre."

Today, stories can be told vividly. Although Rembrandt's "Belshazzar's Feast" is a wonderful illustration, it strains our period vision – but not as much as Rubens' "Samson and Delilah". William Blake's Dante watercolours are icicle-crisp and sharp as flames, and some of them are time-free. Stories were left out of painting for nearly a century, but now we do what we like, and we are "narrative" if we like to be. Ken Kiff has led me into many strange grottoes and dells to confront the beasts he imagines. For his "Echo and Narcissus", Kiff used acrylic on paper. Ovid told stories that often fitted the ideas of artists more easily than the big biblical themes. (For instance, it was difficult to accommodate 13 at a long table for "The Last Supper", although Stanley Spencer made it into an exciting picture of feet – or hundreds of toes!) The itinerant story-teller is no longer awaited in the village, yet Coleridge's *Ancient Mariner* continues to hold us spellbound in a book, or when read aloud – and David Jones' illustrations of Coleridge, and other subjects, are superb story drawings.

Take up your brush. Do not fear. Believe everything you tell yourself. You will paint your favourite story: the one that makes you shiver, the one living in the fastnesses of your being and tearing you from the practical.

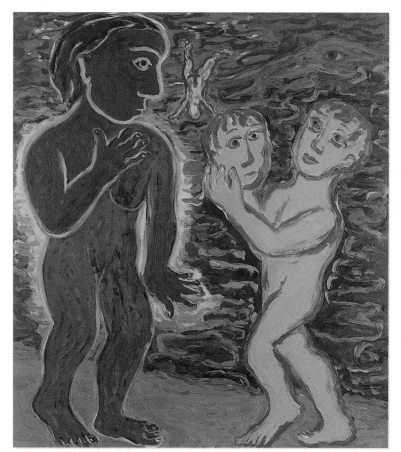

Eileen Cooper, *Woman Surprised by a Young Boy*, 1991

Family life is made up of stories, themes, and surprises. There is no need for any other subject. Remove their clothes, make everybody superb in long, charcoal swathes: the rhythms will not date. Then paint them in strong colours: challenge the stained-glass of the Sainte Chapelle in Paris. As Norbert Lynton wrote of Eileen Cooper: "Paint the family and you end up a 'history painter'. History painting used to be the most highly valued category of art, because it demanded such directorial talents..."

Green is telling the story of his childhood, as remembered in the London flat where he lived for many years. The grandest doll's-houses come apart. Green's flat is no doll's-house, it is furnished detail by detail to be present. The viewer is caught impaled, as on Royal occasions, in a time warp.

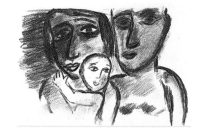

After Cooper

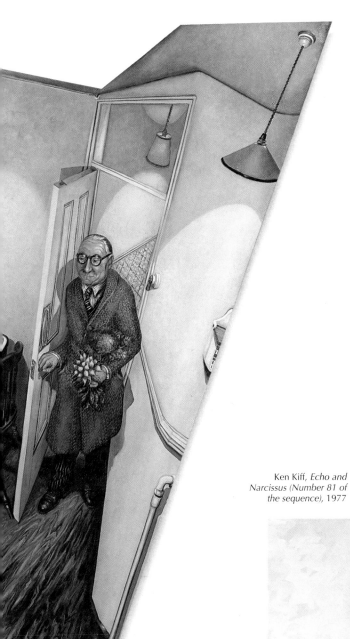

Ken Kiff, *Echo and Narcissus (Number 81 of the sequence)*, 1977

Anthony Green, *Victory in Europe: The Greens*, 1945

The woman is playing with the dog, possibly even telling it a story. The picture's story is of buff, pink, and grey, and it is a little frightening.

Paula Rego, *Snare*, 1987

Gwen John

A UGUSTUS JOHN learned a kind of sweeping line drawing from Tonks. It was swishy and not very useful. It was less slick than Tonks, but compared with Sickert's workmanlike drawings, or the gentle poetry of his sister, Gwen, it was too polished to be good for anything, except its august boast. But Augustus was fond of his sister, and by his example showed exactly what she did not need. She went and found a greater ego in Rodin (an even faster draughtsman, and a great sculptor). She met Picasso, whose enormous ego had a brilliant pencil to go with it. Plainly, surrounded by so much macho puff and virtuosity, she was left only a little space for spiritual retreat: a tiny room, a chair, a softly filtering light falling on a table and a book, a stillness punctuated only by the silent

Probably "Sweet" again

paw-falls of her cats. Her technique for painting was frugal and sufficient and no different from the one she had learned at the Slade. Flax canvas tacked to a stretcher was sized with warm rabbit skin glue, then coated with a half-chalk ground, left rather absorbent. She used only a few primary colours – the main one bright, the others less bright. They were mixed with half-and-half turpentine and oil with more oil added as the painting proceeded. She had been taught to paint tonally, sight-size. But what they could not teach was Gwen's feather-light touch, the delicate crumbles, the pale colours, or the power of her spirit. (Have you ever tried to break a feather with a straight pull?) Gwen posed for Auguste Rodin. It is difficult to imagine him posing in Gwen's cane chair!

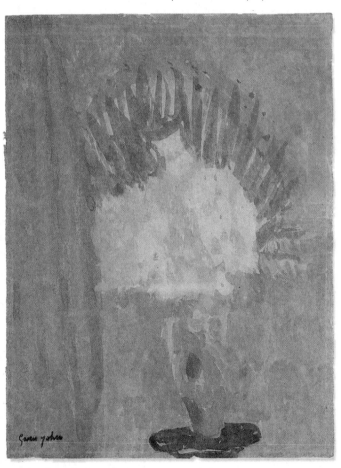

A soft-coloured watercolour.

Gwen John,
Faded Dahlias, 1925

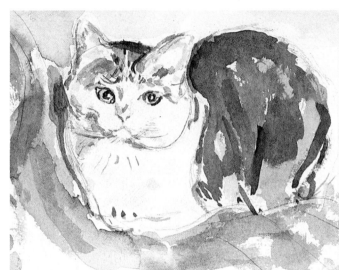

Gwen's beloved cat (called both "Sweet" and "Edgar Quinet"). She would search all night, by moonlight, when the cat went missing.

After
Gwen John

After
Gwen John

The quiet room with its simple contents – a book, a table, a chair, and a view through a window.

After Gwen John

She used dove-soft greys and almost no line, still as a pudding, with simplest composition. The near cheek and a cat's eye are on the middle division, and her invisible breasts half-way up (detail below).

Gwen John, *Girl with Cat*, 1920 (detail below)

Gwen John, *Flowers in a Vase*, 1925

Good Humour at Court

MANTEGNA IS AN ARTIST of serious moods. He painted the family of the Duke of Mantua, in the Ducal Palace. A visit to it can change a painter's life. Swathes of fruit and foliage decorate the castle. The "Camera degli Sposi" is full of painted people. Mantegna must have intensified the lives of the Duke, his family, dogs, horses, dwarf, and servants – whose portraits are uniquely recorded on the walls. Art historians try to discover the identities of those depicted – whether, for example, a small profile portrait in Naples is Francesco Gonzaga, pretending to be four years older so as to be Cardinal Deacon, and shown in Mantua full-face, and grown-up. The wonderful

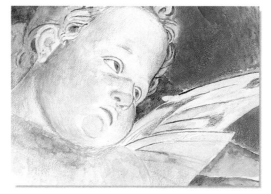

surprise of the "Camera" comes when you look up at a circle of painted blue sky (the oculus) and find Mantegna, the serious painter, in relaxed mood, depicting smiling faces looking down, and playful babies. A gentle comedy of this kind does not fade.

Make a diagram of the ceiling. Its lovely design is unfathomable, but rule up what diagrammatic links you can. Clues may be buried in the cloud. The cloud is concentric, as are many of the forms. Paint with gouache, or oil, some of the Putti against the blue-eye-paradise-firmament. Their butterfly-wings would not keep them aloft without Mantegna's art.

After Mantegna

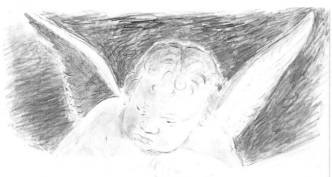

Using wax crayon pencils. *After Mantegna*

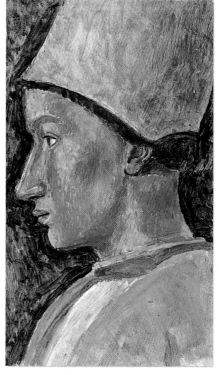

"Francesca Gonzaga". Copy from Mantegna to engage with the structural power of painting. The force that raised Renaissance domes.

After Mantegna

Lucille's baby. Not quite a cherub. Better-tempered, softer. But Mantegna's hardness is beautiful.

Is she a good friend, a servant, a relative? Some light reverberates around the face – it is almost Impressionism. Perhaps she is the children's nurse. *After Mantegna*

178

Andrea Mantegna, *Oculus, from "The Painted Room" (Camera Picta), in the Gonzaga Palace, Mantua,* 1465–74

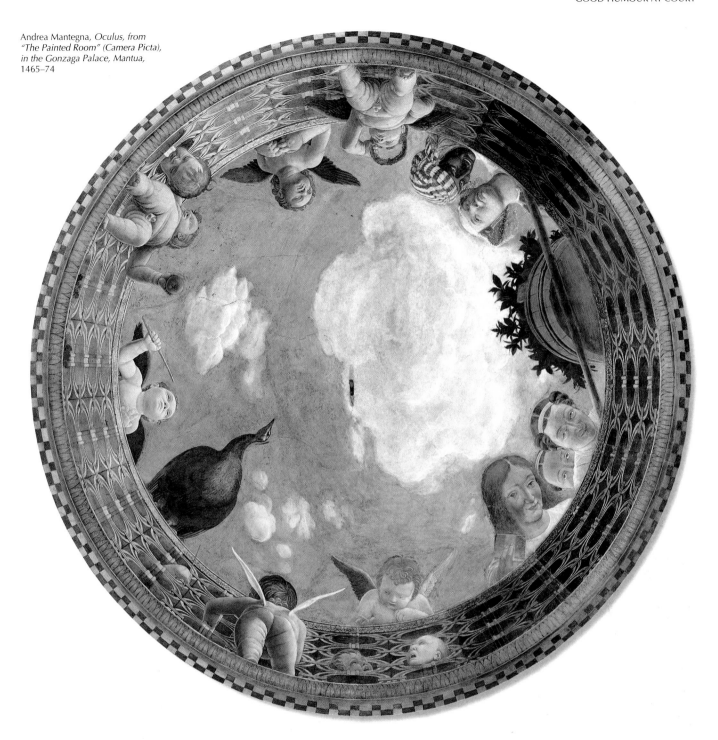

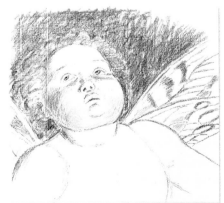

Cherubs playing (using pastel pencils)

After Mantegna

A tracing, to suggest a few of the links you may find. Mantegna fitted everything together with watchmaker precision, and the counterpoint of Bach – and "three pounds of walnut oil".

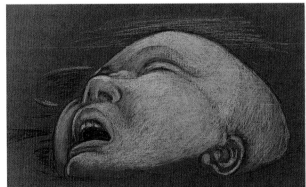

Using pastel-pencils on grey paper. It is possible to buy very soft pastel-pencils. If you use these they require a special sharpener – I used a medium hardness.

After Mantegna

179

Birth

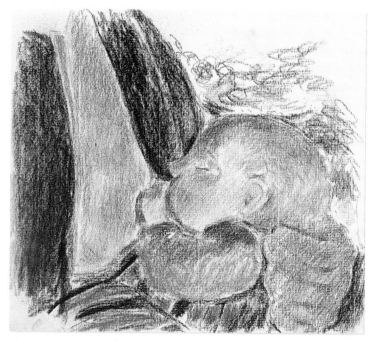

PAULA MODERSOHN-BECKER WROTE: "I know I shall not live very long. But why is that so sad? My sensuous perceptions grow sharper, as if I were supposed to take in everything within the few years that will be offered to me…."

History hurts. We would like to change it, and bring back the gifted who died young – Masaccio, Raphael, Gaudier-Brzeska, Harold Gilman, Eric Ravilious, Christopher Wood – and to know what would happen to their art. Old Master lives were short, compared with present expectations. Centuries are fixed by men, but 1900 seemed like a new beginning. Painters launched on a time of great innovatory painting. The Barnes Collection Matisse, "Joie de Vivre", was a large new painting of 1906. If Picasso had died before he painted "Les Demoiselles d'Avignon" in 1907, would we guess

After Modersohn-Becker

the years of Cubism? Braque would have soothed us. A far worse historical hurt was the death from heart attack in 1907, 19 days after giving birth to her baby girl, of Paula Modersohn-Becker aged 31. For now we do not know how a great woman artist would have painted through the years.

Paula Modersohn-Becker was unique. Women artists of the past (Artemisia Gentileschi, for example) were excellent but thought like men. Paula painted and thought as a woman. She painted a woman's subjects, and what is a surprise, did it with a tough strength. (Mothers have always said girls are healthier and easier to raise than boys; and women generally outlive men by several years.)

She knew exactly what she wanted and needed, and went for it. An extract from Marie Bashkirtseff's diary shows the difficulty of the time: "I know I could be somebody, but with petticoats what do you expect one to do? Marriage is the only career for women. Men have 36 chances, women have only one." But at 21, Paula wrote: "In art one is usually totally alone with oneself. My whole week has consisted of nothing but work and inspiration. I work with such passion that it shuts out everything else."

She had gone to an art school in London when 16, and the Berlin School of Art for Women at 20; lived in an art-village, Worpswede, at 21; attended the Academie Cola Rossi in Paris at 27, and later, the Beaux-Arts anatomy class.

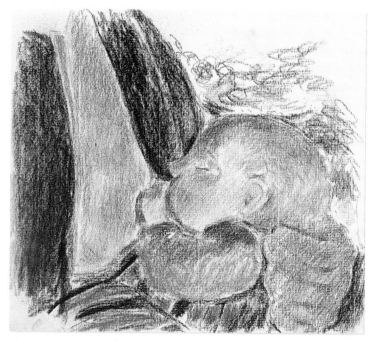

The almost closed eyes show contentment.　After Modersohn-Becker

Breast-feeding a baby

A rough diagram　After Gauguin

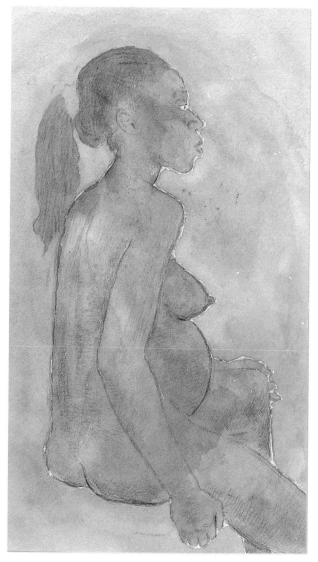

A beautiful black girl awaits her baby. A monumental verticality meets a taut hemisphere.

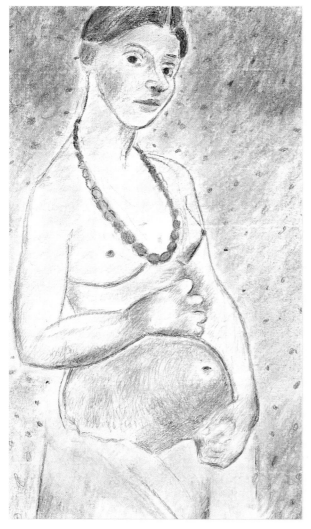

After Modersohn-Becker

A pregnant black girl firm as a gourd or fig makes one think of an aubergine.

After Modersohn-Becker

The diagrammatic way Modersohn-Becker copied was rough, even wayward, but it aided memory and understanding. Try marking as a diagram a Gauguin painting with ten chalky dabs.

The suckling baby is blended into the shadows of Tahiti. Paula was influenced by Gauguin's once-for-ever way of painting.

After Gauguin

Mother and Child

Paula loved Clara Westhoff, who married Rilke. When in Paris, where she went on long visits, she looked at art and found what she needed from the past: the rough, coarse-grained texture in Rembrandt, as well as the many individual qualities of Maillol, Munch, Vuillard, Bonnard, Michelangelo, van Gogh, Millet, Goya, and Gauguin. In the Louvre, she studied sculpture. Her copies were slight mementos – like tracings done with an elbow. But she knew that her open sketches would leave spaces for the swathes of paint she could move with such power.

When she was not visiting Paris, she lived in an artists' colony at Worpswede with her husband Otto Modersohn. They often painted the same subjects. She thought of birches as female, and pine trees as strong men, painted the people in the poorhouse, and peasant mothers nursing babies and children over and over, and self-portraits over and over.

A prehistoric mother goddess

"Through drawing I wanted to feel how a body has grown." (Rilke writing about Rodin: "There was no part of the human body that was unimportant to him.")

"All along", Paula Modersohn-Becker wrote, "I have striven to give the heads, drawn or painted, the simplicity of nature. Now I felt deeply how I can learn from antique heads, how they are seen in the large, and with such simplicity! Forehead, eyes, mouth, nose, cheeks, chin, that is all."

About a favourable criticism Paula said: "The criticism gave me satisfaction rather than pleasure. The real pleasures, the overwhelmingly beautiful hours are experienced through art, without being noticed by others. The same applies to the sad ones." In 1937, the Nazis seized 70 Becker pictures as "degenerate" art. She left some four hundred paintings and about one thousand drawings, and I would like to see all of them.

"An Old Woman".
The rough chalk drawings resemble those of van Gogh using "mountain chalk".

After Modersohn-Becker

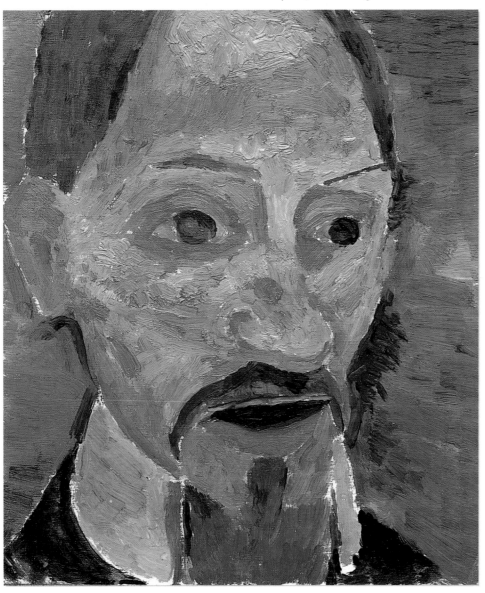

Rilke (who was Rodin's secretary for a time). The simplification resembles the pre-Cubist Picasso, when he was looking at African sculptures, and painted Gertrude Stein. Paula looked at Greco-Roman encaustic coffin-lid portraits – in order to make the "human clay" weigh as heavy as the world.

After Modersohn-Becker

After Modersohn-Becker

"Mother and Child"

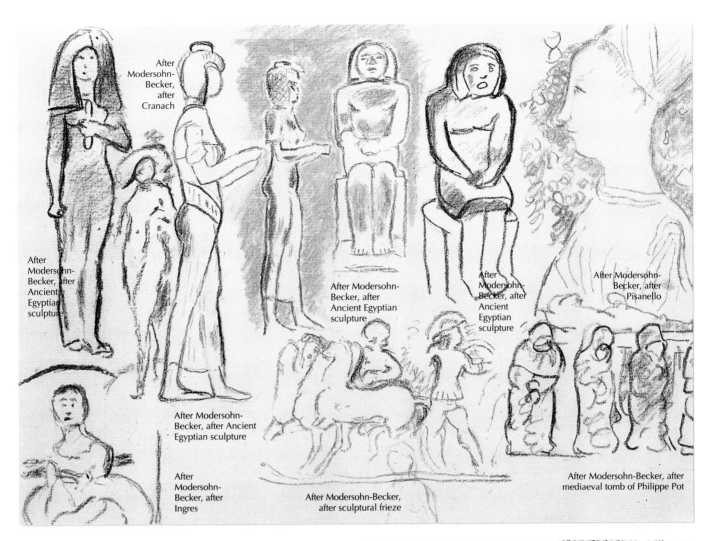

After Modersohn-Becker, after Cranach

After Modersohn-Becker, after Ancient Egyptian sculpture

After Modersohn-Becker, after Ancient Egyptian sculpture

After Modersohn-Becker, after Ancient Egyptian sculpture

After Modersohn-Becker, after Pisanello

After Modersohn-Becker, after Ancient Egyptian sculpture

After Modersohn-Becker, after Ingres

After Modersohn-Becker, after sculptural frieze

After Modersohn-Becker, after mediaeval tomb of Philippe Pot

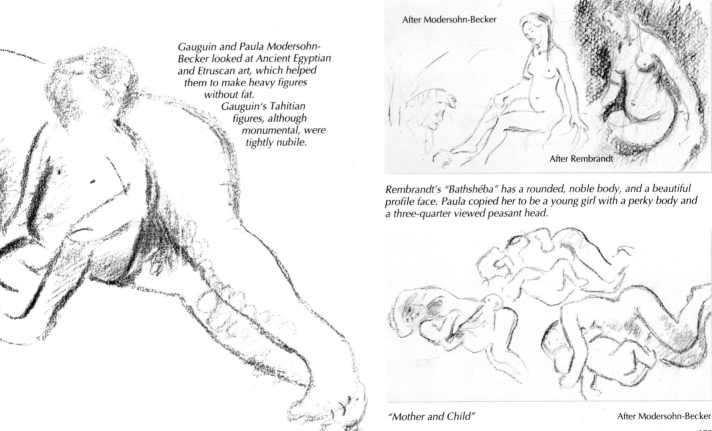

Gauguin and Paula Modersohn-Becker looked at Ancient Egyptian and Etruscan art, which helped them to make heavy figures without fat.
Gauguin's Tahitian figures, although monumental, were tightly nubile.

After Modersohn-Becker

After Rembrandt

Rembrandt's "Bathshéba" has a rounded, noble body, and a beautiful profile face. Paula copied her to be a young girl with a perky body and a three-quarter viewed peasant head.

"Mother and Child"

After Modersohn-Becker

Lively Death and Deep Despair

WHEN TOLD HE HAD got the positions of his fighters wrong, George Bellows said: "It is of two men trying to kill each other." The great painter Gerard David painted a flaying, which I can hardly bear to look at. Titian painted "The Flaying of Marsyas" – which is one of the summits of art. Negro spirituals wail with pain. Initiation ceremonies involve pain. Max Beckmann knew about sufferings in hospital in wartime. Agonies abound, great painters digest them. Carpaccio made a picture of one thousand martyrdoms.

Great art can be cathartic. Poor art makes agony sordid. Michelangelo's "Last Judgement" shows a muscular youth being bitten. There are three to weigh him down. His knees are squeezing, he is in the closed foetal position, protecting his centre. The lowest devil has baby horns, the middle one a nasty tongue and eagle's claws. (A Mannerist mask is roughed-

After Picasso
"Skull" (bronze)

up and made alive.) The warm adolescent is thrust hard-edged against a cold blue sky, doom laden with leaden grey clouds. He has nothing to hope for. He is the ultimate, obvious image of despair, and has haunted me always. My copy misses the suffering, but I discovered some technical ingredients: the chopped-out sculptural coming-and-going of the drawing, which supports the paint; then the strangeness of the fingers. (Rodin's "Thinker" is a distant free-copy.) When images possess such power, the arts seem to come together – and this one would illustrate Hamlet's soliloquy, or breathe with a late Beethoven quartet.

Mahler made death symphonic. Life tilts at death. Munch made a lot of it; his dying relatives drove him alcoholic. Rembrandt's mother, wrinkled as a corpse, would have allowed him to forget death's imminence. Painters keep death in place. Crows came for van Gogh, magpies for Brueghel, a shrike for Bosch, a corset for Matisse.

"Dempsey through the Ropes" After Bellows

"Stag at Sharkeys" After Bellows

A howl from Hell After Michelangelo

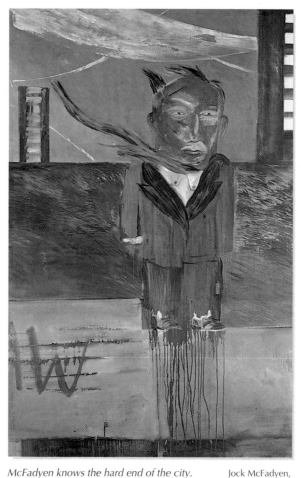

McFadyen knows the hard end of the city. Paint the next nasty thing you see, purge your system. In the north of England they compete at making ugly grimaces. The toothless win. For the adolescent, despair confronts acne, sores, and boils. Francis Bacon painted a moving picture from a Muybridge photograph of a spastic child. Painters shout, and never weep.

Jock McFadyen, *Even Dwarves...*, 1987

Icarus flew too near the sun and melted his wings. Rubens' freshly mixed lead pigment melted flesh into the painted sky. After Rubens

"Death and the Maiden" After Baldung

"Envy" After Munch

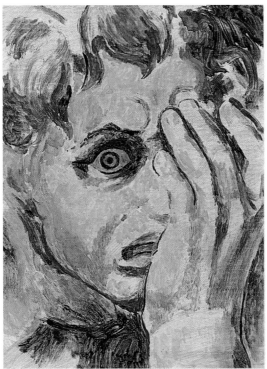

A woman with a dead child

After Picasso

"Self-portrait and Monsters"

After Michelangelo

After Michelangelo

A young man, damned, and falling to Hell – on the end wall of the Sistine Chapel. He had more than acne to worry him. Meet terror with a brush. Paint horror intimately.

After Picasso

Max Beckmann, *Birds' Hell*, 1938

Creamy White Players

RECREATIONS CAN LEAD to a large inventory of forms. Join me to watch cricket on Clapham Common in south London. You need not follow the score! Ruskin started his Italian journeys with sketchbooks, a carriage, and horses, not far from here. We will turn him in his grave. Here, the freezer-bag keeps the cucumber sandwiches cool, the jar of water is at hand, the watercolour box and a sheet of rag paper – "hot-pressed", "NOT", or "rough" surfaced. We will choose "rough". The fine and springy sable brushes are at our command. It only remains to wet the brush, and start the "game".

Be relaxed. Turnover to "automatic". Mess with the paint. Do not fear Ruskin. His detailed investigations were honourable and interesting. But Dürer also watercoloured a hare with every hair in place, an owl feathered neatly, and a lovely clump of lush grasses. Never mind. We will allow ourselves to make a mess, and let the runny colour flow. The white flannels absorb most green at the legs. The parching, orange common turns the shirts pale blue. Perhaps the blue in the sky was a mistake: the blue of the shirts is so pale, it survives no rivalling blue…. Think in terms of rounded splurges of Terre verte and black – then all will become leafy, leafy shadows, and balls of tousled hair. I was caught out when I added blue to the sky. I could remove the blue! I could leave the blue! Feel free to accept, from the vast complications of nature, more than you can control.

Allow the mind to expand, and from the unfinished or empty pieces and from stabs, marks, and blobs attempting the depiction of nature, controlled pictures may one day grow. On this occasion I mean by Nature, all that is visible, sitting on the grass in the middle of this common. An area for the common people, and for a painter, a common source. But commons are not meadows. Humanly grubby commons absorb trash, orange peel, dog poop, Coke cans, cigarette packets, and sun cream. Picasso advised painters of the need to dirty their hands. Rodin arranged for a different prospect: several naked models would move around in his studio, and he would draw them when interested. Janacek would collect street conversation for use in his operas. Seek a richness from which to select and adapt. Common sources give life to all the arts.

When you have nothing more you feel strongly about; when it comes on to rain; when the joggers have run home. When a red bus would unsettle your greens; when pollen has filled your eyes – STOP. Do not fill in. Leave unfinished. If there is a calamity, remove the offending piece with a typist's eraser. Hard watercolour paper will accept erasure using a razor blade or cutting knife, or obscure mistakes using acrylic Titanium white delicately.

Clapham Common, 1984

The child on the left has become displaced. Never mind. If I had not drawn him there I would not have recorded him at all. The girl below him is smoking a cigarette. Some people quickly moved away, leaving me with little more than a nose, or a hooded eye. Some artists are always finalists, but most need to pry around in preparation for their important works.

A pencil drawing becomes full of activity when a background of brown-green watercolour is brushed in. A dog leaps for a stick. A jogger jogs. Discover what forms motivate painters you admire. Look at their history. See how Leon Kossoff, for instance, concentrates on people walking in the streets or underground stations. Then makes surprising swimming pools full of people and copies early Cézannes. See how, in this way, he carries his life's work forward.

A pencil drawing is watercoloured with black. It is almost monochrome. Tiny additions of green and orange make it full of colour.

Flowers and Nudes

FLOWERS OFTEN COME WRAPPED IN PAPER. An unwrapped body is almost as full of character as a countenance. When flowers are unwrapped, some are more like nudes than others. Roses, lilies, and tulips are smooth: they do not embarrass. The unclothed body is vulnerable and meaningful. The mind touches it at every point. It can be eloquent as paint. No cloth, gaiter, or shoe rivals it as subject matter. A bath of nude is flower-like, fubsy, or rude. Try painting a body against a tulip. Fix it so the parts most similar are adjacent; make the colours equal, and the tones and textures equal. Allow your mind to slip. Paint a tulip as a figure, and a figure as a tulip.

Flowers can be enormous. Georgia O'Keeffe painted very large pictures, sometimes of the middles of flowers. The "Two Calla Lilies" could be seen as made of very pale nudes. A very large tulip could be with a tiny naked body.

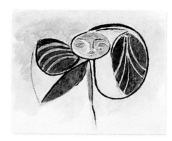

"Woman-Flower"
resembles one of
Picasso's flat ceramics
from Vallauris.

After
Picasso

Lily and nude

The green-blanketed girl resembles a bursting bud.

A flower-like abstraction

Georgia O'Keeffe loved the dry blankness of the hot, red desert, and painting enormous flowers. (A black hollyhock was one metre across.) This picture called "Two Calla Lilies on Pink" is erogenous – like a Mae West invitation to her pink boudoir, without the girl.

After O'Keeffe

Smooth paper and waxy crayon pencils are sleek enough for tulip textures. Hot-pressed watercolour paper is nearly like the China clay-filled process papers that are smooth as nudes.

Beyond the body is a rose bush, and the sea. The bedclothes are like petals surrounding the nude, cream around pink.

Nude drawing

Apple-blossoms bloom so fast, you have to try and draw at Giacometti speed.

Smooth, rhythmic curves make bodies flower-like. Brancusi-smooth and flower-like as the youthful Madonnas of Botticelli.

After Modigliani

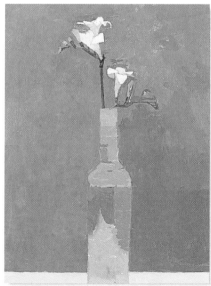

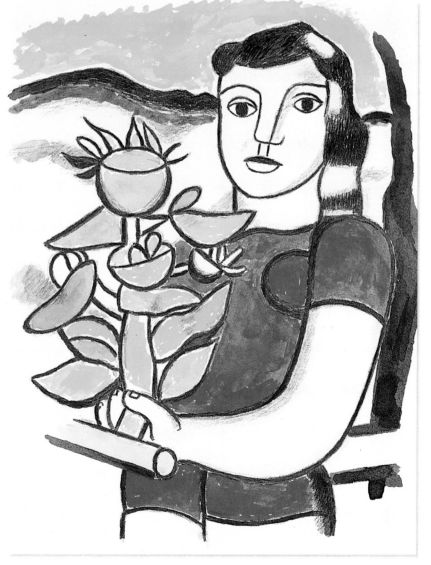

The flower has reduced the bottle to being weightless. The stalk has become important: the effect is stiff.

Euan Uglow, *Orange-flower in Bottle*, 1983

"The Campers". The flower-shapes comment on the girl-shapes.

After Léger

189

STILL AND FAST LIFE

Animals, Objects, and Flowers

THE RISING BIRDS OF LIGHT pass the falling birds of darkness. Birds inspire artists, and cause mortals to flap in dreams. Painters have filled their pictures with angels' wings: without genius, the wings of Icarus (waxed on) will not adhere. The wings of the heavy bodies of painted angels are a problem anatomically: for instance, in Annunciations one set of shoulder blades has to serve both for pointing and for flying! Design some wings. Odilon Redon was good at it. Braque painted hundreds of birds – some were boomerang-shaped, some like paper aeroplanes. Wings can be used to express all moods, from the evil harpies by William Blake, to the sacred pinions of Poussin's "Pegasus". The recording angel in Blake's *Illustrations to Dante* has pale wings; and a devil in hell (Canto 28) has dark, transparent wings, batlike, angular, "draculant".

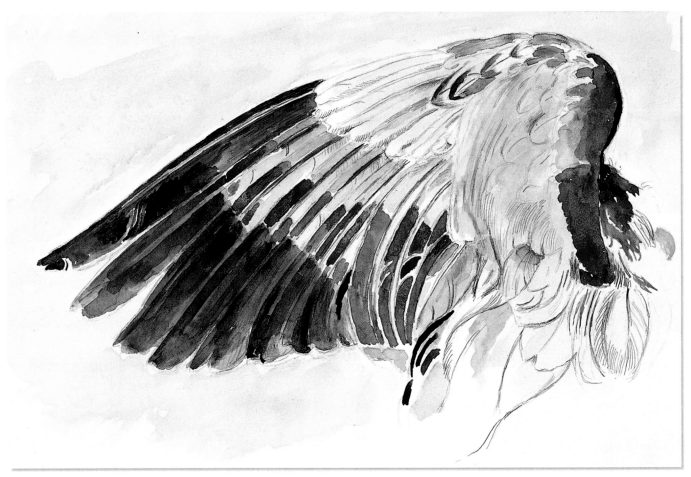

A wing of a blue roller on vellum. I did not make it hard, sharp, delicate, and soft – or detail the tiny feathers sufficiently. I missed the airy secret – the radiating sequences whose exactness enables air to be thick enough for flight. Dürer was even drawing the spines of feathers.

After Dürer

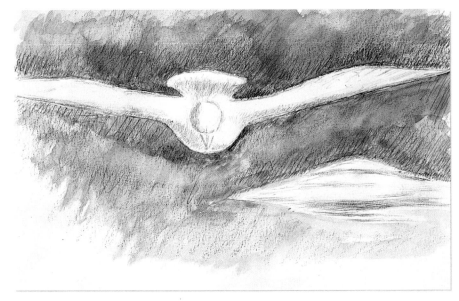

The Dove from "The Baptism"

After Piero della Francesca

190

Magpies

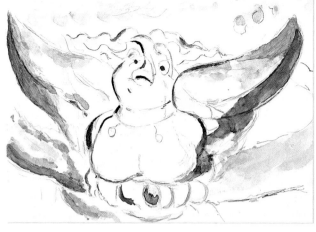

A harpy After Blake

Braque's birds fly with eloquence. After Braque

Dabs become birds

Seagull After Avery *Magpies*

"Les Tenebres". Dark Wings After Redon *Magpies* After Brueghel *Songbirds in snow*

Cats and Pets

After Auberjonois

HORSES HAVE US AS PETS. Picasso petted and painted a goat, cats, dogs, an owl, and pigeons – but our real pets are cats and dogs. You can have pet rats and alligators, but it is not the same. We have adapted to dogs and cats; they even sleep in their owners' beds. Goats, stoats, and hedgehogs are never allowed under the duvet. Cats are fastidious (except for the tom's rancid perfume), and we think we understand them. Cats, if you warm them, will pose well. Black cats, like those of Manet, are easier than white. Carefully manipulate a blob of black, and it will become a cat. Use Burnt umber and ultramarine or other colours for spectral blacks. Cats are tabby, striped, Siamese, slinky, tail-less, dappled, and hairless.

After Bonnard

Try pencilling around the sphinx-like, eagle-like, mysterious presence of an Ancient Egyptian feline sculpture – more monumental and sacred than any other cats. (They mummified cats!)

We owe a lot of great art to the waving tails of cats. How much "Fritz" (Paul Klee's cat) physically did in applying colour, I do not know; but I believe he was the inspiration for many of Klee's paintings. Balthus did a self-portrait of "H.M. The King of Cats". His cats have massive heads, and are important in many of his paintings of young girls. Paint pets! Unlike some infants, they do not mind, and there is much to enjoy. They are not as testing as a torso, but keep the brush moving! Encourage a child to play with a cat and a balloon. When the balloon bursts, you can continue from memory.

"A Cat and a Girl" After Balthus

A screaming cat After Auberjonois

Scribbles of several Bonnard cats After Bonnard

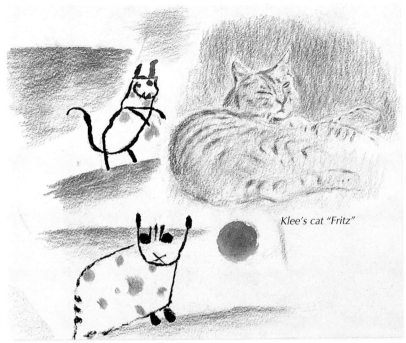

Klee's cat "Fritz"

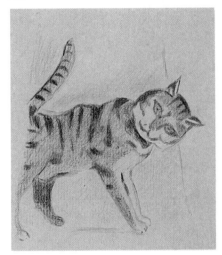

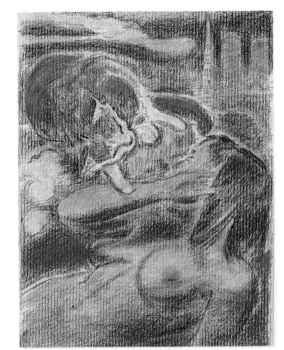

"Pets"

 After Klee

Playing with a cat

After Balthus

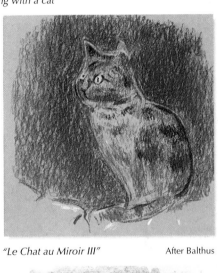

"Le Chat au Miroir III" After Balthus

After Ensor

As Ensor became older in Ostend, he became eccentric. Perhaps he looked at Hieronymus Bosch.

After Bonnard

An early, almost Art Nouveau design

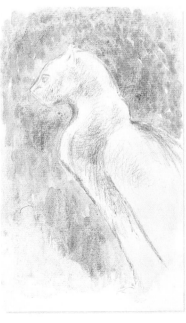

An Ancient Egyptian sculpture

Horses

ONCE THERE WERE HORSES EVERYWHERE…. It was the horses' day off at the stables, except for one. She would pose for me. A bay. I wondered if a naked man on a horse would seem special. It was: they brought a potent symbolism with them. David sat without a saddle; the thighs encircling the horse's back were tense. The horse looked at me in a boss-eyed, disconcerting way. The willow leaves pointed all ways, and met the nettles, willow-herb, mullein, and blackberries; beyond were the boletus-toadstool-shaped, deer-nibbled oaks of Richmond Park. Picasso did gouaches of youths and horses (probably from drawings of circus people). Horses are difficult. Degas, Géricault,

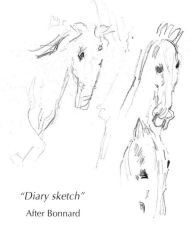

"Diary sketch"
After Bonnard

Delacroix, Seurat, and Stubbs kept quite close to their appearance, but Chinese horses can vary a lot; and one of Bonnard's last works would have surprised Stubbs.

George Stubbs made a book of horse anatomy after cutting horses up in layers. The smell must have ensured privacy. The famous vine at Hampton Court was planted with a dead horse to feed on. For a bay-coloured horse, use Burnt sienna, an earth colour, a low-tone orange of great versatility.

Try scrubbing from thick to thin; but be careful when adding white – unless you want lifeless, doughy, flesh mixtures.

In Bonnard's diary are scribbled memory-aids for his penultimate painting, "The Circus Horse". Laugh at my messy diagram-copies, and discuss with me. Has he painted his last self-portrait as a Pagliacci-clown-weeping-horse, whose skull-eyes are confronting the artist when he was young, brush in hand? Bid farewell to Bonnard, acting in a sweet nightmare, with a winged dream horse; an image which haunts and dwells in the mind. Try copying this vision – an accretion of tentative scrubs of paint – and good luck be with you.

In the gloom as I left the bath, a tiny mirror caught a crinkly, wrinkly old horse's eye. My reflection.

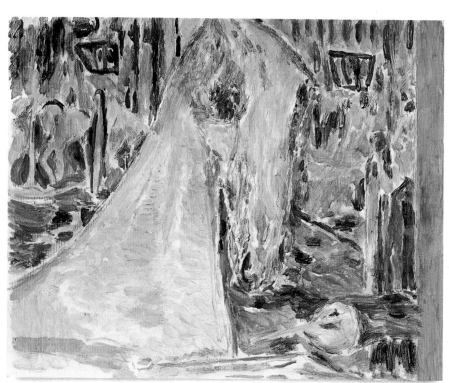

"The Circus Horse"

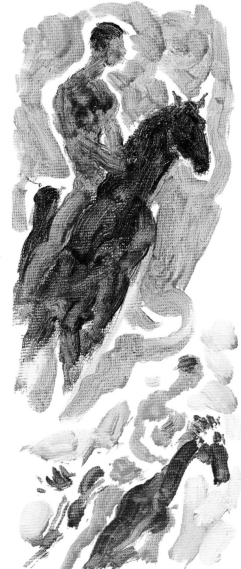

After Bonnard

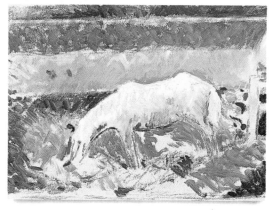

After Seurat

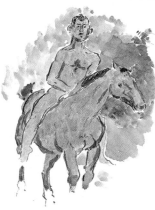

Youth on a polo pony

When you have tried all that the colour can do on its own, try adding yellow or red to Burnt sienna, the results are astonishing.

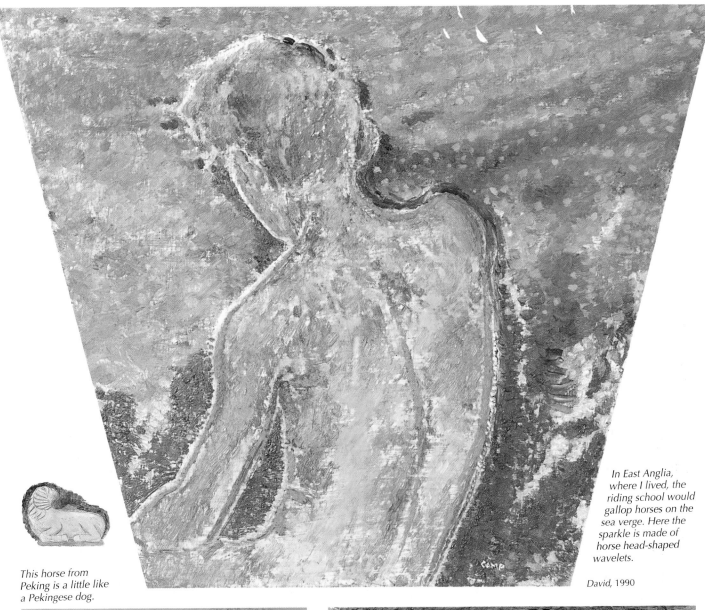

In East Anglia, where I lived, the riding school would gallop horses on the sea verge. Here the sparkle is made of horse head-shaped wavelets.

David, 1990

This horse from Peking is a little like a Pekingese dog.

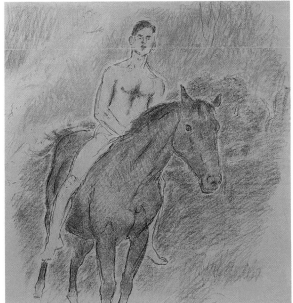

David on a horse

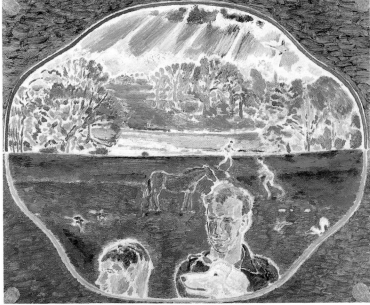

A Horse near the Serpentine, 1992

Race Horses

CARS ARE ADJUSTED, wetted, and polished, and horses are wetted and groomed. Their smell does us no harm. Despite the robots of the Twenties and Léger's "Art Méchanique", advertisers are unable to make cars love back. Horses have long eyelashes, and floor teenage girls with their soulful frantic eyes. The whites of the eyes are surprisingly far back. Horses are difficult to draw, but easier to paint. Colour in the centres of forms first, as these change less than the edges of the silhouette. Look at a book of Géricault's horses, George Stubbs' *Anatomy of the Horse*, and Muybridge's *Animals in Motion*.

I went to Sandown Park race-course to see the horses. Not such open country as Newmarket, but there were wide views from the stadium. I felt the racing life was

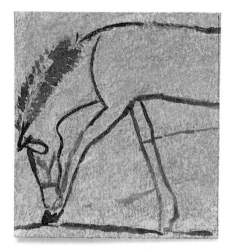

After an Egyptian brush drawing

in some ways a version of all human activity. Binoculars covered much of it: the place where the winner was greeted; the toffs; the owners; the trainers; the punters; and the jockeys in pretty silks – some young, some shrunken.

Scribble-sketch the cars, the picnics, champagne, beer tins, fish and chips, and the bookies. The gamblers standing indoors surrounded by television screens and thick smoke are depressing to behold, as they yearn only for money. I had a vision of the "Night Mare" whinnying through an art world of collectors and dealers. It was time to go and stand close to the lush grass of the track. The "field" galloped by me in one-hundredth of a second. I remember the blundery hooves, whips, and tails. Stubbs and Degas would have known what to make of it.

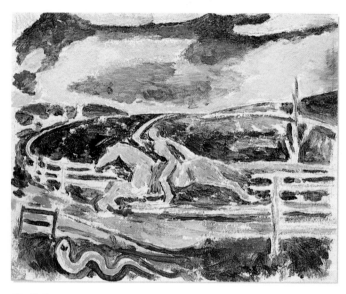

After Ryder

Albert Pinkham Ryder used all kinds of makeshift techniques, resulting in cracking and yellowing. His "The Race Track" or "Death on a Pale Horse" compares the sharp curve of Death's scythe with the roundness of the course. The time-track of life where all are ultimately coursed and scythed.

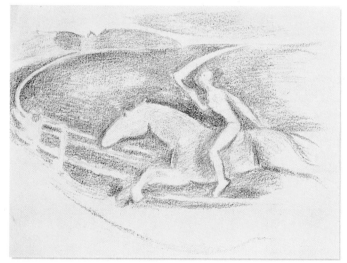

After Ryder

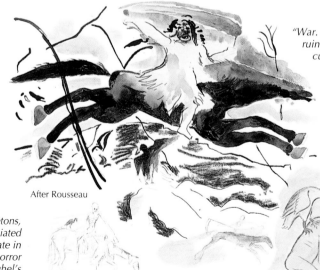

After Rousseau

Scythes, skeletons, and emaciated horses excruciate in tumbrils of horror in Brueghel's "Triumph of Death".

After Brueghel

"War. It passes, terrifying, leaving despair, tears and ruin everywhere." Henri Rousseau painted a curious Russian story involving a chestnut horse dyed black; inspired at the same time by "The Apocalypse", where the fire and sulphurous smoke issuing from the horses mouths, and a like power in their serpent-tails, kills a third of mankind. Ravens with bloody beaks obey the loud angel who tells all the birds to eat the flesh.

Painters of a certain temper have seemed to enjoy painting Hell, and knew what went on there. Medieval art is rich in "Dooms"; here, birds are shown enthusiastically biting the impious.

After the Angers
Apocalypse tapestries

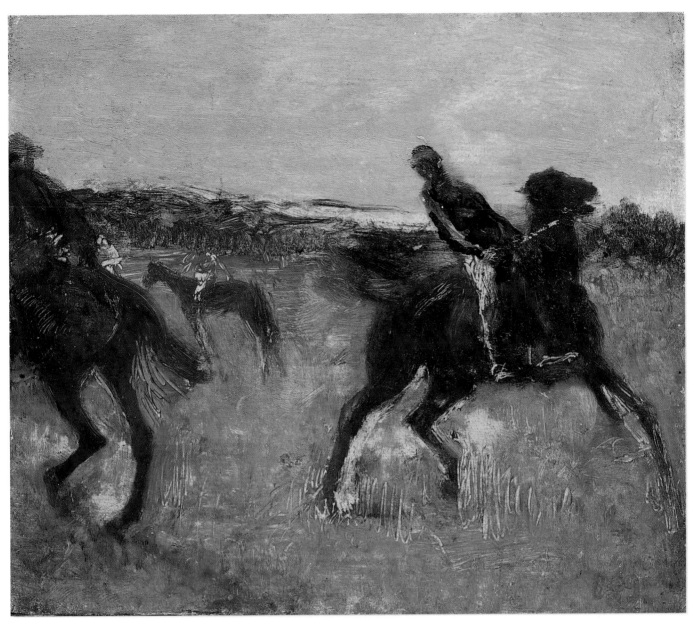

Degas uses the pointed end of the brush for bursting energy. Eakins and Degas were among the first to know (by photography) how horses really moved their legs at speed. Muybridge used banks of cameras with trip-wires, but scratchy paint is faster than photographs.

Edgar Degas, *Jockeys*, c. 1890

A long neck speeds up a gallop.

After Auberjonois

Draw with hurtful Indian ink lines from photographs.

Pegasus and the 'Oss

AFTER BEING A STUDENT AT EDINBURGH, I painted the lush, undisturbed Suffolk countryside. My paints, rag, palette, brushes, and even the painting – all of which I carried in a basket – were warm in the sun, and I felt part of the hedge and the high grasses, the air thick with pollen. While I sat deep in umbellifera and nettles painting, a man invited me to see his collection of pictures. They were hung frame to frame, every picture was of a horse – he said he "knew an 'oss". I expect his aesthetic appreciation was slight, so it is fortunate he did not see my painting of "the noble creature". I felt rural: dug a celery trench, rushed from tree to tree, dabbing fast as the buds burst into flower. I followed a horse as it moved around a field. In those days, my sheets of paper became filled with detached hooves, manes, fetlocks, and other pieces of horse.

Happy the horse! Adored by girls, the noble horse, with whom no boyfriend can compare. Paint with watercolour the loved, lovely eyes, which make the jodhpured swoon.

Roger and Angelica, and a fine, winged horse

After Redon

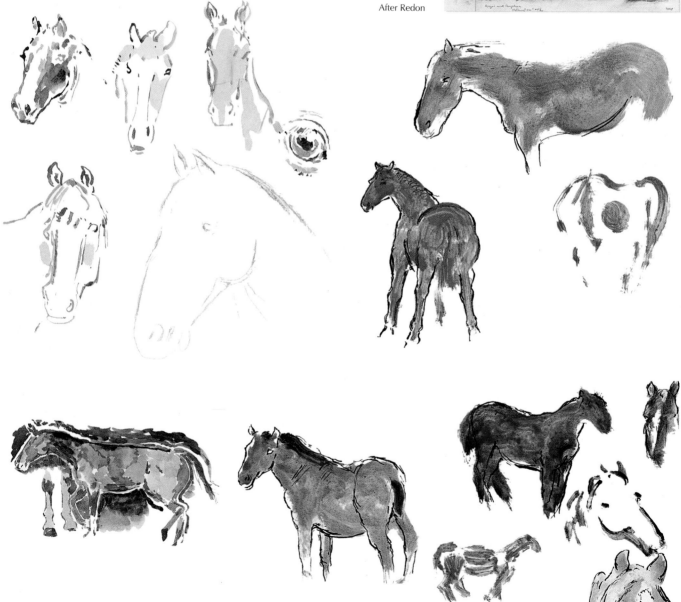

Thinking of Bonnard's diary sketches, and his advice about moving a pencil with ease, do sketch-drawings at a good pace, while looking at a large book of horse photographs. Keep up a flow, using a dryish brush, if you like, or a pen. Look at Eadweard Muybridge's Animals in Motion *– too small, but seeing a sequence of movements can help in arriving at an image. Degas and Eakins found these sequential photographs useful.*

This winged horse, Pegasus, looks somewhat Chinese.

After Redon

Pegasus. The stables breed for speed, while the artists design sunken eyes.

After Redon

After Redon

A nocturnal being, of the White Goddess/Night Mare family, perhaps?

After Redon

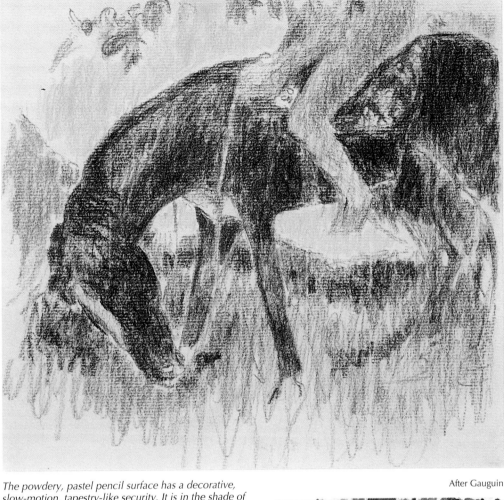

After Gauguin

The powdery, pastel pencil surface has a decorative, slow-motion, tapestry-like security. It is in the shade of hot sunlight. In the original, small strokes of colour are painted on a canvas almost as rough as sackcloth, but not so hairy. (When canvas is too hairy, stretch it, and pass a flame across it fast, and do not set it on fire!) Because there is little gesture, Gauguin and Bonnard depend on the colours buzzing on the spot.

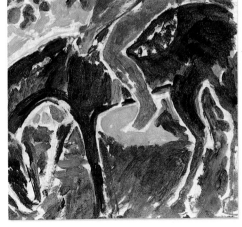

The paint marks are too active for this rough daub to look like Gauguin. Many paintings work by moving rhythms vigorously through and across the picture. Animals invite a galloping application. Munch and Manet have made horses gallop towards the spectator. There is a Courbet in Munich of a riderless horse which crosses the canvas dramatically.

After Gauguin

The soulful eye of the horse

That house filled with horse paintings had none more important than by "Sartorius". This rough is about "Hambletonian", a famous racehorse of the time, by the great artist Stubbs.

After Stubbs

Lurchers, Pigdogs, and Mastiffs

WERE THE CHINESE able to enter the lives of their subjects? Well, they concentrated on the lives of snails in ways pop-artists never did. David Hockney's dachshunds care nothing for dogs on television. Some of us pursue sights as urgently as dogs smell trails. London transforms yard by yard, glance by glance; as Cézanne said, "Only turn the head and there are many subjects". The city is a smell-paradise for dogs. Do they care for the smells we smell? Coffee, croissants, fried bacon? Perfumes and Thames mud? The triggers of emotion are mysterious. William Blake wrote: "How do you know but ev'ry bird that cuts the airy way, is an immense world of delight, closed by your senses five?"

D'Arcy hunts a thrown ball so fast he almost disappears, then returns triumphant. At other times he is still as a lizard, instantly entranced. Paint with animal urgency.

D'Arcy rests

Jock McFadyen owns a fine poodle, George. He is McFadyen's watchdog, and keeps his dog forms right. Two dogs smell. They symbolize degradation but are themselves actually overjoyed by the odour trail. Litter is offensive to the upper classes, but McFadyen's pictures are bought by nobs for safe slumming. The gemlike cars and houses are remote enough to be charming.

Jock McFadyen, *Copperfield Road*, 1990 (detail below)

Draw a dog. Some dogs can be asked to keep still. The entranced state D'Arcy drops into seems to be like the painting state. Trances can be entered fast or slow; films show Matisse drawing quickly. The lizard may be still but its tongue is fast. Be aware: the lurcher of the imagination is a greyhound. Except for the nose, a dachshund is not like a wolf; and except for the peeing, a wolf is not like a pekingese.

After Mantegna

Susan and D'Arcy enjoying the night air.

Dogs, bone-formal, in the "Camera degli Sposi" in Mantua.

D'Arcy at night. London and St. Paul's in the distance. The side panels declare that he is indoors, the haloed edges of the dog allow the sky dabs to fall back from the animal who is in a monumental pose.

D'Arcy in Islington, 1992

D'Arcy running at full-speed. His owner, daffodils, clouds, ocean, even the dog itself, are demolished in the energetic clifftop rush.

D'Arcy Running, 1992

Owls

GOYA'S OWLS accompanied witches, and when Shakespeare wrote of mysterious foul deeds, he shook nature with storms, while owls screeched. Owls are symbols of wisdom, are quiet as a falling feather and possess tiny brains. Picasso had a pet owl. It meant that any pair of circles could be brushed into being an owl, whenever he did not want them to become a skull, or one of his popping-eyed late self-portraits.

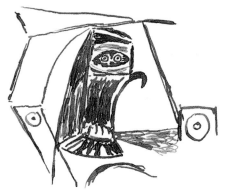

Pen-copy a pet owl After Picasso

The top part of a decoy. (The tethered owl is on a long pole, carried by a boy.) After Goya *A conjuration of owls and witches* After Goya

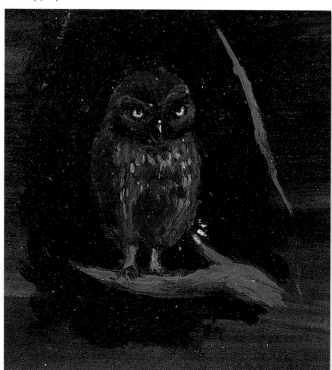

A wise owl. In humans an owl-look does not denote wisdom. Standing with a deep grey streaky ground, paint an equal dabbing of grey of the same darkness for the body. Flick in the breast feathers and eye with creamy white. Then paint with darks until the bird looks ready to hoot. After Bosch

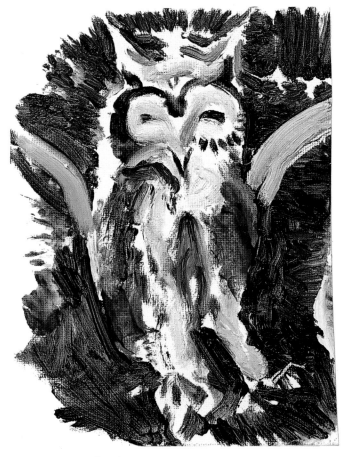

Paint a tantric sexual oval, topping it with two circles for eyes. Make a flying bird-shape become a flesh-tearing beak. Let the brush take charge: like a decoy owl on its string, it will go in for the kill. Hardly more than a doodled pair of circles with an oval, and you have an owl to play with.

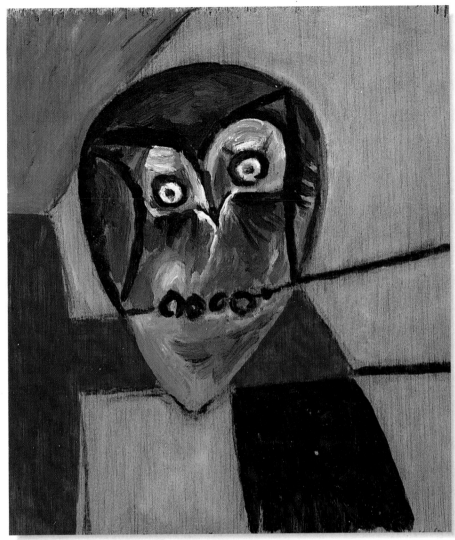

After
Picasso

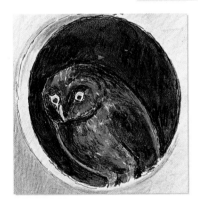

After Bosch

Dab into wet white:
skulls become owls,
sometimes.

After Picasso

Penned and crayoned skulls

After Bosch

An African mask, with circles
for supernatural eyes.

After Picasso

Cats sometimes resemble owls
and accompany witches.

Fish and Crustaceans

AT BIRTH WE CRIED AT THE DRY AIR. Fish out of water gasp. Water attracts us. To see fish alive, visit the Brighton Aquarium, gloomy after the brilliance of seaside light. Its old tanks are conducive to drawing a strange eel, or a Nursing Shark. Light may come from below, which is eerie, and the eye of a spectator seen through a tank is like an extra small fish in a shoal. Michael Andrews braved aquaria kitsch to paint schools of tropical fish. On television, fish perform so well the "box" seems to fill with water. Fish are strange. (Even stranger when

brought up from deep water.) Klee, Redon, Picasso, and Matisse painted fish in all their strangeness, as wildly as in nature. The fish of Hieronymus Bosch fly people through the sky. Soutines's herrings are about poverty. Choose from the often magnificent still-life arrangements on the fishmonger's slab. Most kinds of fish – lobsters, prawns, oysters, and crabs – have been painted superbly by Chardin, Ensor, Goya, Picasso, and Braque – but never Cézanne. I expect fish did not stay fresh long enough for him to complete his slow pictures. Goldfish in bowls circulated continuously for Matisse.

After Picasso

After Picasso

After Picasso

After Picasso

The surprise of their tiny circle eyes combines with their ravenous mouths for Picasso comedy.

Painted with a succulent affection, and few colours. The touch has followed the spiny sliminess, and climaxed at the large dark eyes.

William Nicholson, *Gurnards*, 1931

Fish carrying people. So exact is the Bosch world we believe his dreams. Copy and do not make them comical.

After Bosch

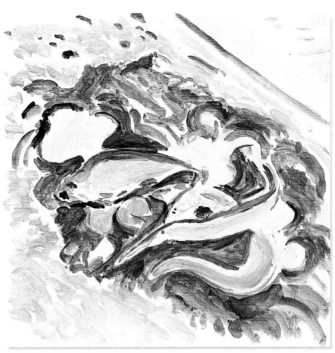

The catch spread on the beach. By an obliging fisherman perhaps.

After Matisse

Marouflay (stick) canvas to wood. The flatness of the surfaces are emphasized. The small head begins a sequence of overlappings within the picture.

Mackerel, 1971

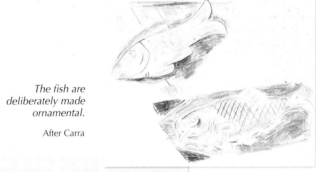

The fish are deliberately made ornamental.

After Carra

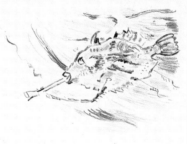

Fish are comical. The large lips and round eyes are funny. Sharpen greasy crayons and try a Trumpet fish.

After Ensor

Herrings symbolize poverty.

After de Chirico

The Nursing Shark

The eel resembles an aunt who is an "old trout".

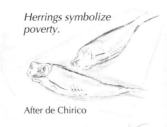
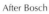

Sunflowers

THE SIGNS FOR PUBLIC HOUSES named "The Sun" have human features and flame-like rays. Van Gogh gave up preaching, and spent his last ten years tuning in to the brightness and life-giving force of the sun. Do not look at the sun: it blinds. Through blackened glass it is boring. But feel its warmth waken your bones.

Make diagram-drawings and scribble paintings of van Gogh's sun-marks; the beautiful daubed rounds of close yellows, creamy oranges, and apple-greens. He was endlessly inventive, no one can copy the sun and see.

In a picture, the sunflower is a symbolic face as powerful, and as paint-shattering as the sun. Van Gogh gave Gauguin two pictures of sunflower heads in exchange for his picture of Martinique, then relentlessly filled the rooms in the Yellow House (where Gauguin was to sleep) with six sunflower masterpieces.

Aspire to beat the sun in your picture, let colours batter each other until they glow like beaten gold. The van Gogh sunflowers, as we remember them, are bright yellow; but in actuality, they are mainly ochres. Matisse painted the sun black. A yellow house need not be round to be the sun.

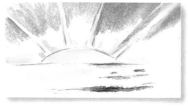

After Blake

Sunflowers have been subjects for John Bratby, Georges Braque, Norman Adams, Paula Modersohn-Becker, Piet Mondrian, Emil Nolde, and William Blake. But when Blake came to the end of his wonderful series of illustrations for Dante's vision, his feelings rebelled; the mystical white rose of chastity, which supports the Queen of Heaven in glory, became a sunflower, sepalled and dishy as a flying saucer. It is well worthwhile to copy. Examining William Blake's Dante designs, copy-follow the body-forming rhythms of Blake's imagination that urgently contruct Earth, Heaven, Purgatory, and Hell. Like most of us, Blake was more puzzled by Heaven; the highest points are less lusty. Pencil-scribble lines; strengthen, swell, and sharpen, using a tiny brush. Follow the vision, which gradually takes charge. Like the plots of William Shakespeare, these night-gowns, from Gothic sources, and Michelangelo engraving-derived bodies are second-hand. But Blake is world-shaking.

Picasso said: "It's the sun in the belly with a million rays. The rest is nothing. It's only for that reason that Matisse is Matisse – it's because he carries the sun in his belly."

The rough shapes on the right are shown to be sunflowers by the circular flowers on the left, sunflowers at night are mysterious: as are eclipses.

Sunflowers, 1993

*A whirling
sunflower
becoming a
flaming sun.*

After
Paul Nash

*Graham Sutherland
found swelling forms
and ogees in Blake,
which he could use.*

After
Sutherland

*The sun descends,
jackdaws fly roughly,
like fragments of burnt
paper in the wind. The
feather flutters, random in the up-
draught. Use light, broken marks,
for a subject that is little heavier than
clouds. Clouds are a pretend steam bath
for the reddening sun.*

*Beachy Head, Sun,
and Feather, 1989*

*Late, eccentric
suns by Giorgio de
Chirico. The dark,
distant sun is
connected to a lighter,
closer sun on the easel.*

Other suns

After de Chirico

Sunflower heads

*Diagrams of over 30 corn circles. Whoever did them, they suggest
sun-engendered forms.*

The Queen of Heaven in Glory (Paradiso Canto 31)

After Blake

Sun-diagrams that move and rotate

207

Daisy

DISTANCING BY OVERLAPPING is especially hazardous when subjects are not easily recognizable.

Unwittingly trendy, throwing pollen to the wind, the child wore a daisy-chain. I wanted to paint daisies and clover. Both are small. Nurserymen have bred daisies to be large, and in many colours, but I like the common daisy. This year daisies throve. No painter has painted clover; with eyes baby-high I overlapped flower over flower; recession on the level. It did not work! The clover looked like chrysanthemums.

"Chrysanthemum" After Hokusai

In most landscape paintings where the eye-level is low, some overlapping is involved.

Plain and muddled daisy-chains:

A *Seen end-on, no-one would know it was a daisy-chain.*

B *Daisies in chains.*

C *Wounded daisies await enchainment.*

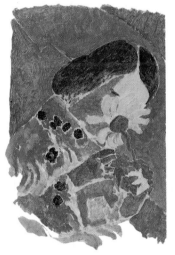

"The Resurrection, Cookham". The revived girl in Cookham churchyard buries her face in a small sunflower, or big yellow daisy. Most flowers can be thought of as having faces.

After Spencer

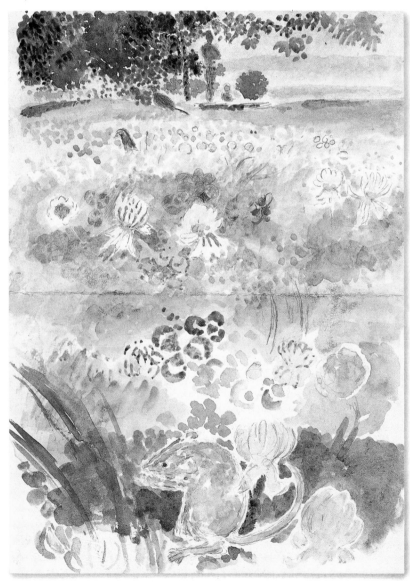

The clover's size is made clear by a mouse.

Daisies look their natural size, because dandelions have not been bred large. Clouds of daisies like starry meadows mirror the Milky Way.

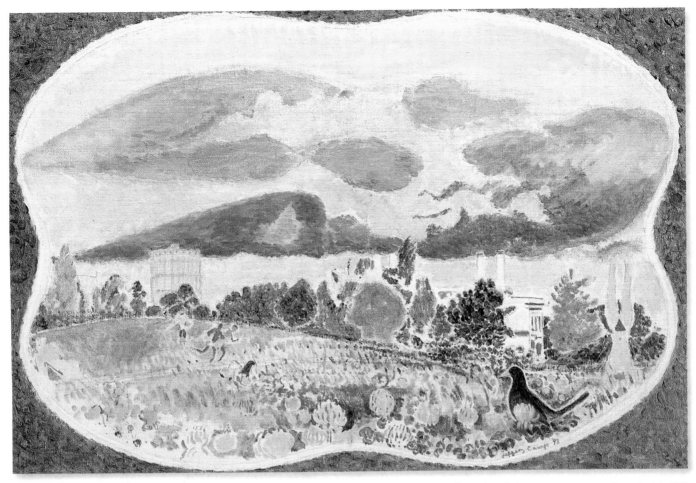

Although Gainsborough planted water-ducks so he could put them in foregrounds, close-ups are still rare in painting, although frequent in photographs. Corot played safe, treating the middle distance as the foreground.

Battersea Power Station, 1993

Daisies, 1993

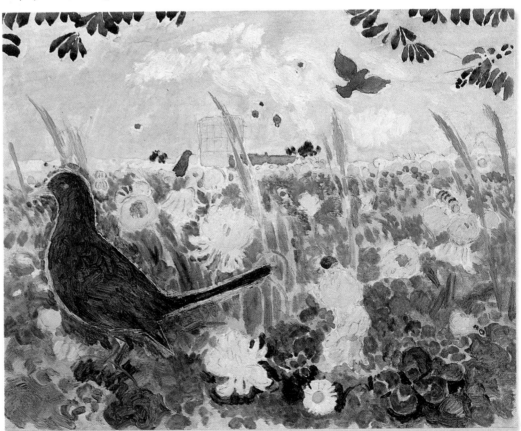

To make the clover appear its proper size, I introduced a blackbird. A cockney blackbird's "manor", grub-rich daisy and clover embellished – a bird paradise. Paint him black enough and he might sing.

Roses

WHEN ANDY WARHOL silk-screened Marilyn Monroe, the erotic lips were squeezed on to canvas, over and over. There were red rosebud lips for all. Fashion designers are much kissed: after clothes shows their cheeks are lipsticky and high with perfume. Renoir and Balthus painted roses as if they were the girls of their dreams. Picasso had a rose period but rarely painted roses. Corot painted a rose as sumptuously as Chardin painted raspberries.

Rose buds, sharp edged with watercolour

Inhale the rose heavy air, and paint a rich, deep, red rose, with Cremnitz or Underpainting white, over a copper-coloured priming. Matthew Smith might have used "Maroger's Medium", we could use a thixotropic gel. When the rose shape is set, sweep in the luscious transparent plum and mulberry colours. Permanent rose is cleaner than Alizarin crimson, but not as dark. For the depths of the flower, use Cobalt violet, Manganese violet, or Mineral violet.

Permanent rose and Permanent magenta are light-fast. Even when pale, Genuine rose, Madder, and Rose madder deep have stood the test of time. Rose doré is a paler, slightly scarlet form. The Madder plant is getting rarer. Use it only for enchantment.

Historians divide time into periods, "Ages" of Stone, Iron, Bronze, and then came times for Glass, Plastics, and the Media. Warhol lived in the Media Age. Andy was a personality of massive media dissemination. Like Dali, he had been a window-dresser, and used every media-means to make himself known: the press, film, radio, books, magazines, television, and the reproduction and repetition of photographs. Images were printed in paint: Marilyn Monroe was dabbed and squeezed through a silk-screen. Having Marilyn repeated a lot of times on a traditional, primed canvas from the Warhol Factory was good for selling to museums, and to the rich. The pictures were tasteful. Silk-screening flattens automatically, and flattening has been one of the easy ways of making art look advanced. The repetition makes a pattern. A Warhol is easy to recognize and looks decorative. Shocking pink, acid greens; cows, giant flowers, and for the serious viewer, motor accidents and electric chairs. Wow! That was the Media Age. Now for ours. An electronic era? A rose is a rose is a rose – a Gertrude Stein reminder.

A rosehip. In autumn, roses are full of surprises, wasps, hips, earwigs, and falling petals.

Rosebuds opening, soft pinks against orange chalks

A soft, old ash-pink rose

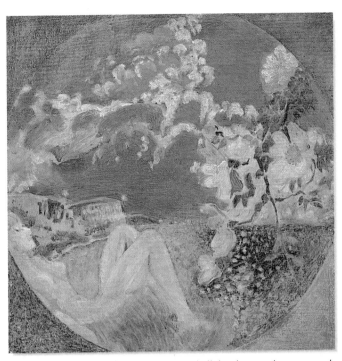

A wild rose by the sea. Rub and scrub until all the shapes edge up to each other, and clouds allude to knees, and breasts allude to petals, and the softness of summer haze is flower-like in the circular format.

The old rose is angular and concave.

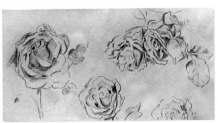

After Balthus

Lips

After Corot

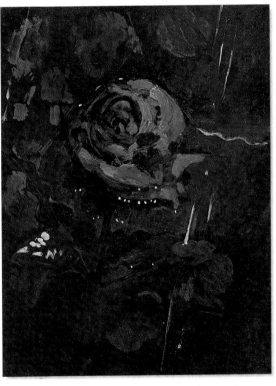

The rose is not having an easy time; although not sick, it is being soaked by rain. Drops are forming necklaces on its petals and a flying worm is approaching (only partly visible).

Roses can be eloquent, petal-sweet or maliciously thorny.

After Warhol

A frightening, repulsive flatness occurs if lips are pressed against glass.

Grasses and Moths

GRASS CAN BE SCRUBBED in casually, or be an assemblage of grass-blade-shaped brush marks. If you care as much about the wonder of it as van Gogh, it becomes a tragic meditation. (His letters tell of the pain of red and green, and he painted poppies severely red against the grasses.) But grass is complex and can be treated like portraiture. Stanley Spencer and Albrecht Dürer knew the way to do this, and would paint each grass as a separate subject, of graceful filaments. Sometimes, van Gogh would almost fill his picture with grass, looking down on it. I have made grass less heavy. It is possible, on cliffs or hills, to see grass from below. It is dry and light as froth, and softens the margins of rivers. Try some light gouache over grey, or fill the interstices with water or sky colour. For filaments and flecks, you might use masking fluid (a rubber solution that peels off). The pale shapes left can be modified afterwards. Edward Bawden, Paul Nash, Eric Ravilious, and others scratched in dry and wet watercolour and used wax crayons as resists.

Sit in the long, blowing grass on the cliffs near the sea, and touch in the tiny seeds and distant yachts. Do not disturb the dozing moth. Moths are mysterious – silent and camouflaged by day, and at night, harmlessly disturbing. They are furry, like tiny mice, with crawly legs and feelers. They flutter in the grass. Some are fast and small enough to enter a nostril or water an eye. Odilon Redon was inspired by real moths to invent imaginatively.

Scented herbage of my breast
Leaves from you I yield, I write, to be perused best afterwards,
Tomb-leaves, body-leaves growing up above me, above death,
Perennial roots, tall leaves – O the winter shall not freeze your delicate leaves,
Every year shall you bloom again – out from where you retired you shall emerge again.

Walt Whitman, *Leaves of Grass*

Whitman was thinking of those slain in the American Civil War, pushing up the grass.

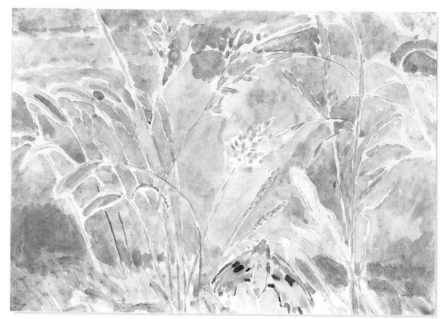

Foreground grasses, and a moth. The grasses increase the vibrancy of the blue.

Moth and Grasses, 1993

These complex overlappings in the views above and below must be done clearly, each item presented somewhat obviously, in its characterful shape: jackdawy; appley; grassy; yachty; lighthousey; skyey; seay; finally, painterly.

Cut an apple in half and pencil in the many tiny items around it: jackdaws; grasses; yachts; the lighthouse; a knife; another painter; a seagull…then fill in around them with small brushfuls of background colour until it looks real.

Beachy Head, Grass, and Apples, 1993

Real artists follow their desires. Inveigled even to play with subjects as light as thistledown. Daniel Miller has not feared to follow this dead moth's camouflage – a merge of pink and brown, almost disappearing into twilight greys.

Daniel Miller, *Moth*, 1993

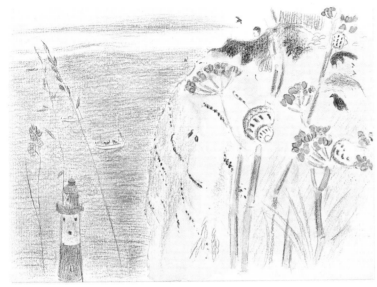

Grasses over the lighthouse, Beachy Head. The cliff, like an immense convexity, subtends the hollow space.

Beachy Head, Jackdaws, 1993

On a wood panel – all is done by suggestion. At the top right are the leaves of a horse chestnut tree. The picture could be continued.

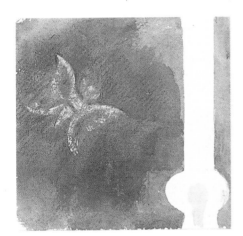

The moth hovers, made frantic by the oil lamp. It is almost weightless, painted with a pale dragging brush. Balthus painted on rough surfaces. His slow rhythms make for quiet moods.

After Balthus

Redon would wander from form to form. After looking at living moths, the mysteries would thicken. Browns joined pinks or reds on umber nights.

After Redon

Shine

LEONARD MCCOMB is aware of tradition, and enjoys working within it. He has made the rarely painted aubergine exist as a "Still Life". McComb works within the easel-painting categories of the last 200 years: Still Life, Portrait, Landscape, and Nude. He does not get his categories

The aubergine shape resembles many other subjects – slugs, leeches, beetles, and hedgehogs.

Sacred sculptures are oiled and stroked smooth by hands. Constantin Brancusi rubbed and smoothed his sculptures to a keen finesse. Gloss is attractive. In the old days, enamelling was called "coach-painting". It involved doing a lot of rubbing, and using sun-thickened linseed oil, or stand

mixed, as I do. Usually, McComb places the main subject close to the centre of the picture. The categories have a long history. Remove the storyline and altarpiece framework, extract the arrows, and St. Sebastian becomes a Nude. Remove the figures from Giovanni Bellini's "Agony in the Garden", and you can call it a *Landscape*. Steal the blue cloak from the Madonna, and a cushion from Christ, and you have a *Portrait*. Remove everything else from a Signorelli reredos, and a Still Life full of fruit remains.

oil with varnish, and the longer it took to dry, the better. Lead, cobalt, and manganese driers might weaken the paint film.

Slick gloss is unpleasant, but armour by Giorgione shines beautifully. With your discriminating eyes, paint an aubergine, dark and glossy. And perhaps, if a beetle scuttles by, paint it large and scarlet. Or if a shiny lacquered "Beetle" car comes by, paint it any size you like. The traditional categories are all-embracing. Use a gel, or the oil-vehicles of the past – and may your subjects shine!

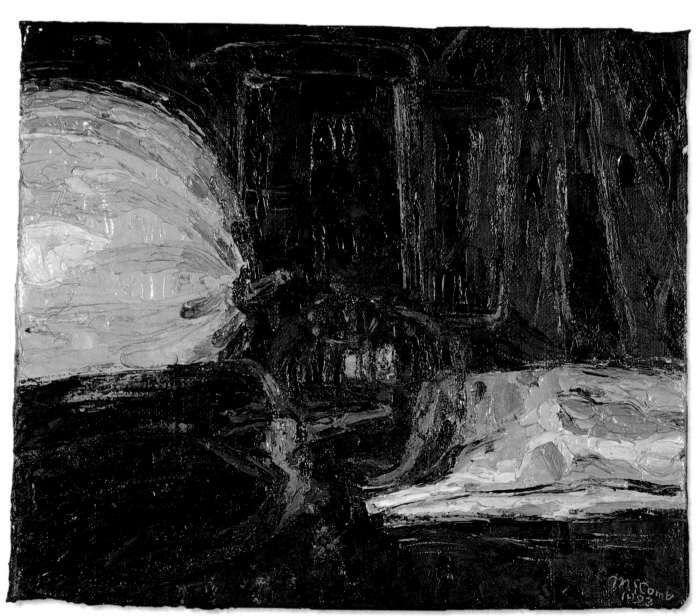

A thick, rich palette-knifing of aubergine-coloured paint. On the fruiterer's counter, it shone with wine-black brightness. Painting with knives is painting with shines. (But, with beeswax added, Mary Potter made pictures that did not shine.)

Leonard McComb,
Aubergine, 1994–95

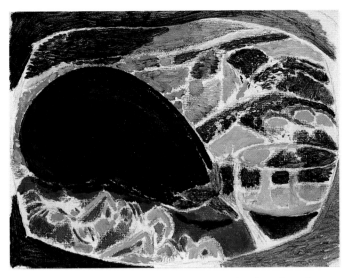

My aubergine is accompanied by two affectionate heads, a glass of stout, puddles on the cliffs, and the sea. It is done using the very poisonous Emerald green, which Cézanne liked to use.

An Eggplant

After Matisse

Hen's eggs decorated with figures. Painter friends who were given boiled eggs for tea by Patrick Symons, were encouraged to decorate an egg for Easter. With a small brush, see if you can ornament a simple, perfect, natural egg. Passionately. If you cannot incorporate the whole Easter story, paint a celandine, king cup, or buttercup. The unprimed eggshell surface is enticing, the surface-area of an egg is surprisingly large. Try painting with a brushful of golden Cadmium yellow, as if it were the yolk.

Every time we take the top off an egg there is a surprise: delicate as a flower. Real eggs are much deeper surprises than Fabergé eggs.

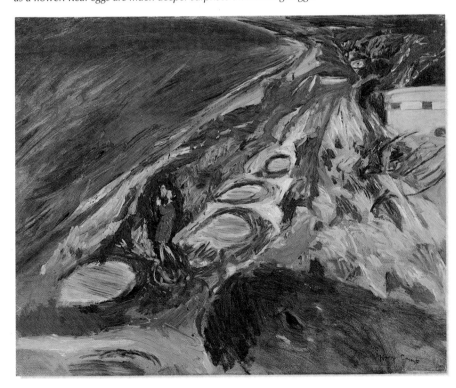

Blobs beginning to look like ladybird beetles. They swell to suggest plumpness. If shines had been added they would have blown up like balloons.

Puddles on the cliffs are egg-shaped, but flat ovals naturally tend to become plump. Puddles must be kept flat.

215

Manet's Last Apple

IT MIGHT HAVE BEEN THOUGHT A "STUDY" if the painter had been young. But it is one of Manet's final statements. Pencil copying is fast, copying with paint is technically demanding. Do it elaborately only to help in penetrating the thought of a painter you particularly admire. On a simply primed surface, think with brush in hand, aiming at discovery.

A little before Manet's grisly end in 1883, he painted an apple on a plate. I hoped, as I copied a little piece, that I would find its quick, bright, oily secret. I felt the ease of Goya and Velásquez. I made it almost as swollen as a fruit by Edward Burra; a cross between an apple, a grapefruit, and a melon. It made me thirsty. After a lifetime making grand figure compositions, Manet painted violets, asparagus, clematis, an apple, and a lemon, each on its own. Courbet may have been the first to do a pear alone. Somehow it seems, by doing these subjects in isolation, a new awareness in painting was born.

An apple seems a modest subject, but it will test you. Pose the apple simply. Mine is against the sea, a near-circle in a near-square. Paint your apple robustly. It will not look like mine, or like any other painted apple. Think of all the pippins painted by famous artists. Scribble-copy from Milton Avery, Paula Modersohn-Becker, Giacometti, Picasso, Manet, de Chirico, Matisse, Balthus, Magritte, Cézanne, Klee, Renoir. They all look like apples. The essence of apple is secret. Artists may think they know the right conditions for its distillation. But good pictures of apples are rare.

A sculptor's drawings. Follow with a small brush and thin grey paint.

After Giacometti

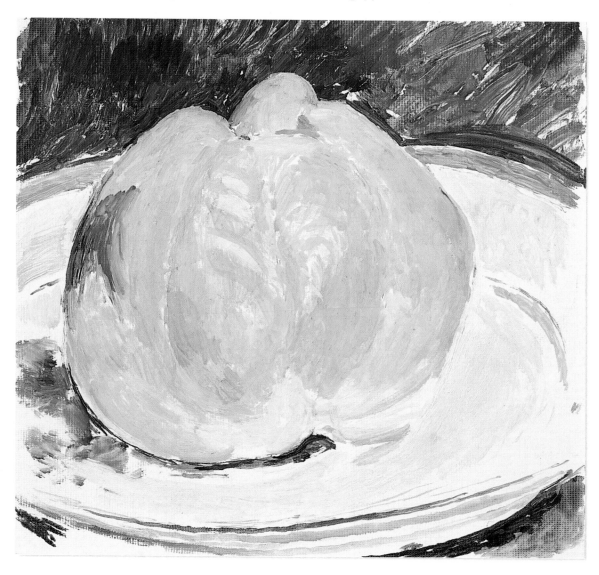

After Manet

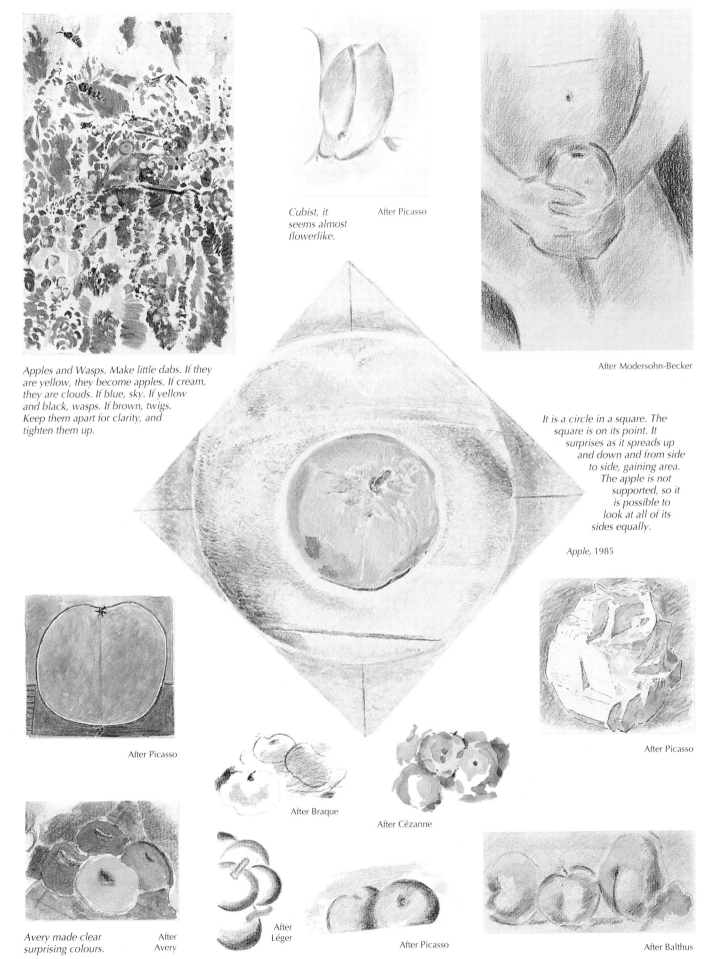

Cubist, it seems almost flowerlike.

After Picasso

Apples and Wasps. Make little dabs. If they are yellow, they become apples. If cream, they are clouds. If blue, sky. If yellow and black, wasps. If brown, twigs. Keep them apart for clarity, and tighten them up.

After Modersohn-Becker

It is a circle in a square. The square is on its point. It surprises as it spreads up and down and from side to side, gaining area. The apple is not supported, so it is possible to look at all of its sides equally.

Apple, 1985

After Picasso

After Picasso

After Braque

After Cézanne

Avery made clear surprising colours.

After Avery

After Léger

After Picasso

After Balthus

Apple

PATRICK GEORGE SAID IN 1994 that although his measuring way of thinking had not changed, he did not now make arm's-length measurements so often. Vermeer used a camera obscura. William Coldstream and Patrick George did not. They looked carefully, and believed what their eyes showed them. (The resulting pictures were scarcely as soft as Graham Bell, or designed as hard as Seurat.) George thinks two-eyed, measures one-eyed, and paints a solution. When an apple is close, the eyes see around it a little. I wonder what would be the effect of a prolonged viewing, wearing widely-spaced prismatic lenses? Would we see extra-stereoscopically? A distant view, seen upside-down with your head between your legs, is surprisingly spatial. Patrick George marks out an apple with feeling, to be non-scrumptious, no show-apple, and naturally green as seen. And he paints in quick perspective.

Here is a tract, a credo: an inoculation against obscurity, the ubiquity of puffed, fixed, developed photographs: those shiny seducers, which Degas, Sickert, and Hockney squeezed life into, at personal hazard. Photographs contain a lot of information you do not need, and little which is useful, while a good paint-drawing contains all that is needed and little else. Polaroids attract and engender sloth.

Painting directly from a subject is demanding. I have worked longer than was comfortable in windy, cold, or excessively hot places. It is good to look a long while at something special. The subject fixes itself in your mind like a nest full of eggs which may hatch soon or late. Making art is rarely comfortable. Even in the studio something will ache, or be difficult to see. Out-of-doors, aiming for verisimilitude or precision in the teeth of a howling gale can be agonizing.

Paint fragments of a bitten apple

Apples oily on black

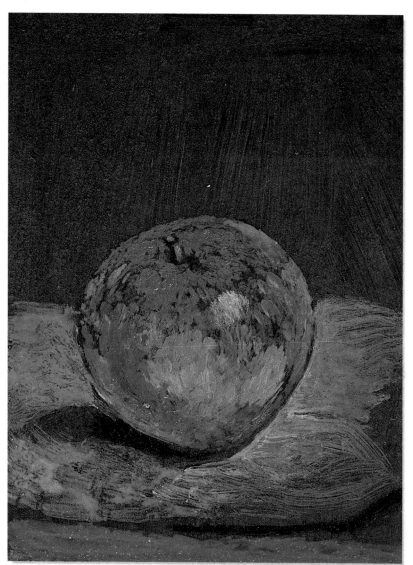

Paint glowingly, close-tonally, on a dark ground without white.

Make fat, tart, lemon-green dabs radiate, like a star in a faceted circle, within a raw, umber oblong, framed within a rectangle.

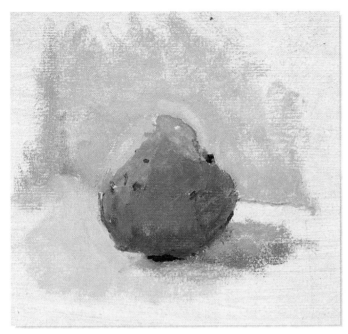

Patrick George's apple. The voluptuous fruit offers itself to the artist, who gives it a careful viewing, and with long practice in looking, brushes it in drily; and dismisses it, with as much juice as it had before, and curiously present on the cardboard.

Patrick George, *Apple I*, 1994

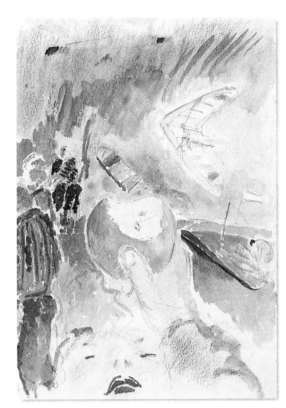

Apple and Hang-glider, 1991

Hang-gliders, high on Beachy Head. The wind whistles through the fingers, harness, and rigging. By the sea, when waves become large enough to be spectacular, conditions are brutal. At Beachy Head, for hang-gliders to soar, the wind must be strongly from the South-east. (The bigger you are, the bigger the kite must be.)

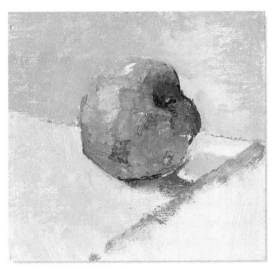

Patrick George, *Apple II*, 1994

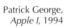

Seaside apples

It has been said of Cézanne that his paintings were done with the tip of the brush. Certainly, his touch was sensitive. He may have used the responsive "mongoose" hair brushes (mottled grey and fairly springy). Meaningful touches are only possible if the paint is of just the right consistency. A carefully prepared canvas helps the paint to leave the brush consistently.

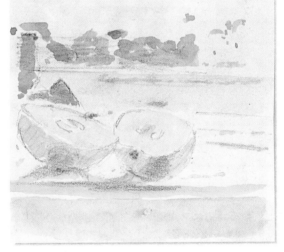

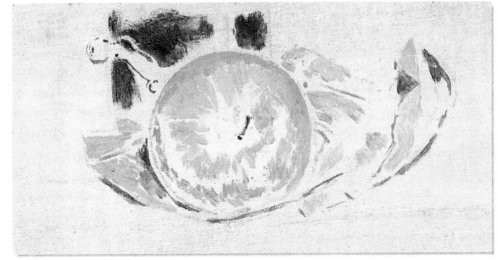

Lemon

IMAGINE, IF YOU WILL, a solid lemon, flat. Paint some lemons. They hang on black twigs in Italy in winter. On a small, rectangular canvas, previously brushed with Lead white, with some brush strokes of Zinc yellow, white, and transparent Golden ochre, caress and form a lemon shape. Dab it with little strokes, thinking in terms of circles of various sizes, each trying to escape. Then do something similar to the background, dabbing in circles as if each were trying to nudge the fruit. Make arcs at the corners of the canvas, thus preventing the background slipping from the level of the lemon. (It is as if you were tucking the lemon up in bed, and making it secure in its picture.) Concentrate. Paint carefully, and all will happen intuitively, even beautifully. Paint at your natural pace.

Matisse used Lemon yellow at its brightest. Lemon can be modified subtly towards pink, with Permanent rose, or towards green with Light cobalt green. Think of the rose-tinted glasses on the lights of St. Mark's Square in Venice – golden posies against the sharp mystery of the lagoon.

Paint a lemon as flat as you can. It is ovoidal, with cones pointing away from a central sphere. Examine possible colours. Lemons are dimpled, and move through the spectrum, from Monastral green towards Burnt umbery-lemony-orange. I have described a lemon: solid, ripe, and sculptural. But you desire

Little Renoir-like dabs

flatness, because flatness allows the colour to shine bright and clear. Imagine a garden roller has squashed the lemon flat to become bigger in area, and pictorially closer in size to that of a real fruit.

Next, place a lemon on a surface. Perhaps you can describe the shape of the shadow – a long half-moon, with added half-moon additions at each end, and a straighter variation beneath. You will see, after this description, that painting is not easy to describe in words. If you are dismayed by the shadow, hang the lemon up by a thread, or arrange it, free from shadow, on glass. For another lemon exercise, cut the lemon in half. Its segments form a radiant rose-window of juice, like solid juice hanging in space. Braque painted lemons with thin, transparent paint; this was supported on a dark ground containing particles of powdered cork, sand, or sawdust (this prevents the paint running down). You do not have to paint a shadow. (Gauguin said shadows were "optional".) Dream a lemon. A lemon dream is less an exercise, more an inspiration – which is learning's goal.

Renoir caressed lemons with small strokes of a brush and Matisse found cursive, casual ways of drawing on canvas with charcoal so that this, the brightest yellow fruit, could be used for areas of explosive colour. Cézanne and van Gogh enjoyed using Chrome yellow and Chrome orange.

Expanding and contracting marks

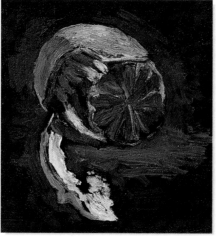

Semi-transparent paint over black

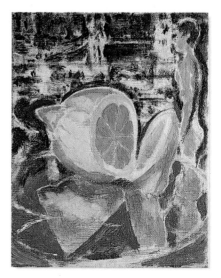

Reflections, and a yellow lemon gleams in the night.

Tower Bridge Lemons, 1986

Charcoal energizes even pale yellows.

After Matisse

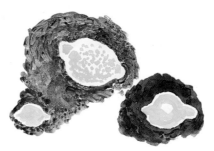

Painting lemons by painting backgrounds

Various brown-yellow mixtures

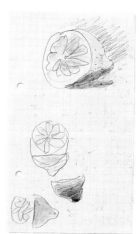

Exploratory scribble-diagrams in the manner of Claes Oldenburg

Opposite: the cut surface of a lemon – almost trompe l'oeil.

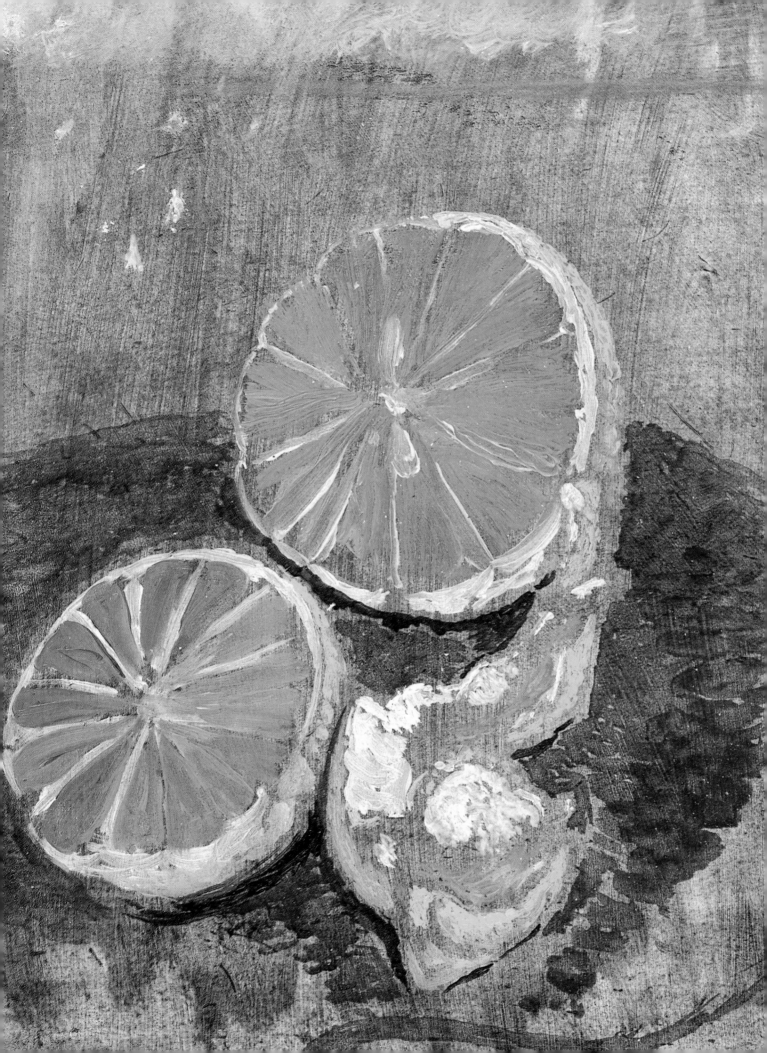

Pear

THE TWO WARS SPOILED MY PARENTS' LIVES. Claude Rogers said his life had been blighted. Harold Gilman escaped the enormous slaughter of the First World War, only to die of the great influenza epidemic that followed. In the boredom and blight of war and its aura, fear stalks sensitive artists. William Coldstream, reacting against the specious dealer-led Parisian arty painting of between the wars, invented and developed an unprecedented way of painting. Using arm's length measuring with' thumb and pencil, closing one eye,

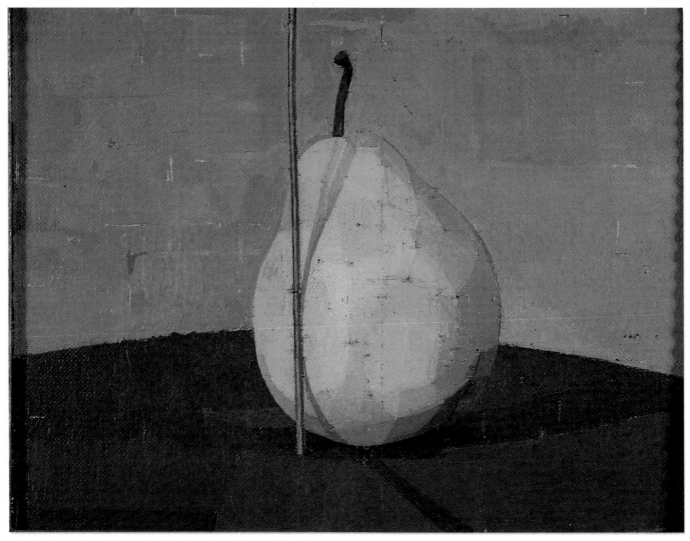

he made cautious, continually adjusted touch-diagrams, which gradually became sensuous pictures. He accepted certain limits of colour, gesture, and design. The measuring marks, cutting the cone of vision, might be vermilion. He painted some very fine portraits during the 1940s, very slowly.

All measurements of Time are disturbing and frightening: watches, clocks, pendulums, and the hourglass "Sands of Time". The measurement marks invented by William Coldstream are the marks of his decisions in time, the spore of his fear.

Euan Uglow, *Oval Pear*, 1974

I have looked at Euan Uglow's painting of a pear for 30 years. Its measures continue to move me. He has always painted pears: they are the cornerstones of his art. He makes strong pears, marking them as a sculptor points stone, establishing safe eye-holds and nodal points. He uses the same process

for a nude, a duck, a loaf, and the things chosen are mostly rounded and are placed against flat backgrounds. Seurat wrote: "They see poetry in what I do, but I just apply my method."

The shadow cast by a blue steel rod is plotted meticulously. The rod implies a central stalk, a visible spine. The whole is like a strong girl with a healthy complexion.

Euan Uglow, *Pear*, 1982

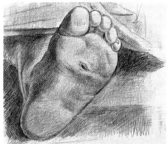

The dead Christ's big toe is pear-shaped. It is from imagination. After Mantegna

A flat pear, which, except for its context, could be a toad or the back of a woman. After Braque

After Crivelli

An apple, imagined with a lively roundness, and a fly for life's transience. Flattening is achieved by making strong-contrast outlines as hoops.

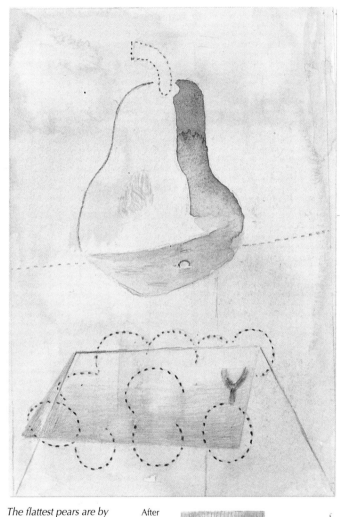

A poor diagram to suggest some edges by Uglow. Apples, pears, stomachs, thighs, and loaves made flat, and with arcs of fixed extent pressing against background areas. Although under firm control, geometric, and tested by eye, the subjects are most sensuous, and he knows pears are less still than apples.

After Uglow

The flattest pears are by Stuart Davis. Flat is simpler than bas-relief. Bas-relief is simpler than free-standing sculpture. To be flat, simple, and good, you must be very good!

After Davis

After Pissarro After Pissarro

After Gris

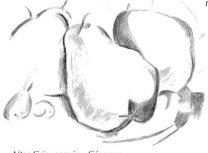

After Gris, copying Cézanne

After Picasso

Sandwich

WE ARE HUNGRY AND NEED a snack. We are open to suggestion. Here is a sandwich shop, its window full. The sandwiches look like mouths full of lettuce, cheese, and mayonnaise ready to greet you, and tongues of ham ready to lick you. Where a rogue is selling sandwiches in the park, the filling is a smarm of lard and it is called a Pork Sausage Sandwich. In The City, sandwiches are meals, and customers give exact orders. But the mouth-shape is a confidence-trick: the stuff is in the middle and nowhere else, then it is sliced so that the stuff is more visible.

Bonnard knew how to compare paint with food. Here is tomato ketchup out of a tube, a knife full of Naples yellow as butter, and a brushful of brown ochre depicting bread.

Paint some sandwiches out of your head. From the filling side they are ogee-shaped. Put into them your favourite foods. You can be inventive, or you can look at the menu-board. It is mostly a new subject matter, for sandwiches are rarer in art than guitars. The texture and colour of brown bread will enhance many colours. Think of beef, horseradish, and wholemeal bread. Or go for it: mix avocado, gorgonzola and anchovy in a bap. Some Scandanavians enjoy open sandwiches, which really are still lives.

Before the age of spread bread, Bonnard lived in a world of tarts, oysters, strawberries, and wondrous sweetmeats. Each had its special basket or dish, and a gardener, servant, or cook was pleased that Bonnard would eat or paint it.

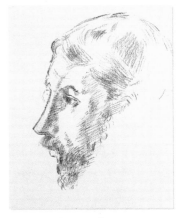

A portrait of Bonnard. The nose is a long arc. Redon has lessened the spectacles. After Redon

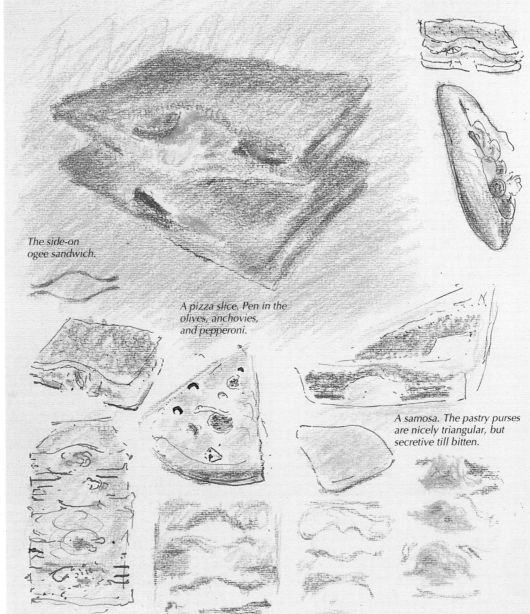

If it helps, think of it as a still life. With pastel pencils, draw two brown sandwiches with tomato slices. Almost a face: with a prawn nose, it almost grins.

A pen-drawn sandwich with crayoned filling is a fast food sketch.

No longer a sandwich-shape: a torpedo of French bread, bursting with ham, onions, tomatoes, and mayonnaise.

The side-on ogee sandwich.

Scribble the bread texture. The white and green bulb of spring onion entices.

A pizza slice. Pen in the olives, anchovies, and pepperoni.

Two sandwiches in a plastic carton. Record the various textures, shiny to rough. The more elaborately you do it, the more hungry you will become.

A samosa. The pastry purses are nicely triangular, but secretive till bitten.

A pile of sandwiches in a shop window. A tower of deceit?

End-on sandwich-mouths with hammy lips, or pink with seafood relish.

Pierre Bonnard's table of visual and edible delights. Bonnard did not need elaborate materials to make his pictures. A bowl of cherries; peaches; an orange and a lemon. A little rectangular palette (the kind which fits in a painting box); a set of watercolours; a can of oil; five or six brushes (square, not round as I had expected); and plenty of newspaper and rags. The fruit bowl and the smeared palette resembled each other in 1937 to the short-sighted Bonnard. Without his glasses, all was a mingle of colours.

"Strawberries". Paint them till the juice oozes soft and strong. After Bonnard

With watery marks, see what is on the large tablecloth. Two blues move between shadows and objects, making straight linkages. The blues oppose the creams, oranges, and yellows; obviously begun on a day when Bonnard's diary entry was "Beau".

After Bonnard

The cats have seen the oysters. Take a pen and some slightly diluted (use distilled water if possible) Indian, non-waterproof ink, and scratch around some Bonnard foods. They are so delicious you will want to eat the paint. Watch the marks you make. Each medium can enchant, and be as mouth-watering as a Bonnard raspberry cream. Remove rotten pieces fast, or the rot will spread. (By "rotten pieces", I mean your mistakes.)

Bicycle

TRAIN-SPOTTERS, CAR THIEVES, and Tour de France cyclists are all in thrall to machines. Hell's Angels embrace their bikes. When young, I was not more attached to my bicycle than to my knees or my roller-skates – they were all a part of me. I felt closest to Jeffrey Dennis' "Brink of Dissolution" when I remembered flying over the handlebars after braking on a steep hill. He has tubed and conduited his way through his pictures. Now, in "A Journey Postponed", he paints the tubes of a bicycle and says: "At a certain point, the circular elements were giving me an uneasy sensation of instability, as if the painting were about to whizz off the studio wall; and it seemed necessary to slow the whole thing down, by letting the components drift apart and embed themselves in the field of bubbles. (The sustaining and defining 'atmospheric pressure' for the other elements.)" He pondered the truth of Flann O'Brien's long discourse on bicycles in *The Third Policeman*: "On how, with excessive use, bicycle, rider, and ground start to interchange their qualities."

When Braque and Léger were young (and girls were wearing bloomers) bicycles meant freedom and emancipation – The Open Road! Years later, Braque painted the machine nostalgically, slightly decoratively, and in one picture, including in large letters "MON VELO" (my bike). Bicycles are popular and pollution-free, as Amsterdam, Cambridge, and all wise places know. Bikes can be bright-coloured, riders can take up wonderful poses. You can recline on bicycles. Paint them as lively diagrams of happiness.

A rather tentative assembly of the components. See how confidently he eliminates and even truculently deals with the spokes in "The Big Julie". After Léger

The bike would take Braque, when young, from Paris to the Normandy coast. In this mess-copy, apple blossoms are suggested – casually depicted, as if the spectator would know all about it anyway. After Braque

"The Big Julie". Obviously cloudily, touchily fond of his machine in 1929. Ten years later, harder pristine bicycles accompanied family outings jauntily. After Léger

Bicyclists, intent on entering The City of London, via the heavily engineered Tower Bridge. Use tiny sable brushes to suggest these complexities.

Jeffrey Dennis, *A Journey Postponed* (detail), 1992

Dennis says: *"I like the idea that a painting may only reach its resolution when the entire structure is on the brink of dissolution."* The artist, struggling to erect his deckchair in time for the end of the universe, is seen more than once.

Bicycles are triangles, lines, circles, and, unlike the fast-forward tilt of a runner, the rider is looped. Choose swinging lines to make him race. Or paint the velocipede of olden times leaning quietly.

Jeffrey Dennis, *A Journey Postponed*, 1992

After Braque

After Braque

After Picasso

After Picasso

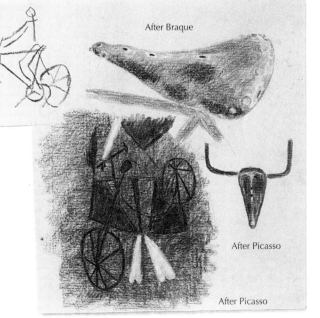

The girl's bicycle in *"Night Fishing at Antibes"*.

Still and Fast Life

I N GRIS' PAINTINGS, MOUNTAINS come indoors through the window, transforming to become all sorts of things. Cubism demands transformation. Windows are also important exits. The three top Cubists were Braque, Picasso, and Gris; but almost all good artists since have been Cubist to some extent. The changes in painting this century have often been about still life on a table. Familiar, even humdrum objects were chosen, challenging the painter to make a new kind of beauty. Cubism was the biggest change in depictive ways, and Gris, before he died, had pursued the picture more thoughtfully and thoroughly than any other painter. It would have been exciting to see what came next.

After Picasso

The last Gris are concise objects, in "enamel", "house", or "coach" type paint. (De Chirico had a similar surface, and Picasso had bought a good commercial paint called "Ripolin".) Into this "enamel" Gris would sometimes melt a thicker, knifed paint.

Chardin was the grand artist of still life. He would prepare wonderful, rich surfaces as carefully as cheese makers ripen Camembert. Graham Crowley prepares his paint surfaces so that, at a latter stage, they can receive colour glazes. His "Kitchen Life II" was an onslaught of the nasty utensils.

Test out with watercolour your own reactions to kitchen stuff: knives; graters; choppers; forks. Kitchens can be nervy.

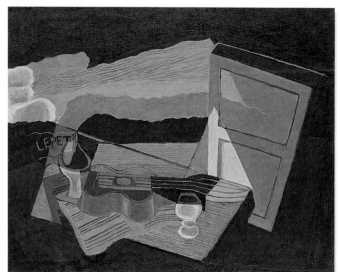

"The View Across the Bay" is one of several late pictures by Gris where the outdoors comes indoors. A cloud, or a mountain, turns into a napkin, or a compôte, and tables or windows serve as false frames. Once the main areas are filled in, lines are made parallel to the ripples on the bay: the guitar strings, the staves on the music-paper and the wood grain of the table. The yacht and the flag also act as triangular patches of sunlight.

Victor Willis, after Gris, *The View Across the Bay*, 1995

Hard sparks and ectoplasm, the terrors of the kitchen – not easy to compare them with Gris' gentle float through the window.

Graham Crowley, *Kitchen life II*, 1982

A scrub-in copy of a kitchen group.

After Chardin

After Gris

The mountains join a violin, and resemble the tablecloth. The top of the carafe is joined to the near mountain.

After Gris

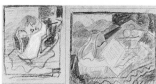

Scribble around some late Gris. His designs became increasingly elided.

After Gris

After Picasso

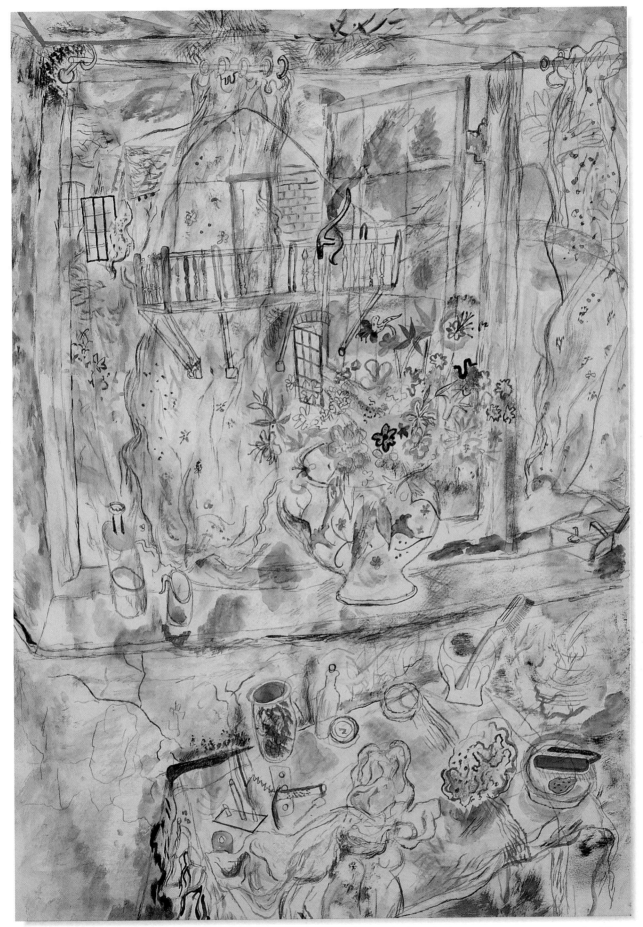

Watercolour blurs are energized by the Celtic rhythm-lines of the great Welsh poet of In Parenthesis *and* The Anathemata. *Indoor rhythms join outdoor rhythms through the window.*

David Jones,
Curtained Outlook, 1932

IMAGINATION

Symbols, Theories, and Artists

WE SEE THINGS ALL THE TIME our eyes are open. Walking through a wood, we may see no toadstools; then, finding them tasty, we see them everywhere. What we see is what we decide to see. Inevitably, painters and less specialist viewers see things differently. Perhaps the separation is greater today than in the past, because so much of our looking is channelled through photography, film, video, and television. This brightly-lit media version of the world may make it less easy to enter a painted world. And photos can also be made shapely.

"Young and Old at Beachy Head", is without any trace of photographic vision. I will try and describe its shapes. It is about people of various ages. A false frame is a little like a

crystalline four-pointed star. Its straightnesses suggest wide-open spaces: rhythmic brush strokes rush at the sheer cliff. At Beachy Head, the verticals stabilize, as do the horizontal lines in the frame that make linear equivalents for multiple horizons and distance and the layers of chalk. High-up are the birds and bird-shaped pieces of sky. At the left, a feather sinks, as magpies whizz by. In the centre, a black-backed gull is active (when seen as a gull), but seen as a vertical mark, it is stabilizing. The humans are mostly depicted in pairs. A black girl is given a pickaback by a ginger boy. To the right, a boy puts on a pullover close to a jackdaw and two old people. Above a lighthouse, lovers kiss, and my eyebrow resembles a looping-the-loop seagull.

A realization of Goya's "Drunken Mason". In Goya's other, similar picture, "The Wounded Mason", the friends are very serious.

Laetitia Yhap,
Drunk, 1990s

A sketch-copy of "The Wounded Mason"

After Goya

The flats have dated, but this beautifully arranged painting will continue to slide eerily into our consciousness.

Michael Andrews, *Flats*, 1959

230

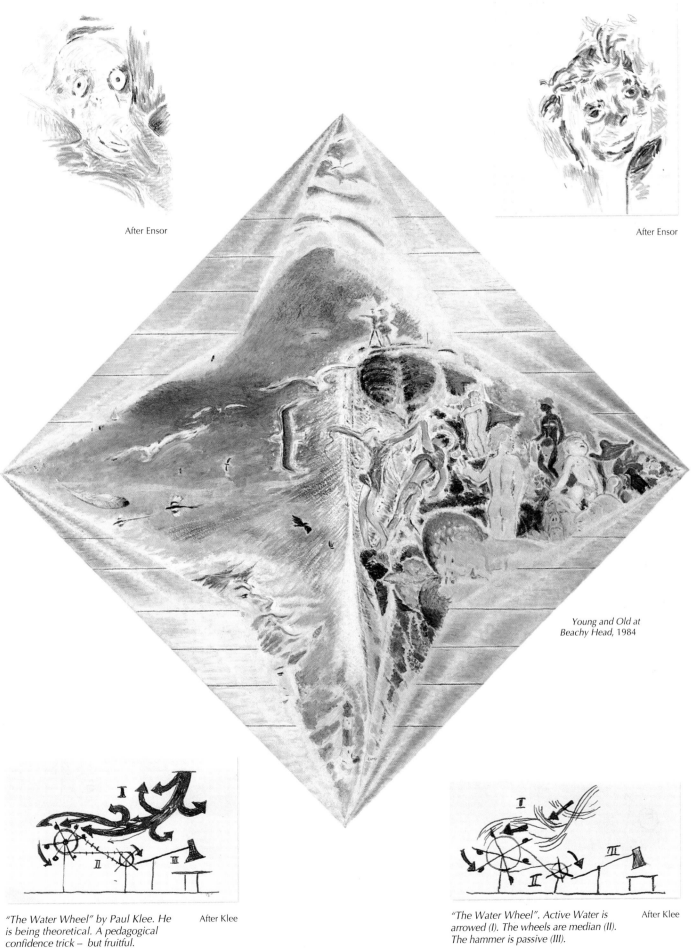

After Ensor

After Ensor

*Young and Old at
Beachy Head, 1984*

*"The Water Wheel" by Paul Klee. He
is being theoretical. A pedagogical
confidence trick – but fruitful.*

After Klee

*"The Water Wheel". Active Water is
arrowed (I). The wheels are median (II).
The hammer is passive (III).*

After Klee

Teaching and Learning

YOU CAN LEARN MORE by teaching than by being taught. For a young student, art is glamorous. I had not heard of Cézanne before attending Ipswich Art School. My ignorance was sniffed at by the teacher of painting there, a Mr Fortin. This made me find things out. I read Gerstle Mack's book on Cézanne. Cézanne was glamorous. Doing painting was intoxicating. If you are fortunate, and if the art you admire is poor, a good teacher or cultured friend will sniff in a superior way. Tradition is secured by sniffing. When the "way" is healthy, a sneer is not needed. I learned a lot from being smiled at in a lukewarm way. Teaching is done by coaxing, cajoling, nodding, sneering, and by demonstration.

Teachers have a tiny number of star pupils, and they always believe there are more. To teach well is to lie convincingly, to encourage in the most discouraging circumstances, even when the student's work is failing. Failures are inevitable in the beginning. If the student is gifted, he will find his way. There have been avenues of teaching which have been good for the teachers. Max Bill, Kandinsky, Klee, Moholy-Nagy, Oscar Schlemmer and others had the resources of the Bauhaus at their disposal. Figurative painters teaching at the Slade school before the 1960s also enjoyed facilities of a different kind, and some worked from the 16 models who posed in various rooms throughout the building. A prolonged looking at the figure can generate compelling images in paint. Correction in the past could be scathing: Henry Tonks was a disciplinarian and made girl students weep. I taught at the Slade after 1960. It made me nervous. We

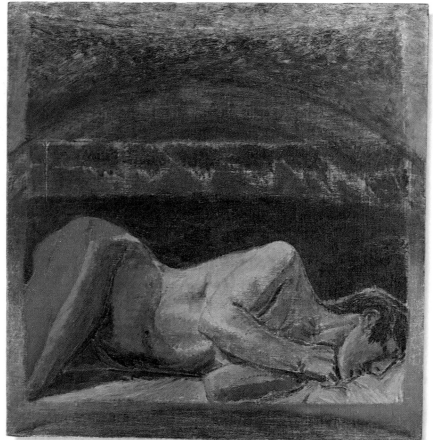

were so polite, it was slow getting through doors. Most of the staff spoke with the "thrown" university voice of Sir William Coldstream and wore suits. During the next ten years, those in suits became aware that Pablo Picasso and Jackson Pollock did not wear suits.

Students in those days did not have shows of pictures, but were expected to produce studies and acquire skills. The work was placed in a room and assessed. Most were given a diploma. The students fought month after month to rid themselves of examination requirements. Meanwhile, the art scene made other demands. Star teachers showed the use of masking tape, photographs, spraying, and how fashionably to cover the white walls of new museums throughout the world. Things were being done in art that had never been done before, and 20 years later they are being done again. But such dramatic furores as those at the first performance of Stravinsky's *Rite of Spring* cannot happen again. The big changes in art have been made, yet some continue to yearn for an "avant-garde". The big mistake the art schools made was to believe it possible to learn to be a painter by doing art. Previously, students had done exercises. They did them cleverly, tastefully, usefully, and it bored them. It did not leave much time for original painting.

Corporeity

In 1907, John Fothergill (one of the first Slade students to be taught by Tonks) wrote *The Teaching of Drawing at the Slade*:

> Art comprises colour, form and the spiritual element. (The spiritual element is dictated by the artist's character and is not susceptible to teaching.) Drawing being colourless, the pursuit of drawing is to represent form. A good drawing is the simplest statement in light and shade of the artist's comprehension of forms.

It was, he wrote, research into (and not judgement on) the forms in nature which enabled the draughtsman to represent forms, and which gave rise to emotion. But style occurs only when research ceases. True style is not manner, but the expression of a clear understanding of the raw material.

> Colour, silhouette, pattern of the form, light and shade together give us the idea of an object's corporeity. But not from the eyes alone. For this corporeity is learnt from infancy by touch and our ability to move.

In the light of this testimony, it is interesting to consider the fixed point of view and measurements practised by Coldstream, Uglow, and Patrick George. The mystery of establishing corporeity by drawing was – in the light of the philosophy of Bishop ▶

A brush drawing of two models

A figure lying down in a life room transformed to become part of an imagined, rainbowed, stormclouded night.

Summer Storm, 1976

▶ Berkeley – fascinating to David Bomberg and other artists. In simple terms, Berkeley stated material objects have no independent being, but exist only as concepts of a human (or divine) mind. "The spirit in the mass" aimed at by Bomberg's Borough Group – which included Auerbach and Kossoff – was a response to this belief.

To teach in an important art school is to confront ignorance, erudition, strongly-held views, no technique, and some skill. This mix is energy-absorbing and most good artists teach less if their paintings are in demand. (Matisse gave up teaching in his own art school after one year. He found he was giving the same advice over and over.) Here is Thomas Eakins after a visit to the Prado, Madrid, where he particularly liked Ribera and Velásquez. He said: "Rubens is the nastiest, most vulgar, noisy painter that ever lived. His men are twisted to pieces. His modelling is always crooked and dropsical and no marking is ever in its right place."

He would not mind if all Rubens' paintings were burned up! But Rubens was Cézanne's favourite painter, "the prince of painters". Good art schools thrive on controversy and excess.

A Spanish model, with a seascape background.

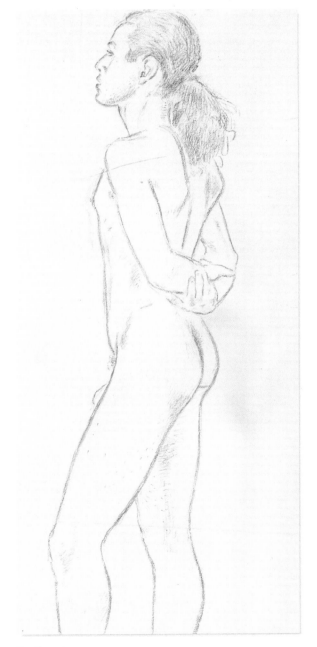

Youth posing

A girl posing, with an added sea background.

An Edge is Not a Line

HEALTH AND EFFICIENCY WAS A NUDIST magazine which expunged all pubic hair from its photography.

In 1939, two spinsters ran Lowestoft Art School. I would draw an old naked man. My lines were cautious. I believed if I drew the model often I would improve. I drew in Lowestoft, Ipswich, and in Edinburgh, where nudes were warmed electrically most days, and even at night. I continued to draw, and as "The Athens of the North" had more contact with Paris than London, some art crept in. I thought it dreadful to draw by using shadows. It never occurred to me that when Seurat used shadows in his drawings they were special.

Miss Musson, the principal of my first art school, had received The King's Prize for a stumped drawing from life, blended using a "Tortillon Stump" of coiled paper and black chalk (sauce). Highlights were removed using kneaded bread. Even such shade drawings could have finesse when done by Picasso, Seurat, Degas, or Matisse (for they were all taught in this way).

When is a drawing a painting? Stuart Davis said his paintings were drawings; Philip Guston said: "It is an old ambition to make drawing and painting one."

Seurat was able to make scribble-darkened drawings of great beauty and subtlety. Drawing by edge-emphasis, and without much line, Seurat knew when drawing could seem like painting.

Eakins' colleague and successor at the Pennsylvania Academy of the Fine Arts in Philadelphia was Thomas Anschutz. Anschutz advised: "Don't copy shades on your paper so as to make round things round. Every line and every shade on a drawing should mean something. The shade on one part of the body must be studied with relation not only to the shades next to it but all over the body." Eakins' robust paintings were not achieved by copying shadows but by modelling with shading. The Pennsylvania Academy also taught clay modelling. Together with dissection and measurement, it was a thorough training for painting mass; and for this the students at Penn. were expected to be manly, healthy, and efficient.

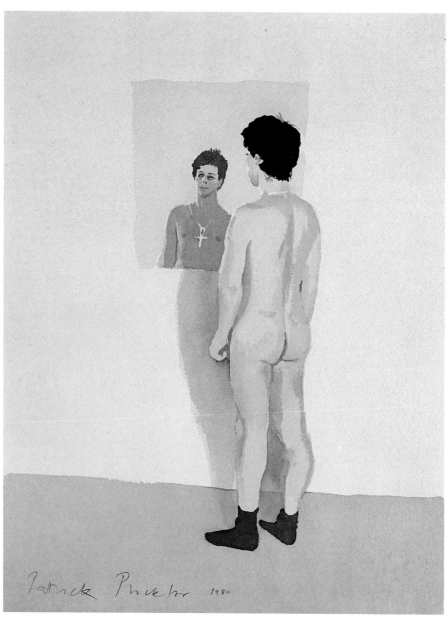

The mirror shows the face.... The shadow suggests the front of the body. The blacks are daring. The touch is sensuous. Procktor called him "Narcissus"; the watercolour flowed delicately. The shadow is important and central.

Patrick Procktor,
Nude Boy, 1980

Use conté crayon on Ingres paper. After Seurat

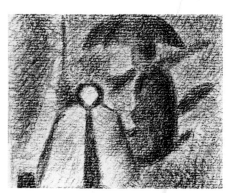

Polygonals on Michallet paper After Seurat

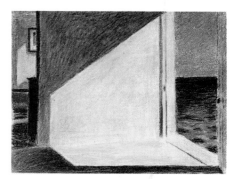

Shadows and openings are used for melancholy. Pencil-hatch shadows and sunlight is prepared. After Hopper

Cloud shadows

A transparent hat

De Chirico used shadows dramatically, for strangeness and loneliness.

After de Chirico

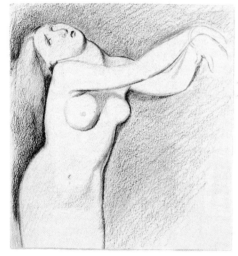

After Seurat, after Ingres

Seurat copied Angelica in oil and also in crayon with no lines. Copy Seurat's crayon study after Ingres' "Angelica Chained to a Rock". It is plain that even if Seurat might save her, Ingres would be more likely to add another chain. As you pencil or chalk-paint her, you will notice the cunning freeing and loosing of the edge by making "passages" between the form and the background. Seurat copied Angelica in oil with maximum contrasts and an acceptance of vigorous distortion. In the drawing, a goitrous throat was of considerable interest to Matisse, who found ways of using it. As you move along the far contours, trying to avoid making lines, you will sense Ingres' influence on Degas and other later artists. Ingres had incorporated The Simple State – a balance of quantities, using arcs and a straightness that he found in Poussin, David, Raphael, and Greek sculpture.

A solidly constructed baby, modelled by shading, is cut across by battlements of hard shadows, as if the painter were trying to demolish the infant. The tones bind the solid to the background. The background is of leaves suggested by palette-knife strokes, reminiscent of Courbet.

After Hopper

Extreme and Simple Painting

LESS IS MORE, but sometimes less is less. It is good to know about all kinds of painting; Albers made an expensive book of silk-screened diagrams. Art colleges bought it for teaching colour. An orange would be seen to buzz on a pink of equal darkness. Matisse worked towards simplicity, but was certain that the young should not take a shorter cut than he had. "The Open Window, Collioure" is dark; I have wondered whether it was always dark (you can still see the railings underneath the black). Compared with Ad Reinhardt's paintings, it is complex. Minimal painters worked close to emptiness and sometimes achieved it.

If an aged curator ever mounts an exhibition of the almost plain rectangles by Newman, Turnbull, Marden, Palermo, Kelly, Ryman, Charlton, Plumb, Graubner, Yves Klein, Joseph etc., perhaps the view will be clear. Yves Klein, an expert at judo and self-promotion, piled galleries with ultramarine powder, rollered-blue canvases, and filled sponges with blue pigment. He induced

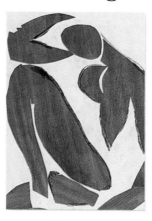

After Matisse

When reproduced in a book, the cut-outs were printed as opaque. But in the original the paper had been transparently brushed, and the streaking gave lightness and energy.

beautiful, blued, nude girls to squirm against large canvases. He lectured on Vermeer blue and Zen blue and I hope he had seen the blue zenith by Giotto at Padua. The simple, rolled rectangles by Rothko remain resonant. They are never blue, but sometimes are soft as sunsets. He became rich, and greys took over; he became depressed. Perhaps he should have heeded Delacroix' warning: "A taste for simplicity cannot last long." Cézanne thought Delacroix a great colourist. Here is a list of Delacroix' colours:

White; Naples yellow (the original pigment); Zinc yellow; Yellow ochre; Brown ochre; Vermilion; Venetian red; Cobalt blue; Emerald green (poisonous, so no longer available); Burnt lake; Raw sienna; Burnt sienna; Vandyke brown (different now); Peach black; Raw umber; Prussian blue; Mummy; Florentine brown; Roman lake; Citron yellow; the original Indian yellow.

With a palette of this complexity, it is clear simplicity was not Delacroix' intention. The bright colours of today are simpler.

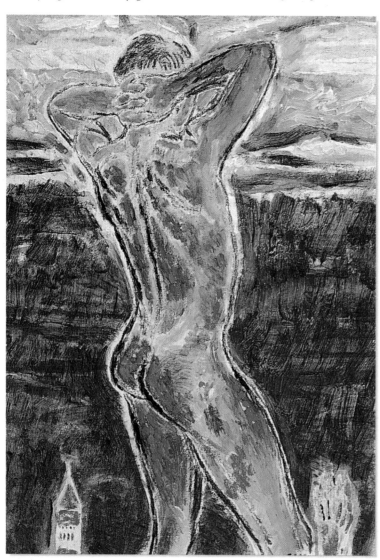

If enough Cobalt blue is used, charcoal lines left visible will appear golden-black. The campanile acts as a foil.

Venice, 1976

Examine with watercolour the cut-outs of late Matisse. They are extreme, but complex.

After Matisse

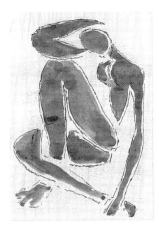

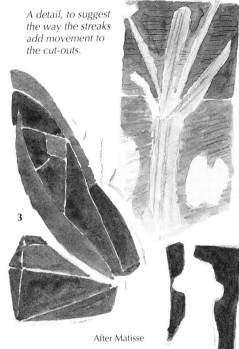

A detail, to suggest the way the streaks add movement to the cut-outs.

3

After Matisse

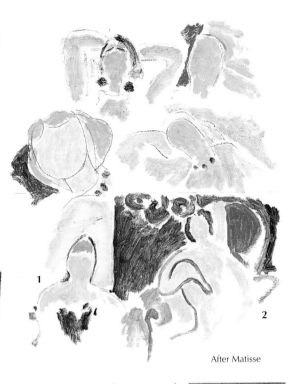

1

2

After Matisse

*Simple heads, without features. (**1**) is brushed in, and (**2**) had its head made by wiping off background paint using a rag. Bonnard said: "A brush in one hand, a rag in the other." The thigh of (**3**) is made of a complex collaging of blue paper. The seams are evident, making his thought visible. As blue as the Mediterranean.*

Cobalt green and Cobalt violet

Green and lilac mix optically.

"The Open Window Collioure". It also makes me think of Diebenkorn.

After Matisse

The spectrum of Ultramarine blue is unexpected: it contains red, blue, and green. Try brushing warm blues over cold blues, and cold blues over warm blues. ▶

◀ *Cobalt Violet*

Ultramarine blue over Manganese blue ▶

◀ *Cobalt violet over Cobalt green. With careful manipulation, Viridian and Cobalt violet (in oil) will make a blue-grey. Here is a lilac-grey.*

Manganese blue over ultramarine ▶

◀ *Cobalt violet over Viridian*

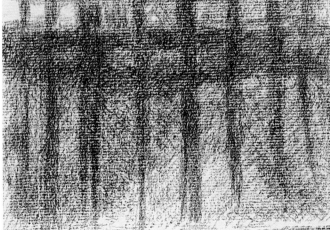

A landscape of verticals and horizontals

After Seurat

Ultramarine over Turquoise blue ▶

Read and Write

WILLIAM BLAKE LEARNED ITALIAN late in life so he could read Dante. In *The Divine Comedy*, a serpent, with six feet, fastens itself upon Agnello the thief. With its middle feet it clasped his belly, with those in front it seized his arms, then fixed its fangs in both his cheeks. The hind feet it spread along his thighs. Eventually, this hideous monster and thief were entwined, and, as if they had been molten wax, they stuck together and mingled their colours until they were "neither two nor one" (Canto 25). For William Blake it was good to put painting and words together. His transparent watercolours were right for the *Inferno*. Watch and copy his flame-shapes turning into fingers and curls. The stuff of his pictures was assembled strangely. Muscles from Michelangelo, gowns from Gothic art, words from Dante, rainbowed miracles from English watercolour. They came together just once in history at the point of a brush. Graham Sutherland looked at Blake to his advantage – but Blake is rarely understood. John Maxwell thought he was one of the world's ten draughtsmen. Blake probably did not see naked figures often enough, but imagination crackled from the brushed water, and the superbly drawn Botticelli Dante drawings are not more exciting.

Some painters are good writers. Michelangelo wrote famous sonnets. Turner's poems were poor. Klee wrote letters, a journal, and two influential notebooks, *The Thinking Eye* and *The Nature of Nature*. I recommend the letters of Cézanne, Degas, Pissarro, and Gauguin (who also wrote *Noa-Noa* and an *Intimate Journal*). Read Delacroix' *Journal*, and above all van Gogh's letters, which change everyone's life. If you have a mammoth monograph open as you read, you can follow his life visually day by day. He was a superb writer. Matisse wrote usefully. Redon wrote well. Picasso aphorized with genius. Stanley Spencer could not stop writing. I enjoyed the early books by Kenneth Clark (his *Rembrandt and the Italian Renaissance* makes clear the breadth of Rembrandt's sources) and Sickert's *A Free House*. I can only list a few books, but books have meant a lot to me. (Sickert's wife said whenever she visited his studio, he was reading.)

Here are a few more:

Gris by Kahnweiler; *Matisse* by Pierre Schneider; *Interviews with Francis Bacon* by David Sylvester; *Constable* by C.R. Leslie; *Blake* by Gilchrist; *In Parenthesis* by David Jones; and *David Hockney* by David Hockney. Other recent painter-writers to explore could be Josef Herman, Paul Nash, R.B. Kitaj, Lawrence Gowing, Wyndham Lewis, Gilbert and George, Andrew Forge, Timothy Hyman, Frank Auerbach, Kandinsky, Mondrian, Dali, William Feaver, Seurat, Redon, and Herbert Read.

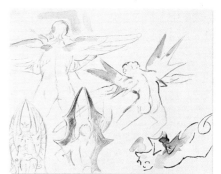

Demon-wings can be bat-like, Dracula-like.

After Blake

After Blake

A rough copy of Agnelli the thief being absorbed. All arts meet as poetry. The sculptor Michelangelo's sonnet set by Benjamin Britten becomes a song.

Sickert painting the nude with his writing arm (when not found reading by his wife).

Walter Sickert, *Studio Painting of a Nude*, 1911–12

After Gauguin

Copy-diagrams, after some idols painted by Gauguin in Tahiti.

Cylinders and Joints

CÉZANNE, THE FATHER-FIGURE FOR CUBISTS, recommended seeing nature as cone, cylinder, and sphere. It was a critic who muddled things by bringing in cubes. Cubic joints are awkward even in David Lynch's science fiction film *Dune*. A crystalline body is a shock. Léger's early pictures were "open", and made of cylinders. For Matisse, favouring cones, the path was simpler. (In billiards, a game Mozart was fond of, the traces of the moving balls are cylinders, jointing as they strike the cushions. Sometimes, we see only the balls.) A cigarette is a cylinder. Its stubs, and smoke, are

After Guston

Clocks from Guston's pictures. He said he measured his life in "Camel" cigarette butts.

present-day subjects. A whole gamut of facial contortions are built around smoking. Van Gogh, Beckmann, and Edvard Munch used cigarettes, pipes, and clouds of smoke in pictures. Philip Guston was a most rampant cigarette-smoking painter, devoting an enormous canvas to an ashtray of "dog-ends". Internationally famous for sweet, abstract paintings, he spent his last years caricaturing his smoking and drinking problems, and painting monster shoes, and parts of his face. Sometimes a wrinkle, an eyeball, a cigarette-butt, and a cloud of smoke were sufficient.

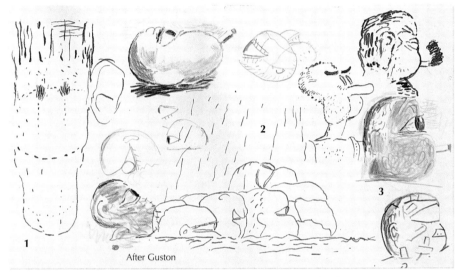

After Guston

1 *John Cage* **2** *Self-paintings with cigarettes* **3** *Richard Nixon*

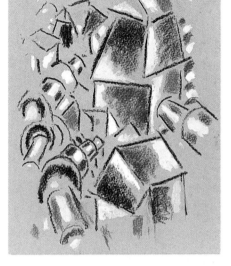

After Léger

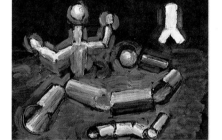

Daub in a tubular way from imagination. Or cut a postal-tube almost through. (This was done on black-painted paper.) Although it suited Cézanne and Léger, seeing in terms of cylinders or planes has never seemed very useful to me. Too many complications arise.

"Cabal". Guston used very few colours – red, blue, black, and white – when abstract or figurative. There are single colour (monochrome) pictures by Dufy, who found vermilion a versatile pigment. After Guston

Léger's Cubism was rather impure, open – even decorative. Paint using simple elements, as did Léger, until your personal style takes over. After Léger

239

Measuring

MEASURING DISTORTS THE IMAGE. Patrick George measures the strangely foreshortened view of Susan. Most portraits in the past were posed like Madonnas; head frontal, dead centre, and higher than the middle. This portrait is close to the middle horizontally, but lower than expected. Thus he breaks the mould, and thus a sensitive eccentric artist flouts tradition. Giovanni Bellini felt arms imaged best when roughly two heads long and half a head thick. Patrick George softly brushes in arms no longer than a nose. Fed by the abstract practice of his time, this play of marks, arrived at by eye, comes to resemble one of Mondrian's analytical compositions – a pyramidal staircase of dabs. (Cézanne liked triangular structures, but would not have measured.) Degas did several little-known landscapes involving sharply receding perspective (which may have been demonstrations for Boudin's

To get the "golden cut" for a given line.

pupil Braquaval). Stylistically, Patrick George's overlapping tree-lines slightly resemble those by Degas: their pictures would not show the viewer around the whole estate, as Rubens' paintings did.

"Dynamic symmetry" was thought valuable: find out by way of Piero, Klee, Seurat, the Bauhaus, Le Modulor, Ad Quadratum, and Basic Design. But one of the effects of using dynamic symmetry in landscape was that if the edge of a tree-trunk was placed on the golden section, it tended to disrupt the flat surface – emphasizing the rift between tree and distance excessively. And if, alternatively, the centre of the tree-trunk was placed on the golden section, the effect might be a bit sedate, like Georgian architecture. Yet any formal devices (and there are thousands: numberings, measurings, surveys, and geometrics) which make painting feel a serious activity are valuable. For a start, it is good to know where the centre of your canvas is.

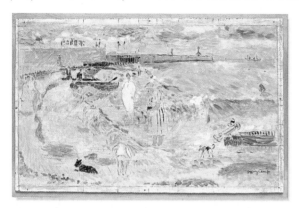

Various measures are visibly marked around the edge of the panel.

Taking a Photograph, 1954

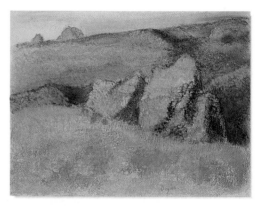

Edgar Degas, Landscape with Rocks, 1892

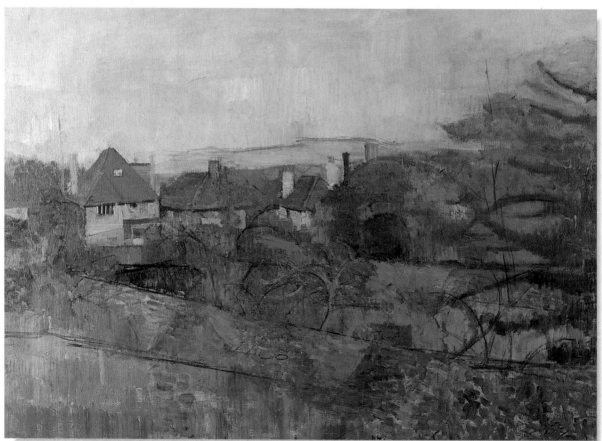

Victor Pasmore, *Suburban Garden,* 1947

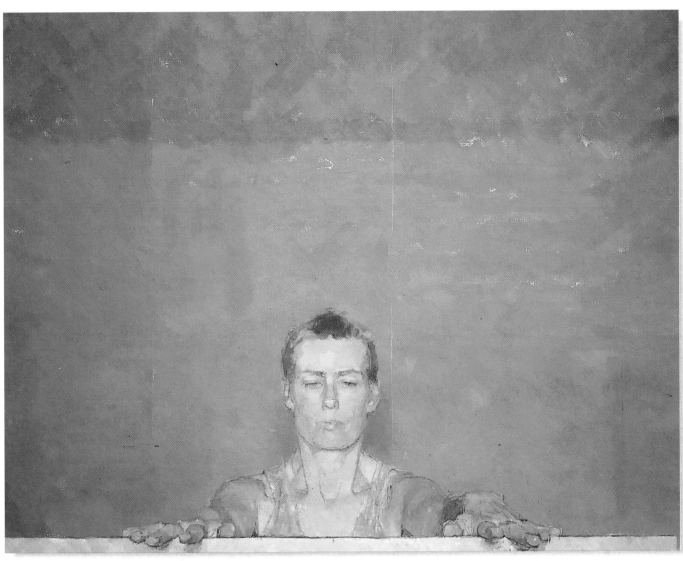

From the top of Susan's head to the top of the canvas is one of Susan's arm's lengths. Similar distances are measured from her head to the sides of the canvas. And she sat at her arm's length from the lining-paper background.

Patrick George, *At Arm's Length*, 1990–94

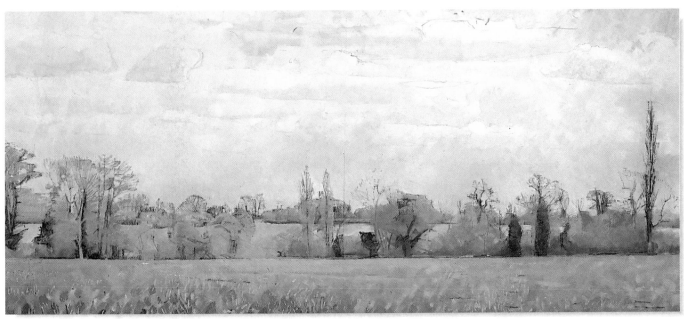

Patrick George, *Saxham Spring*, 1990–94

Vision and Association

WHEN I WAS YOUNG, I had recurrent nightmares. If I remembered them before the next sleep, they did not come again. Perhaps some such notion – a kind of insurance – caused me to put my name and date of death on a tombstone in the churchyard I was then painting. It seems Stanley Spencer had always in mind a homely graveyard at Cookham Church, and a family to join him there at his certain resurrection. When, far from home, he walked up the hill, past the gasworks to Port Glasgow Cemetery, he said: "I seemed then to see that the cemetery rose in the midst of a great plain, and that all in the plain were resurrecting and moving towards it…I knew then that the resurrection would be directed from this hill." (The word "directed" suggests Stanley was thinking more in terms of military manoeuvres than a family reunion.) What makes Spencer's congregations so enthralling is that his resurrection material is prose, and painted as plainly as cups in the kitchen.

If you have nightmares, or gentle resurrections, in your mind, urgent for expression, begin as Spencer often did, with a daisy, a tombstone, or a blade of grass – or, (as Odilon Redon often did), with a tree-trunk. Or instead, take wing and fly with the nightmare. William Blake said: "Nature always puts me out." He illustrated Shakespeare's lines: "And pity like a new born babe, horsed upon the sightless warriors of the air"; for that, a careful depiction of a dandelion would not help much. Ken Kiff's entranced world of creatures inhabit a vivid realm of colours (any of which might, as in a rainforest, be a poison, or drug you into imagination): a mythical underground of flowers and paradise and wonder.

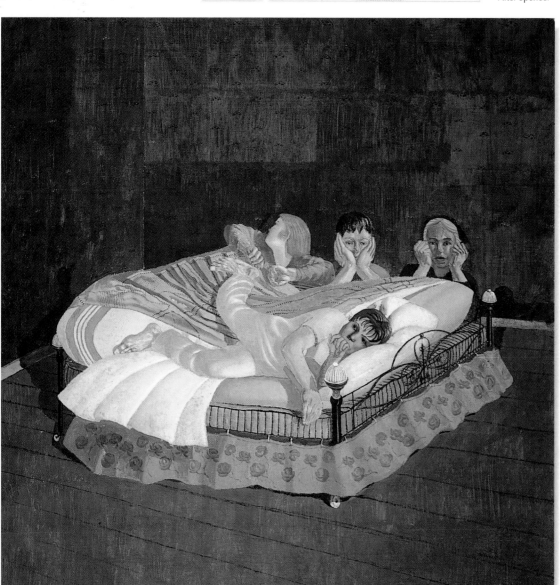

A self-portrait as Spencer imagines himself in "The Centurion's Servant".

After Spencer

"Envy". Stanley Spencer carried a little book on Giotto about with him, when young. After Giotto

"Serpents" After Redon

Stanley Spencer, *The Centurion's Servant*, 1914

The Victorian tombstones were similar to those in Cookham. Spencer must have had a most exact view of things, and one application of paint seems to have been enough. (On a higher level, this was also true for Carpaccio.)

Stanley Spencer, *Port Glasgow Cemetery*, 1947

Kiff is in touch with strange folk-story visions, full of frenzy, and acted out in sight of a volcano in full eruption.

Ken Kiff, *Horse and Cart*, 1981

Egyptian Inspiration

Claude Rogers painted surgeons dressed in green robes. Knifing a thorax is urgent. It caused me to think of Tutankhamun in Ancient Egypt, where religion pervaded the whole community. It is the difference between an operation and a ritual. Rituals are mysterious, and are worldwide. Nowhere have mysteries been shown so clearly as in Egypt. It is the clarity that has attracted artists and helped to purify their work. I copied Tutankhamun harpooning. It was also the pose of a drawing, a painting, and a sculpture by Euan Uglow. He called it "The Spearess". Paul Klee was enlivened by the signs and colours of Egypt, and David Hockney by the flair and bright-brushed pretty beauty of the all-pervading decoration. Uglow liked the hard, formal reality. Egyptian forms are simple. Very few pigments are used. The influence of a visit to Egypt purifies the work of good artists, but they are brave who confront the Sphinx and the mathematical perfection and weight of the pyramids.

"Bed of the Divine Cow" After the Tutankhamun treasures

Responding to a posing girl. Sculpture argues with drawing, drawing argues with painting, and the image can become firm, or in the wrong hands, tired. Practise moving through the media. Buy some Plasticine.

Euan Uglow, *Spear Thrower*, 1986

Uglow has added a bird and a watery background to a Tutankhamun-posed figure. The spear was for ritual, and was in the position for hunting hippopotami.

Euan Uglow, *Egyptian Spearess*, 1986–87

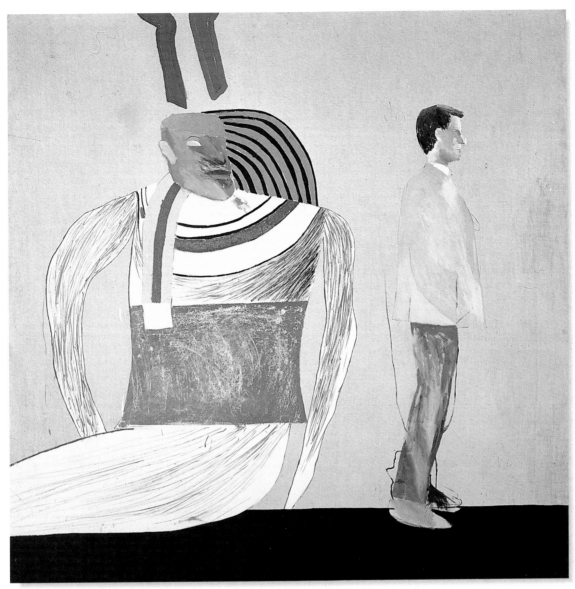

Hockney's movie actor might have been Boris Karloff. Egypt was glamour for early cinema. The artist has taken decorative stripes, hand-carved design, and brush drawing from the Egyptian wall-painting, and combined it domestically with a portrait of a friend. Like a very large, clear Hockney etching, with extra paint.

David Hockney, *Man in a Museum (or You're in the Wrong Movie)*, 1962

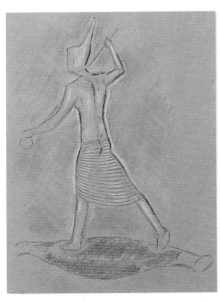

After Ancient Egyptian sculpture

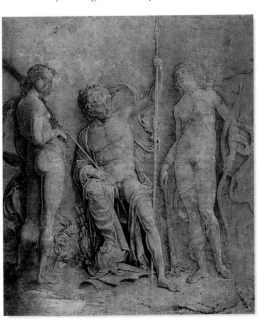

Andrea Mantegna, *Mars, Diana and Iris*, 1490s

"An Egyptian spearess"

After Uglow

Spears, staffs, and supports of all kinds were in classical art, and later in life rooms. A staff, because it is straight, shows up the curves of the body clearly beside it.

Ghirlandaio

AN EXCRESCENCE ON AN OLD MAN'S NOSE, by Ghirlandaio, is a well-loved feature of a world-known painting. Beauty courts ugliness, in painting, as in opera, where the most moving music is about murder and heartbreak and pain. Torture is the martyr's way to paradise; though torture, as a way to death, is often now believed more true. Michelangelo shows his own flayed skin held by St. Bartholomew in the Sistine Chapel, and Titian shows Marsyas being flayed alive in his greatest picture.

Ghirlandaio always surprises: it is his plainness, his interest in the people he sees and his ability to incorporate their everyday features into elaborate compositions. It is almost as if he were above style. There are plain pictures that are as rewarding as more immediately engaging works. Gris, Mantegna, and Carpaccio are less flamboyant than Tintoretto, Picasso or van Gogh, but they are as rewarding. They should be looked at carefully and slowly.

A lifetime is too short for getting to know Piero della Francesca, Giorgione, Velásquez, Titian, and Rembrandt. It takes a long time to assimilate the closely imprisoned meanings in great paintings. Prepare a list of works to look at carefully.

Recently, I found it difficult to concentrate on a magnificent exhibition of Claude Lorraine. One has to be ready. I came late to Altdorfer. One of the ugliest subjects ever painted engages immediately. It moves everyone, it shudders the spine and electrifies all ganglia: it is the "Isenheim Altarpiece" by Grünewald.

The world is full of little-known, but wonderful paintings. French painting may have taken our attention away from German art. Chinese painting may be limited in colour for excellent reasons. Art can be a mysterious purgation, which some painters avoid. Even when ill, Matisse allowed no trace of suffering to enter his pictures. Renoir and Dufy were arthritic, and painted delight, and Bonnard dabbed at paradise when lonely in wartime.

A burnt head, crusty as a cinder. The eyes close so fast, they often escape the scorch. This is not how most people imagine the martyred head of St. Lawrence. Lack of imagination can be a blessing. Perhaps torturers have limited imaginations. Some pictures are painful to look at, like Gerard David's "Flaying" – a powerful narrative picture. Black chalk or ink will scar. Tonks' drawings of plastic surgery were plain, factual, and dull as Gray's anatomical diagrams.

A burned boy recovering against the rather random London East End dockland, the air pale – polluted with sulphur. The blackish scabs and new-growing skin of the face harmonize with the high, dark red leatherette hospital chair. The orange-ochre body was protected from the burns by a shirt. Ice cream, soft drinks, and the TV aid the healing process. Daffodil formica, tubular furniture, and white pyjamas are plain and true. Hurt, sick, and sure to recover: a highly dramatic arrangement would be inappropriate.

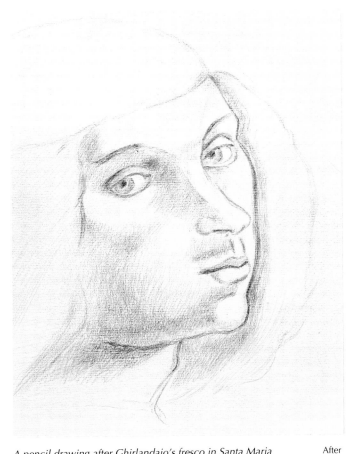

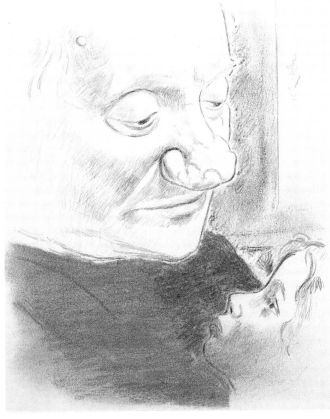

A pencil drawing after Ghirlandaio's fresco in Santa Maria Novella in Florence – the head of Lorenzo Tornabuoni, in "Joachim Driven Out of the Temple". Degas fell under the spell of these paintings when a young man, and they were an influence on his portrait of the Belleli family. Ghirlandaio's frescoes are filled with marvellous true portraits of plain people – of assistants, donors, and even Ghirlandaio himself. The influence of Hugo van der Goes on the fine Florentine design limited its colour and flights of imagination, but the entry of accurate portraiture into Italian painting was a big change.

After Degas

Draw this comparison of noses (to be found in the Louvre). Both noses are beautiful: paradoxically, the old, ugly nose is as beautiful as its young foil. Incas tore out hearts; I suppose, to placate Gods. Rivera, Siqueiros, and Orozco painted torture large. Poussin painted the martyred St. Erasmus with no more "expression" than if he was painting a loaf of bread. Real agony is not frequent in Italian painting. The numerous St. Sebastians are ecstatic targets for arrows. German art shows inflicted pain and Grünewald's thorns and weals are excruciating. Sometimes, a quiet suffering is poignant.

After Ghirlandaio

Tied with chopped hands. Beckmann used the same taut manner throughout his well-designed pictures. The red blood is treated as red paint. Goya's "Disasters of War" are among the great purgatives in art. Use a small nib for copying agony. Beckmann did drawings in a military hospital. They were sharp and expressive.

After Beckmann

The blood is bloodier than Beckmann's blood-red paint. It ran downwards in the crucifixion. Now, in "The Descent from the Cross", the flow is upward.
Otto Dix was eloquent early on, when his effects were sore. An art-sore with pus!

After Rembrandt

Degas

DEGAS WAS BORN LUCKY. Like Cézanne, he had a banker father. He was taught by a pupil of Cogniet, the teacher of Delacroix and Géricault, at the most prestigious school in France, the Lycée Louis-le-Grand. His baccalaurèat showed he was clever. He was set to study law, but wanted to be a history painter. He enrolled at the Ecole des Beaux-Arts. He took from the system what was useful – he was no rebel, but he did not stay, he did not need their bursaries or prizes. He went to Italy, did life-drawing at the Villa Medici (the French school in Rome) and copied hard any art that caught his attention.

He loved copying. In Italy, for example, Venus from Mantegna's "Pallas Expelling the Vices from the Garden of Virtue", Raphael's "Galatea", Michelangelo's figures from "The Last Judgement", Donatello's "David", and many others. (A less usual copy was of Botticelli's "Birth of Venus".) Often, the models

After Degas

at the French school took up poses to be found in masterworks. Degas copied all his life, rather like Dracula, with blue-blood going for the best art-blood. And he had a blood bank, a massive collection of 20 Ingres paintings and 88 drawings, 13 Delacroix paintings and 200 drawings, hundreds of Daumier lithographs, eight Manets, seven Cézannes, two van Goghs, ten Gauguins, and many more, including Pissarro, Mary Cassatt, and Berthe Morisot. He was a worried, unmarried snob, cruel and privileged. But he was about the most "well-educated", and self-educated painter who has ever lived. His late pastels are among the top wonders of the world.

A copy after Marcantonio Raimondi's engraving, after Michelangelo's "Battle of Cascina". Late Degas pastels echo this pose quite often.

"Woman at Her Toilette". Unless your copy is large, pastel pencils are convenient.

After Degas

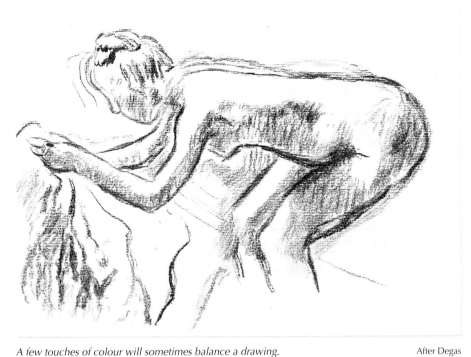

A few touches of colour will sometimes balance a drawing.

After Degas

After
Degas

After
Degas

A figure from Michelangelo's "Last Judgement". It was probably chosen because it is low on the wall of the Sistine Chapel.

After Degas

Copy from Botticelli's "Birth of Venus".

After Degas

The charcoal dabs glitter like paint, any addition of colour would be irrelevant.

A sculpture of a pregnant woman. Degas sculptures had a big influence on Giacometti, and the small Matisse bronzes for the chapel at Vence. Manipulate wax Plasticene or clay, feel your way around a figure. Although his callipers were said to raise blood, his sculptures were erotic, never masochistic. Draw from what you have moulded.

A copy of a Degas drawing

After Degas

After Gauguin

Degas admired Mantegna. This is copied from "Pallas Expelling the Vices".

Awkward poses were a reaction to a "salon" sweetness.

After Degas

Trees and Torsos

GREAT PAINTINGS ARE DONE at a remove. Some painters need to work further away from their subjects than others. Bonnard said that painters need protection when nature is visible, and that Cézanne took from the visible world only what fitted in with the very definite idea he had of his picture. Bonnard said also that Renoir painted models for movement and form, but never copied them. (Renoir exhorted Bonnard to: "Always embellish!") Bonnard said about himself that he was weak when his subject was in front of him, but that this was not the case for Titian. So be warned – but be brave! See how Odilon Redon, after a careful pencil study of a tree, was able to create the visionary trees for his strange worlds.

Young trees dwarf humans less than high ones. Even a little tree may be 20 times as high as a canvas. A human torso is sometimes called a trunk. There are tree trunks which resemble bodies, by van Gogh, Constable, Redon, and many others. There are paintings by Poussin, Blake, and Mantegna of figures turning into trees. You resemble a tree, smooth if young, crinkly when old. Imagine brushing paint from your feet upwards, or believing your hips are where the roots emerge from the earth, and your arms are like branches as in Poussin's "Apollo and Daphne".

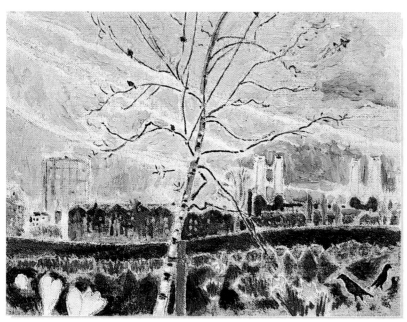

This birch divides the picture, supports the birds, and is not so large that the crocuses and daffodils disappear.

Crocuses and Battersea Power Station, 1994

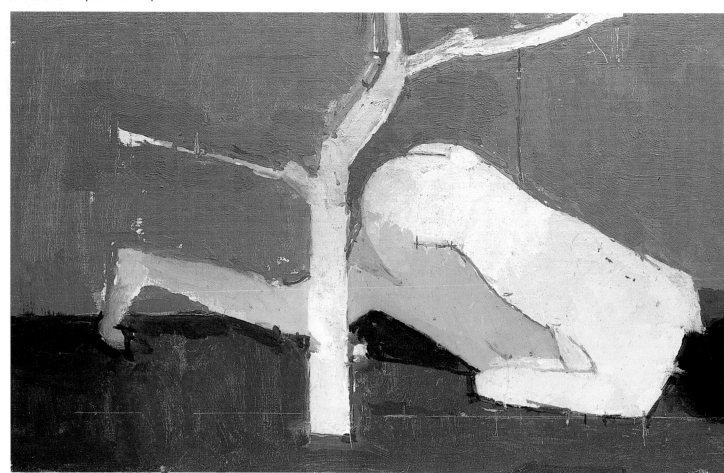

With knowledge of American abstract painting, and Matisse, with a girl in a hard pose, the picture is at a remove. Hard, as if cut by a laser in steel. Blue recedes, so the surface is controlled by plain areas, marks, and seams. The law is done, and is seen to be done. This beautifully designed nude figure – done manfully, in the corset of a broken tradition – rhythmically suggests other branches of the tree.

Euan Uglow, *Nude*, 1990

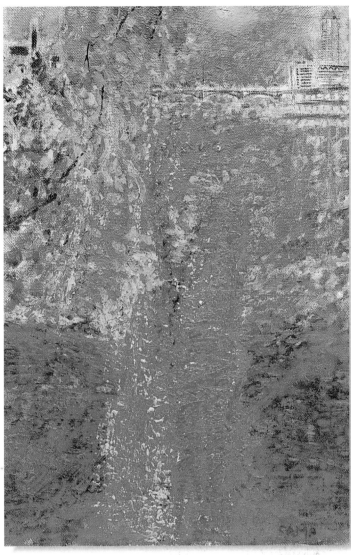

The austerity of this Mantegna design makes it possible for the strangest events to be acceptable in his pictures.

Chelsea Harbour was the region of the Thames where Turner saw the sunset from his house. Coal fire pollution made wonderful reds.

Chelsea Harbour, 1988

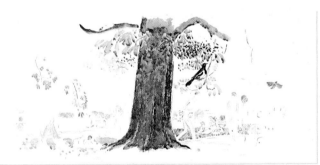

The vignette form enables the painter to choose to look at only what interests him. Art historians would call it a "study".

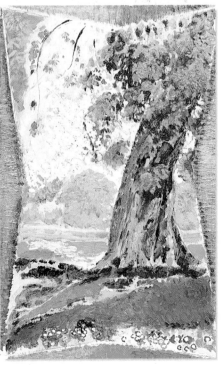

A treebole on Clapham Common

Horse chestnuts are early to burst with leaves. Dab the greens golden with cadmiums.

Doff a Hat to Cézanne

Picasso painted Cézanne's hat, partly in homage, and partly to see what his new Cubist style might gather from the French tradition and the master of Aix.

Cézanne generally wore black when painting outside, probably to prevent reflections. There is a self-portrait of him wearing a grubby black suit and a bowler.

Picasso gently adapted the little sensation before nature style of the great painter who had died two years before. Picasso painted a portrait of Cézanne as a hat. The drapery stands for Mont Sainte Victoire; it resembles his usual triangular still-life shape. There is a still life by Cézanne in Cardiff where the drapery exactly follows the skyline shape of the mountain.

Hats are eloquent. Wearing a cloth cap himself, Léger painted boaters, bowlers, and cloth caps, moving through the social classes. He was determined not to look like a banker.

In Cézanne's day everyone wore hats. Renoir included more than 15 hats in his "Rowers at

Sweatbands and headsets

Luncheon". He loved painting hair and hats; their softness anticipated the blending, soft touches of Bonnard. He had a store of hats that he would give to girls who sat for him. The hatter showed me with a grand flourish how to fold the comfortable, traditional, handmade panama straw hat. Paint this strange familiar form, which seems more like a Möbius strip than it is. Paint it side-on, upside-down, end-on, squashed, and also on a head. The head, once hatted, immediately adopts an insouciant raised eyebrow.

Imagine and paint diagrams of a panama hat brim as if the crown had been removed. The brim tilts at the front and curls up at the back. Imagine a straw hat with a Möbius strip brim.

Sweatbands, hatbands, and headphones mark the way around heads.

Paint the happy summertime hat. Draw and dab. Ochre some white, or pink some lemon. Do it over and over, the hat-rhythms will recur perky as ever. Tradition has you in its grip.

"Cézanne's Hat"

After Picasso

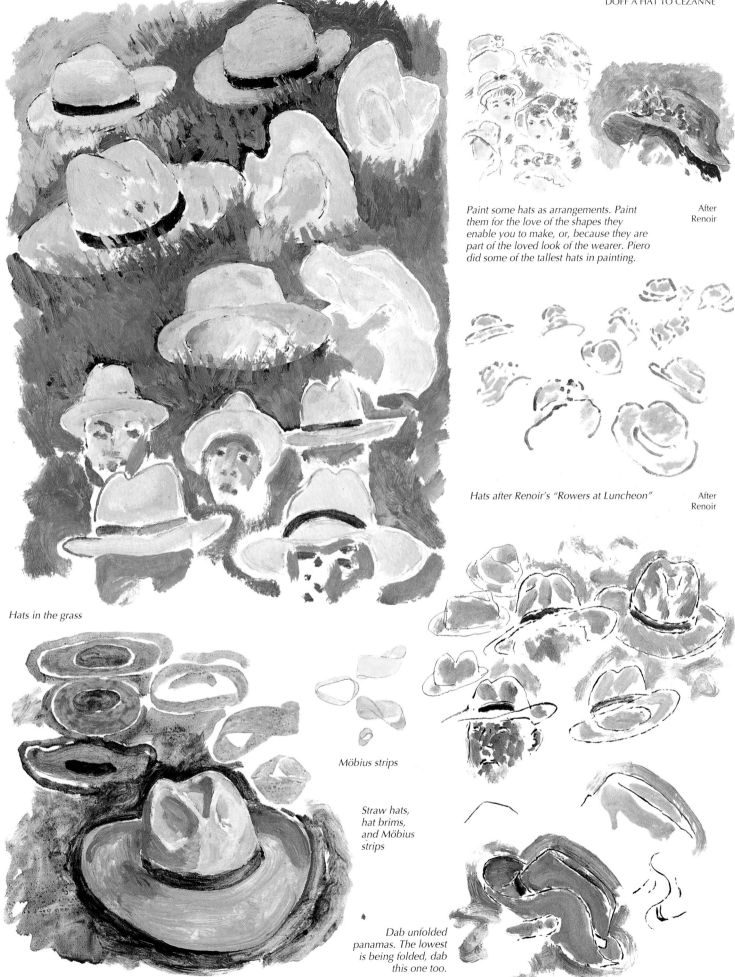

Paint some hats as arrangements. Paint them for the love of the shapes they enable you to make, or, because they are part of the loved look of the wearer. Piero did some of the tallest hats in painting.

After Renoir

Hats after Renoir's "Rowers at Luncheon"

After Renoir

Hats in the grass

Möbius strips

Straw hats, hat brims, and Möbius strips

Dab unfolded panamas. The lowest is being folded, dab this one too.

253

Daumier

AUMIER MIGHT BE CALLED AN "EXPRESSIONIST" caricaturist. He was also a sculptor and a great painter. In his time, handwriting was "copperplate". James Gillray, Thomas Rowlandson, and Daumier used pens with a similar flamboyance in their drawings, squashing and undulating to biting effect. Daumier was generous and masterly in every medium. In his life he did four thousand lithographs, one thousand wood-engravings, three hundred paintings, and hundreds of drawings and watercolours. He knew exactly how to use tame lines to make his main lines work dramatically. He scribbled webs of dancing lines, then tore across them great spoon shapes of black ink, driving home his poignant sensations.

Daumier said: "We have art as consolation. But what have these poor wretches got?", while walking in a distressed part of Montmartre. Daumier was close to a harsh world. He went

to prison because of a political lithograph, and would have understood the newspaper deadlines the Ashcan artists had to keep to, in New York a century later. Perhaps you know the story of Glackens who, as a cub reporter, had to break into the room where a murder had taken place, sketch the body, and finish drawing the surroundings from memory before the next day. Edward Hopper, John Sloan, George Bellows, Jack Yeats, and Daumier might all have met that "dead" line.

Copying Daumier with scribble, you will need all your bravery. Daumier scribbles to measure; he captures life and light and is urgent as fisticuffs. He was too much for me. He made a mock of any ideas I had about painting not being drawing, or vice versa.

A caricature lithograph by Benjamin Roubaud (below, centre) tilted Daumier's 29-year-old nose to a cheeky angle. Caricaturists live off noses. Recently, a well-known politician's nose was made as a beak. As a child, I watched Punch and Judy day after day. They prevented me liking marionettes and puppets. But Punch had me by the nose.

Is the buyer acquisitive, avaricious, or happily appreciative? Sometimes, painting takes charge, and Daumier becomes as free from narrative as Braque.

After Daumier

Don Quixote and Sancho Panza must be drawn with a brush – here, drawing is painting.

After Daumier

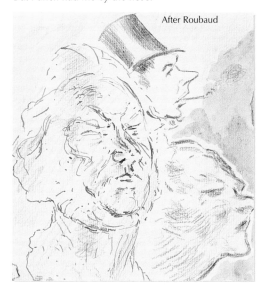

After Roubaud

A "Self-portrait" (left); and the nose of an inquisitive valet approaches the keyhole.

After Daumier

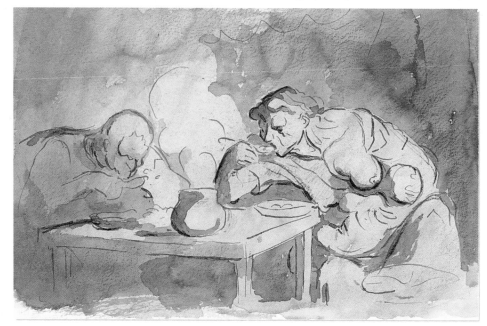

After Giacometti

A desperate consumption of soup supplies the baby.

After Daumier

"The Nose". A very long nose – long enough to cease being caricature.

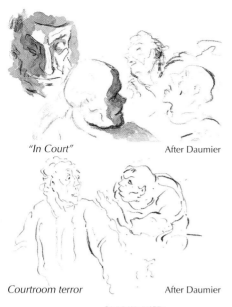

"In Court" After Daumier

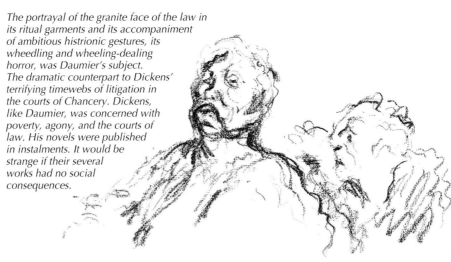

The portrayal of the granite face of the law in its ritual garments and its accompaniment of ambitious histrionic gestures, its wheedling and wheeling-dealing horror, was Daumier's subject. The dramatic counterpart to Dickens' terrifying timewebs of litigation in the courts of Chancery. Dickens, like Daumier, was concerned with poverty, agony, and the courts of law. His novels were published in instalments. It would be strange if their several works had no social consequences.

After Daumier

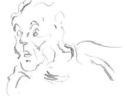

Courtroom terror After Daumier

Three Shakespearian witches (from Macbeth) After Daumier

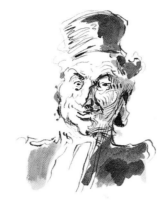

A jolly lawyer After Daumier

Some of the wildest marks in art, and real enough to make my drawing look weak. Daumier needed nerve. We must take nerve, courage, bravery, and something black, to draw these dew-lapped bucolics singing and drinking – one looking a little like Daumier, partnered by a rheumy-eyed clown.

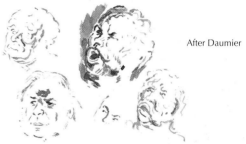

After Daumier

"In Court" After Daumier

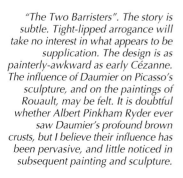

An advocate gestures dramatically. After Daumier

"The Two Barristers". The story is subtle. Tight-lipped arrogance will take no interest in what appears to be supplication. The design is as painterly-awkward as early Cézanne. The influence of Daumier on Picasso's sculpture, and on the paintings of Rouault, may be felt. It is doubtful whether Albert Pinkham Ryder ever saw Daumier's profound brown crusts, but I believe their influence has been pervasive, and little noticed in subsequent painting and sculpture.

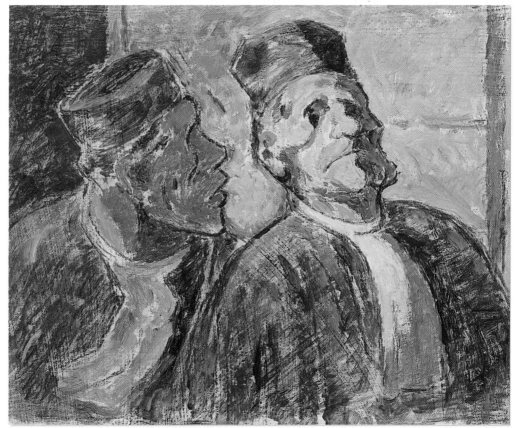

After Daumier

Props for Comedy and Agony

"From the sacrum to the sacred."
Pablo Picasso

GROUCHO, THE MARX BROTHER, had a black moustache. Harpo, a harp. Charles Chaplin, a cane and baggy trousers. Tommy Cooper, a comic clown, possessed a bag of objects as props for his gags. Painters gradually assemble the props they need for expression. Dali used crutches and ants; Matisse and Ben Nicholson collected jugs and objects, which they could paint throughout their lives. Picasso said: "It isn't any old object that is chosen to receive the honour of becoming an object in a painting by Matisse."

Picasso clowned with props for friends and photographers. Always energetic as a painter, in the 1930s anguish was in the air, and he needed props to trigger terrors. He had known the ritual of the bull-ring from infancy, and drawn a goring when only

After Picasso, after Grünewald

nine years of age. Picasso's continuous subject was death. The *corrida de toros* supplied horns, blood, heroic toreadors, piteous horses, injured men, bulls, and death.

In 1930, Picasso made a prop-filled picture – the most complicated, experimental picture he ever painted, and it was never repeated. Red for blood, yellow for sand, white for a bony scare. A Garcia Lorca-dramatic, lilac-runged-and-laddered death. He was trying to make a universal painting, a corrida-crucifixion picture. He did what he was to do all his life: he made a list in his mind of what he wanted, named or unnamed, and this list became the picture. Often, this did not involve making studies. Dots stand for nostrils or noses, eyes or nipples; Picasso fills in what only Picasso knows. I would not dare to list Pablo Picasso's components. But, as I was sketch-copying, some words came to mind. They surround the main picture.

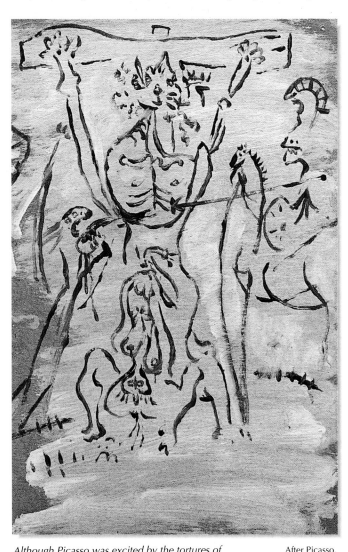

Although Picasso was excited by the tortures of Grünewald and the North, it was the stabbing pains of the South that were to be more influential for the rest of his life.

After Picasso, after Grünewald

After Picasso, after Grünewald

After Picasso, after Grünewald

Sponge Horse-rider Hammer Underarm hair Teeth Small figures as parts of large figures Goggles Necklace

Hair

The rending of the veil of the temple Lightness of Christ The Dinard-bone-sculpture-face of Mary Magdalene Applauding spectator

Blood red sky

Head Wound Lance Ladder Nail Feet Buttocks Sun Girdle Clasped hands

Hand Dark Torture Corn god Grass White faced clown

Torreador-legged soldier

"The Crucifixion" After Picasso

Robe Cross Cross of Golgotha

Corrida sand or sawdust colour Tree or river of life Green hill

Two crucified thieves Cloak Soldier Soldier throwing dice Green god

Dicing for Christ's robe White tighted leg Helmet Jaws Red rays

Water Green raiment Dance of Death The Praying mantis Drum Suture for cranium skull The Madonna

After Picasso, after Grünewald

The tortures of Germany hurt to a different rhythm from those of Goya, or even the wounding pains of Rembrandt. After Grünewald

257

Comical Painting

TWO MASKS PORTRAY COMEDY and tragedy, one white, the other black. Grin and bear it. Laughter is a release from dangerous tensions. The range of comic art is wide, but the main religions, and profound art, do not allow release through laughter. If you flick through a few years of *Punch*, you will not chortle. It was so much to do with the etiquette of the day.

Today, the stand up comedians are thrashing around (with ever diminishing returns) with what few rudenesses are left to them. As there is nothing intrinsically funny about the loins, I think they will have little to depend on, except the "funny walk".

Thomas Rowlandson, a great artist, is safer. His plump forms are compassionate expressions of human frailty. When, in his watercolour the pompous ladies topple on the staircase of the Royal Academy, they

do not suffer injury, except to their pride. With a demolition of these harmonious curves, Gillray would have seen that there was blood around. The gorgeous bottoms of Rowlandson become bloated when Robert Crumb draws his cartoon fundaments.

The comic arsenal of forms is plundered from time to time. The American comic strips were enlarged and made serious by Roy Lichtenstein. There are grotesque caricatures by Dürer and Leonardo – to make us feel handsome; Picasso's "Fish hats" – to show how witty he is; and the gargoyle heads of Hieronymus Bosch's distortions, in "Christ Carrying the Cross", air their gums. Fun art expands the compendium of forms for serious painting. When James Thurber draws a fish, it is not very different from the way Matisse draws a study for a ciborium. But one is drawn for laughter, and the other is not.

After Matisse

Kondracki, taking his little boy to the zoo. The gorilla looks with such power, Henry does not know which side of the bars he is on. Brush strokes are made into wet, stretched paper. (Wet paper is gum-stripped to a board, to prevent cockling.)

Henry Kondracki, *The Zoo*, 1990

"Stolen Kisses". I might have done better with a quill pen. Many rude and charming Rowlandson drawings are in the Queen's collection.

After Rowlandson

Fish hats tilting against fashion

After Picasso

Joyful fauns

After Picasso

Sketchbook copy of a Picasso

After Sutherland

The artist has made his own head open to the world. His brain, worries, traffic, money, socks, and clocks are all visible. See the Universal Perspiration (in the form of large globules of metal, painted blue, as sweat). Mankind likes to know that others also sweat with anxiety.
Paint a strong-box and paint it full of your troubles. Find simple object-images to signify your anxieties. Ferret-burglars tore the memories of your friends in the night. Paint them back before you fail them worse. Drip-in the ills of the world to fill Pandora's box, and shut the lid fast.

Neil Jeffries,
Anxious Head, 1985

Neil Jeffries said: *"Anxious Head"* was made with youthful aggression. Half a head confesses, clipped open like a boiled egg. It releases a pile of things, a descending boot, Belisha beacon, coffin, car engine…intimations of usual fears, some depicted bluntly, others vague.
The pink thought-bubble alludes to a boy scout puberty ritual, remembered domino effects of association and a desire to wallow in corny and comical imagery.
Oil and enamel paint happily take to the primed riveted aluminium and the pastel fleshly quality is achieved by adding the colours to the priming itself.

One can almost imagine the story. Thurber is nearly as simple as Matisse, but for a different purpose.

After Thurber

Grandma is drawn with black inked teeth, like a fortified armchair.

After Giles

"The Fort". To copy the jailor, one has to learn cross-hatching.

After Rowlandson

"Christ Carrying the Cross"

After Bosch

Art Diaries

AT THE END OF EACH DAY, Samuel Pepys wrote in his diary "and so to bed". What happened there demanded some kind of cipher. Picasso's was a visible life, on display even to the underpants. He signed and numbered his pictures like a toreador scoring killed bulls.

A book recording the pictures done, and your thoughts from day-to-day, may be useful. Often the only remains of a bonfire of pictures is a scribble in such a book. If it is done long enough, an evolving pattern becomes apparent. I found springtime made me nervous, searching, wanting to sketch. Autumn was a recollecting, tranquil time. January was when the big pictures happened. Each year in July the dandelions declare that the summer will find you needing more yellow and drinking more lemonade.

Your book, including all the enchantments of an artist's life.

An oeuvre is a diary without words. A book about your art can take various forms. It can resemble a dealer's stock-book. Mary Potter made a photograph of one of her pictures on each page of a very professional book. It can be a sketchbook full of trials, like a Beethoven bird's-nest of crossings-out. I do not have time to write about exhibitions seen or the people I meet, and I do not often look back. How much do we carry in memory? Sometimes, a memorable exhibition, or a nasty accident, will shorten the years. Writing this book devours time; yet while actually writing, time is suspended, and there is nothing to remember! Seeing your old pictures is sometimes useful, as you find paths abandoned, that you could still follow. But take care! In effect, keeping such a book makes the artist more aware of his activity. A mixed blessing!

Two pages from a notebook of pictures, 1973/4. Buy a notebook. Perhaps a loose-leaf binder would be useful, with transparent pockets if you wish to include cuttings, photographs, and other ephemera. Write the year at the top. This alone will frighten you into painting new pictures. Sketch a diagram of each picture. Indicate its measurements in centimetres (vertical before width); where exhibited; the name of the buyer, if sold; the price; or whether destroyed. I found it useful to list the materials used in unfinished pictures, as I would forget colours, and found it difficult to achieve the original mixtures. Kitaj likes to write about the subjects in his pictures. Books and paintings can blend enchantingly, as with William Blake's illuminated poems. Braque, Matisse, Rouault, and other painters have made beautiful art books. But there are also painters who do not write much, and scarcely read. Alfred Wallis was good enough, without words.

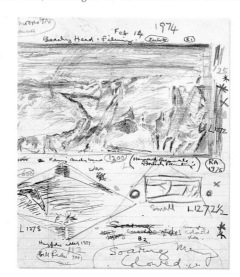

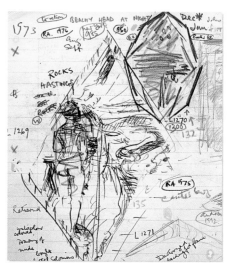

An exhibition planned long ago. Little diagrams of pictures, drawn in proportion, are useful when arranging works for an exhibition. When done on graph paper, you know immediately whether they will fit.

Diagrams made to decide which pictures to hang in an exhibition at the Browse and Darby Gallery.

Mitsou is a story about a child and a cat. Using a brush loaded with non-waterproof ink, draw Mitsou cats. Balthus was 12 in 1920, but cats were always to be important to him.

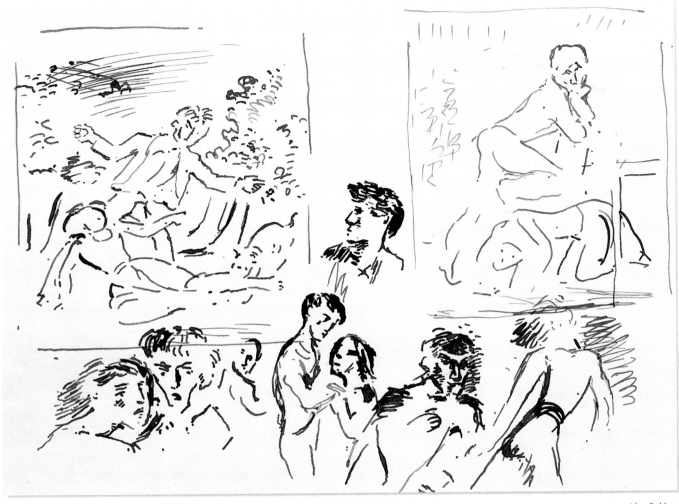

The illustrations for Mitsou, *and later for* Wuthering Heights *contained the seeds of his subsequent pictures: girls, self-portraits, cats, and a mysterious atmosphere. Tenniel, Lewis Carroll, and Courbet were seminal.*

After Balthus

After Balthus

After Balthus

The title page to Jerusalem. The Emanation of the Giant Albion.

After Blake

261

"Fire and Sleete and Candle-lighte"

THIS IS FROM "THE LYKE WAKE DIRGE", a mediaeval ballad that was set in Igor Stravinsky's *Cantata*, and by Benjamin Britten in his *Serenade*. Bela Bartók collected folk-songs. He knew that only significant matter would have moved from throat to throat through the ages, and that country singers were vanishing fast. Great painters and composers value the images that have stood the test of time. All races and religions have produced symbols. They are the stuff of dreams, and form the base material for art.

A cave bison, an Indian sacred buffalo, and a Picasso bull resemble one another. Living in a forest, you will have trees in mind; living surrounded by sheep, you will imagine sheep; living close to our bodies, the figure generates powerful imagery and scalding symbolism. Most strong images are adaptable. A Rose, a Cross, a Fish will inhabit all kinds of paintings. It has been an extremist fashion to attempt to eliminate symbols from pictures – like draining the blood from a body! It was an attempt to jump tradition. Symbols can be boring, if they are not integral. Implicit symbols can spark, shock, and invigorate the ganglia, tingle the spine at the seventh cervical, and make paintings come alive.

Take a brush. Read a John Donne poem. Then read this list of words. The verbal and visual can meet. A word: in the beginning was the Word. An arousal, a seed for embellishment, that will germinate as your hackles rise. Daub a diagram for any words that have a meaning for you. The image demands: see what happens. Scribble the mythical. Try a depiction of a non-image. You may find this a difficult and worthless activity. Brush a comment. See Morandi. His images were pot-shaped, and his images were also the shapes between pots. Klee and Picasso raided the world for images, and were often satisfied with a jug or a skull, a bull, or a cat.

Peacock. Swan. Windmill. Tears. Hourglass. Golden bowl. Serpent in cup. Window. Hands. Lily growing from a mouth in a grave. Lion. Money-bags. Mice. Lock on lips. Dragon. Sickle. Locust. Feather. Pistol. Pitchfork. Sun. Frogs. Plough. Quiver with arrows. Raven and ring. Bridge. Ring in the mouth of a fish. Rosary. Rose. Dying on a bed of roses. Saw. Scales – a devil in one pan, a white figure in the other. Globes. Scorpion. Scallop. Sieve. Skull. Spider over a chalice. Star on breast. Falling star. Nimbus of stars. Thorn. Tower. Winged trumpet. Well. Flaming heart pierced by two nails. Cave. Horseshoe. House burning. Knife. Breasts on a book. Island and serpents. Ladder with angels. Man clothed with leaves. Snail. Owl. Poppy. Yew tree. Hand of Glory. King Herring with red-tipped fins. Playing cards. Banner. Severed hand. Crib. Caterpillar. Breasts cut off. Scapula. Thorns. Knots. Hat. Hare. Harvest moon. Hedgehog. Heron. Leek. Hunchback. Mandrake. Mushrooms. Mirror. Lizard. Mistletoe. Chair. Red thread. Robin. Lily. Goat. Drum. Eggs. Adder. Spoon. Arches. Ants. Beans. Fir tree. Beetle. Bells. Blackbird. Door. Black cat. Black sheep. Bolt. Bones. Boots. Butterfly. Buttons. Cakes. Hook. Pins stuck in a candle. Twigs of Mountain-ash wound with much red thread. Clock. Cuckoo. Dog. Fern. Wolves. Frying pan. Gull. Gorse. Fleas. Ear. Hammer. Thorn-bush. Castle. Pincers. Devil in child's mouth. Child in oven. Chest. Corn. Diamond falling in chalice. Dog with loaf in mouth. Dolphins bringing body to land. Dove above a column of fire above a head. Caterpillars and tree.

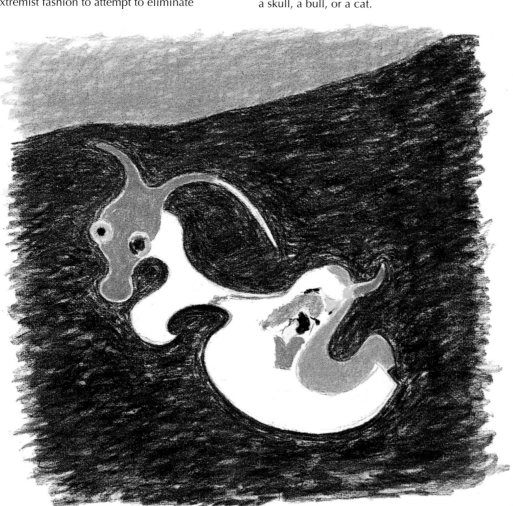

"Landscape (The Hare)"

After Miró

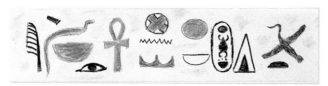

Egyptian signs

A play of symbols

A play of symbols

The Lusty Hare

CHRISTIAN SAINTS TOOK OVER many of the early pagan images. Symbols become buried in painting as they do in words, but their power can remain. Mickey Mouse is not only a mouse, and the original meaning "God Blind Me" is not entirely absent from "Cor Blimey". Candles flame through time, and the electric light bulb high in Picasso's "Guernica" has to be an equivalent. The lights were going off all over Europe. Picasso said he wanted to use "a casserole, any old casserole", he wanted it to express the boring negation of 1945. But when, in "The Charnel House" – his confrontation with the foulest of annihilations – he uses the casserole to stand with the jug, as imaging the commonplace, it does not help to shrivel the mind. Neither for The Crucifixion, nor for The Holocaust, did he find those powerful symbols he could use for full Picasso force.

After Picasso

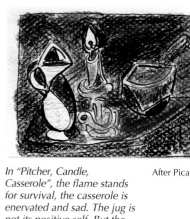

In "Pitcher, Candle, Casserole", the flame stands for survival, the casserole is enervated and sad. The jug is not its positive self. But the casserole and jug in "The Charnel House" express nothing about the subject.

After Picasso

Jug and Casserole from "The Charnel House". Picasso said: "I want to tell something by means of the most common object – for example, a casserole, any old casserole. The one everybody knows. For me, it is a vessel in the metaphoric sense."

Female devil with horns. Dromedary. Geese. Cow. Cave closed by cobweb. Fiery chariot. Comb. Flaming cloud. Child blowing bubbles. Coffin in boat. Cornucopia. Crutches. Crocodile. Jewelled cross of stars. Beehive. Bed. Brazier. Bellows. Birds dropping flowers. Millstone. Bearded woman. Block. Boar. Book pierced with a sword. Bear. Fountain. Cauldron. Bull. Burning Bush. Broom. Scroll. Anchor. Lantern. Chains. Gibbet. Globe fired by a dog with a torch in its mouth. Fiery-tailed foxes. Vases. Severed head with palms sprouting from the neck. Fleet of ships. Roses in lap. Footprints. Fish strung on two keys. Crucifix of leaves and flowers. Cloven head. Eagle.

There are powerful symbols, in many lands, not listed here. For instance, Australian aboriginal pictographs, or the Feathered Serpent of Mexico – and as many more as there are stars in the Milky Way.

A jug in many transformations

After Picasso

A play of symbols

Doodle-symbols in charcoal

*A bull's skull for death, and a
flowering tree for springtime.*

After Picasso

After Picasso

CONCLUSION
Real Shocks are Entrancing

MASACCIO'S BRANCACCI CHAPEL in Florence shocks. It shocked when it was brown. It shocks today. The extreme ways of painting do not surprise as once they did. We are now accustomed to very large pictures, thick, thick, paint, extreme gestures, empty canvases, and bright colours. Extravagant manners now have less impact. Yet art has to shock. It must shock like new love, like early morning – like a morning-glory flower newly opened! Art is sensed, and today the senses are assailed constantly. A shock, for many people, would be to be quiet and alone.

The technical requirements of learning to paint change little. Practice, and an appetite for looking, so that we do not get bored, are important ingredients. Art schools of Cézanne's day demanded several hours daily of rigorous drawing and painting from the antique, and later the figure. Cézanne liked drawing the statues in the Louvre. My father was given a place at Great Yarmouth Art School at the turn of the century, where students had to draw plaster casts from the antique. To him, the prospect seemed appalling and he quickly left. The Slade also imposed a firm discipline on staff and students. It allowed William Roberts to produce a painterly drawing of himself aged 17, and Stanley Spencer to paint his own head superbly aged 22.

"I think," said the child, "and then I paint my think." (I wonder who told me this?) It would work better if it went: "I see, then I think, then I paint my think." To see is the most important thing to do after breathing. A cultivated art-language could be ours before we learn to speak. They learn the violin at four; painters should not need to be trying to learn technique all their lives. Think how good it would be if we could change sight to vision, as soon as we first discovered perspiration.

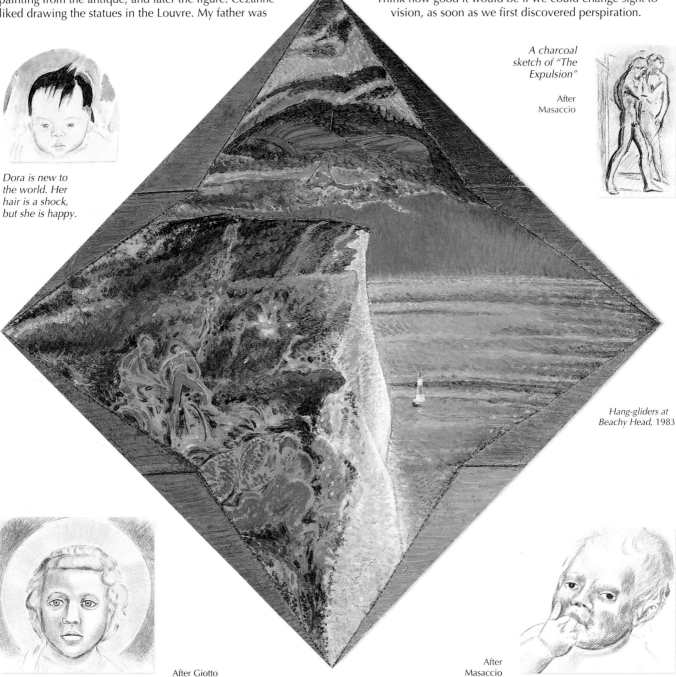

Dora is new to the world. Her hair is a shock, but she is happy.

A charcoal sketch of "The Expulsion"

After Masaccio

Hang-gliders at Beachy Head, 1983

After Giotto

After Masaccio

The Seven Sisters at Birling Gap. The earth seen from the moon is special. But, visually, it is nothing more than cream stirred in coffee. The moon from the earth looks similar, but creamy. Subjects are as they appear, modified by what you bring to them.

This slightly tilted oval finds me perched once again on the hilly cliff at Birling Gap. At break of day, the balmy, salt, herbal wind crazes the vast reflection of sun-drenched cliffs. The chalk gleams like milk in the water, like ricotta cheese, like the white whale, Moby Dick, like pearls in mussels, like moons on clouds, like puffballs, like pale wings, like new white canvases.

"The Expulsion" (detail)

After Masaccio

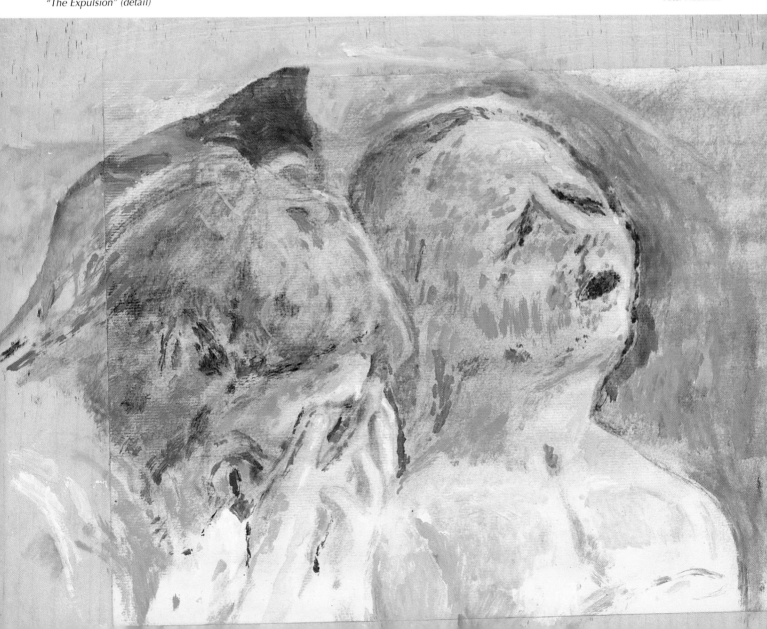

Index